THE RED DEAN

DEAN

OF CANTERBURY

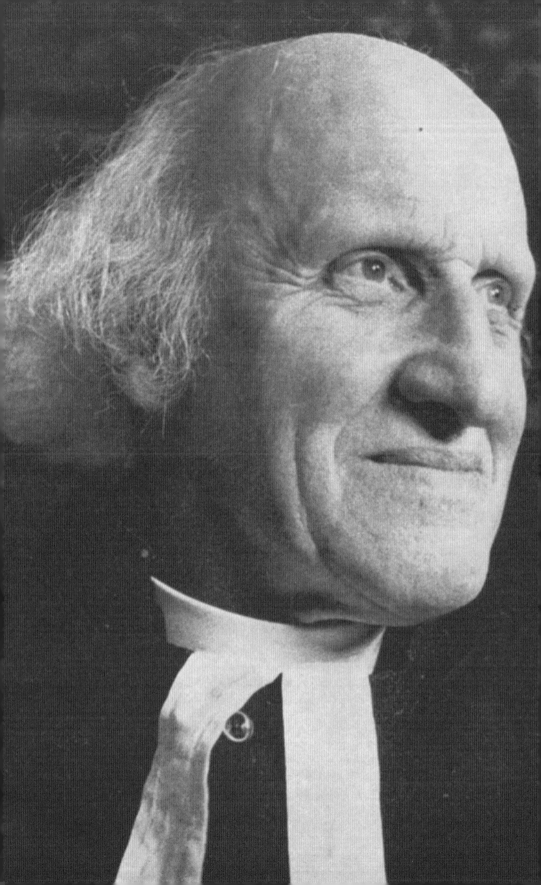

THE RED DEAN

DEAN

OF CANTERBURY

The Public and Private Faces
of Hewlett Johnson

JOHN BUTLER

S C A L A

This edition © Scala Publishers Ltd, 2011
Text © Dean and Chapter of Canterbury 2011

First published in 2011 by
Scala Publishers Ltd
Northburgh House
10 Northburgh Street
London EC1V 0AT, UK
www.scalapublishers.com

In association with Cathedral Enterprises Limited

ISBN 978-1-85759-736-3

Typeset by Seagull Design
Printed in Spain

10 9 8 7 6 5 4 3 2 1

Page ii: Portrait of Hewlett Johnson, probably 1940s
Page vi: Hewlett, Kezia and Nowell Johnson in the Canterbury deanery, circa 1946.

CONTENTS

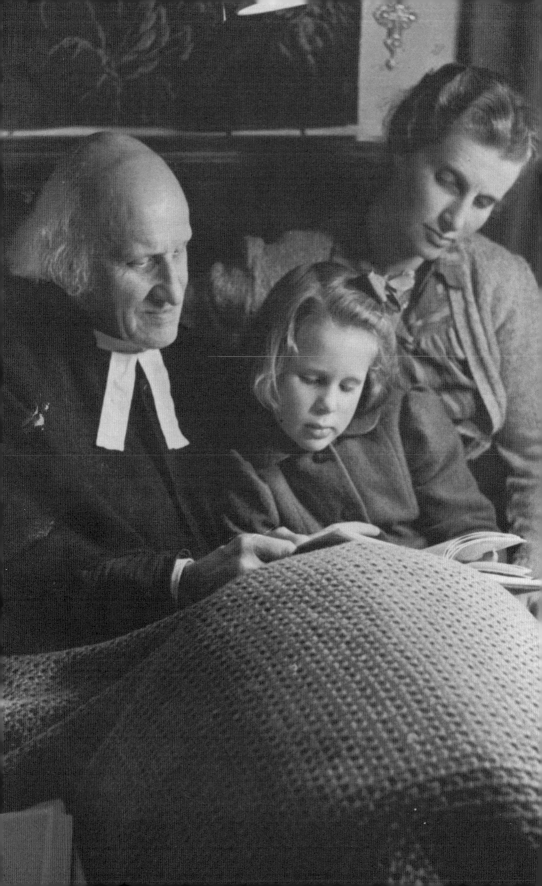

FOREWORD

BY KEZIA NOEL-PATON

A NY BIOGRAPHER RELIES heavily on his material, and in my father's case the sheer quantity of it is almost daunting. When Hewlett retired as Dean of Canterbury Cathedral in 1963 and we moved from the Deanery, my mother Nowell filled a large garden shed with box after box of letters, sermons, certificates, speeches, newspaper reports of meetings and events, and a vast number of photographs. When she died in 1983, we found still more piles of paper at the top of her house in Canterbury.

Many painful controversies had attended Hewlett's last years as Dean, and Nowell eventually decided that she would prefer her husband's papers to be sent to the University of Kent at Canterbury, there to be kept for posterity on permanent loan. Our family was most impressed with the care and trouble taken by the Librarian and the staff in the Special Collections in sorting and cataloguing the papers, and also by Professor John Butler who joined in the mammoth task. So in 2007 my sister, Keren, and I decided to convert our mother's loan of Hewlett's papers into an outright gift to the University.

In writing this book, John Butler has meticulously examined this huge archive and has spoken at length to my sister, myself, and our respective husbands. He has also talked to as many of those who remembered Hewlett and Nowell as has been possible. His portrait of 'The Red Dean of Canterbury' brilliantly captures the public figure, unashamedly controversial, his life filled equally with adulation and hostility; but inevitably in such a work, it is more difficult to catch the intimate, domestic side that, as his daughter, I so well remember.

For example, the majority of the pictures in the archive were taken by professional photographers at public occasions or posed in the house or garden. There are very few informal shots of Hewlett with his family and only a tiny handful taken at Llys Tanwg, the house that he owned near Harlech in North Wales where we young children spent the war with our mother. There is just one small snapshot of him holding me as a baby outside the house, and there is also Nowell's watercolour sketch of him working by a window. Yet Hewlett's brief wartime visits to Llys Tanwg were more important to him than the long weeks and months spent apart

from his family. The letters in the archive tell of the joyful anticipation of these visits and of his sadness as he returned, all too soon, to war-torn Canterbury; but when we were together in Harlech there was no need to write, so the archive has no record of these happy family times.

My parents wrote to each other almost every day during the war, sometimes more than once, and Nowell's letters tell of the many problems of her life at Llys Tanwg bringing up two small children in a changing household of relations, friends, servants and evacuees, all with their own, usually stressed, agendas. Hewlett's letters are a mixture of support, comments and advice to his young wife, jumbled up with accounts of dissent among the canons and reflections on the ominous events taking place in the world. It is sad to realise that, during those wartime years, he never enjoyed Christmas, Easter or birthdays with my mother and us children; but of course this was the case for so many families at the time.

* * *

Keren and I got to know Hewlett much better when we finally returned to the Deanery in Canterbury after the war, though the archive makes no mention of him running along the downstairs passage with the three year-old Keren on his shoulders and I following anxiously, hoping that he would remember to stoop as he went under the low arches. It is astonishing to recall that the man who, in a single year, had private conversations with Generalissimo Stalin and President Truman was also the loving father who carried me around the room, pausing to let me turn the light switch on and off while he sang 'Linger longer Lucy' and 'My mother said that I never should play with the gypsies in the wood' – music-hall songs from his own youth. There is nothing of this in the archive.

Again, the archive tells of Hewlett's huge ability as a speaker and his love of the drama of the great Cathedral occasions, but he also enjoyed telling us stories. A favourite was of the pet guinea pig he had as a child that became ill and would not feed. He thought to himself that when *he* was ill his mother would tuck him up in bed in a quiet room and give him warm milk to drink. So, thinking that his elder sister's room was suitably peaceful, he opened her bottom drawer, made a little nest in her best clothes, poured some milk into a saucer (slopping only a little) and settled the animal in. He was totally unprepared for the resultant hysterics when the young lady opened the drawer! His mother rebuked and then consoled him and explained that what the guinea pig really needed was a clean cage, fresh air and the right sort of food. It recovered. Hewlett would dramatically recount this story on numerous occasions, to our great delight.

Hewlett's papers are full of his love for Canterbury Cathedral, but there is no account of his taking my sister and myself to explore it on our return to the Deanery at the end of the war. Early in the morning, before the vergers were around, he would unlock one of the side doors and take us to see child-sized things – a little chapel with only six chairs, or a magical collection of white fairy-tale models of churches and cathedrals under glass domes in a hidden room up a narrow winding stair, or the tomb of a medieval archbishop, sumptuous in his robes but with his skeleton grimly visible beneath him.

Many of my father's ideas were ahead of his time: his acceptance of Darwinian theory, his respect for the demythologising of the Bible, and his conviction that the Church must be an instrument of social change. Nearer to home were his successful efforts at double-glazing and, more dangerously, his addiction to ball-castors that caused heavy furniture to scoot across the room and that was to lead, eventually, to a serious accident. The archive fails to mention his disapproval of our love of cornflakes and white bread for breakfast. He always ate brown Hovis for its roughage, a habit that would have pleased modern nutritionists. We compromised on porridge, which Hewlett made overnight in a double saucepan in the Aga. Standing on a chair, he would drop threads of syrup to make delightful patterns on the surface of our breakfast. After the meal, Keren and I would go and play in the bombed ruins of Canon Crum's garden, still rich with the most wonderful spring bulbs and blossom, though we never knew of the bad feeling that had developed between the former friends. Even the archive has little to say on this sad subject.

* * *

In every way, John Butler's work with the archive and his constant communication as the book has progressed has been an enriching experience for me and has told me so much about my parents that I did not know. Talking with him has brought new life and dimension to their memory, new knowledge of all the triumphs and tragedies, the pleasures and pains of their tempestuous lives.

My husband, Duncan, has two memories of Hewlett – one when he failed to meet him and one when he did. The first occurred shortly after the Second World War when Duncan's father, a recently demobilised Sapper officer and a life-long Conservative, took him to Canterbury Cathedral. Duncan asked if they were going to stay for a service and was told: 'Absolutely not! That dreadful man will be preaching.' The second was in Hewlett's extreme old age when I brought Duncan to meet my parents for

the first time. Brought up in Epsom, the town with the largest Conservative majority in the country, he was frightened to be left alone with Hewlett, who appeared to be asleep. Suddenly the famously rich voice spoke. 'Stalin was a great man', and after a pause, 'I knew Stalin very well.' It was to be their only meeting, but he autographed his book *Christians and Communism* in a shaky hand and later joined the party at a picnic on the Wye Downs. Duncan's abiding memory of his future father-in-law is of Hewlett sitting peacefully on a folding chair, enjoying the view and cradling a huge bowl of 'Deanery Trifle' in his lap.

Hewlett bought a number of properties in Canterbury and was therefore criticised for being a hypocrite, but he wished to provide for his much younger wife and family in the event of his death. Unfortunately, as a good socialist, he let the properties at low rents, and this led to exceedingly unsatisfactory tenants who were forward in demanding improvements but backwards in paying the rent. The rental income was therefore small and the flats became a millstone for my mother who had to look after them, including scrubbing the floors and searching for second-hand furniture when they changed hands. Money was tight at times, not least because of Hewlett's generosity to family members, friends and good causes; but I did not realise this until I found that the reason for the sale of one of his much-loved Tang horses was to enable Keren and me to go to medical school.

My father was warm, enthusiastic, generous and a staunch Christian. He was tolerant in matters of faith: when my godmother, Sybil Thorndike's daughter, wished to be married again after an unhappy first marriage, Hewlett had no qualms about performing the ceremony in the Cathedral crypt even though it was totally against the rules of the Church. He said that anyone in such a situation was most especially in need of God's benevolence and guidance. He was also greatly supportive of my school friend, Ruth Matthews, when she wanted to become a minister. She has this to say of him:

> In the early sixties, at a time when the ordination of women was rarely even talked about, I was struggling with the possibility of training for the Baptist ministry. I met a lot of opposition and some downright disbelief, but Hewlett Johnson was one of those who stood out by his encouragement and positive response to the suggestion. Not only that, he made me feel that he was treating me as an equal. He listened and talked with me, he gave me helpful advice, and he also gave me his annotated copy of the Synopsis of the Gospels in Greek – a gift that I

still treasure. I owe a lot to Hewlett Johnson for his interest and Christian commitment at that time.

* * *

As the years went on, my father's faculties began to deteriorate, particularly on the political front, and even after Nikita Khrushchev's famous speech in 1956 when he denounced Stalin and all his works, Hewlett stubbornly continued to ignore the fact that the communism that he found in the Sermon on the Mount was now aeons away from the communism practised by Russia and her satellite states. Inflexible to the last, he was unable to stand away and say to himself: 'I could be wrong.'

My mother was immensely loyal and supported Hewlett to the end, but after his death in 1966 she said to a long-standing family friend, Lois Lang-Sims: 'I do wonder if Hewlett and I did make mistakes.' Lois replied: 'Nowell, you and the Dean worked for what you believed to be the truth, and none of us can do more than that.'

My father could have no better epitaph.

INTRODUCTION

T HE VERY REVEREND Dr Hewlett Johnson, Dean of Canterbury Cathedral from 1931 to 1963, was one of the most articulate and controversial clergymen of his day. Born into a wealthy industrial family in Manchester in 1874, he trained as an engineer and read theology at Oxford before being ordained priest in the Church of England in 1906 and becoming the vicar of one of the country's wealthiest parishes. He became Dean of Manchester Cathedral in 1924 and, seven years later, Dean of Canterbury Cathedral. By the time he arrived in Canterbury in 1931, Hewlett Johnson had a burgeoning reputation as a radical clergyman whose left-leaning political views were already beginning to alienate him from the Anglican establishment. He was convinced not only that communism was far closer to the spirit of the New Testament than capitalism but that the Soviet Union, under the leadership of Joseph Stalin, was actually a more Christian country than Britain as it strove to create a just and equal society. And he said so from the many pulpits he occupied throughout the world. Inevitably, the 'Red Dean' (as he became popularly known) was the focus of both rapture and wrath. Depending upon where people stood, he was either the Prophet of the New Jerusalem or the Preacher from Hell. There was very little middle ground.

Hewlett Johnson first visited the Soviet Union in 1937 and made many subsequent visits over the next twenty-five years. He was in Moscow on VE Day in 1945 and later had a private audience with Joseph Stalin and Vyacheslav Molotov. In the course of a long career that did not end until his retirement at the age of eighty-nine, Johnson also had meetings with Mao Tse-tung, Chou En-lai, Fidel Castro, Josip Tito and other leaders in the communist world as well as being received in the White House by Harry S Truman. He was among the first Britons to witness the liberation of Auschwitz in May 1945 and he twice spoke to ecstatic audiences of twenty thousand in Madison Square Garden in New York. His second speech there in 1948 was heard by a young journalist from the *Manchester Guardian*, Alistair Cooke, who used it as the basis for one of his earliest 'Letters from America'.

As Dean of Canterbury Cathedral from 1931 to 1963, Hewlett Johnson achieved a great deal in the teeth of fierce opposition from his colleagues in the Cathedral precincts. He brought the worlds of art, literature and music to Canterbury and he led the Cathedral community through the dark and destructive days of the Second World War. In 1951 he was awarded the Soviet equivalent of the Nobel Peace Prize, following in the footsteps of Pablo Picasso to whom it had been awarded in the previous year. Johnson's path crossed with those of several major political figures on the world stage from the 1930s to the 1960s. Mahatma Gandhi and Georgi Malenkov were among his house guests; Anthony Eden tried unsuccessfully to stop him travelling to Spain to witness the progress of the Civil War; General Bernard Montgomery consulted him a few months before the D-Day landings in 1944; Che Guevara, the Latin American revolutionary, admired his publications about the Soviet Union; and Winston Churchill upbraided him for distorting his famous 'fight them on the beaches' speech.

Through it all, Hewlett Johnson remained a thorn in the flesh of the Church of England. He was not only the most instantly recognisable Anglican clergyman of the twentieth century, with his flowing white hair and frock coat and gaiters, he was also the most controversial. In the 1930s the Archbishop of Canterbury, Cosmo Gordon Lang, accused him of neglecting his duties as Dean and repeatedly but fruitlessly urged him either to resign the Deanship or to renounce his political activities. In the 1940s Johnson's colleagues on the Canterbury Cathedral Chapter publicly denounced him in a letter in *The Times,* and such was the animosity in the precincts that one of the canons even refused to take Holy Communion from him. In the 1950s another Archbishop of Canterbury, Geoffrey Fisher, belittlingly described him in the course of a debate in the House of Lords as 'blind, unreasonable and stupid' but could find no way of getting rid of him.

The secret services also followed Hewlett Johnson's activities with interest. He first came to their notice in 1917 when he organised a meeting in Manchester (at which Bertrand Russell was the principal speaker) to congratulate the people of Russia on their Revolution, and he remained on the watch-list of MI5 until 1952 when the Cabinet concluded that he was no longer a danger to the nation and was best ignored. Such was the concern of the secret services about the threat that he was thought to pose that on occasions his telephone calls were intercepted, his mail was opened, and his private bank account was entered. In fact Johnson was neither a spy nor a traitor, but because of his outstanding gifts as a preacher and orator he was an immensely effective mouthpiece for the Soviet Union in

the Christian West. In this he was actively aided and encouraged for thirty years by one of Moscow's most influential organisations for the recruitment and support of 'conduits of influence' for the Soviet Union in Western Europe and America.

In his private life, Hewlett Johnson had two successful marriages, each of almost thirty years. His first wife, Mary Taylor, died childless in 1931 shortly before his appointment as Dean of Canterbury. Johnson was, for his first seven years in Canterbury, a childless widower who sometimes cut a rather lonely figure in the cavernous depths of the deanery; but in 1938, at the age of sixty-four, he married a removed cousin, Nowell Edwards, who was then half his age. Although he did not become a father for the first time until he was sixty-six (and again when he was sixty-eight), he lived to see two of his grandchildren born. Hewlett Johnson died in Canterbury in 1966 at the age of ninety-two. He was given a glorious and moving funeral in Canterbury Cathedral and his ashes were buried in the cloister garden. The ashes of his second wife, Nowell, who outlived him by seventeen years, were later interred with his.

* * *

This is not the first book about Hewlett Johnson. In 1968, two years after his death, his autobiography (*Searching for Light*) was published. It was largely an edited collection of material from his previous writings, gathered and organised by his widow and augmented with material supplied by those who had known and worked with him. Almost twenty years later, in 1987, Robert Hughes published a more objective biography (*The Red Dean*). It followed the contours of *Searching for Light*, but it was more detached and it recognised the contradictions in Hewlett Johnson's life that he himself either could not or did not face. *The Red Dean* also incorporated a good deal of material drawn from interviews that Hughes had conducted with Johnson's friends and colleagues, almost all of whom have since died and whose testimonies can no longer be revisited.

There is, however, a substantial compensation, for in 2007 Hewlett Johnson's daughters, Kezia Noel-Paton and Keren Barley, generously gave the enormous archive of their father's private letters and papers to the University of Kent at Canterbury. The archive contains some 12,000 items going back to Johnson's adolescence in Victorian Manchester – mostly letters but also diaries, photographs, press cuttings, sermons, share certificates, passports, telegrams, bills, orders of service and assorted other material. The entire archive, including the hundreds of letters that Hewlett and Nowell Johnson wrote to each other during the Second World War, is now

open to the public, and its contents form the basis of much of the new material in this book. Most of the papers in the archive are numbered, but they are still largely in the random order in which they arrived at the University and further work remains to be done in sorting and cataloguing them. Where they exist, archive numbers are given in the endnotes in this book; otherwise items are marked as 'Not numbered in the archive'. For those who may wish to consult them, however, the unnumbered items can usually be located in the archive by reference to their dates and (in the case of letters) the names of the writers and recipients.

Why another book about the Red Dean of Canterbury? Firstly, the archive at the University of Kent casts new light not only on the public career of Hewlett Johnson but also on his private life. It allows him to be seen in a more complete focus – not only as a highly controversial public figure in the middle decades of the twentieth century but also as a husband, father, priest and colleague. In particular, his relationship with the Canterbury Chapter and with successive Archbishops of Canterbury sheds new light on the workings of the Church of England during this period. Secondly, new evidence has come to light in recent years about the Moscow-based organisation (VOKS) that arranged many of Hewlett Johnson's visits to the Soviet Union and supplied him with much of the propaganda material that he used in his speeches and sermons. Thirdly, recently declassified records in the National Archives reveal the concerns of the secret services about the activities of Hewlett Johnson over a long period of time. He was seen as a possible threat to national security until he was almost eighty; and as late as 1952, when he was the subject of a splenetic debate in the House of Lords, Downing Street came under pressure to instigate an enquiry into the accusations he was making about the use of bacteriological weapons by American troops fighting under the United Nations flag in North Korea.

I also have a fourth reason for writing this book. Although I have no bias either towards or against Hewlett Johnson, I believe that he deserves better than to be remembered only as a controversial cleric who alienated his colleagues with a theology that was ahead of his time and who split public opinion with his strong political views. History will doubtless still remember him as The Red Dean of Canterbury who stubbornly supported a murderous and godless regime, but at least there is now a footnote in the historical record that says: there was more to the man than just this. Much more.

John Butler
Canterbury, July 2011

CHAPTER ONE
FINDING A VOCATION

I N HIS OWN ESTIMATION, the contours of Hewlett Johnson's religious and political sympathies were shaped by the family into which he was born. 'Many lessons can be learned in the working life', he wrote in his autobiography, 'but a whole range of other qualities can only be learnt in the family. Strength of character can be acquired at work, but beauty of character is learnt at home, where the affections are trained.'[1] His own family, into which he was born in Manchester in 1874, was representative of a certain kind of prosperous Victorian evangelicalism. It took religion seriously, shifting its affiliations from Anglicanism to Presbyterianism and back again as it nurtured the spiritual and moral development of its members. Mr and Mrs Johnson were conscientious Sabbatarians who never allowed a Sunday newspaper to enter the house and insisted that boots should be blacked the night before. The maids were ordered to avoid any Sunday chores that might prevent them from attending church. Once, when Hewlett's birthday fell on a Sunday, the wooden bicycle-horse that had been bought for him was locked in a shed until the next day; but he found it and guiltily tried it out in the gloom of the Sunday evening.

Hewlett Johnson's mother Rosa, with her simple but robust belief in the inerrant truth of the Bible and her absolute assurance of the presence and power of God, provided the religious glue that held the family together. She abjured high-heeled shoes, wore no stays or bustles, and avoided crinoline. She did, though, instil in her children a love of the countryside, especially the hills of Scotland and Wales, and she encouraged them to see the hand of God in the beauty of nature. Hewlett's father Charles had wanted to enter the Anglican ministry but was directed instead into the family business – Johnson's Wire Works. He compensated by spending much of his spare time in voluntary work with the YMCA. When the family was living at Macclesfield, Charles Johnson was so devoted to Sunday observance that he campaigned for the Sunday post to be stopped. He was opposed by the vicar of the nearby village of Prestbury who did not want his Sunday deliveries to end; but it was Charles who won.

Another important familial influence in Hewlett Johnson's early life was his maternal grandfather, the Reverend Dr Alfred Hewlett. A noted Lancashire preacher, Alfred Hewlett held the living of Astley, a small town between Bolton and Preston, for fifty-three years. There in his Tudor vicarage he raised eleven children on an annual stipend of £300, as well as kindling and nurturing the aspirations of the working-class boys of the town. There, too, Alfred hosted Christmas parties for the family that were to reinforce the values Hewlett Johnson was busy acquiring from his parents. 'In Astley vicarage', he later wrote, 'I learnt that the best start in life lies in a simple home with cultivated tastes and no enervating atmosphere of financial endowment.'[2] And it was at Astley that he also began to understand that, with a sound education and plenty of encouragement, children from poorer backgrounds could do just as well in life as those from wealthier families. The foundations of his socialist beliefs were being laid down.

There were other cultivated acquaintances around the Johnson household who also left an abiding impression on the young Hewlett Johnson. Notable among them was the family doctor, Dr B J Massiah, who introduced him to the Jewish communities that were bringing domestic comfort and cultural sophistication to the southern suburbs of Manchester. Dr Massiah was a courteous man of artistic taste and liberal inclination tinged with an exotic background: his mother owned a sugar plantation in Demerara and he kept a parrot and a monkey as pets. Evenings spent at the doctor's home were a revelation to Hewlett Johnson as he read the *Manchester Guardian*, listened to the Hallé Orchestra over the telephone, and wandered in the garden from which flowers were sent each week to hospitals in the city. 'I owe an incredible amount to Dr Massiah', he wrote in his autobiography, 'for he taught me to love Ruskin, Turner and the pre-Raphaelites; he taught me to love comfortable chairs, and gas rather than smoking coal fires, and good food.'[3]

Whether Dr Massiah realised the influence he was having on the young Hewlett Johnson will never be known, but he did recognise the signal part that Mrs Johnson was playing in her son's development. He once told Hewlett that 'you owe an incredible amount to your mother.'[4] Not that Johnson needed any telling.

My mother was a wonderful woman, and long after maturity I habitually consulted her because of her wisdom. She loved her children passionately and conducted her home with a stately, kindly and vital calm. It was a lovely atmosphere of peace and security and creativity

to live in, with kindly common sense and shot through with deep religious fervour.[5]

Throughout his life, Johnson held a high view of the importance of women in the family, a view that must surely have owed much to his mother's example. The maids in the Johnson household also played a part in shaping his early images of womanhood. Annie Yates came to the family in about 1880 as a laundry maid and remained for many years as a carer to Charles and Rosa Johnson; and Annie Mason, his nursemaid, must have had as great an influence on the young boy as his mother. In 1932, possibly in acknowledgement of Johnson's appointment as Dean of Canterbury, she wrote:

> I was the first to teach you to walk and talk. I had charge of you day and night for nearly three years, and it was the happiest time of my young life. Wherever the family went, I went with them and was treated as one of the family. ... Eventually I did everything for yourself and your sisters. When the weather was favourable I used to take you where you loved to go, on Kersal Moor, and play among the purple heather and sand. There was no such thing as crying, you were too happy.[6]

* * *

Hewlett Johnson was born into a large family: he was the middle of nine children, three girls and six boys. On Saturday afternoons the family went on cycle rides, with Mr and Mrs Johnson sitting side by side on a 'sociable', the girls on tricycles, and the boys on bicycles. His three sisters were all older than him, accentuating the feminine influences in his early life. Yet strong masculine influences were also present, for as well as the Reverend Alfred Hewlett and Dr Massiah, Johnson imbibed from his father the ethos of industry and business. Johnson's Wire Works, the family firm that Charles Johnson had been forced to enter and now managed, specialised in woven wire for the paper-making industry. The company's hundredth birthday in 1891 was celebrated with a centenary banquet for all the employees. As the nineteenth century drew to a close, however, the company began to lose its distinctive family ethos as new technologies came in and the drive for profitability intensified.

> The small primitive handlooms of my boyhood, with men at either end plying the shuttles and with a boy on an elevated platform in the centre pulling up the beam which drove home the weft, have given way to

mighty power looms, weaving golden wire no thicker than a human hair, into endless sheets which in the making of paper would run at incredible speeds, turning off endless rolls.[7]

As long as it had remained, in Hewlett Johnson's words, a 'comfortable, lesser industrial concern always in the hands of a single family', the company was able to adopt a Victorian paternalism towards its employees; but technological change brought with it a 'harder and less human atmosphere'.[8] This shift in the moral climate of the company was not lost on Johnson, who saw in it the rise of a new, ungodly economic order rooted in the pursuit of profit and wealth. 'The only thing we can do', he wrote to his brother Charlie, 'is use some of the money that we gain in philanthropic purposes.'[9] But however much Hewlett Johnson may have deplored the increasingly soulless nature of competitive business, the 'money that we gain' was enough to support the Johnsons in a comfortable lifestyle.

In 1874, when Hewlett was born, the family was living in Kersal, then a fashionable suburb to the north of Manchester. From there they moved to Didsbury, in the south of the city, and from there to Upton Grange, a spacious country property just outside Macclesfield with a large garden and paddock, a tennis court, a cricket pitch, and a range of stables. With such an expansive estate and so many children, the Johnsons needed a good deal of domestic help. The precise complement of staff is not recorded, but 'many girls' passed through Mrs Johnson's hands as she taught them the arts of domestic service. There was at least one full-time nursemaid and several housemaids. Mrs Johnson later recruited the unemployed husband of one of the housemaids to look after the boys once they had outgrown the nursery. Several members of staff accompanied the family on the long holidays they took each year on the Isle of Arran and in North Wales.

Yet for all its material comforts, life for the Johnson children was a continuing lesson in social morality. Serving the needs of others, they were taught, was the right response to God's providential grace towards them.

> In times of economic stress, food was always ready for the 'down-and-out' passer-by. The food we gave was the same we ate ourselves, good and wholesome, not second-rate because they were poor. I think one of the sternest rebukes I ever received from my father was in connection with our food. One Sunday the joint tasted of paraffin, and we found that it had been placed near the paraffin tin; we all refused it. I thought it a pity to waste it all and so I suggested: 'Why not give it to the poor?' I shall never forget my father's indignation.[10]

Exhausted social workers from Manchester and tired Salvation Army offi-cers from the City Mission came to Upton Grange for rest and recuperation, bringing the adolescent Hewlett Johnson into contact with a world that must have seemed as far removed from the middle-class comforts of Cheshire as Johnson's Wire Works were from the Isle of Arran. The contrast between his own privileged surroundings and the miserable lives of many working-class families in Manchester was an unquestionably formative element in his later political views. Yet although Johnson often attacked the social and economic systems that produced such vast disparities between the rich and the poor, he never saw his own upbringing as anything other than blessedly Christian. Families like his were typical of the industrial capi-talism that he was later to condemn, yet there was no remorse in his auto-biography over the debt it owed to men working for pitiful wages in the factories of Manchester. Without any sense of irony, Hewlett Johnson remembered his own privileged childhood and adolescence with gratitude.

* * *

Until the age of fourteen, Hewlett Johnson was educated at home by his mother. When he began his formal education at the King's School in Macclesfield in 1888 he was ill equipped to cope with institutional life. He was, by his own account, a dull boy who was described in one of the master's reports as dreamy and inattentive. He was unable to follow the intricacies of mathematics and he hated Latin grammar; but he did better in subjects such as history, geography and scripture where he was able to work things out for himself. His only success was winning a divinity prize for two years running. At the age of sixteen he left the King's School and went to Owens College in Manchester. Conscious of his family's industrial roots, Johnson enrolled to study civil and mechanical engineering. He lived at home in Upton Grange and travelled the twenty miles to Manchester each day, often remarking upon the great contrasts between the green lanes of Cheshire and the dirt and grime of the city streets. It was another obser-vation that nurtured his political sensitivities.

When he started at Owens College in 1890, Hewlett Johnson still held fast to the biblical certainties that he had absorbed from his mother. A letter from his sister Emily, written when he was about to leave his school in Macclesfield, provides a telling insight into the religious environment in which the Johnson children had been raised.

My dearest Tulip, I feel that it is the proper and acknowledged thing for an old veteran in College ways to address words of warning and

advice to the young stripling about to enter on his first year at Owens. Seriously, the object of this letter is to tell you that I am praying this morning for you that every day you are at College, you may not be ashamed of our Master, but may glorify Him in everything you say or do. I know by experience that it is not the easiest thing in the world to shine for Jesus at College, but 'His grace *is* sufficient for thee'.[11]

At Owens College Hewlett Johnson made friends with two brothers whose father owned a large chemical works in Manchester and who were devotees of the temperance movement. Accompanying them to mass temperance meetings in the Free Trade Hall, Johnson found himself so caught up in their evangelical fervour that he experienced a kind of Damascene conversion, and for a number of years he seems to have lived up to Emily's expectations of him. A letter written to him in 1894 by Mr D S Stewart, a fellow student at Owens, suggests that, even into his twenties, he still retained the largely unreflective belief in the faith he had grown up with. The letter was written in response to an accusation by Johnson that Mr Stewart was somewhat lacking in his faith in Jesus Christ.

I doubt whether you have gone through what I have, as it was just because I did not go along 'in an easy sort of way as a Christian' that doubts came into my mind, how Christianity affected me. I cannot help a feeling of astonishment at the glib way in which you propose solving the infinite mysteries of being by the words 'Bring your difficulties with you to Jesus and he will solve them'. Were Jesus the professor of chemistry and I in the next room engaged in a difficult analysis, then the matter would be all plain sailing and I should know *exactly* what to do, but as the words stand, they are devoid of any *objective* meaning. You must surely see this for yourself![12]

Yet beneath the surface of Hewlett Johnson's unquestioning faith, a great deal of spiritual turmoil was taking place. Indeed, he was convulsed with doubt as he wondered whether he was religious enough, and he feared that he might have committed the sin against the Holy Spirit. The moment of crisis, when things either move on or fall apart, came for him when he attended a lecture by Professor Sir William Boyd Dawkins, the eminent geologist and palaeontologist, who almost at a stroke in the course of a single lecture persuaded Johnson of the truth of the Darwinian theory of evolution. The effect was devastating.

I turned from the lecture room with a passive face and a calm voice. But within there was tumult and utter darkness. The Evolution theory was true – of this I was convinced. And it made the story of Genesis and the Bible false.[13]

For weeks, life was utterly black for Hewlett Johnson. His health suffered as he was wracked with anguish over the possibility that none of his family – not even his beloved mother – might move from death to eternal life. If the Bible was in any way fallible, then all hope for them had gone. Johnson was rescued from this slough of spiritual despond by Professor Mowle, a theologian at Cambridge, who wisely advised him: 'Keep on your college course, continue your geological studies. They are on the road to truth. But at the same time see the truth of the Christian life and its effect in your mother and family. Both lines of truth are real: they will ultimately join.'[14] The effect was dramatic: a new light began to dawn that set Johnson on a path that eventually enabled him to bring his religious convictions into a seamless conjunction with his political beliefs.

* * *

Graduating from Owens College in 1896 with a degree in civil and mechanical engineering, and still emerging from the black cloud of despond that had accompanied his enforced reappraisal of the Bible, Hewlett Johnson felt called to 'offer my whole life to God in gratitude, and be ready to undertake the hardest tasks'.[15] He decided to apply to the Church Missionary Society for a posting as an 'engineering missionary', but he was persuaded by his father to spend time first acquiring experience on the shop floor. So he went as an apprentice to The Ashbury Railway Carriage and Iron Company in Openshaw, a company that 'catered for the Empire's growing network of railways, producing and repairing all kinds of rolling stock, from carefully-sprung luxurious passenger carriages to specialised wagons for carrying everything from pig iron to eggs'.[16] Johnson remained there for three and a half years, learning (quite literally) the nuts and bolts of production engineering and rubbing up against the grim realities of sweated labour. He also marked, learnt and inwardly digested the human price that was being paid for the triumphs of Victorian capitalism.

The years that Hewlett Johnson spent on the shop floor at Ashbury's were seminal for him. At one level they equipped him with precisely the technical skills and practical experience that his father had wanted him to acquire. The diaries that he kept are full of diagrams, calculations, and dramatic accounts of the drilling, chipping, hammering, chiselling, turning

and milling that occupied his days. Much of his time was spent working in cramped and awkward positions, surrounded by heat, noise, vibration and fumes. At another level, however, Hewlett Johnson was also learning about the economic facts of life. Due to fluctuations in the price of copper, Johnson's Wire Works was running into financial difficulties, and the family had to move from Upton Grange to Dacres Hall in Yorkshire, on the moors road from Ashton-under-Lyne to Holmfirth. It was still a large house for a large family, and its gardens were spacious enough to take the swimming pool that Hewlett and his brothers dug and filled with fresh water from a nearby stream; but economies were now having to be made.[17] For his part, Hewlett Johnson determined to save every penny and live entirely on his own earnings. He gave up smoking, washed his own overalls, seldom used a bus, and walked from Dacres Hall to Mossley Station rather than the nearer Greenfield Station to save four pence on his return fare to Manchester. He also kept a meticulous record of his expenditure, noting that he paid sixpence for dinner, threepence for a haircut, six shillings a week for the lodgings that he moved into at some point during his time at Ashbury's, and a further six shillings for his meals at a cheap cookhouse.

It was not only his own finances that occupied Hewlett Johnson's thoughts during the Ashbury years: so too did those of the men on the shop floor, many of whom were struggling to pay the rent and feed and clothe their families on seventeen shillings a week.[18] The chasm between his own position and those of the others in the factory was too glaring to ignore; and it led Johnson to a fundamental reappraisal of the lessons he had learnt within his family. He had been brought up to believe that it was the moral obligation of the rich to give charitably to the poor, but he now began to see this as a hopelessly inadequate response to the social and economic inequalities that were scarring the face of late Victorian Britain. The poor, he began to realise, remained poor for the very same reason that the rich remained rich: both were locked into an economic system that relied upon the cheap labour of many to generate the wealth of the few. But while one side was locked *involuntarily* into the system, the other was in it by choice. The poor were powerless to change the system and the rich had no intention of doing it themselves. The fault line, in other words, was systemic in origin, and no amount of noblesse oblige could eradicate it.

> Sharing would touch but the fringe of the problem. Justice, not charity, was the only remedy. Charity had become inadequate – a dangerous clearing of conscience. The problem cried aloud for a new and more scientific approach.[19]

Once Hewlett Johnson had grasped this, it was but a short step to the real-isation that any solution to the endemic poverty he encountered at Ashbury's had to be political in nature; and for that to happen, something dramatic was needed to challenge the vested interests of those whose hands were on the levers of political and economic power. Johnson found what he was looking for through the passionate evangelism of two young apprentices with whom he shared the lathes: socialism. Though far less well educated than Johnson, they were sufficiently well versed in the history of the Labour movement and the theory of socialism to convince the Owens College graduate of the essential truth of their message. They gave him a copy of Robert Blatchford's influential book, *Merrie England*, published a few years earlier in 1893. It was another important landmark in Johnson's early political pilgrimage.

> I had thought from the intellectual height of my university degree that I could continue to hold my political Conservative doctrine, which I had never thoroughly thought out. They [the two apprentices], however, in the long run, won. They had sowed seeds which were destined to ripen in later years.[20]

Yet the evangelising that took place on the shop floor at Ashbury's was not all a one-way process, for while the two nameless apprentices were seeking to convert Hewlett Johnson to socialism, he was seeking to convert his workmates to Christianity. Still imbued with the idea of offering himself to the Church Missionary Society, he saw his apprenticeship at Ashbury's as an opportunity not only to acquire the technical skills of an engineer but also to learn the persuasive arts of the missionary. Johnson felt he must begin at once, and his diaries from the period are full not only of the drawings and calculations needed in his work but also his accounts of his missionary endeavours on the shop floor.

> Worked partly at hoists and then at some brasses to which we had to fit some steps and cups instead of fitting steps and cups to bed. My eyes began to be slightly sore. Had a long talk with a fellow on the way to salvation. He wishes to talk it well out so I'm going (D.V.) to have him up to tea some time. May I be used as an instrument to lead him to the Light.[21]

* * *

Hewlett Johnson left Ashbury's Carriage Works in 1899 as a fully qualified mechanical engineer and an Associate Member of the Institute of Civil Engineers. He took with him a glowing reference from the Board.

> We have pleasure in bearing testimony to the character of Mr Hewlett Johnson who has been in our employ for the past three and a half years under our Chief Engineer in the repairs and maintenance of the Tools, Machinery and Plant of this Establishment. He is most respectably connected and while in our service was always punctual, attentive and regular in his duties. We feel sure that his services will be valuable on any Foreign or Colonial Railway requiring the services of anyone in his capacity and any enquiries respecting him we shall be pleased to answer at any time.[22]

For reasons that are not entirely clear, Johnson delayed his application to the Church Missionary Society for a year and joined his father and his eldest brother Alfred in the family firm; but by 1900 he was ready to proceed. Yet there still remained a stumbling block, for although he was now amply qualified and experienced in half the skills required of an 'engineering missionary', he was still quite green in the other. To remedy the lack, the Society sent him for a year's theological training at Wycliffe Hall, Oxford, financed by his father. He was now twenty-six. By this time, with business picking up at the Wire Works, the Johnson family had moved yet again, from Dacres Hall to a large house at Wilton Polygon, near Crumpsall to the north of Manchester. During the vacations from Wycliffe Hall, Hewlett Johnson helped out at a club for poor boys from the neighbouring district of Ancoats and there he met the leader, Arthur Taylor, the son of a prominent Manchester industrialist and himself a successful merchant in the city. He also met Arthur's sister Mary, 'a woman as competent and single-minded as he, and possessed of the same charm'.[23] Socially, the Taylors were a cut above the Johnsons and somewhat wealthier – a distinction that did not trouble Hewlett Johnson until he found himself falling in love with Mary. In 1901 his proposal of marriage was accepted and they became engaged. It must have seemed a good match to their families and friends: both had a strong evangelical faith, both had ambitions of missionary work abroad, and both were familiar with the social expectations that went with wealth and privilege at the turn of the century.

Hewlett Johnson's year at Wycliffe Hall was a difficult one. He not only had to adjust to life in a residential college, he also had to resurrect and refurbish the academic skills of reading and writing that had lain largely

dormant during his years at Ashbury's. The difficulties were compounded by the fact that his fellow students, most of whom were several years younger than him, were 'at the peak of their ability after their university examinations'.[24] There was, too, a major new challenge to his Christian faith: having adjusted his views on the Bible to accommodate the theories about evolution that he had encountered at Owens College, he was now faced at Wycliffe Hall with another threat to his inherited belief in the Bible as the unassailable word of God: literary criticism. There was, of course, nothing new in the idea that the Bible, like any other ancient text, must be read in the light of its cultural origins; but it was certainly new to Hewlett Johnson and it posed a challenge that had to be assimilated into his developing theological understanding.

> The year at Wycliffe Hall made a vast difference in my theological outlook. Mr Woodward lectured on the Old Testament, and in a very thorough way he introduced us to the higher critical point of view which made, for the second time, an assault upon my belief. However, before the end of the year I had begun to realise the value of the new outlook, which began to fit in singularly well with my evolutionary views.[25]

Hewlett Johnson worked so hard during his year at Wycliffe Hall that, to widespread astonishment, he gained the top marks in the final examination. But once again his overtures towards the Church Missionary Society were put on ice when Francis Chavasse, the Bishop of Liverpool, advised him to remain at Oxford for another four years to take an honours degree in theology. Although it would mean the postponement of their marriage, Mary agreed that it would better equip them for the mission field; and in September 1901 Johnson enrolled as an undergraduate at Wadham College, Oxford. He was now twenty-seven, and once again his studies were financed by his father.

Hewlett Johnson's years at Wadham were 'some of the happiest' of his life, doubtless made sweeter by the fact that he was able to marry Mary in 1902. Mary's father settled a substantial sum upon her, enabling the couple to set up their first home in Oxford. How Mary passed the time is largely unknown, but Hewlett threw himself into his studies, mastering Latin, Greek and Hebrew in sufficient depth to be engaged by Mrs Wykeham-Musgrave as a classics tutor to her son when Winchester School was closed with scarlet fever in 1903.[26] He also found an outlet for his immense physical energy in the Wadham College boat where he achieved a good deal of success without quite gaining a Blue. Johnson graduated with a second-class

honours degree in theology after only three years instead of the normal four. He is said to have been disappointed to have missed a first,[27] but it would have been an extraordinary achievement for a mature student who had returned to academic study in an alien field after several years in industry. He could, though, now justly claim to be not only a fully qualified civil and mechanical engineer but also a theologian with increasingly radical views.

* * *

When he left Oxford in 1904, Hewlett Johnson was faced with the problem of what to do next. He was now thirty, married, a qualified engineer and a graduate in theology. He had been supported financially by his father for most of his life, and had he so chosen, he could have lived comfortably on his wife's inherited money. But that would have been a negation of his maturing political beliefs, and after the happy interlude of Oxford he was ready to re-engage with the 'real world'. Johnson's first choice, once again, was the Church Missionary Society, and he followed up the contact he had already made with the Society by offering himself and Mary for work in the mission field. He was turned down. A possible reason can be imagined behind his cryptic remark that his views were 'too broad'.[28] This was still the heyday of Empire when missionaries were generally expected to preach a simple and uncomplicated faith to the natives based upon a belief in the Bible as the absolute Word of God. To raise questions about the literal truth of the creation stories or the historical accuracy of Jesus' sayings in John's gospel was not what was needed. Nor, indeed, was the kind of political radicalism that challenged the Establishment. As a free-thinking theologian with burgeoning socialist sympathies, Hewlett Johnson hardly fitted the Society's template of the ideal missionary for Edwardian times. He tried to get to South Africa with a Presbyterian missionary group in the hope that his views would be more acceptable there than in more traditional mission fields, and he toyed with the idea of joining his brother Charlie in Canada where there were said to be good openings for qualified engineers.[29] But as his options narrowed and his convictions deepened, he eventually surrendered himself to the one course of action he had long tried to avoid but which in retrospect seems all but inevitable: he offered himself for ordination.

The year 1905, in which Hewlett Johnson reached the age of thirty-one, was critical for him and Mary as he was ordained deacon and began the search for a curate's appointment in an impoverished east London parish. Had he found one, it would probably have allowed him to continue his theological and political development in a tolerant environment while

doing something constructive to alleviate the conditions of the working poor; but it was not to be. Bishop Francis Jayne of Chester, whose son had rowed with Johnson in the Wadham College boat, invited him to accept a curacy in the parish of Dunham Massey, in the wealthy Cheshire town of Altrincham. 'I am in a difficulty', Jayne wrote to Johnson. 'Archdeacon Woosnam of St Margaret's Altrincham is ill and lacks a competent curate. Will you help him?'[30] It was an extraordinary question that seemed at first sight to turn Hewlett Johnson's inclinations and ambitions upside down.

> The Bishop's offer was to a parish diametrically opposite to the poor parish I sought in London – St Margaret's being in one of the richest parishes in England. ... I felt that my growing socialist views were bound to meet trouble.[31]

To add to the complication, Mary's theologically conservative parents were also members of St Margaret's. Yet daunting though the appointment appeared to be, it was not in Hewlett Johnson's constitution to shirk a challenge, least of all when it seemed to be an answer to prayer; and he and Mary left Oxford in 1904 to return to their roots in greater Manchester. He was ordained priest in June 1906,[32] and two years later, in the summer of 1908, he succeeded Archdeacon Woosnam as vicar of St Margaret's, Dunham Massey. He was now thirty-four. The appointment, which greatly surprised him, was made by the patron of the living, Lord Stamford, after receiving a petition from the congregation and seeking the advice of the Dean of Westminster, Foxley Norris. More than a third of Hewlett Johnson's long life had passed before he finally found his vocation. There were to be many in the Church of England who later wished that he had not.

VICAR OF ST MARGARET'S ALTRINCHAM

S OCIALLY AND ECONOMICALLY, the congregation of St Margaret's Altrincham was strikingly polarised when Hewlett Johnson arrived as the new curate in 1905. At the top end of the scale he encountered 'as distinguished and delightful a company of industrial magnates as in any parish in the land'.[1] He called them the 'big men', and they lived, screened behind hedges of laurel and beech, in large houses on the high ground of the parish. 'We used to say, jocularly, that no one lived on the top of the hill who had a fortune of less than a quarter of a million pounds.'[2] Among them were:

> ... the head of Fine Spinners; a head of the largest British Insurance Society; the head of the great steel works that aided Mr Lloyd George during the war; the engineer who built the Manchester Ship Canal; the heads of two great northern banks; and two barristers who became judges of the High Court, to mention only a few.[3]

Other 'big men' in the congregation during Johnson's time at St Margaret's included Sir Drummond Fraser, chairman of the Union Bank; Sir John Leigh, who had made a substantial fortune from the Lancashire cotton industry and was rumoured in 1921 (when he purchased the *Pall Mall Gazette*) to be worth fourteen million pounds; and Sir William Crossley, the Liberal MP for Altrincham from 1906 to 1910 and the owner of the company of the same name that made high quality motorcars. Hewlett Johnson later said of Sir John Leigh that 'he became extremely rich by the dubious methods of the capitalist society'.[4] The patron of the living was Lord Stamford, whose heir at the time of Johnson's arrival in 1905 was his ten-year-old son, Roger Grey. The schoolboy earl and the rookie curate immediately struck up a good relationship, venturing together on outings to tea shops, riding on the tops of trams, and exploring the lesser known areas of Manchester.[5] The friendship lasted a lifetime, and long after Johnson had moved to Canterbury he continued to lunch with Lord Stamford

(as he became in 1908) at the Goring Hotel, the Earl's favourite watering hole in London.

At the bottom of the hill, things were very different. Here, among the lowest rungs of the social ladder, was squalor and disease aplenty. If 'a clean privy is a credit to the Lord',[6] then rank godlessness pervaded the low-lying slums of the parish. In a Petition to the Local Government Board in May 1914, Hewlett Johnson gave a vivid description of the deleterious effects the squalid and unsanitary conditions were having on the health of young and old alike.

> In each of the houses in Burgess Square last summer a baby died and the doctor in attendance informed me that the death of the baby in the smaller house was caused by its food becoming contaminated by the flies from the two privies and manure heap near the house. The New Street cellars are presently occupied by old people. ... Yesterday we killed a huge cockroach on the wall by the back door. There is no drain at the cellar step and when the water pours down they have to ladle it all out. ... I should particularly like to emphasise the indecency of Chapel Street in the matter of closets ... and the Albert Street Schools: the nuisance from the manure heap and swarms of flies which this brings into the school. The manure heap is only some 15 or 18 feet from the classroom. The smell is very bad. The Sanitary Inspector's attention has been called to the offensive smell on several occasions but nothing has been done. ... In very severe epidemics of measles and mumps when children were sickening morning and afternoon in school I wrote, and the headmaster wrote repeatedly, and the headmistress of the infant school wrote to the Medical Officer but there was no acknowledgement of the letters and no action was taken.[7]

The symbolism was not lost on Hewlett Johnson of the manure from the rich men's ponies at the top of the hill being dumped at the bottom to become a breeding ground for the flies that brought disease to the poor. Many years later, as Dean of Manchester, he claimed at a civic dinner in the Town Hall that Henry Ford had been responsible for saving more babies' lives than all the doctors and hospitals together. To his puzzled audience he explained that, by making the pony and trap redundant, Henry Ford's cheap cars had done away with the manure heaps that swelled the infant mortality rates in poorer neighbourhoods. 'May we drink to Henry Ford, the life-saver!'[8] Appropriately, Johnson's farewell

gift from the grateful congregation of St Margaret's when he left the parish in 1924 was a brand new all-weather Crossley motorcar. It had the power of fourteen horses.[9]

* * *

It was to this highly stratified parish that Hewlett Johnson came to minister first as curate and then, from 1908, as vicar. There could have been few other priests so well qualified to hold these extremes of wealth and poverty together: he had had first-hand experience of industrial capitalism and he was now clear in his own mind about the reasons for the gulf between rich and poor. He was also developing a theology robust enough to hold his Christian faith in a constructive tension with his burgeoning socialist beliefs. It was – as it was to be throughout his life – an intellectual position that evoked grateful approval and angry condemnation in equal measure. His curate from 1910, the impoverished Samuel Proudfoot, was among those who sang his praises.

> To expound socialism to such a people as you minister unto is a task requiring for even moderate success unusual gifts and graces. ... You have imagination and sympathy enough to penetrate below the plutocratic skin and to see there the common stuff of humanity.[10]

Johnson also carried some of the 'big men' with him. Judge J K Bradbury wrote at the end of his first year as vicar:

> Your sincerely modern, but as I think and believe, most truthful and stimulating interpretation of the Gospel you preach is, if I may say so, warmly appreciated by myself and I am sure many others in your congregation. The present period is one of considerable difficulty for the earnest, honest and open-minded clergy ... and great courage and earnestness with whole-hearted devotion to truth are required.[11]

Another judge, Spencer Hogg, who sat in the County Court, was so impressed by Hewlett Johnson that he invited him to become godfather to his son Anthony. Johnson remained in touch with Anthony and his family throughout his life. Moved by a sermon that Johnson preached about the slums of the parish, Spencer Hogg pledged to 'put my services at the disposal of the public with regard to The Housing Question in Altrincham'.[12] Mr Wainwright, another member of the congregation at St Margaret's, also saw in Johnson the qualities of an ideal Christian minister.

The rich variety of your attainments and the admirable completeness of your experiences and the wide outlook of your literary thinking and the sympathetic breadth of your religious temperament – these things, in combination with your courageous attitude, render your pastorate a matter to rejoice over, as affording proof to us of what a Minister of the Gospel ought to be, can be and actually is.[13]

Yet for each approving parishioner there was an angry counterpart. After preaching a sermon in 1918 on the inefficiency of Britain's military leaders, Hewlett Johnson received a stinging letter from Mr William Stiff.

You will doubtless receive other letters with regard to your sermon of this morning, for your words must have deeply pained and distressed many besides myself and my children. … I cannot refrain from protesting most strongly against the abuse of your position in criticising from the pulpit the military efficiency of our brave officers, especially at a time when they are necessarily an almost insupportable burden of responsibility and anxiety and giving their lives to save ours. … In my opinion it is most unfair to take advantage of your position to make in God's House a statement on military matters which if made on any public platform would be instantly and indignantly repudiated by any audience of Englishmen.[14]

But perhaps the most wounding assault on Hewlett Johnson's integrity as a priest came from his brother-in-law, Arthur Taylor, who had suffered grievously in the Great War and who died from gas poisoning shortly after it ended. Taylor's scathing attack on Johnson's pacifism must have owed much to the contrast with his own suffering.

You allow yourself to be identified with some of the most notorious supporters of craven cowards that exist. … Your influence is waning fast, and you will be regarded merely as a crank. … How can you have influence with thinking people when you identify yourself with creatures who have yet to learn from the beasts of the field that their first duty is to protect their young? I tell you plainly, old fellow, it is an insult to the gallant lads who have died for YOU.[15]

* * *

Hewlett Johnson was nine years into his ministry at St Margaret's when the Great War erupted in June 1914. The 'cream of the parish' volunteered to

serve in the trenches and 'few returned'.[16] Johnson, who regarded himself as 'ninety percent pacifist at heart',[17] saw his duty as a priest rather than a soldier and he accordingly placed his services at the disposal of the chaplain-general of the armed forces in the north-west.

> If my services as chaplain are of any use they are at your disposal. As a priest I cannot fight, but there will be priest's work to be done. I am 40 years of age and am Examining Chaplain to the Bishop of Chester. I was captain of my college boat at Oxford and save for a slightly weak throat I am very strong and can rough it.[18]

Mary Johnson also offered herself to the war effort in a non-military capacity. 'She is', her husband wrote by way of a reference, 'splendidly energetic but could not stand a campaign'. If he himself were sent abroad as a chaplain, he would have to go alone. In fact Johnson spent the war years in Altrincham, but he did engage with the enemy when he informed the Bishop for Northern and Central Europe, Herbert Bury, that he had been appointed chaplain to a German prison camp in the parish. The appointment, which was typical of Johnson's penchant for acting first and sorting out the formalities later, placed the Bishop in a quandary, for he knew nothing of it. He wrote anxiously to Johnson: 'You know, do you not, that you will have to apply to me for a licence?'[19] Immediately Johnson's account of the arrangement shifted: he had actually been approached informally by Colonel Pritchard, the commanding officer of the camp, who was having difficulty finding a licensed chaplain and who invited Johnson into the camp in his capacity as vicar of the parish. A relieved Bishop Bury accepted this explanation and happily confirmed that if an informal arrangement was agreeable to the commanding officer, then it did not need his approval.[20] As 'chaplain', one of Johnson's tasks was to conduct the funerals of German prisoners-of-war who died in the camp, a job that he carried out with reverence and dignity. It mattered not that these men had once been enemy soldiers: they were human beings like anyone else, and Johnson saw it as his priestly duty to conduct their last rites in a compassionate and Christian manner. The families of the dead German soldiers wrote letters of appreciation, but he was attacked by the editor of *John Bull* for his disloyalty in placing flowers on the grave of one of the soldiers.[21]

Mary Johnson's war was spent in the service of British troops returning from the front. Although she had no formal qualifications as a nurse, she had gained experience of hospital work in preparation for her planned career as a missionary, and in 1915 she placed herself at the disposal of

the Cheshire Red Cross.[22] Sir John Leigh, the wealthy industrialist in the St Margaret's congregation, was persuaded to buy and equip a large house at Bowden as a hospital for 'the terrifying and ever-increasing stream of wounded soldiers coming back to England from the war'.[23] Named Haigh Lawn, it cost £20,000 and eventually contained 194 beds. Mary was appointed by the Red Cross to be its Commander. Paying tribute to Mary on her death in 1931, the *Altrincham Guardian* praised 'the inspiring lead she gave locally to Red Cross work during the war.'

> Mrs Hewlett Johnson combined capable management with her well-known characteristics of gentleness and kindness, and neither those who served under her nor the men who found themselves placed in her care are ever likely to forget her example and inspiration, or her quiet determination to ensure the best possible in treatment, rest and encouragement for her patients.[24]

Hewlett Johnson believed that it was the stress of war that 'laid the seeds of the illness from which she subsequently died'.[25]

* * *

From an early time in Altrincham, Hewlett Johnson was looking outward beyond the parish as well as attending to his duties within it, and by the time he left in 1924 he had become a national figure of some note in Anglican circles. In 1916 he preached in Westminster Abbey at the invitation of the Dean, Herbert Ryle,[26] and in 1920 he was invited by the Vice-Chancellor of Cambridge University to preach at Great St Mary's Church.[27] In the following year, 1921, he was summoned by the Archbishop of Canterbury, Cosmo Gordon Lang, to preach the December ordination sermon in Canterbury Cathedral. Lang's letter of thanks following the service had an element of prophecy about it.

> I do thank you cordially for giving us the gain and stimulus which your visit brought, and it was a great pleasure to learn from your letter that you had yourself enjoyed the few days at Canterbury. That does not surprise me, for I always think that our Cathedral has a power of 'uplift' for a thoughtful man who [?relishes] the English Church, past, present and, I hope, future.[28]

Other notable Anglicans with whom Hewlett Johnson made contact during his time at Altrincham included the Reverend Philip Clayton, the founder

of Toc H; the Reverend Dick Sheppard, the high-profile vicar of St
Martin's-in-the-Fields who went on to precede Johnson as Dean of Canter-
bury; and Canon F Lewis Donaldson of St Mark's Leicester, an outspoken
supporter of the Labour Party who later became Archdeacon of Westmin-
ster and a life-long friend of Johnson. In 1924 Johnson renewed some of
his earlier acquaintances at Oxford University when he took a three-week
reading sabbatical under the direction of the Regius Professor of Divinity,
Henry Goudge. Surprisingly by contemporary standards, he was awarded
the degree of Doctor of Divinity on the strength of a guided reading course
and an extended essay.[29]

The principle vehicle through which Hewlett Johnson's fame spread
among the higher echelons of the Church of England was *The Interpreter*,
a pioneering journal of theological commentary that he began in 1905 and
edited for the whole of his time at St Margaret's. It grew largely out of his
continuing struggle to articulate and preach a Christian faith for modern
times – one that required believers neither to become religious Luddites by
rejecting the findings of science nor to pretend that modern biblical schol-
arship had no relevance to their faith.

> My work on *The Interpreter* took much of my time and energy, but it
> was worthwhile, and neither the Bishop nor the parish wished me to
> give it up. It kept me on the living edge of theological thought and in
> touch with the universities. Of course it also had an effect upon my
> sermons and was just what was needed in a parish such as St
> Margaret's, with its highly cultivated 'top-of-the-hill' supplemented by
> the industrial element at the foot of the hill.[30]

The Interpreter was Hewlett Johnson's explicit attempt to bring together
his engineering interest in the material world and his priestly interest in the
world of theology and spirituality. They were, he thought, two worlds
that had become entirely separated by both language and substance; and
The Interpreter sought through the contributions of distinguished writers
to bridge the chasm. In his first editorial Johnson set out the purposes of
the journal.

> In the settled conviction that ignorance, not knowledge, is the enemy
> of Christianity, we seek the fullest light from every source to reveal the
> firm foundations of our Faith. Science has brought us new ideas of our
> Faith's past history, criticism has altered the literary aspects of our
> sacred books, and archaeology has revealed a Past peopled with

nations that were civilised and great. In accordance with this attitude it is our aim, as occasion may arise ... to discuss the questions they have raised, and to seek their true solution.[31]

The editorship of *The Interpreter* was a huge undertaking, both intellectually and managerially, but such was Hewlett Johnson's energy and commitment that he somehow took it in his stride. He must have spent copious amounts of time not only eliciting contributions, dealing with the publishers and entering into correspondence with his subscribers but also writing most of the editorials and a good many of the book reviews as well. Johnson was, plainly, an enormously persuasive editor: even for the first few editions, when he was still largely unknown outside his own circle of acquaintances, he managed to elicit articles from some of the biggest names in early twentieth-century British theology, including several professors from Oxford and Cambridge. Johnson was rarely given to under-statement, but to describe his editorship of *The Interpreter* as a useful way of keeping 'in touch with the universities' must surely qualify as a very large one.

Among the very few refusals that Hewlett Johnson received from his first batch of invitations to write for *The Interpreter* was one from the Bishop of Durham, Handley Moule, who harboured deeply orthodox suspicions about the wisdom of the enterprise. In declining Johnson's invitation to submit an article he wrote:

> I can only earnestly commend you to the guidance and blessing of God, while sorrowfully unable, as much as ever, to think that the new criticism of the Holy Book can lead ultimately to stricter faith and purer light.[32]

Handley Moule was not the only one to feel uneasy about the theological direction in which Johnson was moving: so too were family. His sister Emily, who in 1890 had urged her brother not to be ashamed of Jesus while he was a teenager at Owens College, was still hoping twenty years later that he might not entirely have abandoned the trusting faith of their childhood.

> You won't mind my saying that I do ask God that if *He* sees you to be mistaken in any of your conclusions about His beloved Son or His own inspired Word, He Himself will show it you, because I know you only want to know the *truth*, as I do myself. So I hope you will pray the same for me.[33]

The depth of Emily's concern for her brother's lurch towards theological liberalism in the years before the Great War is evident in the rest of the letter when she asked that, if ever her sons were at one of his services, he would preach nothing other than orthodoxy. And if the boys should happen to be present when he was engaged in a theological discussion on some point of controversy, he should 'send them off about their business first'. Emily explained her reason: 'I feel so strongly that it is dangerous to destroy a child's faith in *one* of the narratives of the Bible lest it imperil faith in the whole book.' There is no record of Johnson's reply to his sister, but emollient though it would have been in tone, it would no longer have endorsed the literalist faith in which they had been brought up.

* * *

Largely because most of the contributors and subscribers to *The Interpreter* were priests or theologians (or both), the journal became much heavier on academic theology than Hewlett Johnson had originally hoped and much lighter on the connections between theology and social life. In particular, relatively few of the articles discussed the theoretical and practical links between Christianity and social action, especially *socialist* action. In some ways this is surprising, for long before Johnson founded *The Interpreter*, the movement that came to be known loosely as 'Christian Socialism' was well established, with its own roll-call of heroes and its own body of literature. There was something to build on. Among the mid nineteenth-century luminaries of Christian Socialism were Frederick Denison Maurice, an Anglican priest who was sacked from two professorships at Kings College London in 1853 because of his unorthodox views; Charles Kingsley, at one time Regius Professor of Modern History at Cambridge whose concern for social reform was made everlastingly famous in *The Water-Babies*, published in 1863; and Thomas Hughes, the author of *Tom Brown's Schooldays*, who joined Maurice in the Christian Socialist movement in 1848 and was later involved in the formation of some early trades unions.

Partly because of persistent charges of theological unorthodoxy and partly because it failed to establish a viable working class base, Christian Socialism petered out. To the extent that it left a vacuum between religious and political thought in the Church of England, it was filled by the 'Holy Party', a small circle of high churchmen in the tradition of the Oxford Movement whose devotion to ritual was Anglo-Catholic but who also campaigned against social evils such as sweated labour and cheap liquor. Among their number were Charles Gore, Francis Paget, and Henry Scott Holland. Hewlett Johnson would have been very familiar with the ideals

of the 'Holy Party', but they were several degrees removed from his own position. By the time he became vicar of St Margaret's in 1908 he was sure that if the New Jerusalem was ever to be built in England's green and pleasant land, it would come less through the divine intervention of God than through political agitation among those who took seriously the words of Jesus about the kingdom of God on earth. It was a far more radical idea than any that the 'Holy Party' espoused.

There were, though, a number of other Anglican clergymen in a very similar position to Hewlett Johnson, and although they never coalesced into anything that could be described as a movement, they maintained a circle of correspondence that affected their respective ministries. Prominent among them was Conrad Noel, who joined the Independent Labour Party at its inception in 1893 and left it in 1911 to become a founder member of the Marxist British Socialist Party. In the previous year (1910) Noel had been appointed by Lady Frances Warwick (an early convert to Christian Socialism following a period as mistress to King Edward VII) to the living at Thaxted, in Essex, where he became known as the 'Red Vicar' and caused a rumpus by hanging the Red Flag alongside the flag of St George in his parish church. Robert Hughes said of him that he 'preached revolution with extravagant abandon without, one suspects, once giving thought to the means by which revolution must be achieved'.[34] Conrad Noel seems to have been quite close to Johnson: not only was he a contributor to *The Interpreter*, he organised a series of 'Thaxted Conferences' that Johnson attended in 1912 and 1913[35] and the two also shared a platform at a socialist rally in Stockport in 1909.[36]

* * *

Hewlett Johnson's confident faith in the power of social action to change the lives of people for the better was not merely theoretical; it also formed the bedrock of his ministry in Altrincham, notably through the camps that he arranged for the children of the parish and through the public protests he led against the unsanitary conditions in the slums. It is tempting to think – and may well be true – that the large holiday camps which Hewlett and Mary organised throughout most of their time in Altrincham were partial compensation for the children that they themselves did not have. Grateful for their own childhood experiences of long summer holidays in beautiful and remote locations, they began taking poorer boys from the parish to the sea – 'not for one hectic day, but for many days, and not to the noisy haunts of trippers, but to the nobler quieter spots of Wales'.[37] When the girls of the parish protested that they were being ignored,

Hewlett and Mary organised camps for them as well. Over the years they went with the girls to places such as Abergele, Llanfairfechan, Barmouth and Harlech that had come to mean so much to them. Then, as the children became adolescents, the demand arose for mixed camps, and again the Johnsons responded by risking the moral outrage of the Mothers' Union and taking teenage boys and girls on holiday together.[38] It does not take any great imagination to sense the special appeal these camps must have held for the youngsters who took part in them. Johnson wrote in the parish magazine in 1911:

> How one could chat about camp! How one could tell of bathes and sails, and mountain climbs and country walks; of gay scenes and fun and jolliness; of holy and solemn times; of small bits of mischief and little acts of kindness. All these things are now woven into our past; they help to build up the pattern of our life. Yes, the days will come when we will look back over our camps, and thank God for them.[39]

The camps had a broader aim than just the offer of holidays to children who might not otherwise have had them: they were also practical expressions of Hewlett Johnson's deep beliefs in the nobility of fellowship and the breaking down of class and gender barriers. 'All the time', he wrote in his autobiography, 'I was striving for these bigger things under the light of such books as Tawney's, the Labour Party's efforts, and the Pankhursts' efforts to break down the inequality of women by giving them the vote.'[40] Yet Johnson was also given to seeing the camps in a romantic light, depicting them as times when boys and girls had jolly and fun-filled holidays together in healthy and beautiful surroundings, with plenty of fresh air, abundant spiritual nourishment and never a hint of rebellion or carnal imaginings. The mixed adolescent camps surely cannot have been quite as idyllic as this. It was the same kind of idealism that allowed Johnson later to see the children of Joseph Stalin's Russia and Mao Tse-tung's China in a similar light.

In contrast to the camps, Hewlett Johnson's efforts to improve the sanitary conditions in the slums of the parish were realistic and hard-headed. At the top of a formal Petition to the Local Government Board that he organised in 1914 he wrote, in his own hand: 'We are careful to understate.'[41] It would be too much to describe him as the Charles Booth of Altrincham, but like Booth in London, his reforming energies were based on a careful mapping of conditions among the slum areas of the parish. In March 1914 he and three others assembled and submitted the evidence

required by the Housing of the Working Classes Acts of 1890–1909. In street after street they documented the appalling conditions they found there. In the Police Street area there were only two stand-pipes for eleven houses, no water closets, and a manure pit. In Victoria Street a lodging house was kept in an intolerably filthy condition and the closets, only ten feet from the back door, were flushed by wastewater from the kitchen. In Burgess Street there were four privies that should have been condemned as nuisances, and the opening by which one of them was emptied was only eight feet from the window of an adjacent house. In Chapel Square four WCs served fourteen houses, many of them containing children. In Chapel Street there were twenty lodging houses with steep and narrow stairways that afforded no escape in the event of a fire. And so on.

The headmaster of St Margaret's School in Albert Street, Mr Critchlow, added his evidence to the portfolio compiled by Hewlett Johnson.

> I find that during the period May, June and July 1912 I reported to Dr Collard two houses of measles and two with mumps and one with diphtheria. … The fly nuisance from the manure heap has … been … a source of evil and a decided nuisance particularly in two classrooms the windows and doors of which open right onto the objectionable yard. This is most noticeable in June and July. Occasionally the smell from the disturbed manure … is almost unbearable. We do our best to shut it out by closing both doors and windows. The Sanitary Inspector's attention has been called to the offensive smell on several occasions, but the nuisance still goes on.[42]

There is no record of the outcome of the 1914 Petition to the Local Government Board, but that matters less than the fact that Hewlett Johnson saw it as an integral part of his Christian ministry to press for improvements in the material conditions in which his parishioners were living. It was no longer for him a matter of the social obligation that the 'haves' owed to the 'have-nots', it was now a theological imperative that flowed from the gospels. Johnson was fond of saying that 'Jesus was a materialist',[43] pointing out that Jesus saw the physical as well as the spiritual needs of people and dealt with them accordingly. To seek to save souls while ignoring the stench of the manure heaps was not, for Johnson, a Christian option. Bad housing was a theological as well as a social issue – and therefore the proper concern of a Christian minister.

* * *

It was in the wake of the first Russian Revolution in March 1917 that Hewlett Johnson took the first of a series of steps that were eventually to bring him to the notice and patronage of the Soviet authorities. Following Kerensky's seizure of power, he chaired a large public meeting in Manchester in June 1917 at which Bertrand Russell, already a world famous mathematician and Fellow of the Royal Society, was the principal speaker.[44] The meeting was called to pass a motion 'congratulating the Russian People on their attainment of Civil Liberties, and [calling] upon the Government to grant the same liberties to the British people'. A report in the *Manchester Guardian* noted that the meeting was interrupted by a detachment of troops in search of army deserters. The troops were barracked by the audience, but Johnson appealed for order and, when the search had been completed, the detachment left. Typically, Johnson put an entirely different spin on the story: for him, it was a triumph of political evangelisation.

> A small military detachment had been placed at the end of the hall to keep order in case of trouble. … The detachment got so interested in the speeches that the officer, fearing penetration of socialist ideas in the army, formed fours and marched them out.[45]

Some years later, as Dean of Manchester, Hewlett Johnson was at a dinner party given by Lady Anna Barlow in Sandbach at which he found himself sitting next to the First Secretary to the Soviet Embassy in London. In the course of their conversation, Johnson reminded him that it was he who had chaired the Manchester meeting in June 1917, to which the First Secretary replied: 'Oh, that was you?'[46] It was probably the moment when Hewlett Johnson first came to the attention of Moscow as someone to be nurtured for propaganda purposes.[47] It was also the beginning of a process that was to bring him onto the radar of the security services. A routine report of the June 1917 meeting had been submitted to the Chief Constable of Manchester, where it lay in the files until early September 1920 when it was sent to the Special Branch of the Metropolitan Police.[48] The transfer was occasioned by Johnson's application to the Foreign Office in August 1920 for permission to travel with Mary to Austria, via Germany, 'for the purpose of paying a visit to Friends Relief Mission in Vienna'. The FO, evidently feeling the need to check his credentials before issuing the permit, contacted the Special Branch, which in turn contacted the Manchester police.[49] The wheels of officialdom turned quickly, and within a few days the Foreign Office had received the information it sought.

In reply to your letter R.3371/M.I.5.B3 of September 2nd, we have no information at all about the Reverend Canon Hewlett Johnson, except that he is a subscriber to the National Council for Civil Liberties. I do not think that this fact, and his connection with Bertrand Russell, would be sufficient grounds for refusing him permission to go to Vienna via Germany.[50]

The security services' files on Hewlett Johnson remained active until 1952.[51]

* * *

By the summer of 1924 Hewlett Johnson felt that he had done as much as he could in Altrincham. He was now a middle-aged man of fifty with considerable experience as a priest in a high-profile parish. He was well known in some of the highest circles of the Church of England, including Lambeth Palace, and he had preached in Westminster Abbey, Canterbury Cathedral and Great St Mary's in Cambridge. Although he would never have considered himself an academic, he was very familiar with the work of contemporary theologians through his energetic editorship of *The Interpreter*. His political views, which were now fully formed, were seamlessly integrated not only with his theology but also with his understanding of Christian ministry, seeing it as a central part of his priestly duties to improve the material lives of his people – if necessary, through political action. A fine orator and preacher, he was possessed of a boundless self-belief that he drew upon to speak and write on matters that he knew would offend many in his own congregation and beyond. Although reluctant to join any 'movement', not least the Labour Party of which he was never a member, he was in touch with many on the left of the political spectrum, including some who were openly Marxist in their views. His name was on the records of both the Kremlin and Scotland Yard. He might, perhaps, have looked forward to another parish appointment for fifteen years before retiring at a sensible age and enjoying his life with Mary.

Yet as he left Altrincham for higher office, Hewlett Johnson was only a third of the way through his career as a priest in the Church of England. His most famous and controversial moments still lay ahead of him. So also did fatherhood.

CHAPTER THREE
DEAN OF MANCHESTER

THE POLITICAL AND ecclesiastical processes that took Hewlett Johnson from the vicarage at Altrincham to the deanery at Manchester cannot be known with certainty, but the people most likely to have been involved can be identified.[1] One was Judge Spencer Hogg, who had supported Johnson throughout his ministry at St Margaret's, not least in his efforts to improve the living conditions of the poor. Johnson recounted in his memoirs how Hogg had canvassed the parish when the Deanship of Manchester suddenly became vacant in the late summer of 1924 and, finding widespread support for his nomination, had petitioned the Prime Minister, Ramsay MacDonald, to appoint him. MacDonald confirmed the essential truth of the story in the interview he had with Johnson. 'It was not only my people in the Labour Party who asked me to appoint you', he told Johnson, 'but also the leaders of your own parish, rich and distinguished men'.[2] The Prime Minister doubtless welcomed the appointment of a man who was already well known not only for his trenchant views as a Christian socialist but also his striking ability to express them. The satisfaction was mutual, for Hewlett Johnson made much of the fact that, having been appointed by a Labour Prime Minister, he had a licence to preach socialism. It was, at best, a mischievous *non sequitur*.

The Bishop of Manchester, William Temple, must also have had a hand in Hewlett Johnson's preferment. Indeed, his may possibly have been the most influential hand of all. According to one version, King George V's private secretary, Lord Stamfordham, wrote to both the Prime Minster and the Archbishop of Canterbury, Randall Davidson, with a list of possible names.[3] Davidson then consulted Temple, whose suggestion of Hewlett Johnson found favour in both Downing Street and Lambeth Palace. Davidson regarded him as a heavyweight who would be a considerable Anglican presence in the North-west, while Temple must have anticipated with pleasure the arrival of a high-profile Dean whose political views were close to his own. Johnson's Herculean labours with *The Interpreter* must also have counted in his favour. So the well-oiled cogs

of the ecclesiastical machinery began to turn and Hewlett Johnson was installed as Dean of Manchester in December 1924.

* * *

Manchester Cathedral stands in the centre of the city, a fifteenth-century perpendicular building that, when Hewlett Johnson arrived in December 1924, was blackened with the soot of ages. Hard by the Lancashire and Yorkshire railway station and surrounded by factories, canals and business premises, it had few nearby residential areas and no natural congregation that might have looked to it as a parish church. The 'big men' at St Margaret's may have made their fortunes in the grime of the city but they did not live there. The Cathedral was, though, symbolically important for both the city and the diocese. The Sunday morning congregations were small, but there was a tradition of well-attended evening services with big set-piece sermons. A fine preacher and orator, Johnson was only too happy to continue the tradition, and he later came to see the Sunday evening services as the 'high point' of his work in Manchester.[4] Among the themes to which he repeatedly returned were those that had often exercised him in Altrincham: the evils of an economic system that prevented the poor from ever rising above the squalor of their lives, and the implications of modern scholarship – especially in the fields of evolution and biblical criticism – for the faith of modern Christians.

It was, though, a relatively trivial storm in a chalice that propelled Hewlett Johnson into the spotlight of media attention. It had been a tradition for the lights in the Cathedral to be lowered during the Sunday evening sermons, and while this may have aided the concentration of some in the congregation, it created an ideal environment for young men and women to engage in a little canoodling in the warmth and semi-darkness of the rear pews. Johnson was urged in an open letter in the *Manchester City News* to abandon the practice and, for the sake of decency, to keep the lights raised; and when he refused, he drew a gentle warning from the editor.

> Beware of cheap applause. Do not sacrifice decorum to popularity. We like your after-dinner wit and we enjoy your social humour; we smile at your Ford car anecdotes, and forgive the occasional pun. But when you lately won the favour of every clerk and milliner by delivering an address on 'Why shouldn't young people hold hands in church?' and declaring that 'Church is the right place for courting and we conveniently turn the lights low' – then you risk losing the esteem of the rest of your hearers. It was playing to the gallery.[5]

Johnson defended himself with typically robust good sense, pointing out that while it had never been his intention *deliberately* to create an atmosphere conducive for courting, it was nevertheless much healthier for young people to enjoy each other's company in church than on the unfriendly streets of the city.[6] Ever ready to take an optimistic view of human nature, he added, in an interview given some years later to *The People*, that: 'They come to church primarily to worship, but they also come to make their love sacred. I would much rather that they came to church and held hands than lounged in the streets'.[7]

There were more serious ways in which Hewlett Johnson sought to open up the Cathedral to the people of Manchester. Early in his Deanship he installed a glass porch in front of the west door that allowed passing pedestrians to:

> ... see through the dim light of the Cathedral up to the lamp above the high altar and the robed choir passing four times a day in front of the organ screen: a most inspiring and beautiful glimpse of medieval beauty in the midst of that very modern, busy, and at that time rather ugly city.[8]

In the summer he opened the doors of the Cathedral from early morning till dusk. There was a price to pay in the shape of overtime wages for the vergers; but Johnson was sure that it was all worth while and that the people of Manchester 'will learn to value the great building in their midst, and will use it for prayer, meditation, rest and inspiration'.[9]

What the Dean wanted people to find when they looked or came into the Cathedral was a place of beauty, colour and reverence where sight, sound, light and movement were brought together in the worship of God. Ever conscious of the cultural delights of his own upbringing, he wanted others to find them in this Christian place. He introduced banners and processions. He filled the building with flowers and once said that, had it been up to him alone, he might have used incense in the services.[10] He encouraged the organist to expand the traditional repertoire of the large choir and he nurtured the choir school. Children began to play a larger part in the Cathedral services: a children's corner was established and at Christmas a *tableau vivant* of the nativity was put on by children who remained more or less motionless for an hour.[11] To worship the Lord in the beauty and the variety of holiness was, for Hewlett Johnson, the aim and purpose of the Cathedral's services. If a touch of theatricality helped

to raise the spirits of the worshippers, so much the better – provided it was done well. Worship, Johnson believed, should engage all the senses.

* * *

It was not only the profile of the Cathedral that Hewlett Johnson sought to raise: also high among his priorities was the promotion of his own image in the cause of the things he believed in. From the outset of his time in Manchester he cut a distinctive and highly photogenic figure as he strode around the city in frock coat and gaiters, his long hair already turning white in middle age. He courted the media and the media returned the compliment. Ever the showman, he was only too happy to be pictured with giggling chorus girls in a music hall,[12] with costermongers as he inspected their donkeys,[13] with the cast of *Ali Baba and the Forty Thieves* at a Christmas pantomime,[14] and with stagehands behind the scenes at the Manchester Opera House.[15] The more conservative newspapers were uneasy about such stunts, believing that the Dean was compromising himself and his office. The editor of the *Manchester City News* warned that, by risking decorum for popularity, his dignity might vanish and his effectiveness suffer.[16] But it could never be said of him that he left Mancunians in any doubt about his aspirations for their city.

Some of causes to which Hewlett Johnson allied himself were part of a wider vision to enhance the satisfaction of life in a place that he once described as 'the filthy city of the north'.[17] For someone of a fundamentally liberal nature, the issues that he contested sometimes revealed him as a moral conservative. He picked and mixed his causes. He opposed the Sunday evening opening of cinemas and won.[18] He challenged an extension of licensing hours for clubs and pubs in the city and persuaded the Chapter to buy out the licences of public houses on land that was owned by the Cathedral Foundation.[19,20] He opposed an application for planning permission to construct a greyhound-racing circuit in Salford.[21] He campaigned against gambling, which he said 'undermines character, wrecks homes, and threatens industrial and commercial soundness'.[22] Other causes to which he lent his support sought simply to improve the material quality of life in the city. He complained about the noise of tramcars in heavily populated areas.[23] He advocated the introduction of third-class sleeping cars on trains between Manchester and London so that less well-off passengers could travel in a degree of comfort.[24] He highlighted the plight of working-class mothers in Manchester and Salford who were unable to escape to the fresh air and pleasant surroundings of the country[25] and he supported the work

of the Cathedral's country home at Mellor, in Cheshire, that provided a thousand holidays a year to poor families.[26]

Unifying these disparate endeavours was Hewlett Johnson's determination to use the force of his personality and the influence of his office to make Manchester a better place in which to live. He was, it might be said, the people's Dean. And he insisted, as he had done throughout his time in Altrincham, that it was no more than his priestly duty to do so. The idea of religion as something unconnected to the material circumstances of people's lives was alien to him.[27] He was fond of pointing out that Jesus had come 'that people may have life and may have it in all its fullness'; and this, for the Dean, included material and cultural as well as spiritual fullness. 'It is', he said in a sermon preached at a civic service before the Lord Mayor and members of the City Council, 'our task to humanise our city and then to spiritualise our people.'[28] In that order.

* * *

Prominent among the causes to which Hewlett Johnson devoted a great deal of time and energy were the connected issues of air pollution, child health and housing. Having battled the smell of the manure pits in Altrincham, he now turned his attention to the smoke and smog of Manchester 'which had disastrous effects on every man, woman and child'.[29] When he complained to the City Council about air pollution and was told by the Civic Sanitary Department that the street cleaning measures in the city were a model for England, he saw the misconceived reply as a parable about the divide between public and private accountability. It was a municipal duty to clean the streets, but the coal smoke that belched from the chimneys of a hundred mills and factories was a private matter for the owners to deal with as they chose. Yet Johnson knew that improvements in air quality could be made, for he had seen and been impressed by the progress that had been achieved in European capitals such as Copenhagen and Stockholm.[30] He also had an insider's grasp of how the system worked, for one of his jobs at Ashbury's Carriage Works in the late 1890s had been to check the amount of smoke emitted from the factory's furnaces. This kind of experience, allied to his qualifications as an engineer, must have given an added credibility to his message that coal had had its day: the future lay with the 'clean' fuels of electricity, petrol and smokeless heating in the home. A brief vindication of his thesis came during the general strike in 1926 when the mills and factories fell silent. Johnson doubtless over-dramatised the effect of the strike, but it made the point.

The skies suddenly cleared and Manchester appeared in a new garb. For the first time we saw that the city was girt with hills rising 2,000 feet above the sea. The gardens and parks suddenly bloomed, and I could read the face of the Town Hall clock some distance away.[31]

The malign effect of atmospheric pollution on the health of the children of Manchester was a particular concern, brought home to Hewlett Johnson during one of the annual Whitsuntide walks of Sunday School scholars. The walks, which had begun in Manchester in 1821, were still a distinctive feature of city life when he arrived as Dean. In 1926 a hundred bands and twenty thousand children from forty-one Sunday Schools across the city took part in the walk from the Town Hall to the Cathedral.[32] On the surface, it was a memorable celebration of childhood.

There were smiling faces everywhere, in harmony with the festival music of a hundred bands. The thousands of girls were arrayed in new and lovely frocks, many white with coloured sashes, white socks and well-polished shoes; fathers and mothers had been up early; the streets were swept and many pavements washed. ... The whole Cathedral body was present and led the procession, after the choir and banner-bearers. ... It was a wonderful and deeply stirring sight.[33]

Beneath the surface, however, a different picture began to form. An American visitor standing next to Johnson as they watched the walks asked him: 'Are you Manchester people proud of these children?'

I saw at once what he meant. They were C.3 children under their pretty frocks and new suits, many of them ill-nourished, all of them suffered from lack of sunlight; the black pall of smoke always hung over Manchester, producing a physically C.3 people.[34]

Very slowly things did begin to improve; but Hewlett Johnson had to face up to an uncomfortable contradiction in his position during the general strike of 1926 and the ensuing six-month lockout of the miners. Although he declared himself to be 'entirely in sympathy with the miners'[35] and was prominent among those who pressed for aid in kind to help them and their families, his sympathy was compromised by his high-profile opposition to the burning of coal. It was, moreover, widely known that several of the Dean's relations were among the mine owners and managers determined to break the resistance of the miners. His eldest uncle, Alfred Hewlett, was Chairman

of the Mining Owners Federation and another uncle, his godfather William Hewlett, was head of the Wigan Coal Company. The evidence, such as it is, suggests that the Dean accommodated the contradiction by ignoring it. His Christian compassion towards the short-term needs of the miners was more important than his long-term desire to rid the city of pollution.

Air pollution was not the only evil that Hewlett Johnson fought against in Manchester. Bad housing was another. In fact, as he had discovered in his work among the slums at the bottom of the hill in Altrincham, the two were often inextricably linked, for the deleterious effects of pollution were magnified in places where people lived cheek by jowl in overcrowded and unsanitary conditions. 'You cannot live twenty in a house which is only meant for four without suffering,' he wrote in the *Daily Dispatch* in 1928.[36] Together with other churches in Manchester, the Dean helped to launch a campaign to rouse public opinion about the scandal of much of the city's housing, and on a Sunday evening in 1925, shortly before a round of elections to the City Council, a 'wake-up call' was sounded from all the pulpits at which electors were urged to vote only for candidates who were pledged to support a vigorous housing policy.[37] The Cathedral Foundation did its bit by selling some of its land for low-cost houses (built for an average of £429 each) to be made available to large families at reasonable rents.[38]

* * *

It was as Hewlett and Mary Johnson were driving home from a holiday in the south of England in the late 1920s that Mary told her husband of a swelling in her breast. She underwent surgery and a tumour was removed. A year or two later the cancer returned, and in the autumn of 1930 she withdrew from the extensive work she had been doing in the Manchester diocese for the Red Cross, the Mothers' Union and the Band of Women Messengers. Hewlett wrote in his autobiography that:

> I used to nurse her at night, and she said: 'No-one can settle my pillow like you do.' She never uttered a sad or complaining word, but assured me that God would give us both the strength we needed. 'It will be all right', she said, 'I shall always be by your side'.[39]

Mary Johnson died in January 1931 at the age of fifty-seven. Hewlett was devastated. Perhaps because they had had no children of their own, they had created for themselves a shared ministry that drew children of all ages and conditions into the circle of their care, enthusing them with

their interests and encouraging them with their optimism. Mary was the perfect foil to Hewlett, quietly smoothing the many feathers that were ruffled by the whirlwinds of his enthusiasms as she went about her own work among the Cathedral community. Her funeral in Manchester Cathedral on 19 January 1931 was a moving celebration of her life of dignity and service. The *Mothers' Union Journal* carried a report of the occasion.

> Very few who have been accustomed to the beautiful services held in Manchester Cathedral can recall any more glorious one than that which was held for our dear late President's funeral. Neither gloom nor the usual sadness which generally accompany such a service were in evidence. Everything was as joyful as Mary Johnson would have wished. Hundreds of people were present ... and the many organisations which claimed our late leader's support were well represented. Nobility, University, Civic Authorities, humble Mothers from Ancoats and Hulme were there to pay tribute to one who is so universally loved. ... The road to the graveside in Hale cemetery was lined with a great crowd who had gathered together as an act of love towards one whose love and bravery have left an example which will never be forgotten.[40]

Never one to reveal his private emotions too readily, Hewlett Johnson made only a brief reference to Mary's death in his autobiography; but the little that he said about it laid bare the depth of his grief. He tried, pathetically, to convey to a friend the day-to-day reality of his bereavement: 'Just lately, I've had a bad toothache: if Mary had been here I could have told her.'[41] The most eloquent expression of Johnson's grief is in the draft of an undated letter to an unknown recipient. Written in Johnson's own hand and addressed to 'My Dear Lady', it appears to have been intended as a pastoral letter of encouragement to a woman whose husband had died in difficult circumstances.[42]

> My only excuse for writing at all is that in a certain sense your experience and mine are parallel. The companion of 28 years of a supremely happy marriage died, after a long illness and torture, of cancer. No prayers of mine and no efforts of man stayed the illness or the end. Yet something emerged which made me conscious that the tragedy, being lifted onto a new plane, became creative and grand. And that emerging thing was due to what my wife had done and to this day, I believe, continues to do from 'the other side'. My wife met the inevitable end

with sublime courage and even radiance. Her love transformed the tragedy and made it sublime. ... Such death is creative and inspires us who remain.

As well as being an eloquent summary of his personal faith, the letter also cast an instructive light on the Dean's deepening theology.

As to God – don't worry much about that at present. ... I am convinced that your husband looks to you to carry on and make complete in your life the work he has so grandly begun. Action in this life, here and now, and not mere dreaming about another life and a distant God is, I am sure, the right and only way. And any such action will make the world more free from the barbarities which crucified and killed your husband. Good lives are inextinguishable. They go marching on.

* * *

At the time of her death in January 1931 Mary owned a large collection of valuable artefacts and investments. She was a rich woman. A handwritten will was signed and witnessed in August 1925,[43] but whether it was superseded by a later and more formal one is unclear. Mary's wishes in 1925 were that, if she died before Hewlett, a small number of legacies and bequests should be paid to people and charities who had been particularly close to her but otherwise 'money from the sale of furniture etc [is] to be divided between the two estates of Hewlett and Mary.' It is difficult to know what this means, for on her death her own estate would be wound up and everything that she bequeathed to Hewlett would automatically become part of his estate. It may have been a way of signalling her wish to return to her own family the fiscal dowry that came with her marriage. At all events, the evidence suggests that on her death in January 1931 the bulk of Mary's estate passed to her husband, for only four months later he had the whole of his personal effects valued for insurance purposes.[44] The great majority of the items on the inventory are likely to have been inherited from Mary.

The inventory listed a very substantial collection of valuable objects. They included a great deal of Chippendale, Sheriton and Hepplewhite furniture; multiple sets of Georgian, Regency and Victorian cutlery; antique tea and dinner services; Turkish and Persian rugs; silverware from India; jewellery that included a gold ring set with diamonds and turquoise and a necklace set with pearls and diamonds; Chinese and Japanese sculptures;

and a grand piano by John Broadwood. There were also books, paintings, tapestries, glassware, mirrors, candlesticks, lamps, clocks, watches, soft furnishings and the like. The inventory was valued for insurance purposes at £2,000, which would be worth about a hundred times that sum at today's prices. As he was preparing to leave the deanery at Manchester in the summer of 1931 Hewlett Johnson was a wealthy man. Some of the many items of furniture and other valuables in the inventory must have accompanied him to Canterbury, but most were probably sold soon after Mary's death to finance the purchase of several properties that he bought in the 1930s in London, Canterbury, Charing and Harlech.

* * *

During Mary's illness and after her death, Hewlett Johnson received many letters of support and sympathy. One that merits particular attention came from the Reverend George Edwards, a cousin on his father's side and the vicar of Crossens, in Southport. A week before Mary died, George wrote:

> I have been wanting very much these last weeks to write to you and assure you of our deep and continuous sympathy ... in the so long continued and so painful sufferings of your dearest Mary. They will have been ever memorable weeks to you, weeks of a fuller and more prolonged effort to learn that major lesson in life, that our nature is at bottom spiritual, for we are in truth spirits whose chief task it is to trust the Father to show us the way home to Himself.[45]

George Edwards and Hewlett Johnson enjoyed a close relationship, partly no doubt because of their shared political and theological views. They also had a shared sense of the theatrical: while Hewlett was being photographed with chorus girls and costermongers, George was exploring the workhouses of Lancashire disguised as a tramp.[46] He was a devout and scholarly man, proud of his four children, and taking a genuine interest and pleasure in his cousin's rise to fame.

> I was listening in to you [on the wireless] last night whilst you were speaking at the Cathedral, and remembering your needs. So far as voice was concerned, I thought you spoke very distinctly and clearly, and on our little set we could hear you very well. You took a very difficult, but a very beautiful subject, and handled it well. May your words bring forth fruit in due season.[47]

George Edwards was struck by Parkinson's disease while at the height of his powers, and for the last twenty years of his life before his death in 1934 he watched helplessly as one by one his capacities began to wither – preaching, visiting, writing, dressing, feeding. But he could still listen and pray, and when Hewlett Johnson became Dean of Manchester, he was recruited into the praying ministry of the Cathedral. It was an act of faith and imagination that Edwards deeply appreciated.

> I do most sincerely and with a full heart thank you for the way in which you have been helping me to keep first things first, and to put and keep prayer more in the right position in which it should be as the major force in our life.[48]

As George Edwards became increasingly disabled, the Johnsons took his children under their wing, 'helping them with warm winter clothes and presents that made summer holidays possible'.[49] Although the children were actually Hewlett's first cousins once removed, they had known him throughout their lives as a much-loved uncle: Nowell Edwards, for example, romped with him on the floor as a child and addressed him in her letters as 'Dearest Uncle Hewlett'. From his sick bed, George Edwards updated his cousin from time to time on their progress. A particularly full report came in August 1932.[50] Of his three sons, Stephen was working as a curate in St Helens, Hewlett (the family name crops up yet again) had given up trying for a theological tripos at Cambridge and was doing community work in Hoxton, and Menlove was completing his medical training at Liverpool University (with some difficulty) and indulging a passion for rock climbing that would see him become one of the finest and most innovative climbers of the twentieth century.[51] The boys' sister, Nowell, had just completed her studies at the Royal College of Art.

> Her success [at the RCA] is a thoroughly deserved merit. Then she has now the pleasure of looking forward to a time of preparation for visiting the leading galleries and seeing as much of the best architecture of Europe that she and her friend can see when she starts off with the early coming of spring in February next. She is at home at present, having been housekeeping while her mother was away, for I cannot be left very long now unfortunately. Next week she and Menlove go off for a few days to Whitby, which is the subject given to eight selected members of the Royal College of Art, to form one of a new series of

posters to advertise one or more of the activities of the North Eastern Railway. The award is £25.[52]

In 1932, as he updated his cousin on the achievements of his artistically gifted daughter Nowell, George Edwards could never have imagined that within a few years she and Hewlett would be married.

CHAPTER FOUR
FROM MANCHESTER TO CANTERBURY

A LTHOUGH HEWLETT JOHNSON found ways of filling the void left by Mary's death, her memory and her inspiration never left him. In his letters to his second wife, Nowell Edwards, he referred to his sense of Mary's continuing presence in his life, mediated particularly by a daily 'devotion book' that she had kept and that he read on a regular basis. Writing to Nowell in February 1940 as a fearful storm was about to break over his strained relationship with the Canterbury Chapter,[1] Johnson said:

> I'm prepared. I read these lines under today's heading in Mary's devotion book. 'The really devout man ... has a still greater love of that which is good. He is more set on doing that which is right than on avoiding what is wrong. He is not afraid of danger in serving God, and would rather run the risk of doing His will imperfectly than not strive to serve Him lest he fail in the attempt'. That rather hits it today. I may have made a thousand blunders – I have – but there is the effort to serve. That must suffice. And a thousand thanks for all your courage too.[2]

Two years later, in 1942, Hewlett Johnson again acknowledged Mary as a seminal and continuing influence in his life along with his mother and Nowell. Commenting on the observation of a colleague that he was 'one of three English public men who could command the greatest audiences everywhere', he confessed in a letter to Nowell:

> I know it is true. I take no credit whatsoever for it. It is my subject and the experience God has given me, and above all due to the three great women who have moulded and supported my life – my mother, Mary and my darling Nowell. It is beyond calculation what you have done for me. And now it shows itself in this great worldwide mission, for such in a sense it is. Thank God. I feel the ultimate support of the goodness and love of the three great women.[3]

With Mary's death in January 1931, Hewlett Johnson felt that he no longer had a role to play in Manchester. Theirs had been a joint ministry and now one half of it had gone. Yet he was still only fifty-seven, full of physical, moral and intellectual energy, with a great deal still to give to his career. He not only needed a change, he was ready for a larger stage than Manchester had given him. Various accounts exist of the route by which he came to be appointed Dean of Canterbury. One account directly implicated King George V, who was said to have been impressed by Johnson when he preached to the royal family at Windsor.[4] But others also had a part to play. One was the Archbishop of York, William Temple, who as Bishop of Manchester had been instrumental in securing Johnson's preferment to the Manchester Deanship in 1924 and who obviously knew of his work at first hand. Temple proposed Johnson as an ideal replacement for the Very Reverend Hugh Richard Lawrie (Dick) Sheppard who, for reasons of ill health, had resigned as Dean of Canterbury in February 1931. Another influential hand was that of Ramsay MacDonald, who as the first Labour Prime Minister had appointed Johnson to the Manchester Deanery and was now in his second spell as Prime Minister. 'I cannot better serve the interests of the Church', he wrote to Johnson, 'than by offering you the succession to the Deanery.'[5]

The Archbishop of Canterbury, Cosmo Gordon Lang, was naturally consulted about the appointment and was genuinely pleased with the Prime Minister's choice. From his sickbed he penned a personal letter to the Dean-elect in March 1931.

> [This is] a personal letter of greeting and blessing on your appointment as Dean of Canterbury. I am very glad that you accepted the proposal of the Prime Minister about which I need scarcely say I had full communication with him. It seemed to me and to him that you had gifts of mind and experience and spirit which would especially fit you for the charge of the great Cathedral of Canterbury, the Mother Church of English Christianity. ... You will miss the busy life of Manchester: but Canterbury will bring its own consolation and a supreme interest. Meanwhile, accept this offer of my own personal thankfulness that you are coming, and my heartfelt blessing on the work which awaits you.[6]

Archbishop Lang later felt the need to advise and even to warn the new Dean about his behaviour, but the relationship between the two men was always courteous and usually friendly. Lang often gave the impression of

tolerating Hewlett Johnson as a devoted father might tolerate a gifted but wayward son. 'Dean, Dean,' he once said in exasperation, 'you always have an answer for everything.'[7] For his part, Johnson had an obvious respect and affection for the Archbishop. 'I was much attached to him in spite of our many differences', he wrote in his autobiography, and continued:

> He was a humble man at heart and I think a lonely man. He was shy and never entered a shop in Canterbury. I remember once saying to him it was strange he had never married. He answered jocularly that curates and chaplains could be sacked, but once married a wife was permanent. ... Lang's tastes were simple; when alone at tea time he had no silverware – just a brown teapot.[8]

* * *

The Canterbury Chapter at the time of Hewlett Johnson's arrival in the summer of 1931 had been together for a number of years and was rather set in its ways. The Archdeacon of Canterbury was Edward Hardcastle; the Archdeacon of Maidstone was John Macmillan; and the canons residentiary were Claude Jenkins, John Crum, Samuel Bickersteth and Thory Gardiner. They were a conservative group of clerics who were comfortable in their own procedures and did not welcome innovation.[9] Hardcastle and Gardiner were older men who represented a link with the past. The former, who self-deprecatingly titled his autobiography *Memoirs of a Mediocrity*, remained as Archdeacon until 1939; the latter was well into his seventies when Hewlett Johnson arrived and feeling increasingly at odds with the spirit of the times. Gardiner had had a lifelong interest in social questions, especially urban housing, and he had served as a member of the Royal Commission on the Poor Laws and Relief of Distress between 1905 and 1909; but he was more a Fabian than a revolutionary and he was uncomfortable with grand political schemes.[10] It would be no surprise if Gardiner viewed Hewlett Johnson's arrival with a degree of alarm – something that may have been hinted at in his obituary in the *Diocesan Notes* in 1941, which observed that 'his robust mind avoided the snares of Utopian ideologies'.[11]

Claude Jenkins was a scholar, albeit an untidy and absent-minded one, and the repository of an astonishing array of knowledge. In January 1932 he informed the Chapter that the number of pigeons in the precincts was fifty.[12] He probably had no set views or expectations about Hewlett Johnson one way or the other, and in any case he was soon to leave Canterbury for the Regius Professorship of Ecclesiastical History at Oxford and a stall

in Christ Church Cathedral. John Crum, though, was to become an alto-
gether more potent force in the Dean's life. A canon of Canterbury since
1928, he had been educated at Eton and Oxford and had spent most of his
career before Canterbury as a parish priest. He had been a staunch
supporter of Johnson's predecessor, Dick Sheppard, defending him against
the conventional view that his appointment to the Deanery had been a
mistake. He even claimed that Sheppard had been the best thing that had
happened to Canterbury since the arrival of St Augustine in 597.[13] John
Crum and his large family were very kind to Hewlett Johnson when he
first arrived in Canterbury, taking pity on the childless widower rattling
around on his own in the cavernous spaces of the deanery. He often invited
the Dean to spend evenings at his home in the precincts and Johnson
returned the compliment by allowing the Crums to use Llys Tanwg, his
holiday home at Harlech. Unhappily, Crum's initial warmth towards the
new Dean was eventually to turn into a dark and malevolent despising, to
Johnson's magnanimous regret.

> I was sad because I loved Crum, with his wit and brilliancy. I never
> forgot the surprise he gave us at the Friends' Festival when John Mase-
> field, the Poet Laureate, came to speak to us. Crum was to propose a
> vote of thanks, and to the astonishment of all – perhaps to Masefield
> most of all – he replied in perfectly charming verse.[14]

It is not difficult from these brief sketches to see that Hewlett Johnson might
not have struck the Canterbury Chapter as the ideal successor to Dick Shep-
pard when his appointment was first announced. In many ways Johnson
stood for much that the canons studiously avoided. He wore his political
convictions on his sleeve; he espoused the ideas of liberal Protestant theol-
ogy and held radical views about the relationship between theology and
social action; he wanted, as in Manchester, to open up the precincts to the
wider community; and he saw the need to bring a modern business
approach to the Cathedral's affairs. There was also, it seems, a delicate and
probably unspoken issue of class. Hewlett Johnson hardly fitted the Canter-
bury template. The son of a northern industrialist, he had been educated at
a grammar school, read engineering at university, served an apprenticeship
in heavy industry, been rejected by the Church Missionary Society on
account of his liberal theology, and was now being tracked by the security
services. Was this really what Canterbury wanted? It is true that he had a
bachelor's degree from Oxford – but it was only a second-class degree. It is
true also that he had a higher doctorate from Oxford – but his DD was

awarded for nothing more than a three-week reading course and a single essay. His most accomplished scholarly achievement, the editorship of *The Interpreter*, was by now some way behind him. Set against Crum's Etonian background, Gardiner's standing with the political establishment and Jenkins' reputation as a scholar, it may all have looked a little thin.

* * *

For his part, Hewlett Johnson hardly went out of his way to endear himself to his new colleagues. There is a sense in which he did not need to: compared to Manchester, where the Dean had been the central pivot around which everything in the Cathedral community had revolved, Canterbury seemed to have an ancient rhythm of its own, running on well-oiled tracks and overseen by those who knew exactly what they were doing. On a day-to-day basis, Canterbury Cathedral was less dependent on the Dean than Manchester had been, and the far smaller city of Canterbury offered much less scope than Manchester for the kind of civic engagement that had become Johnson's ministerial hallmark. Robert Hughes described it thus:

> In Manchester, Hewlett had been at the centre of the biggest industrial complex in Europe. He mixed daily with the 'big men' whose decisions involved millions of pounds and affected thousands of lives. There were important issues (such as clean air) that cried out for pioneer campaigns and there was an obvious role in the community waiting to be seized by the Cathedral. In Canterbury, by contrast, the Cathedral was already playing its age-old role with serene assurance, and both issues and personalities were very different.[15]

Because of these differences, Hewlett Johnson felt freer than he had been at Manchester to turn his attention beyond the precincts and the local community to a wider international stage.

> My conception of my work when I left Manchester was not only to integrate the life of the Cathedral with the city of Canterbury, or Kent, or with the life of the English people; but to integrate the Christian spirit where Christians are found, and still further to various nationalities which I sought to approach and understand.[16]

An early opportunity to put his philosophy into action came shortly after he arrived in Canterbury when he received a visit from the Reverend Charles Andrews, an Anglican clergyman whom he first knew through *The*

Interpreter. Three years older than Johnson, Andrews was similarly interested in the relationship between Christian theology and social justice, especially in the subjugated nations of the British Empire. In 1904 he joined the Cambridge Brotherhood in Delhi where he became involved with the Indian National Congress before moving to South Africa to help the Indian community in its conflicts with the government. There he met and was deeply impressed by a young Gujarati lawyer, Mahatma Gandhi, whom he persuaded to return with him to India in 1915. The two worked closely together in the cause of Indian independence, and in 1931 Andrews accompanied Gandhi to the first Round Table Conference organised by the British government in London to discuss constitutional reform in India.

It was while he was in London that Charles Andrews travelled to Canterbury to ask if Hewlett Johnson would invite Gandhi to visit him.[17] Johnson agreed, and Gandhi duly turned up at the deanery in a Rolls-Royce dressed in a white robe and accompanied by police and detectives. Among his luggage were a small handloom and a goat. Johnson plainly regarded his relationship with Gandhi as cordial.

> Gandhi arose at a very early hour and said his prayers. I rose at the same time for my prayers, and after finishing I went into the kitchen to get some tea. He came to find me; he was immensely amused and sat on the kitchen table watching me, swinging his legs and chatting. He came with me to the Cathedral and was much impressed, sitting beside me in the stalls; he was very intent on the service and said of the hymns that were sung that they might have been written especially for him. ... In the evening we sat on the hearthrug before a blazing fire, he in the oriental cross-legged fashion: he erected his small hand-loom and began to weave whilst we talked.[18]

A reception for Gandhi, arranged in the deanery, was boycotted by the canons who objected to the presence of such a prominent enemy of the British Empire in their midst.[19] Hewlett Johnson saw it as an ominous sign of the gulf that even at this very early stage was opening up between (as he saw it) the parochial outlook of the Chapter and his own, much more expansive horizons.

> [After Gandhi's visit] I never extended the same kind of invitation; many of my guests were likely to be anathema to them [the Chapter] politically. It was the same with [Pandit] Nehru, whom I entertained alone when he came from prison to visit his dying wife in Switzerland.[20]

Nor was I encouraged or inclined to invite them when representatives of many countries came from all over the world. The Chapter remained ignorant of any vision of the great newly-awakening Socialist and Eastern countries.[21]

If the prospects for a cordial relationship between Dean and Chapter were never very good, after Gandhi's visit they were even less promising. Hewlett Johnson responded the next year (1932) by insuring himself for £10,000 against death and kidnap, and going to China for four months.

* * *

The idea of going to China came to Hewlett Johnson through the visit of Charles Andrews in 1931. Andrews had just returned from China where he had witnessed the devastating effects that were still being felt from the floods and famine that had struck many northern areas of the country in 1928. As many as two million people may have died of starvation. Johnson was moved by Andrews' account of what he had seen.

> He [Andrews] saw men and women dead and dying on the roadside, some with limbs cut off to serve as human food – 'Two of my companions had seen this form of cannibalism with their own eyes' – and had stood before a multitude with grain adequate to save but a fraction of them; he had to choose who should live. He begged me to go to China in that present year of famine.[22]

Johnson was as keen to respond to Andrews' proposal to visit China as he had been to invite Mahatma Gandhi to Canterbury; but certain problems had first to be overcome. One was the small matter of permission: as well as getting the consent of the Canterbury Chapter, Johnson also had to seek the blessing of the Archbishop of Canterbury, Cosmo Gordon Lang. After the lengthy absences from Canterbury of Johnson's predecessor Dick Sheppard, Lang was very anxious that Johnson should give the impression of being a resident Dean. The Archbishop pointed out that the absence of a Dean for four months was a serious matter in the life of a Cathedral. However:

> I find it impossible to put obstacles in the way of the fulfilment of your very generous proposal to visit China and endeavour afterwards to arouse the conscience of this country and other countries. … You seem to have been so strangely moved to make this venture that for my own part it is not in me to say you nay.[23]

Hewlett Johnson's original idea had been to form an international party of senior observers to visit the flooded and famine-stricken areas of China where they would study the work of the relief agencies and stimulate educational and fund-raising activities on their return. In September 1931 he contacted one of his missionary heroes, Albert Schweitzer, and invited him to join himself and Andrews on the expedition.[24] He offered to pay Schweitzer's entire costs, including locum cover for his hospital in Gabon, from money left to him by Mary;[25] but Schweitzer found it impossible to leave Africa.[26] Others whom Johnson considered for inclusion in the party were the medical missionary Wilfred Grenfell, the Japanese Christian reformer and labour activist Toyohiko Kagawa, and Mahatma Gandhi; but they too declined the invitation. In the end, Johnson seems to have travelled to China on his own – though his accounts of his experiences are often written in the first person plural.

Hewlett Johnson's 1932 visit to China was a hugely important event at this stage in his life, setting the tone for his future ministry in Canterbury. He devoted more space in his autobiography to these four months than to his entire time as Dean of Manchester. Yet there is much about the visit that is vague and uncertain. He probably funded it from money left to him by Mary; but nothing is known about the way it was organised, and it is impossible from his diary accounts to reconstruct the four months he spent in the country. Johnson did, though, identify some of the people he met along the way. They included Sir John Hope Simpson, the director of the China International Famine Relief Commission; Dr Wellington Koo, the Chinese Ambassador to America; Major Oliver Todd, the American chief engineer of the Famine Relief Commission; Bishop Logan Herbert Roots, a communist sympathiser who was a dominant figure in the Christian missionary movement in China; and the Misses Ruth Verhulst and Lilly Johnson, Moravian missionaries based with the China Inland Mission in Lanzhou.

From Trieste Hewlett Johnson travelled to Shanghai on an Italian boat making its maiden voyage and shocked Benito Mussolini's daughter, who like himself was travelling first-class, by inviting 'coloured third-class passengers' to tea in the first-class saloon.[27] He then travelled along the Yangtze River from Shanghai to Nanking, and it was on this part of his voyage that he first encountered the drug culture of China.

> The lower decks of our steamer were crammed with refugees from Chapei [an area of Shanghai under fire from the Japanese]. Leaning over the taffrail, we could see their black heads and blue gowns. Curious sickly fumes ascended and I made my first acquaintance with the

fumes of opium. Visiting the lower decks, I found the crowding was terrible, human forms were everywhere, in tiers or bunks, on shelves, rolled up in padded quilts along the gangways or passages.[28]

Once in China, getting around was often difficult and occasionally treacherous, especially in the western mountains. Johnson travelled mostly by car or truck, helped out occasionally by oxen and mule harnessed to the vehicle for the more difficult mountain passes. Photographs show him in conventional western attire, complete with shirt, tie, waistcoat, socks, lace-up shoes and trilby hat.[29] It was hardly a pioneering expedition, for even the more far-flung places that he visited were home to western Christian missionaries; but it was demanding enough for a solo traveller nearing sixty. Accommodation was sometimes basic and some tricky moments occurred with bandits and border guards. Even among the modernity of Shanghai, Johnson heard the Japanese guns pounding the Woosung and Chapei areas of the city. But it does not appear that the Canterbury Chapter came terribly close to claiming on the insurance policy that the Dean took out against his death or kidnap.

* * *

Hewlett Johnson's itinerary took him first to Shanghai where he visited Sir John Hope Simpson, the director of the China International Famine Relief Commission, and learnt at first hand of the catastrophic extent of the floods and the consequent famine and epidemics. Hope Simpson suggested that Johnson should go to Anhui, a province to the west of Shanghai on the farthest edges of the flooded Yangtze basin. 'This was', wrote Robert Hughes, 'one of the most memorable journeys of Hewlett's life: sordid, spectacular, dangerous, beautiful and sublimely uplifting in turns.'[30] Steaming up the Yangtze River to Nanking, the Dean's descriptive powers found full rein.

We left the wharves, looking like a busy anthill with its hundreds of blue-robed workers, and crossed the river in the ferry to begin an inspection of the refugee camps. Hungry multitudes, driven from home by flood and famine, had massed together from hundreds of miles around to seek relief at centres like Nanking. Poor pitiful hordes, a woman with a babe and family of small children and the father gone; an old man staggering beneath a pole with his infant grandchild in a basket at one end, counterbalanced by another basket swung at the other end full of various fragmentary belongings. Such as these would be the sole survivors of a family.[31]

1. Hewlett Johnson on his appointment as vicar of St Margaret's, Dunham Massey, 1908.

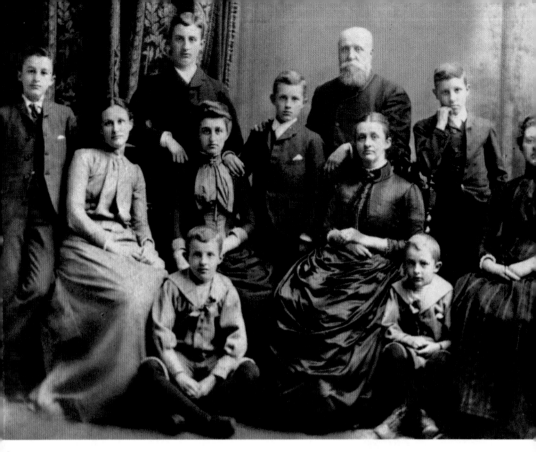

2. Charles and Rosa Johnson and their children, circa 1885.
Hewlett Johnson is on the far left.

3. Employees of Johnson's Wire Works in the 1890s.
Hewlett Johnson is on the far left.

4. As an undergraduate at Wadham College, Oxford University, circa 1903.

5. Hewlett Johnson (seated centre) with members of the Wadham College rowing VIII, Oxford University, 1903.

6. Hewlett Johnson on his wedding day to Mary Taylor, 1902.

7. Hewlett Johnson with his first wife Mary Taylor (right) and her mother (centre), circa 1903.

8. Hewlett Johnson with the Crossley motor car presented to him by his parishioners on leaving St Margaret's in 1924.

9. Hewlett Johnson with a member of the congregation outside Manchester Cathedral, probably late 1920s.

10. Hewlett Johnson
during his time as Dean
of Manchester Cathedral
between 1924 and 1931.

11. Hewlett and Mary
Johnson outside the
Manchester deanery,
circa 1930.

12. Hewlett Johnson on his appointment as Dean of Canterbury Cathedral, 1931.

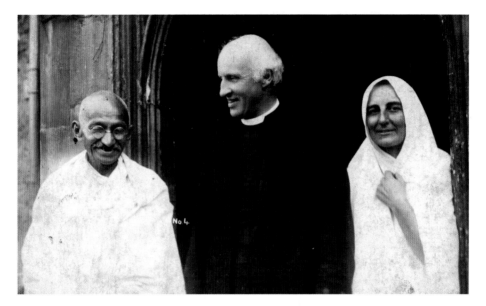

13. Hewlett Johnson outside the Canterbury deanery
with Mahatma Gandhi and Madeleine Slade, 1931.

14. Hewlett Johnson travelling in China under the flag
of the Famine Relief Commission, 1932.

15. Hewlett and Nowell Johnson on their wedding day in Stokesay, Shropshire, 1938.

16. A page from Hewlett Johnson's passport in 1937, at the time of his first visit to the Soviet Union.

17. Glaziers attending to medieval glass in the
Trinity Chapel of Canterbury Cathedral, circa 1939.

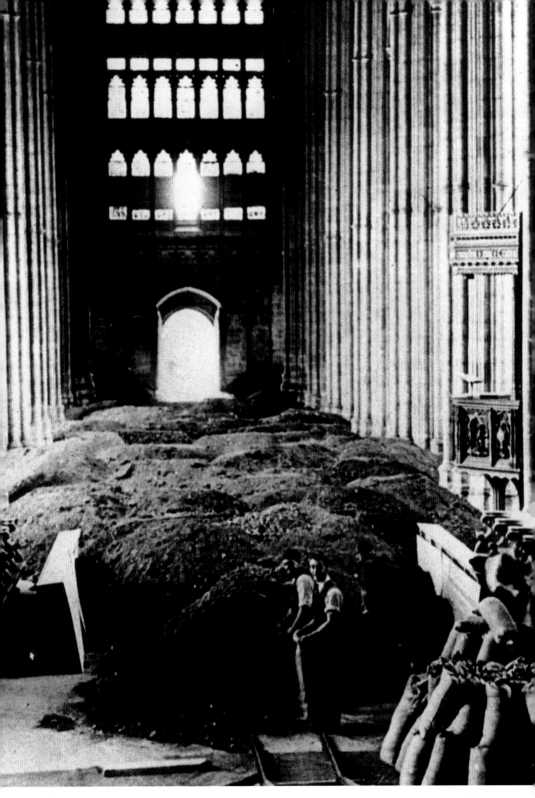

18. Earth deposited in the nave of Canterbury Cathedral awaiting removal to the choir aisles to protect the crypt beneath in the event of bombing, circa 1939.

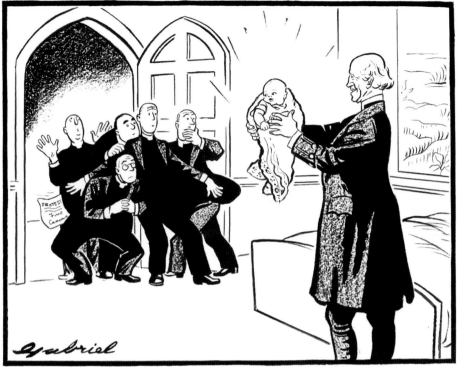

"HOW'S THAT FOR SIXTY-FIVE ?"

19. Cartoon by Gabriel in the *Daily Worker* to mark the birth of Hewlett Johnson's first child, Kezia, when he was sixty-six (incorrectly given in the cartoon as sixty-five), March 1940.

20. Kezia Johnson's christening, May 1940. Nowell Johnson is on the far right, next to Margaret and Mary Crowe.

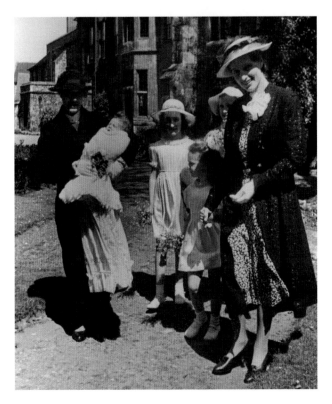

21. Hewlett Johnson with
Kezia at Llys Tanwg, 1940.

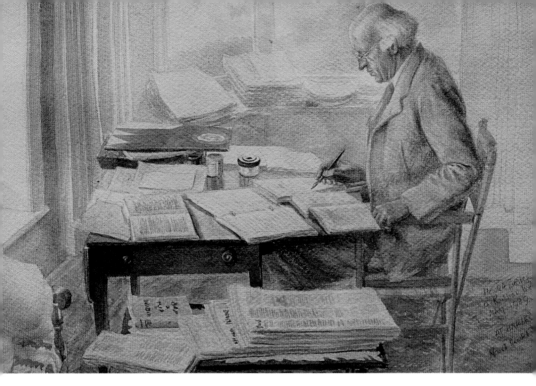

22. Watercolour by Nowell Johnson of Hewlett Johnson working at Llys Tanwg, near Harlech, during a war-time visit.

23. Watercolour by Nowell Johnson of Freda Watson serving tea in the Canterbury deanery, late 1930s.

IT IS AFTERNOON.

FREDA IS GETTING THE TEA READY. THERE ARE TWO CAKES. SHE IS ATI BY HERSELF MARY WAS UPSTAIRS. IRIS WAS OUT FOR THE DAY. HILDA WAS IN THE KITCHEN BUT SHE HAD BEEN OUT UNTIL TEA TIME. AFTER TEA MARY CAME AND PAINTED THIS PORTRAIT.

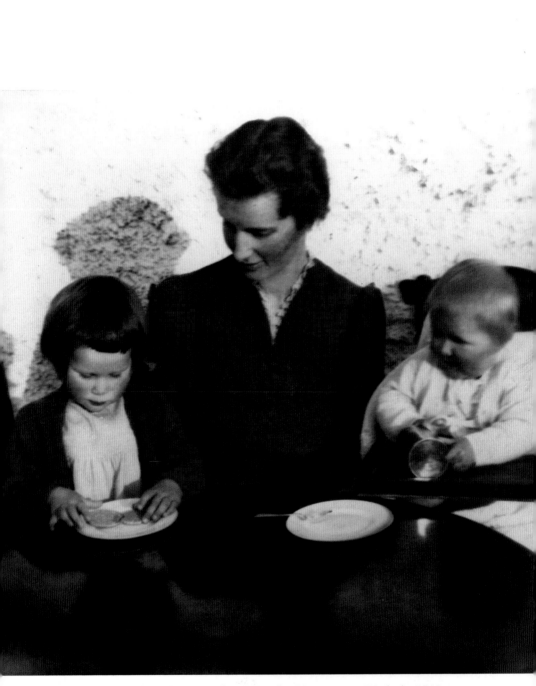

24. Kezia, Nowell and Keren Johnson at Llys Tanwg, near Harlech, 1942.

Johnson filed a story for the *Manchester Guardian*[32] before travelling north to Peking where he met Major Oliver Todd, the chief engineer of the Famine Relief Commission. The two engineers struck up a fine relationship and Todd invited Johnson to accompany him on a journey he was making to the Qinghai province, some 1,600 miles southwest of Peking. The idea was to 'study the associated problems of poverty, famine, bandits and communications'.[33] They travelled in a Dodge truck flying the blue and white flag of the Famine Relief Commission, and they took with them ropes, picks, spades, poles and planks. The journey began at Xian, once the capital of China, before moving westwards on steadily deteriorating roads through the poppy-growing areas.

> Fields of poppies, immense and rainbow-coloured, bloomed in masses like tulips in the Netherlands. Poppies grew where wheat was needed; poppies which yielded three or four times the profit of wheat. Indeed, that was why poppies grew there at all; that and the fact that opium weighted light for value and was easily transported in a land where transit was difficult.[34]

The incentive to grow poppies, Johnson discovered, was overwhelming. Poppies alleviated rural poverty and it was quite easy for the growers and traders to evade the tax on opium. Continuing westwards to the multi-ethnic city of Xining, Johnson met the staff of the China Inland Mission and 'rejoiced in Scottish scones and English cakes and all the charm of an English home'.[35] South of Xining, the group made a detour to the fabulously decorated Buddhist Temple of Kumbum before traversing the bandit-infested Liupan Pass, where they needed an escort of four armed men. Descending into Lanzhou on the farther side of the pass, Hewlett Johnson met the American Bishop Logan Herbert Roots. Four years older than Johnson, Roots was an outstanding figure in the history of the Christian missionary movement in China, but he was no ordinary churchman. He entertained senior figures of both the Kuomintang (the Chinese Nationalist Party) and the Communist Party in his drawing room at the mission, happy to discuss politics with whoever came along.[36] Roots had been 'carefully reading' Lenin when Johnson arrived, and the two talked at length about communism and Christianity. It seems to have been a significant moment of confirmation for the Dean, for Roots was articulating what Johnson had already come to understand for himself – that communism and the New Testament were not too far apart.

Roots was wonderfully open to the idea of communism, and hoped that some method of approach might be made so that when communism came they might discover that there were elements in Christianity strongly allied to the very things the communists were aiming at for themselves.[37]

* * *

Hewlett Johnson travelled home to Canterbury via America where he spoke of his experiences and appealed for help on behalf of the relief agencies working with the victims of the floods and famines. His visit was widely reported in the United States where the press could hardly get enough of the gripping adventures of this tall, austere and somewhat old-fashioned clergyman who prophesied in a cultured voice about the ultimate collapse of capitalism; but his pleas on behalf of the starving and the dispossessed in China were barely mentioned in the hundreds of column inches devoted to the Dean.

> Taking their cue from the *Shanghai Sunday News*' reports of the dangers he had faced, the papers told hair-raising tales of narrow escapes from bandits, a terrifying flight at treetop level in a light plane, and a 30-mile walk though the night to fetch petrol when the Dodge ran out. By the time Hewlett returned in July 1932, the press had him in its spot-light, the new star of the metropolitical stage.[38]

It takes little imagination to sense the anticlimax that Hewlett Johnson must have felt as he re-entered the cloistered life of the Canterbury precincts. Although he kept in frequent touch with many of those he had met in China, particularly Major Todd and Bishop Roots, there was work to be done in Canterbury, and immediately on his return he had to deal with a request from the Cyclists' Touring Club for guidance on the wearing of shorts in the Cathedral. Unsurprisingly, Johnson was soon proposing a revision to the Foundation's statutes that would release the Dean from 'too sole a responsibility' for the affairs of the community, thereby enabling him 'better to undertake matters of wider import connected with Church and Nation'.[39] Keith Robbins remarked that Hewlett Johnson 'would not allow his vision of the regeneration of the world to be blotted out by narrow ecclesiastical preoccupations'. There was never any danger that he would.

CHAPTER FIVE
BEING DEAN
IN THE 1930s

T HE SEVEN YEARS between Hewlett Johnson's return from China in 1932
and the outbreak of the Second World War in 1939 was a busy time
for him both professionally and personally. Shortly after his return, the
Chapter engaged the services of the noted medieval art historian, Profes-
sor E W Tristram, to make reconstructed copies of some of the early
artwork in the Cathedral, including an end panel of King Henry IV's tomb
and the tester above the Black Prince's tomb. While in Canterbury, Tristram
suggested that one of his pupils at the Royal College of Art, Nowell
Edwards, might use some of the time she was planning to spend among
the art galleries of Europe to copy one of the series of six Flemish tapestries
that had originally been given to Canterbury Cathedral in the early
sixteenth century but had later been sold to the Cathedral of the Holy
Saviour in Aix-en-Provence. Nowell Edwards, who was actually Johnson's
first cousin once removed but who always called him 'uncle',[1] completed
a fine watercolour painting of one of the tapestries in 1933.[2] She also
painted a portrait of Johnson in oils for the deanery's series of decanal
portraits. During her visits to Canterbury it was natural for her to stay at
the deanery where she was greeted in the precincts as an honorary daugh-
ter giving welcome companionship to a much older widowed relative
whom she had known for all her life.

Yet there was far more to the relationship than that, and the extensive
correspondence that passed between them from 1932 (when Nowell was
twenty-six and Hewlett was fifty-eight) until their marriage in 1938 paints
a delicate and sensitive picture of a young woman falling in love not only
with someone much older than herself but one with whom she had hith-
erto enjoyed an entirely different relationship. In the space of a few years
the man she had known for all her life as a kind and friendly uncle came
to be seen in a wholly new way as, surrounded by the peaceful opulence of
the deanery and the intellectual and aesthetic pleasures of the precincts,
Nowell Edwards found herself falling in love. Robert Hughes wrote that:

There was beauty, in mellow brick, in the kaleidoscopic flint facings of buildings and the soaring splendour of the Cathedral itself. There was stimulation in long talks with Hewlett about art, religion and politics. And there were other interesting people to be met, artists, thinkers and writers drawn by the Cathedral's magnetism.[3]

It could hardly fail to impress the artistic imagination of a sensitive young woman. In December 1932, after she had returned to London from a stay in the deanery, Nowell wrote lyrically about the impact the house was having upon her.

I do appreciate all the beauty of it; the lovely house, the garden with the trees and the old wall and the little fawn and the singing fountain. ... There is the Great Room, with the soft curtains drawn, and the warm fire, and opening off it into the Gold Room with its radiant warmth and glow. It's a lovely little room, there's the painting over the mantelpiece and there are colours in its golden walls. And a bedroom with a low wooden roof, and four narrow windows, and an opening onto a winding wooden staircase.[4]

Yet the true object of her affections was less the building than its occupant.

No wonder I love it, and you, my Uncle, are there, the centre of it all. Without that it would be worth nothing. There is quite another side of it all – do you realise what a difference it makes having you? Because it does, it amazes me how much, to myself as well as to other people. ... You see, I had never mentioned you before at all – it's an extraordinarily funny world, for all of this matters not at all really – and yet the difference it does make! – the fun of it all! It's such luck, Uncle darling, I really feel as if it's a fairy story. ... I do love you.

Subsequent letters continued to witness to the gentle unfolding of Nowell's love for Hewlett. In October 1933 she wrote of the universal longing that lovers feel when they are apart from their beloved. 'I'm afraid I'm badly wanting to come back. ... I want so much to be with you. ... Goodbye my darling Uncle – it's three weeks today that we meet! ... Goodness, it'll be lovely to see you again!'[5] These are surely the words of a young woman in love; but it must have seemed at times a difficult relationship for Nowell to manage as she faced the ambiguity of expressing her adult love for 'the uncle whose huge and friendly frame she had clambered all over as a little

girl'.[6] And she may well have sensed a matching ambiguity in Hewlett's expressions of love for her. How could he signal, without either distressing or deterring her, that he was crossing a fragile line made even more delicate by the disparity in their ages? He would have been acutely aware of the scandal that could engulf the Cathedral if his behaviour gave rise to the slightest suspicion of impropriety, and he must have been scrupulously careful to avoid any hint of exploitation in an asymmetrical relationship where status and experience were all on his side.

* * *

Slowly, tentatively, the relationship unfolded throughout the 1930s with a privacy that took the precincts by surprise when their engagement was announced in the spring of 1938. The courtship was conducted with a decorum that never gave occasion for scandal, and Hewlett Johnson and Nowell Edwards were married quietly in the autumn of 1938 in the Shropshire town of Stokesay where one of Nowell's three brothers, Stephen Edwards, was vicar. They honeymooned in Spain, revisiting some of the places that Hewlett had travelled to the previous year. The wedding was not the family gathering that Nowell would have wished. Five years earlier another brother, Hewlett Edwards, had been killed in a motorcycle accident in Liverpool where he was attending the third brother, Menlove's, graduation from the Liverpool University Medical School. The tragedy was a burden too heavy for their father, George Edwards, who himself died a short time later. The accident may also have been a factor in Menlove Edwards' increasingly fragile mental health, a family burden that Hewlett and Nowell helped to carry for many years until his suicide in their house at Charing in 1958.

Nowell felt Hewlett Edwards' death very deeply as she edged towards a bleak and despairing place. She wrote:

> Everything seems so hopeless, all the struggling to live. One longs and
> longs to go too, I know Mother and Father do. And I – I think one
> longs for oblivion, not another life. Just for quiet and peace and noth-
> ing more to strive for or bother about. It all seems such a weary job,
> and the soul of man so unutterably lonely, that one even stops longing
> for God and wants just nothing.[7]

At moments like this, Hewlett Johnson became for Nowell not only a friend, mentor and lover but also an older and more experienced spiritual guide. It was a role that he maintained to a greater or lesser degree throughout their

marriage and one that Nowell seemed able comfortably to combine with all the other facets of their relationship. The depth of her dependence on his spiritual experience is revealed in a letter she wrote to him shortly after her brother's death in Liverpool.

> Uncle Hewlett darling, you have been a great, great comfort to us all. You *know* how to tackle this trouble. ... Death has opened doors, and it does bring one up against things to see how poor one is. ... I don't know what I should have done without you. God is wonderful in that he gives one the things one has absolute need of. Spiritually I have needed you rather desperately – for the strength and oh the purity and the something bigger and better.[8]

* * *

By the summer of 1932 Hewlett Johnson had fully immersed himself again in the many routines of a great Cathedral. He still hoped that the canons would adopt a less parochial attitude towards their duties (his first Annual Report to the Chapter in 1932 was devoted largely to the lessons he had learnt from China)[9], but it was always likely to be a hope too far. Immediately he was caught up in a dispute that had broken out among the Chapter during his months in China when the Canon Treasurer, who had been duly appointed as the Dean's representative in his absence, seized the office of Vice-Dean exclusively for himself. It was a move that unilaterally usurped the custom of rotating the Vice-Deanship among the canons, much to the annoyance of Canon Samuel Bickersteth who had been absent through illness when the deed was done. He complained that:

> It is, in my judgement, out of order for the Treasurer to act as Vice-Dean and to occupy the Vice-Dean's stall, always hitherto reserved in my experience for the Canon-in-residence or, in his absence, for the Canon next to him in seniority.[10]

As well as dealing with two squabbling canons and another who vehemently denied that he had 'encouraged Miss Sugden to run in and out of my house',[11] the vexed issue of guiding visitors around the Cathedral also required the Dean's periodic attention throughout the 1930s. It was customary for the relatively small number of visitors to the Cathedral to be taken round the building by virgers[12] who were paid directly by the tourists for their services. Some of the lay clerks also supplemented their incomes in this way, and one of them, Albert Coole, even advertised his services in

a leaflet handed out to customers at the White Swan teashop run by his wife. Concerned that, having paid for their guided tours, visitors might then decline the invitation to contribute to the upkeep of the Cathedral, the Chapter withdrew Coole's authorisation to guide,[13] prompting an anguished rejoinder that the Dean was not only paying him a pittance as a lay clerk but was also denying him the opportunity he had enjoyed for many years of supplementing his earnings through guiding.

> As it is not possible for *all* the lay clerks to be provided with employment, it becomes necessary for some of us to make up a living in the best way we can, and the Dean and Chapter have always granted me special facilities for taking private little groups around the Cathedral, and it is such threes and fours (sometimes lame or even blind persons) who find my services useful to them.[14]

Ever ready to see the human cost of administrative rules, Hewlett Johnson relented and bent the rules.

> I shall be glad for you to continue, until you hear further from me, to take small parties around the Cathedral, and I can trust you to make a point of telling those you take that the Cathedral is kept open without charge by virtue of the fact that visitors contribute to the box, and [I] do hope that they will do so although they pay a regular fee to you for your general tour.[15]

* * *

Much weightier matters to which Hewlett Johnson turned his attention in his first few years as Dean were the Friends of Canterbury Cathedral and the King's School. The Friends had been formed some years earlier by Johnson's predecessor but one, George Bell, who had appointed Miss Margaret Babington to the post of Honorary Steward and Treasurer. By the summer of 1931, when Johnson arrived in Canterbury, the Friends were not only raising large sums of money for the Cathedral, they were also mounting ambitious annual festivals of music and drama. What George Bell began Hewlett Johnson continued and extended. He would not have regarded himself an expert on things artistic, but he well understood the power of music, colour and movement to enhance the beauty and impact of Christian worship. He had also begun to correspond with writers, artists and performers throughout the world, among them Paul Robeson, Ezra Pound, Eric Gill, Jacob Epstein, Sybil Thorndike, Lewis Casson, Norman Rockwell, Ralph Vaughan

Williams, Hermann Fechenbach and, later, Erwin Bossanyi. Developing a network of artistic contacts was central to Hewlett Johnson's vision of Canterbury as an international centre not only of Christianity but also of culture and learning. Indeed, he was probably the first prominent Canterbury citizen to articulate the case for a university in the city since Archbishop Baldwin in the twelfth century. 'From the first,' he wrote in his autobiography, 'I wanted Canterbury to be one of the most outstanding educational centres, with its own university and its own first-class schools.'[16] It was not a vision that held much appeal for the Chapter, but Johnson realised early on in his time in Canterbury that if he was to remain faithful to his twin aims of integrating the life of the Cathedral with that of the wider community, and of extending the spirit of Christianity into places where it could mingle with other kindred spirits, he would have to make much of his own running.

The Friends' Festival of 1932 was largely arranged when Hewlett Johnson became Dean, but he threw himself into the 1933 Festival with enthusiasm in pursuit of his lifelong aim of using the outward delights of the world to feed the inward life of the spirit. His introduction to the festival programme was written with great feeling.

> Pre-eminent over all its other stirring qualities we find ourselves most deeply moved by the spiritual significance of this wonderful Church. For eight hundred years it has stood, a silent and mighty witness to the world of eternal realities; and to that transcendent end it blends its glorious compound of strength and mystery and beauty. ... As we look at this complex but harmonious whole, presenting itself majestically to the outward eye, and as we pass through it to a perception of the unseen world which breaks upon the inner soul, we understand afresh that they build best even in this world whose eyes stretch out beyond it.[17]

Staged in the first week of June, the 1933 Festival of Music and Drama was peppered with big names that the Dean had managed to attract. Sir Walford Davies gave a lecture in the Chapter House on Haydn and Mozart; Dorothy Silk and Frank Phillips were soloists in a performance of Brahms' *German Requiem*; Dr Adrian Boult brought the BBC orchestra and chorus for a serenade in the cloisters and a concert in the Cathedral; John Masefield, the Poet Laureate, gave a lecture on Chaucer and *The Canterbury Tales*; and a performance of Alfred Lord Tennyson's *Becket*, designed by Laurence Irving and directed by Eileen Thorndike, took place in the Chapter House. The Cathedral's treasures, including the Canterbury Psalter, were on display in the library, and the 'royal window'

in the Martyrdom was unveiled following its restoration by the Cathedral's senior glazier, Samuel Caldwell.[18]

Hewlett Johnson's capacity to entice big names to perform at the annual Friends' Festival continued in later years. In 1935 the first performance of T S Eliot's *Murder in the Cathedral* took place in the Chapter House; in 1936 Laurence Binyon's play *The Young King* was performed; and in 1937 Dorothy Sayers' play *The Zeal of Thy House*, based on Gervase's eye-witness account of the rebuilding of the Cathedral choir after the great fire of 1174, received its world premier. Sybil Thorndike, Lewis Casson, Adrian Boult and John Masefield continued to appear, along with such eminent speakers as Sir Arthur Bryant, Sir Edward Grigg, Sir Edwin Lutyens and Arthur Mee.

It would, though, be wholly inaccurate to imply that Johnson was the sole – or even the principal – driving force behind the 1930s' festivals. He may have been the front man whose name attracted other names, but it was the redoubtable Margaret Babington who controlled and directed the proceedings. From her office above the Christchurch Gate she masterminded the work of the Friends for thirty years until her retirement in 1958, prodding, cajoling, encouraging and (where necessary) reproving those who crossed her path. She soon had the measure of Hewlett Johnson, formally deferring to his rank while making her expectations abundantly clear. Her letters to him were replete with such phrases as: 'On reflection, Mr Dean, you may come to think that ...' When a Mrs Maitland complained about the 'travesty' of allowing secular performances to take place in the Cathedral during Ember Week,[19] Margaret Babington left Johnson in no doubt as to how he should reply.

> I cannot say how much I dislike the attitude of people who want everyone to do exactly what they wish in regard to church matters, and expect everyone else to be helped by exactly the same things that have helped them; and they are *always* the people who have had help all their lives, and are apparently quite unable to put themselves in the place of people who have never cared twopence about religion, and hate the idea of going to Church, and indeed would never set foot inside a place of worship for such a purpose. Yet, if and when something brings them in, their whole lives and outlook may be changed.[20]

Regrettably, there is no record of the Dean's reply to Mrs Maitland.

* * *

If the Friends and their festivals were welcome legacies for Hewlett Johnson upon his arrival in Canterbury, the King's School and its problems must have seemed like a millstone. In every way, the school was in a perilous situation: the buildings were in urgent need of repair and modernisation, the number of pupils (182) had dropped almost to the point of non-viability, and the debt stood at about £40,000.[21] (To set this in context, £40,000 in 1931 had the purchasing power of about two million pounds at today's prices.) The whole of the school's financial credit had been expended on the construction of the junior school at Sturry, but the timing could scarcely have been worse as the country moved into what was to prove a long and deep depression.[22] As Dean, George Bell had been a driving force behind plans to modernise the school in the 1920s, but the momentum had faltered under his ailing successor, Dick Sheppard. Now it was Hewlett Johnson's turn; but he began with the enormous handicap of being ideologically opposed to private education. Caught between the rock of his political convictions and the hard place of his position as Chairman of the Governing Body, he took a principled line that elevated his office above himself.

> Fundamentally, I was opposed to the idea of public schools with a class division in education. But like so many other things, one had to accept the situation as it was and not as one would like it to be. My feelings with regard to public schools have never changed [and] my longing for another educational basis has extended year by year. But as part of my duty as Dean, so long as there was this public school attached so closely to the Cathedral, my duty was to assist it to the utmost in my power.[23]

An appeal was launched in 1934 for £20,000 to deal with the worst of the backlog of maintenance on the school buildings, but less than half that sum had been raised when the headmaster, Norman Birley, accepted the headship of Merchant Taylors' School in 1935. At the same time, Canon Claude Jenkins was appointed to the Chair of Ecclesiastical History at Oxford, leaving a vacant stall behind him. The King's School governors immediately realised that, by retaining the canonry and combining it with the headship, a better field of applicants might be attracted; but the Archbishop of Canterbury, Cosmo Gordon Lang, was against the move for reasons of cost. A senior King's School governor, Sir Arthur Luxmoore, urged Lang to change his mind.

> As I see it, there is only one chance of saving the School and that is the appointment of a headmaster with sufficient business ability and

organising capacity to re-establish the educational standards of the past. Frankly, these have been allowed to fall to such a degree that numbers have suffered, and at present there is little beyond the Cathedral connection and surroundings to attract parents. ... There must, I think, be some further inducement [to attract a headmaster of the required calibre], and unless it is to be found in the prestige attaching to a Cathedral Canonry, I am at a loss where to look for it.[24]

There were probably other considerations also in Luxmoore's mind, not least that by appointing the new headmaster as a canon, much of the cost of his salary might fall on the Chapter and the headmaster's house in the precincts might become available for other purposes. Lang acceded to Luxmoore's plea and put the case to the Prime Minister, who agreed.[25] In the event, the headmaster's post was never advertised: instead, the name of the Reverend Dr Frederick John Shirley, then the headmaster of Worksop College, emerged as perhaps the only man in the country who could rescue the King's School from oblivion.[26] With seemingly little debate, the governors offered Shirley the headship, and the Archbishop agreed to recommend him to Downing Street for appointment to the vacant canonry.[27]

John Shirley, however, was unsure whether he wanted the post. He visited Canterbury a number of times, where he impressed the Archbishop as well as the governors, but he was so horrified by the state of the King's School, materially as well as financially, that he was minded at first to refuse the invitation. But having followed up his visits with a detailed list of questions about the school and its resources, he set out the conditions under which he would agree to the appointment.[28] He demanded that the canonry be announced in *The Times* before the announcement of his appointment as headmaster,[29] and full mention should be made in the second announcement of 'the wonderful things' he had achieved at Worksop. His degrees should also be listed in full. His personal requirements included a butler or parlour maid, a chauffeur-gardener, the use of a telephone, an entertainment allowance, medical attendance for his family, free heating and lighting, and a salary of £1,000 a year from the school as well as £750 from his canonry.[30] Shirley wanted a free hand in fixing the level of fees and he demanded the immediate sum of £10,000 (to be added to the school's debt) for urgent work to begin on the buildings. The governors agreed and John Shirley arrived in Canterbury as the new headmaster of the King's School in the summer of 1935.

* * *

With John Shirley's appointment to the headship of the King's School, another figure of immense energy, ability and passion had arrived in the precincts; and for the next quarter of a century his complex and sometimes turbulent relationship with Hewlett Johnson was to dominate the politics of the precincts and create a mutual suspicion between the King's School and the Cathedral that Archbishop Cosmo Gordon Lang once described as 'Cathedral blight'.[31] Robert Hughes described Shirley thus:

> Charming enough to cultivate the richest patrons and make life-long friends of his boys, ruthless enough to achieve any goal he set for himself, Shirley was a brilliant leader and an abrasive colleague. His capacity for hard work rivalled Hewlett Johnson's own. The sheer savagery which he could introduce into any disagreement promised stormy Chapter meetings in the years to come. Canterbury's second personality had appeared upon the stage.[32]

Even before taking up his appointment, John Shirley gave notice of his intentions. In a letter to the Dean he warned that, as someone who knew better than most the fierce competition that existed among the public schools for pupils, the situation of the King's School was critical. To have any hope of improvement, the decision-making machinery of the school had to become far more efficient.

> If the King's School is to be thoroughly established and to develop, every day counts, and until some more urgent method of dealing with grave problems is evolved than the ordinary Governors' Meetings, I see little chance of the School's being successful in the more or less immediate future.[33]

Having identified the three main problems that in his opinion confronted the school (the level of debt, the 'inefficiencies' of the senior school, and the 'feebleness' of the junior school), Shirley went on the offensive. He pensioned off several elderly teachers and replaced them with ambitious young men, including three whom he brought with him from Worksop. He set the aim of increasing the number of pupils to at least 300 and started to move towards the target by 'poaching' twenty-two boys from Worksop – an act that brought him temporary suspension from the Headmasters' Conference for unethical behaviour. He threw out existing plans for a temporary dining hall in favour of an impressive permanent structure that would appeal to potential parents. He planned to enhance the school's

publicity, beef up science, appoint a full-time chaplain, and reduce the school's dependence on Cathedral services. He also wanted much more personal freedom in running the school.

> I am not a young, rash, hot-headed fool. I used to be all of those, but I have a lot more sense now that I have grown up. But nobody can expect me to do what seems to be the toughest job in the school world in England if I am to be the mouthpiece merely of the Governing Body. … I do profess to know something about how a fading show should be galvanised into new life, and if the Governing Body says that my ideas are either wrong or impossible, then it is useless for me to take on the job.[34]

John Shirley's ideas proved to be neither wrong nor impossible, for as the 1930s progressed, he moved the King's School steadily away from the brink of disaster towards the stable, flourishing institution it was to become in the post-war era. It was an extraordinary triumph of imagination, will-power and even ruthlessness as sensitivities were overridden with little regard for any consequences other than the good of the school. David Edwards judged him to be one of the greatest English headmasters of his generation.[35] Yet Shirley would have been the first to acknowledge that behind his outward success lay a great deal of internal anguish. By his own account he knew the arts of the bully and was not afraid to use them; but he also knew the insecurity of one who felt himself misunderstood and unappreciated. In a series of remarkable letters written to Hewlett Johnson in 1936 and 1937, Shirley vented his anguish at having been let down by the very colleagues whose support he should have been able to take for granted.

* * *

The Shirley letters of 1936 and 1937 treat Johnson as part friend, part confessor, part Dean, part Chairman of Governors, even part idol. They reveal John Shirley as a restless, stressed, ambitious, autocratic man, frequently bitter about his treatment by a Dean and Chapter that failed to understand the nature and demands of his job and threatening on several occasions to resign unless his concerns were addressed. Less than a year into his headship, Shirley sent the first of many letters to Hewlett Johnson declaring his intention to resign over a matter that should easily have been resolved.

> What have I done? You rounded on me before communion this morn-
> ing. … In future I will do nothing whatever about the School, secular

or ecclesiastical, but will first acquaint you with whatever the business is and there leave it. ... I realise now that I ought never to have come, but I shall look out for suitable employment at the earliest moment. ... I know quite well that I shall never see the visions I have for the school, and I realise that a majority of governors are against my views. ... I shall rid you all of my undesirable presence at the earliest moment.[36]

The litany of complaints to the Dean continued. In February 1936: 'I am sorry if I have offended you. I do not know how. I suppose I must have, since neither you nor Crum have been the same to me in the last fortnight. Why is life so difficult in this little place?'[37] In May 1936: 'Ought I not to be encouraged rather than criticised? I feel that the Chapter would not be sorry to have my resignation, and I am contemplating it. I am not happy.'[38] In January 1937: 'I am tired to death of these utterances [of Archdeacon Hardcastle against the King's School], and it is the poorest possible thanks to me who have laboured on a work which all engaged on public school education in the country said was impossible. I must have the active and zealous support of the Chapter or I can't continue – I shall be mentally ill.'[39] In May 1937: 'I am rather concerned to be told by someone who had it from headquarters that the Archbishop dislikes me! I don't mind that very much personally, but it won't be good for the School if it is known.'[40] In June 1937: 'I am, I confess it, grievously hurt – and it is growing on me more and more that I cannot do these two jobs [headmaster and canon]. I get no exercise, I don't get time to read, not even the newspapers: I go to bed dog-tired. How do people think that in less than two years a miracle has taken place?'[41]

A particular flashpoint came in September 1937 when Hewlett Johnson unilaterally (and quite uncharacteristically) annexed part of what had hitherto been regarded as King's School land in order to enlarge the deanery garden and extend the buffer between himself and the noise of the pupils. John Shirley was furious – and this time his wrath was a personal invective against what he perceived as the Dean's hypocrisy. His denigrating use of the past tense when expressing his admiration for Johnson seems to have been deliberate.

I've had a shock over which I haven't got yet. Two weeks ago at Chapter Crum spoke with that cutting sneer about the School's "encroaching"; that was bad enough, since if the Chapter regards the development of its own School thus grudgingly, the sooner it shuts up

the better. But far more than that was your claim that the Deanery amenities must be protected [by enlarging its garden]. You don't know, but you had come to be a kind of idol to me. I was very proud of you and rejoiced in your Christianity and socialist love of others. … You were the man who would do anything for anybody, who cared nothing for comforts and wealth. Then all of a sudden you say you will add to your garden so that your peace may not be injured. The real thing was that you were considering private interests against public ones.[42]

And then, not for the first time in his correspondence with Hewlett Johnson, John Shirley turned his antipathy towards the Dean into a personal spiritual crisis.

I've lost my own soul and don't now believe in anything vitally. I've got a temper and I'm impatient; but the lack of unity in the Chapter, the sneering, the biting remarks, the selfishness – all have combined to destroy me. … When I came I felt how much easier it was going to be to be a real Christian, to live with men pious and devout, selfless and serving. I can't understand it at all. … I've been bowled over and lost my hold on what little faith I've got. I'm not interested in anything except the prospect of somehow recovering my soul.[43]

On the specific issue of the land, John Shirley found an unlikely ally in the Archdeacon of Canterbury, Edward Hardcastle, who made a number of rather pernickety observations to the Dean about the annexation. 'I confess I should like to hear the matter discussed in Chapter and settled amicably in the best interests of all concerned.'[44] Hewlett Johnson's reply to Hardcastle bristled with controlled irritation. He had plainly had enough of squabbling colleagues. Visibly annoyed by the Archdeacon's obsession with what he regarded as 'trivia', he pointedly put Hardcastle down by loftily pitching his own concerns at a far more elevated level.

I often think of what my wife used to say about worrying over small matters when so great things were at stake in the world, urging one to look out on the wider horizon, and by the same post that your letter came I opened one from the Russian Ambassador. I had applied for a passport more than a month ago but could not get it. He discovered my application and has got me a pass. Therefore I felt that … I ought

to use all my spare time for bigger things, and I purpose going tonight or tomorrow to Russia. Naturally there are great difficulties, and in some respects elements of danger in this course, even at the outset in the transit through Germany, but I feel I must go. [45]

Johnson concluded, tartly and deliberately, that he hoped Hardcastle's own holiday at Wells-next-the-Sea in Norfolk would go well.

INTERNATIONAL TRAVELLER

I N 1937, after several years spent largely tending the Cathedral and its communities, Hewlett Johnson turned his attention to the world stage again. He was now sixty-three. At an age when many of his contemporaries may have been thinking of retirement, he was still as fired with a Christian quest for social justice as he had ever been. On the point of becoming engaged to Nowell Edwards, who wholeheartedly shared his political and theological views, Johnson may well have felt himself entering a new lease of life. And while his first attempt to get to the Soviet Union had had to be delayed over the issue of a visa, there was always Spain.

The Spanish civil war, which erupted in the winter of 1936–37, divided European opinion between those who supported Manuel Azaña's Republican government and those who backed General Franco's Nationalist junta. Young men from Europe and America flocked to join the fighting, believing they were engaged in a principled struggle for the soul of Europe. Non-combatants also travelled to Spain, and in March 1937 Hewlett Johnson joined a small group of Christians hoping to investigate claims that the Republican government was suppressing the freedom of worship by closing churches and banning the sale of religious material.[1] Travelling with him were Monica Whately, a Roman Catholic campaigner for women's rights and civil liberties; John MacMurray, a free church representative and Professor of Moral Philosophy at the University of Edinburgh; the Reverend E O Iredell, the left-wing vicar of the 'Red Church' of St Clement's, Barnsbury; and Kenneth Ingram, a Catholic historian and writer on communist affairs. The Foreign Office tried to block the visit and the Foreign Secretary, Anthony Eden, told Johnson personally that he could not authorise his going;[2] but a change of mind was forced upon the FO by the publicity given to the ban.

The group flew from London to Bilbao on 29 March 1937 and during their month in Spain they visited Valencia, Madrid and Barcelona as well as the Basque cities of Bilbao and Santander.[3] They found that, whatever might be happening elsewhere in Spain, religion in the Basque region was

flourishing and both Catholic and Protestant churches remained open. 'Some of our delegation', Johnson noted, 'attended mass every morning and always found a goodly congregation: 7,000 had communicated on the previous Sunday in one church alone.'[4] In fact it was less the state of religion that distressed the group than the privations caused by Franco's blockade of the Basque ports. Very little food was getting through, and Johnson confessed that he felt ashamed to eat while so many people were starving.

> The Basque country was completely surrounded by the enemy; food could reach the [Basque people] only by sea, and Franco's ships blockaded the ports. We were among a half-starved people; for three weeks there had been no bread, meat or sugar. Small children suffered most, and under-nourished mothers could not feed their babies. Horses and dogs were eaten.[5]

It was during their stay in Bilbao that Hewlett Johnson's group heard reports of the German bombing of Durango, a small industrial town twenty miles to the east, and they were taken to see the damage for themselves. As they approached Durango, the drone of aeroplanes filled the sky, and taking cover in a nearby wood, they saw a second wave of German bombers dropping their payloads on the defenceless town. A huge black cloud of smoke and rubble billowed upwards from the streets. After dark, Johnson entered Durango on foot to see the damage for himself.

> It was almost completely destroyed. Masses of masonry lay around and walls still tottered. Churches and the Augustinian Convent had been hit. Durango was our driver's home. He sought his brother and found him safe; his sister, a nun, had been killed.[6]

Durango was the first place in the world to be blitzed by Hitler's Luftwaffe. On the evening of the raid, Nationalist propaganda claimed that it was the Republican International Brigade that had blown up the churches and killed the nuns. Incensed, Hewlett Johnson somehow managed to gain access to a radio station in Bilbao and was able to broadcast his own account of what he had seen, contradicting the Nationalists' version of events.[7] Three days after the bombing of Durango, the neighbouring town of Guernica was obliterated by the Luftwaffe. Hewlett Johnson's path was later to cross with that of Pablo Picasso on a number of occasions.

* * *

On his return from Spain, Hewlett Johnson threw himself into the task of publicising the plight of the Basque people and mobilising relief. He preached about the civil war in Canterbury Cathedral and spoke passionately on behalf of the Republican government at meetings throughout the country. He also took a lead in organising a Christian Committee for Food to Spain to coordinate the work of local organisations raising funds for a food-ship to breach the blockade of Bilbao.[8] For the first time, Johnson became a truly national figure, attracting widespread approbation for his humanitarian efforts. As so often before, however, he aroused as much vehement hostility as warm approval. Canterbury's MP, Sir William Wayland, complained bitterly that Johnson had 'scandalised all good Churchmen' by using his pulpit for 'an incursion into secular controversy',[9] and the Reverend S E Cottam of Oxford brutally informed the Dean that 'prayers will be offered next Sunday for the eleven bishops and 15,000 priests assassinated by your friends in Spain'.[10] But it was the response of the Anglican hierarchy that most angered Hewlett Johnson and led him passionately to justify his actions. In a terse exchange of letters with Archbishop Cosmo Gordon Lang, Johnson exposed the gulf of understanding that was now opening up between the deanery and Lambeth Palace.

The correspondence began in April 1937 shortly after Hewlett Johnson's Canterbury sermon about the events in Spain. The fact that Cosmo Gordon Lang felt the need to write at all suggests that Johnson was now becoming a national figure whose pronouncements were embarrassing the Church of England. Lang wrote:

> I cannot but think it unfortunate that a man in your very responsible position should have so openly identified yourself with one side in this most unhappy Spanish trouble when the whole weight of the country is being thrown on the side of preserving impartiality and so assisting in the prevention of foreign intervention which might lead to even graver consequences. As to [Johnson's sermon in Canterbury Cathedral], I think I know myself what you mean when you say such words as: 'It does not matter what people say with their lips, even if it means denying that there is a God, if they have religion in their hearts'. But phrases of this kind are obviously bound to give rise to serious misunderstanding.[11]

Hewlett Johnson's reply was full of moderated passion as he castigated the moral failure of churches throughout Europe and raised fundamental questions about the very meaning of the Christian faith.

What I see in Spain and elsewhere shocks me – there are horrors, and terrible ones, on both sides; and it does not surprise me. The religious front throughout Europe crashes and crumbles; even in England religion wilts. We have condoned an economic and social order [capitalism] which is sub-Christian. And now there arises the suggestion of another order [communism], more fundamentally Christian in essence, however much it repudiates the name. This suggestion of another order, where the service motive radically replaces the profit motive, and where class, sex and racial barriers disappear, has gripped the imagination of many. ... They fling themselves into the task of working it out with passionate and religious fervour. Where the Church has been indifferent they despise it; where it has been destructive they hate it. I feel sure these men are fundamentally right in the positive thing for which they fight.[12]

And then the gloves came off as Johnson candidly challenged the Archbishop over the failings of the Church of England.

My dear Lord Archbishop, you have been friendly and frank with me. May I be frank with you? I hear so many things you can never hear. There is scorn at the Coronation excesses of the Church[13] whilst tolerating not merely the misery of the depressed areas but the servile insecurity of working class life in general in this rich age. There is the scorn of a call to religious revival which ... is devoid of the moral fervour which might remove the real hindrances to a knowledge of God. And these scorns are not amongst the worst but amongst the best of our people, especially of the younger people. My words may horrify and challenge. I cannot restrain them because I am convinced that for me to do so would be to fight against God.

Archbishop Lang began his rejoinder by saying that he found it 'most distasteful to me to enter into any controversy with one with whom my relations must be close as they always have been and I hope will always be most friendly'.[14] He had originally intended to make a full reply but decided instead to focus on the single issue of Johnson's peculiar institutional responsibility as Dean of Canterbury.

I cannot think that you would so wish to use the prestige and publicity given to the position of Dean of Canterbury as a means of propagating your own opinions on political and economic matters so as to

involve in them, however unfairly, the special position of Canterbury Cathedral itself and of all that Canterbury means throughout the world. Of course you are entitled to your own convictions and to give the fullest expression to them as an individual. But it seems to me that this would be done more fitly if you were in the position of greater freedom and less responsibility. I do not wish to say more. I could scarcely say less. I am very sorry that I should be obliged to say anything at all.

If Lang's letter was intended as a serious call to Hewlett Johnson to rethink his position, it failed. The Dean had no intention either of moderating his political activities or relinquishing his office. He did apologise for the distress he had caused the Archbishop, acknowledging that it was 'quite intolerable that you should be blamed for what I have done';[15] but otherwise it was to be business as usual. Lang was left with little option but to distance himself publicly, through a statement to the General Assembly of the Church of England, from anything the Dean might say. 'It really became necessary to prevent these misconceptions', he wrote to Johnson, 'and I think I made it clear that it was with the utmost possible reluctance that I did so.'[16]

* * *

Hewlett Johnson finally achieved his long-standing ambition of visiting the Soviet Union in September 1937. His connections with Moscow went back to the early 1920s when he first came to the attention of an official from the Soviet Embassy in London,[17] and by the time he arrived in Canterbury in 1931 he was 'a constant visitor to the Embassy in Kensington Palace Gardens'.[18] He attended garden parties there, much to the displeasure of the Canterbury Chapter, and he may even have been present at Ivan Maisky's installation as the Soviet Ambassador in 1932. Thereafter, Maisky must have been the principal conduit through which Moscow was kept informed of the Dean's growing stature as a public figure whose outspoken loyalty to the Soviet Union would repay careful cultivation.

Ivan Maisky's friendship with Hewlett Johnson was personal as well as political. He visited Canterbury on a number of occasions and sent his good wishes whenever something special happened in the Dean's life. With an extensive background in Russian politics, first with the Menshevik Party and then (from 1921) with the Bolsheviks, Maisky was a cultured diplomat whose personal charm and openness, together with his command of several languages and his sensitive understanding of European history, allowed

him access to high political places. In 1943 he was recalled from London to Moscow to become Stalin's Deputy Commissar for Foreign Affairs, and in this capacity he was a member of the Soviet delegations that met with the Americans and the British at the Yalta and Potsdam conferences in 1945. Shortly before Stalin's death in 1953, Maisky was tried for espionage and sentenced to six years imprisonment; but he was 'rehabilitated' after only two years. His last known contact with Hewlett Johnson was in 1963 when they corresponded about the latest volume of the memoirs that Maisky was then writing. In an extraordinarily candid letter, he asked Johnson how he had maintained his Christian faith while championing Stalin's Russia for three decades.[19] He seems genuinely to have wanted to know the answer.

The lead-up to Hewlett Johnson's visit to the Soviet Union in the autumn of 1937 was somewhat chaotic: indeed, it was not until he was on the verge of departing that all the arrangements finally fell into place. With only three weeks to go his visa had still not arrived and he sought the assistance of Ivan Maisky. As usual, Maisky was the model of helpful courtesy while gently chiding the Dean for leaving things until the last moment.

> Unfortunately, I had no knowledge beforehand that you intended to go to the USSR in September, but now, having received your letter, I will make enquiries in Moscow straight away and hope to expedite the reply. I think, therefore, that you should not feel disappointed, but must have patience a little longer until the matter is settled.[20]

Maisky got to work, and two weeks later, on 15 September, the visa came through. Yet even at this late stage, with less than a week to go before Johnson's planned departure, Maisky still appeared to know nothing about the arrangements that had been made for the Dean's time in the Soviet Union.

> I should, of course, like to do everything I can to help you on your visit, and to this end should be glad to learn how long you propose staying in the USSR, whom you would like to see while you are over there, and to know of anything you would particularly like us to arrange for you.[21]

By the third week of September everything had finally reached the stage where Johnson could set off, and he informed his soon-to-be fiancée Nowell Edwards (who was totally in the dark about his plans and wanted to know what he was doing)[22] that:

I found I could get off to Russia today and so off I am going. There are various snags but I hope they will be surmounted. Germany is the first. I propose to cross the Black Sea to Turkey and come home via Greece in a French boat.[23]

Johnson finally left for Russia on 20 September 1937.

* * *

Hewlett Johnson claimed in his autobiography that this first visit to the Soviet Union lasted for 'most of three months',[24] but this was an exaggeration: in fact he left on 20 September 1937 and was back by the beginning of November at the latest. The visit is shrouded in mystery. Following his many visits abroad, both before and after the Russian trip, Johnson habitually wrote at length about the things he had seen and the people he had met; but of his 1937 visit to the Soviet Union there is nothing. All he said of it in his autobiography was that he travelled widely and saw 'more of the Soviet Union than many other men'.[25] Obvious questions arise. Who invited him? Who arranged and paid for the visit? Where did Johnson go and whom did he see? Who were his guides and interpreters? These are not just minor questions of detail: they raise important issues about whether Hewlett Johnson's first visit to the Soviet Union was the initial step in his grooming by Moscow as a propagandist in the Christian West.

No certain answers are known to these questions, for nothing exists about the visit beyond his correspondence with Ivan Maisky before his departure. There is, though, strong circumstantial evidence that the visit was arranged and financed by VOKS, the Communist organisation based in Moscow that had been formed in the 1920s to target and equip western intellectuals as mouthpieces for Soviet propaganda. Many, if not all, of Hewlett Johnson's later visits to the Soviet Union are known to have been arranged and financed by VOKS. In 1945 he was met at Moscow airport by 'Mr Kemenov of VOKS',[26] and on the Asian part of the same visit he was escorted by 'Mr Karaganov, the Vice-President of VOKS'.[27] The organisation also arranged his later visits in 1956 and 1959.[28] Even the names of some of the VOKS guides are known: Inna Koulakovskaya in 1945 and Yuri Andreyev in 1954. Johnson also received periodic letters from VOKS thanking him for his work on behalf of the Soviet Union, and the organisation occasionally sent him unsolicited material that it thought would interest him.

The question, then, is not whether Hewlett Johnson was ever associated with VOKS – he was – but whether the association began as early as 1937.

The evidence suggests that it probably did. Unable to speak or read Russian, it would have been very difficult for him to be an independent first-time traveller in the Soviet Union. Someone (other than Ivan Maisky) must almost certainly have arranged the visit, planned the itinerary, briefed the guides, and probably also footed the bill; and these were all part of the service that VOKS provided for its guests. There is also the highly suggestive fact that, only five months before Johnson's visit, his close friend and collaborator Victor Gollancz had himself been to the Soviet Union as a guest of VOKS.[29] The aim of the visit, as far as VOKS was concerned, was to persuade Gollancz to arrange a programme of activities in London to celebrate the twentieth anniversary of the October Revolution. In fact he did no such thing, but that did not stop him from enthusing about his time in Russia, and on his return to England he encouraged three more parties of British tourists to do the same.[30] Against this background, it would be strange if Hewlett Johnson's own visit in September 1937 had been entirely unconnected with that of his friend and collaborator a few months earlier.

* * *

VOKS are the initials of the Russian organisation that translates into English as the All-Union Society of Cultural Relations with Foreign Countries.[31] It was probably the innocuous sound of its name, together with the collaborative links it forged with cultural societies in other countries, that created an impression of VOKS in the West as a non-political organisation driven solely by the desire to bring together people with a common love of Russian art, history and culture. It was not until Ludmila Stern gained access to the VOKS archives in Moscow in the late 1990s that the deeper objectives of the organisation became generally known.[32] Far from existing solely to nurture cultural relations between the Soviet Union and other countries, it actually had the same political goals as the Comintern, the international organisation of Communist parties formed by Lenin to foster revolution in non-Communist countries. Its targets were western intellectuals and its methods were civilised; but its ultimate aim was nevertheless political – to spread propaganda about Communism in the Soviet Union by using cultural and intellectual leaders as 'conduits of influence' in their own countries.

VOKS was founded in Moscow in the 1920s, possibly on the initiative of Lenin. Its director for the first five years was Olga Kameneva, the sister of Leon Trotsky and the wife of Lev Kamenev, who together with Alexander Zinoviev and Joseph Stalin held the Bolshevik Party together after Lenin's death in 1924. Through these connections VOKS became a powerful political organisation, but it was not beyond the control of the Krem-

lin: both Olga Kameneva and one of her successors as director, Alexandr Arosev, were shot on Stalin's orders in the early 1940s. Under Kameneva's leadership in the 1920s, the organisation pursued two main objectives: to create a network of cultural rapprochement societies in foreign countries, and to bring foreign intellectuals to the Soviet Union, ostensibly for their enjoyment but actually to cultivate and equip them as propagandists on behalf of the Soviet Union.

Both strategies were impressively successful, at least at first. Within a year or two of the foundation of VOKS, nineteen Soviet rapprochement societies had been formed in eleven countries. The British Society for Cultural Relations with the USSR may actually have predated the birth of VOKS. The Society's journal, *Soviet Life and Work*, was edited by Johnson's friend Denis Pritt, the Labour MP and Communist sympathiser.[33] Hewlett Johnson was among the active members of the Society, and his increasing involvement during the 1930s gave yet more ground to his critics and opponents, including Archbishop Cosmo Gordon Lang. The depth of Lang's concern is revealed in a letter to Johnson in March 1933.

> I am given to understand that you propose to give a lecture in London tomorrow on religion in Russia organised by the Society for Cultural Relations between this country and Soviet Russia. ... I confess I regret that ... you should publicly identify yourself with this Society for Cultural Relations which I understand is really promoted by the representatives of the Soviet Government in England. I quite recognise how desirable it may seem not to sever all connexion between this country and Russia ... but it is difficult to see how this can be done without seeming to condone what I *know* to be the oppression and cruelty which goes on behind all the cultural enthusiasms of the Communist party in Russia. It seems to me (if you will forgive my saying so) like having amicable conversations on a picture with a neighbour who is known to be brutally ill-treating his servants.[34]

Johnson demurred, underscoring the word 'know' in the Archbishop's letter as if to elevate his own understanding of events in the Soviet Union above that of Lang. As Robert Hughes put it, 'what Lang *knew*, Hewlett challenged'.[35]

Olga Kameneva's second strategy of bringing foreign intellectuals to the Soviet Union was also hugely successful, and throughout the 1920s and 1930s large numbers of them – authors, poets, playwrights, artists, musicians and the occasional cleric – made the pilgrimage to the Soviet Union

and came back entranced by what they had seen. Among the Britons who made the journey in the two decades following the October Revolution in 1917 (not all of them necessarily the guests of VOKS) were H G Wells, Arthur Ransome, Bertrand Russell, George Bernard Shaw, W H Auden, George Orwell, Julian Huxley, Sidney and Beatrice Webb, Joseph Needham, G D H Cole, Stephen Spender, Harold Laski and Cecil Day Lewis. The French pilgrims included André Gide, possibly the most influential French writer of the inter-war period, and Anatole France, who won the Nobel Prize for literature in 1921. The Americans included the dancer Isadora Duncan and the singer Paul Robeson. The Germans included the writers Lion Feucht-wanger and Stefan Zweig. Hewlett Johnson was by no means alone among the company of those who came to be known as the 'fellow-travellers'.

* * *

The hospitality of VOKS was generous and the organisation smooth. VOKS officials handled all the arrangements, offering the typical visitor an intensive cultural programme that took in all the traditional tourist sights in Moscow and Leningrad as well as items chosen to reflect each visitor's special interests.[36] The accommodation was luxurious, and a visit would often include a holiday on the Black Sea. Writers had their literary works translated into Russian and published in runs of hundreds of thou-sands, and they were invited to address large audiences of admirers. Visi-tors were, of course, expected to do something in return for the generous hospitality they received at the hands of VOKS, most obviously to speak well of the Soviet Union when they got home. Attempts were made before their departure to find out what they were planning to say, and informa-tion packs were prepared that reflected their particular areas of expertise. Their reception on returning home was studied carefully in Moscow.

By the mid to late 1930s, when Hewlett Johnson was making his first visit to the Soviet Union, perceptions and expectations had begun to change for VOKS, as they had for the Soviet Union. The collectivisation of the farms, the famines, the repressions and deportations, the show trials and the terror – these had all dramatically altered the way the Soviet Union was seen abroad and had forced VOKS to become more watchful of the behaviour of those it invited. Under the chairmanship of Aleksandr Arosev only handpicked westerners were chosen to be the guests of VOKS, and then only if they had something distinctive to contribute to Russia's image overseas. The guides who escorted the visitors around the Soviet Union were also controlled more closely in the later 1930s than they had been earlier. They were now officially accountable for their guests. Standard

forms were introduced in 1936 requiring the guides to report not only the places they had visited but also the character of their clients, their moods and fancies, the strength of their commitment to the Soviet Union, and the things they were planning to say on their return home. Compared to the more relaxed atmosphere of the visits a decade earlier, guests in the late 1930s were not allowed to depart from the official itineraries set for them and they were no longer permitted to wander off on their own.

In fact, visitors rarely if ever asked to see places that were not on the approved tour. As Ludmila Stern observed: 'Former visitors and sympathisers had clearly done a good job of supplying an audience that could fit into the VOKS mould.'[37] Before the visitors left, their guides were required to ascertain whether they were leaving as friends or enemies and what they might say about the Soviet Union when they got home. The answers went into the files. But grateful for the generous hospitality they had received during their stay, most visitors were only too keen to speak well of their hosts. Aided by the literature they had been given, the more prominent guests of VOKS often became major 'conduits of influence' for the dissemination of Soviet propaganda in their own countries.[38] Among them was the Dean of Canterbury.

* * *

Did Hewlett Johnson understand what he was doing when he accepted the hospitality of VOKS? There is no certain answer. He must have been perceptive enough to realise that VOKS was no ordinary travel agency and that something significant was expected in return for the care and expense it lavished upon him. He must even have realised that VOKS had a political programme that extended beyond the mere entertainment of foreign celebrities. Whether he would have been surprised to learn that VOKS had similar aims to the Comintern is difficult to say; but Johnson was certainly among its more enthusiastic clients, willingly falling in with his guides' suggestions and valuing the materials they gave him. VOKS only allowed its clients to see what it wanted them to see; but that suited the Dean for he, too, saw what he wanted to see and he was only too happy to go along with his guides' proposals. While some of the fellow-travellers have been depicted as the innocent objects of political seduction, the same could hardly be said of Hewlett Johnson. He was a fully consenting adult. And as he became ever more closely identified with the defence of Stalinism, so it became ever more difficult for him to reassess his position. Indeed, he continued to accept the hospitality of VOKS until well into the 1950s – long after most of the other big names had fallen, disillusioned, by the wayside – and he never repudiated Stalin or the Soviet Union.

CHAPTER SEVEN
THE SOCIALIST SIXTH OF THE WORLD

WITHIN TWO YEARS of returning from his first visit to the Soviet Union in 1937 Hewlett Johnson had completed his first and most important book, *The Socialist Sixth of the World*.[1] It was to stand for almost two decades as the definitive statement of his views about life in the Soviet Union under Joseph Stalin. Johnson claimed that some four and a half million copies were sold worldwide in twenty-five languages,[2] and although this is almost certainly an exaggeration, the book was undoubtedly a publishing sensation at a time when paper and other printing materials were at a premium.[3] In all, twenty-two impressions were published in Britain by Victor Gollancz Ltd, the first in December 1939 and the last in March 1947. British sales probably amounted to about a quarter of a million.[4] Both the title and the publisher changed for the American market. The book was first published in the United States in January 1941 by International Publishers of New York under the title *The Soviet Power*, and according to the publisher a quarter of a million copies were printed within two months. A cheap edition of the book was also produced for the American market by International Publishers, and a million copies were said to be 'in circulation' within a few weeks.[5]

At face value these figures are impressive, but they are almost certainly misleading. American sales of a million and a quarter within a few weeks of publication are intrinsically improbable, the more so in a country that was becoming deeply suspicious of communism. International Publishers of New York was a political publisher specialising in books on Marxism and Leninism, and the apparently huge print run of *The Soviet Power* may have been a political decision taken to exaggerate the book's importance. The number of books printed is not the same as the number sold. There is some evidence that the Communist Party of America (CPA) may have been involved in the decision, for Johnson's contract for *The Soviet Power* was signed on behalf of International Publishers by Mr Trachtenberg, a leading member of the CPA, who later said that the book had done much to inform the American public about the Soviet Union at a time when 'a great

deal of anti-Russian sentiment was being whipped up by the reactionary press'.[6] There was even a suggestion that the title of the book may have been changed for the American market (from *The Socialist Sixth of the World* to *The Soviet Power*) to emphasise the strength of the Soviet Union.[7] VOKS may also have helped to subsidise the print run, though there is no direct evidence of this.

* * *

The Socialist Sixth of the World had a complicated history. The first edition was published in Britain in December 1939 by the wealthy social-ist Victor Gollancz, a close friend of Hewlett Johnson until their falling out over the Soviet Union's non-aggression pact with Nazi Germany four months earlier. Gollancz deplored the pact as a capitulation to fascism; Johnson defended it as a regrettable but necessary expedient for the secu-rity of the Soviet Union's western border.[8] Because of this, the book's publication was in doubt until almost the last moment. In October, just before printing began, Gollancz decided to withdraw a planned chapter entitled *The Soviet and Peace* and add instead a commentary by Johnson on the non-aggression pact. It was a risky manoeuvre, for Gollancz was well aware that Johnson might try to use the opportunity to defend the pact; and his anxiety deepened when, only weeks before the book's publi-cation, the Soviet Union invaded Finland.[9] For Victor Gollancz, as for many other fellow-travellers, it was the end of his unconditional support for the Soviet Union. In an impassioned letter to Hewlett Johnson he cautioned the Dean against repeating the standard Communist defence of the Soviet invasion, namely that, with the encouragement of Britain and France, Finland had deliberately spurned a negotiated settlement with the Soviet Union in order to extend its boundaries into the Urals. Gollancz was concerned lest Johnson should be tempted to repeat the argument in any last-minute changes to the text.

> I believe that there is not a single person ... who believes any of this. ... If we have cried out against aggression time after time ... then by defending this action of the Soviet Union in a way which the ordinary man regards as palpably dishonest, we help rather than hinder the line-up against the Soviet Union.[10]

The Soviet invasion of Finland added significantly to the concerns that Victor Gollancz already had about the reception *The Socialist Sixth of the World* would get from the critics. In August 1939 he had offered the text

to the American publisher Random House, presumably in the hope of simultaneous publication in the United States. The reply from Bennet Cerf, an executive at Random House, was scornfully dismissive.

> No American publisher in his right mind would undertake to publish *The Socialist Sixth of the World*. ... Paragraphs like the one at the bottom of page 357, which includes a sentence that 'liberty-loving and peace-loving people throughout the world are learning to see in the Soviet Union the champion of their liberty and peace' would get hooted out of court.[11]

In a letter to Hewlett Johnson in which he conveyed the gist of Bennet Cerf's reply, Gollancz confessed that: 'It is *this* aspect of the matter, and the fear of what its ultimate effect may be, that have caused me so much distress from the beginning'.[12] It was, for Johnson, a bitter vote of no confidence from his publisher; and the relationship between the two men descended into one of uneasy mistrust. The fate of the book was now at the centre of their falling out, for Johnson believed that Gollancz's disillusionment with the Soviet Union in the wake of the Finnish invasion had soured his estimate of its worth.

Hewlett Johnson and Victor Gollancz finally parted company over the speed – or rather, the lack of it – with which Gollancz was reprinting *The Socialist Sixth of the World* in the wake of the first edition in December 1939. When in 1943 Johnson accused him of dragging his heels, Gollancz tried to explain to the Dean that the shortage of paper required him to be fair to all his authors. Johnson's response was blunt: convinced that the book would blow asunder the prejudices of an ignorant and misinformed public, he all but demanded to be placed at the head of the queue for the sake of the civilised world.

> If I venture to say to my friends that you are doing all you can, and that you will print 20,000 copies for the whole year, they would exclaim immediately: '20,000 copies only for a book that is dynamite, that is the most powerful war weapon, that starts factories working and stiffens up the war effort? And this in the most crucial year of the world's greatest war, and his book is never seen on a single bookstall?' What can I reply?[13]

For Hewlett Johnson, the conflict was now a deeply personal one. *The Socialist Sixth of the World* was the secret weapon with which he was

waging war against fascism in Europe, and Gollancz was putting its success at risk. 'I cannot help feeling wounded by your abrupt voice', he wrote bitterly to his former friend. 'Please do not treat me like this.'[14]

* * *

What, then, was it about *The Socialist Sixth of the World* that made it, in Johnson's own estimation, 'the most powerful war weapon that starts factories working and stiffens up the war effort'? The book was a plea to the English-speaking world to set its preconceptions on one side and respond to the true facts about 'the Russian experiment' with an open mind. In the foreword to the American edition of the book, written in 1940, Johnson observed that:

> Deep-rooted hostility and prejudice exist in certain strata of peoples towards the USSR. For their hatred and intolerance we pay a bitter price in blood and tears today. Should any who cherish such feelings chance to read this book, I would beg of them to lay prejudice aside for a brief space and examine what the book has to say.[15]

The Socialist Sixth of the World was arranged in six sections. The first section ('Apology and Excuse') charted the key events in the Dean's life that had led him finally to grasp the intrinsic immorality of capitalism. Much of the material in this section was an abbreviated version of the story that was later to appear in fuller form in his autobiography, *Searching for Light*. Johnson concluded that:

> Personal experience of poverty on the one hand, and intimate knowledge of the circles of the rich on the other, had driven the lesson home and left me in no doubt as to where my duty as a Christian minister lay. No longer could I resist the conclusion that capitalism was doomed.[16]

Capitalism, Johnson asserted, was chaotic and wasteful: it lacked a coherent methodology for producing and distributing the things that were necessary for people's welfare and it spat in the face of the Christian message by denying the legitimate demands of the gospel for justice, freedom and respect.

> To Jesus, every man was of infinite worth: he reveals it as the fundamental truth about man, and to deny it is to court disaster. Jesus was the first man in history to take monotheism with complete moral seriousness: one God, one Father of all, one family of men; therefore no

racial distinctions, no national distinctions, no class distinctions – one brotherhood of men under one God.[17]

A number of important denials flowed from the self-seeking acquisitiveness of capitalism, denials that were an affront not only to a nation's conscience but also to the Christian gospel. Firstly, there was a denial of justice as millions of people were forced into poverty and deprivation. Secondly, there was a denial of freedom for the great mass of people who were excluded from the social, political and economic heights of a nation. Johnson insisted that:

> Real freedom demands provision of opportunity for all – but such freedom cannot flourish in a land in which the overwhelming mass of people lack adequately paid work and ample leisure to enjoy its fruits, and where half the population are underfed and lack freedom of opportunity with respect to education, choice of a profession, provision of health, and insurance against old age and the accidents of life.[18]

And thirdly, there was a denial of creative living. Capitalism divided rather than united people because it treated workers as little more than cogs in the capitalist machine. Those who worked in the factories and on the farms were seen as human resources, useful only in the creation of profit and wealth. Treated as nothing more than commodities, their humanity was violated, their spiritual well-being was ignored, and their cultural potential was crushed. They failed to thrive as full human beings.

* * *

From this scene-setting in the first section, Hewlett Johnson then turned his attention in the second section ('The Soviet Blue-Prints the New Society') to the Soviet Union. He stressed that, although the Soviet Union had passed beyond its experimental stage, it had not yet attained perfection.

> The order of Soviet society is far from perfect. In many directions the Soviet Union has a long way yet to go. Difficulties in the beginning were inevitable. The size of the Union made them appear insuperable. Naturally the new order lies open to criticism in a hundred minor points. But the major achievements of the past twenty-two years are so great ... that no longer can the outer world afford to ignore what is happening.[19]

Having lodged his caveat, Johnson then summarised the range of Soviet achievements since 1917. Factories, mines, railways and land were now owned by the people, and the economic and social life of the country was planned in the public interest. Political and sexual equality was guaranteed by law. Everyone had an equal opportunity in the educational system, and work was provided for all at a fair wage. Workers were entitled to paid holidays and women were entitled to maternity leave. Free medical care was available for all who needed it. All of these benefits, Johnson declared, had either been achieved or were on the way to fruition. He acknowledged that visitors to the Soviet Union still returned home with dismal stories of outdated roads and railways, drab townscapes full of colourless blocks of uniform apartments, and the absence of consumer choice in the shops. But he repeatedly made the point that Russia in the late 1930s must always be compared with the way things had been there in 1917, not with the contemporary standards of western European countries.

> The Soviets are pioneering in a new world: it is idle to expect them to fuss about the comforts of an old order, either for themselves or for foreign visitors.[20]

Hewlett Johnson then turned to the virtues of centralised planning and the achievements of the Soviet five-year plans. For him, the notion of centralised planning flowed naturally from the goal of a classless society in which everyone had access to the essential things of life and no one could exploit the system for private gain. He saw nothing contradictory between a planned economy and the Christian vision of the Kingdom of God, for – rather like a family – both were concerned with the care that people should have towards each other. Indeed, the difference between managing the economy of a nation and that of a family was merely one of degree.

> This vast family economy needs careful planning and faithful execution, as does every lesser family economy. Planning for family use lies at the root of both, and it would be hard indeed to imagine ... a scheme which better meets alike the demands of the Christian conscience and the dictates of a rational scientific order.[21]

Everyone in the Soviet Union had a duty to contribute to the prosperity of the nation, and all could call upon its resources in times of need. There was nothing in this that should upset a Christian, Johnson argued, for there

was nothing in it that went against the grain of Jesus' teaching. Indeed, the very early Christian communities had been organised along precisely these lines. They were prototypes of a communist society.

* * *

The third section of the book (also and confusingly titled 'The Socialist Sixth of the World') dealt with the central element of Hewlett Johnson's thesis. His claim was *not* that communism was a noble aspiration, compatible with the Christian faith and embodying all that was best in human nature. He claimed, much more radically, that the Soviet Union was *already* translating the principles of communism into the reality of a better society where social justice sat comfortably side by side with economic growth. The Union was *already* set upon a path that, in the long run, would deliver the kind of benefits that neither capitalism nor liberalism could ever achieve. And to substantiate the claim, he had to provide evidence that would convince the sceptics and silence his critics. For the most part, he failed to do so.

The nine chapters in this section dealt mainly with the Soviet economy, charting the rise of industrialisation since 1917, the growth in national productivity, the technological achievements of Soviet scientists and engineers, the development of modern communication systems, and the productivity of Soviet agriculture. These chapters were laden with statistics that claimed to show not only the dramatic success of the Soviet economy in the two decades since the Russian Revolution but also its superiority over the capitalist economies of the West. The following extract gives a typical flavour of Johnson's approach.

> In rate of development and in rate of increase in output the USSR easily leads the way. Industry in capitalist countries, after the crisis of 1929, had barely reached 103.5 per cent of its 1929 level in 1937. Since then it has suffered from a renewed economic crisis. Large-scale industry in the USSR in 1937, on the other hand, reached 428 per cent of the 1929 level. Total industrial production, heavy and small together, reached 371 per cent. Again, in 1938 the output of the entire industry of the USSR increased by 412 per cent of the 1929 level, and in large-scale industry as much as 477 per cent. In capitalist countries industrial production in 1938 declined by 13.5 per cent against the preceding year, dropping to 91 per cent of the 1929 level. Rate of growth is, then, the outstanding feature of Soviet production.[22]

It was all very impressive. On every measure, Hewlett Johnson claimed, the economy of the Soviet Union was steaming ahead and its industrial productivity had been outperforming the West for twenty years. There must have been at least a semblance of truth in this, for while the western economies were struggling to cope with the debilitating effects of the great depression in the 1930s, Stalin was diverting every ounce of Soviet resource into manufacture. But where did all these facts and figures come from? Could they really be accepted at face value? After all, economic statistics, especially those that purport to compare one country with another, are notoriously difficult to interpret even when the methods of collecting, analysing and displaying them are reasonably transparent. Was the Soviet economy *really* as wonderful as Johnson made it out to be? These were questions that he did not even ask, much less answer. Instead, he took the statistical and other material he had been given and trustingly passed it on to his readers without reservation or explanation, simply inviting them to believe that it was all self-evidently true. And in doing so, he committed a string of elementary errors. He failed to explain where the statistics had come from, removing any possibility of checking the reliability of their provenance. He failed to offer any guidance as to their accuracy and valid-ity. He failed to explain how key concepts such as 'index of wages', 'national income' and 'productivity' were defined and measured. And he failed even to wonder, much less to judge, whether the international comparisons upon which a great deal of his argument rested were remotely contrasting like with like.

In short, the important third section of *The Socialist Sixth of the World* was a hollow shell. To use statistics that could have come from anywhere as evidence of the superiority of Soviet communism over western capital-ism was at best disingenuous and at worst fraudulent. It was as though Johnson believed that the moral force of his arguments absolved him from any duty of care towards his evidence. It was a fatal position for an author who had earlier pleaded with his readers to set their preconceptions on one side and respond to the 'true facts about the Russian experiment' with an open mind. What true facts, the discerning reader might have wondered?

* * *

The fourth section of the book ('The Greatest Good of the Greatest Number') turned from the economic to the human sphere as Hewlett John-son explained the social and moral benefits of communism in the Soviet Union. These benefits, he argued, were better served by a centrally planned system of production and distribution than by the chaotic self-interest of

a capitalist economy. It transformed greed into altruism. It discouraged lies, deceit and sabotage. It generated a more responsible attitude to work. It reduced crime. It added zest to life by providing creative tasks for all. The centralised Soviet planning system, in other words, was the fount not only of economic growth but of something close to social and moral perfection as well. It was the blueprint for a courteous and cultured nation of happy, fulfilled and secure citizens.

Education in the Soviet Union was one of the examples that Hewlett Johnson used to make his point. The goal of the Soviet education system, he explained, was that of an educated and morally responsible nation. Because competition among schoolchildren had been abolished, the education system was free to pursue such lofty goals in the schools and colleges as the production of 'men [sic] who, in a word, understand the parts of life in relation to the whole'.[23] Once through their education, young people in the Soviet Union were much better placed than their counterparts in Britain to move successfully into the labour force. Since everyone had a share in the ownership of industry and commerce, everyone had their rightful place in the labour force. There was no hunting for jobs; rather, the jobs hunted the workers, and each job was part of a greater whole. Everything was planned. Nothing was left to chance.

The benefits of communism carried through into the workplace. Working hours were regulated, women received the same rates of pay as men for the same jobs, child-care facilities were universally available, sick pay was generous, and at the end of their working lives, people retired with adequate pensions to meet their needs in old age. Because the terms and conditions of people's employment were so good, workers had little need of trade unions to fight their interests. Trade unions did exist, and some of their work did concern the petty grievances and injustices that arose in any workplace; but they functioned mainly as the welfare arm of management, encouraging workers to improve their education, administering social insurance funds, building rest homes and sanatoria, and 'stimulating the general social activity and consciousness of the worker'.[24] In short, the Soviet Union was little short of an industrial utopia.

* * *

The fifth section of *The Socialist Sixth of the World* dealt with the Soviet Union as a confederation of nations, each of which had 'voluntarily accepted the communist principles of planned production for community consumption and had combined their territories under a common scheme to give these principles effect, with common weapons against external

attack'.[25] The chapters in this section painted an unblemished picture of happiness, progress and equality in all the member states of the Union. The sixth and final section of the book focused on the quality of daily life under communism. Understandably, Hewlett Johnson was particularly interested in religion. Writing at a time when Christians in the West were being encouraged to view the Soviet Union as a godless wilderness of unbelief and oppression, his defence of Stalin's attitude towards the Russian Ortho-dox Church was robust. He pointed out that, since the church in pre-revo-lutionary times had been hand-in-glove with the Tsarist regime and deeply wedded to the reactionary forces in Russian society, it was hardly surpris-ing that Lenin had come to see religion as a hindrance to the achievement of the communist project. It was, of course, a matter of regret that the state had found it necessary to resort to a degree of bloodshed, violence and brutality; but these early acts of persecution against the Church had, with the passage of time, given way to a much more tolerant stance. It was wrong, now, to say that the Soviet Union lacked religious freedom, though it was the case that churches were still labouring under serious handicaps. Religious instruction, for example, could not be given to children outside the family circle, and any kind of evangelism through the mass media was forbidden. But Soviet citizens were free to worship in whatever ways they wished, and they were free also to seek to convert others to their beliefs. So too were priests. And so Hewlett Johnson was able to end *The Social-ist Sixth of the World* on an upbeat note.

> The communist puts the Christian to shame in the thoroughness of his quest for a harmonious society. Here he proves himself to be heir of the Christian intention.[26]

* * *

The reception accorded to *The Socialist Sixth of the World* was mixed. Some left-wing journals and newspapers, including the *Daily Worker*, were enthusiastic, as were the scores of private readers from around the world who showered their thanks and praise on the Dean. Whatever the profes-sional reviewers may have thought about the book, it hit the spot with many ordinary people who had long suspected the biased reporting of the Soviet Union in the western media. 'Without your book', wrote one grate-ful reader, 'I should have been reduced to despair. Socialism seemed to have been defeated and money and power entirely triumphant.'[27] 'You almost persuade me to come back to the church,' said another, 'I think your book is the most inspiring piece of work I have read in my twenty-six years, and

a book that is going to do a tremendous amount of good for the truth, for Christianity and for peace.'[28] These correspondents spoke for many.

Most of the critics, however, were unconvinced by *The Socialist Sixth of the World*. Many of the reviews were positively hostile, highlighting Hewlett Johnson's naivety in believing everything he had been told about the Soviet Union and regretting his lack of curiosity about the true state of affairs. Tom Paine in the *New Statesman* wrote that: 'When the smoke has cleared away and existing controversies and personalities are seen in better perspective, the Dean's picture is likely to look naive.'[29] Freda Uttley in *The New Republic* observed that: 'Having imagined a society of abundance, social justice and loving kindness, he proceeds to describe it as if it actually existed.'[30] Professor S R Cross in *The Christian Leader* marvelled at Johnson's 'pious wonder' and castigated him for being 'too easily beguiled by the Siren Song of bogus Soviet statistics'.[31] William Chamberlin in the *Saturday Review of Religion* was brutal in his assessment.[32] Although he had learnt nothing of any value about the Soviet Union from reading the book, he had gleaned a great deal about the effect of propaganda on a gullible and credulous mind. 'The whole impression of the book', Chamberlin wrote, 'is that of a work written in a complete factual vacuum, a Utopia projected in the author's mind and then forcibly planted in the Soviet Union'. He took particular exception to Johnson's laughable claim that 'nothing strikes the visitor to the Soviet Union more forcibly than the absence of fear'.

> Having lived in the Soviet Union for some twelve years, I had to rub my eyes when I read that amazing sentence. I think most residents of the Soviet Union would agree with me that nothing is so characteristic of the country as the universal, paralysing, abject fear, the natural and inevitable consequence of a system that numbers its recorded executions in thousands, its arrests and banishments in tens of thousands.

Some reviewers found the book so incredible that they wondered whether Hewlett Johnson had actually written it himself. Victor Gollancz was sufficiently concerned to draw the matter to the Dean's attention.[33] He was right to do so, for while there can be little doubt that Hewlett Johnson wrote the first section of *The Socialist Sixth of the World*, much of the rest of the book (there can be no certainty exactly how much) was lifted from Soviet material that he took from English-language sources and arranged and edited into a coherent narrative. The material was largely supplied by

VOKS, as Johnson candidly informed his readers when he revealed that most of his information was taken from:

> ... reports, scientific monographs and the mass of ephemeral but extremely valuable literature which daily pours out of Russia itself, with detailed descriptions of various cultural achievements and of actual workings of mines and oilfields, collective farms and factories, together with statistics of fulfilment of Five-Year plans.[34]

Johnson went on to explain, without any sense of irony, that 'much of this material was self-checking' and had been supplied to him through the Society of Cultural Relations with the USSR – the principal channel through which VOKS disseminated Soviet propaganda in Britain. Not only was Johnson able to access VOKS publications through the Society's library in London, he also received material directly from VOKS via the Soviet Embassy.[35]

* * *

It is perhaps instructive of Hewlett Johnson's general approach to his writing that *The Socialist Sixth of the World* was not the only occasion on which he attached his name to a publication that had been written largely by others. In April 1953, six weeks after Stalin's death, he delivered a memorial address at a meeting of the British Soviet Friendship Society that was later published as a sixpenny pamphlet under the title *Joseph Stalin, by the Very Reverend Hewlett Johnson, Dean of Canterbury*.[36] Yet Johnson actually wrote very little of it. The clues are obvious to anyone familiar with his work. The pamphlet was written in a style very different to his own, and it was so flatteringly sycophantic in tone that even the most ardent Soviet sympathiser might have found it a little excessive. Stalin was, the pamphlet proclaimed, a flawless leader whose every action bore the mark of genius. He was wise, conciliatory and just. He was a great military leader who inspired and organised the major victories of the Red Army. He was the inspiration and the force behind the colossal industrial and technological advances of the Soviet Union. He was a man of peace and justice who respected the rule of law and sought only the amicable cooperation of nations. Single-handedly, he shaped the course of twentieth-century history. By any reasonable standards this is the florid language of state propaganda, not the reflective judgements of an independent mind.

The archive reveals that the Stalin pamphlet was produced in two stages. First, Johnson copied the text, word for word, from another

English-language source, and then he made relatively minor editorial changes to produce the final, published version. It is impossible to identify the original source, but it may well have been an official obituary notice written by the Communist Party for use in English-speaking countries. The Party controlled what could be said about Stalin during his life, and it is likely that the Party also controlled what it wished to be said about him after his death. To claim to have been the sole author of the pamphlet when in fact it had been written largely by others was a straightforward act of plagiarism that should have been dismissed for the fraudulent act it was. In fact, the pamphlet became a minor triumph of Soviet propaganda. *The Socialist Sixth of the World* was a major triumph.

> Dawn breaks over the east. And in that fresh dawn men see the promise of a new world, not a perfect world, and not a Utopian world, but at least a world freed from poverty and exploitation, and with heightened possibilities for all to work together for the common good – and a world where mankind, released at last from much that binds it to the earth, may find within itself a nobler and more enduring goodness and beauty.[37]

CHAPTER EIGHT
THE CANTERBURY CHAPTER AT WAR

A T THE OUTBREAK of the Second World War in September 1939 the Canterbury Chapter may well have appeared to the outside observer as an effective, even harmonious, group of clergymen united in their common desire to serve the Cathedral to the best of their corporate ability. Hewlett Johnson may not have been a popular Dean among his colleagues, but he was on top of the job and in the eight years since his appointment he had brought about significant improvements in the governance and worshipping life of the Cathedral. Likewise, Canon John Shirley may not have been a popular headmaster of the King's School, but in the four years since his appointment he had begun to rescue the school from the financial and educational mire into which it had fallen and set it on the road to a recovery that, in hindsight, was little short of miraculous.

But all was not quite what it seemed. Following the Soviet Union's non-aggression pact with Germany in August 1939 and its subsequent invasion of Finland in November, anti-Russian sentiment was rife in Britain, especially among Christian communities that abhorred the suppression of religious freedom in the Soviet Union. Hewlett Johnson was rapidly becoming an isolated figure in the higher reaches of the Church of England, attacked for defending the Finnish invasion and alienated from his colleagues in the Canterbury Chapter by his radical theology. When *The Socialist Sixth of the World* was published in December 1939 to great acclaim from many ordinary people but scornful derision from the critics, the atmosphere of resentment and recrimination within the precincts became ever more toxic. The canons began to plot.

By the end of February 1940 the waves of conflict within the Canterbury Chapter had lapped up to the door of Lambeth Palace. Archbishop Cosmo Gordon Lang, having been informed by the canons that they were planning publicly to disown the Dean in a letter to *The Times*, and realising the damage that such a move would do to the Church of England, persuaded them to hold fire until he had had time to bring his authority to

bear upon Hewlett Johnson. Not for the first time, Lang advised Johnson that his unique position as Dean of Canterbury laid upon him 'the duty of restraint in utterances and activities which otherwise would be quite permissible'.[1] Johnson simply did not have the freedom of a private individual – and if he didn't like it, there was a clear way forward for him. Lang's point was not merely that the Dean's views had 'surprised and given offence to many Christian people of all classes and parties and churches' but that he was in dereliction of his duty by compromising the Deanship of Canterbury with his political partisanship.

> My object therefore in writing this letter is to address to you a most earnest plea that for the sake of the harmony of your Chapter and of the spiritual interests of your Cathedral you may be willing to reconsider your position and ... to intimate to your colleagues that you will not continue the activities which are causing them and many others so much real distress. If you can assure me that you are willing so to do, I think I can promise that the contemplated letter [from the canons] to the Press will not be sent.

Hewlett Johnson's reply to Lang was shot through with righteous anger.[2] Though 'deeply grieved' that his words and actions had caused pain to the Archbishop and disharmony among his canons, he forcefully rejected Lang's central charge of the dereliction of duty. There were three steps in his rejoinder. First, Johnson asserted that to preach the Christian gospel was *necessarily* to engage in political argument. Politics and religion were two sides of the same coin and could not be prised apart. The Church of England understood this very well.

> Don't you yourself, my Lord Archbishop, in the name of Canterbury, wield immense political influence, and do not the twenty-four Bishops who sit with you in the House of Lords speak with powerful political voice in the affairs of the country and exercise the right to assent to or veto every bill a popularly elected assembly sends up to you? ... I only urge the right of voices on either side to be heard.

Secondly, Johnson asserted that if the Christian gospel demanded an engagement with the political life of communities, then no charge could be laid against a priest who did just that. Indeed, to fail to do so would be a far more serious matter. Therefore, Johnson asserted:

> I cannot assent to their [the canons'] request to resign my office and cease to speak of Russia during the war. I can accept no censorship on freedom of speech nor relinquish an office committed to me as a charge. If to speak openly concerning these matters, and to ask for such government as would inaugurate a Christian alternative, is 'political activity', I must accept the charge.

Thirdly, Johnson dismissed the charge that his political activities were diverting his time and energy away from the things he should really be doing. Under his care the dignity and beauty of the services had increased, the fabric of the Cathedral had been secured and enriched, the King's School had been brought back from the brink of disaster, and the Chapter estate had been remodelled on financially secure principles. He himself had preached twenty-three sermons in the Cathedral in 1939 and he had faithfully observed his obligation to worship at least once a day in the Cathedral whenever he was in Canterbury. The number of Chapter meetings had increased, and of the thirty-nine meetings in 1939 he had missed only one. He had taken far less than his entitlement of holidays.

Hewlett Johnson concluded by saying that were the rift with the canons merely a matter of personality, he would gladly try to accommodate their complaints; but 'the principles at stake lie at the very root of my Christian belief and touch upon fundamental moral aspects which I feel it is my duty to preach'.

* * *

Whether or not the Archbishop shared Hewlett Johnson's letter with the canons is not known, but their anger was not appeased. On 13 March 1940 they publicly denounced their Dean in the correspondence columns of *The Times*.

> In order to correct any misunderstanding, we feel compelled to make it known that we, the Canons Residentiary of Canterbury Cathedral, dissociate ourselves from the political utterances of the Dean of Canterbury which, as reported in the public press, have so often given the impression that he condones the offences of Russia against humanity and religion. We have further thought it our duty to tell him that his political activities gravely impair the spiritual influence of the Cathedral in the City and Diocese of Canterbury, give grievous offence to many Christians throughout the world and, in our view, are proving themselves to be incompatible with the proper discharge of the

trust which has been committed to him. We desire to make it known that we are at one with the Dean in believing that it is the duty of all Christians to further social and economic reform, but we believe it to be a dangerous illusion to hold that such reform will ever be achieved by the methods which have characterised the Soviet regime.[3]

The letter was signed by Canons John Crum, Thomas Sopwith, John Shirley, Frederick MacNutt and Alexander Sargent. Canon Crum explained in the *Daily Telegraph* that: 'We have done the most serious act we can think of to show that we consider the Dean is not the right man for his job'.[4] The catalyst for their action had been a sermon that the Dean had preached in Westminster Abbey in which he had said that communism had recovered 'the essential form of the real belief in God which organised Christianity has so largely lost'. Following the sermon, the canons had set out their concerns and invited Johnson to reply. According to Crum, his response had been an apologia of forty pages that was little more than 'an irrelevant political discourse'. As for the way forward now that the canons had made their charges public, Crum was reported in the *Daily Mail* as saying:

> The next move is with the Dean. We have made our attitude plain and it should be obvious to him that it will be extremely difficult for the Dean and Chapter to work together. There is no question of our resigning.[5]

Hewlett Johnson's response to the canons' denunciation took the form of a letter to *The Times* and an article in the *News Chronicle* in which he categorically denied that he had 'condoned the offences of Russia against humanity and religion' or that he had advocated changes in Britain 'by the methods which have characterised the Soviet regime'. He adduced no new evidence, merely pointing to his considerable corpus of published work, particularly *The Socialist Sixth of the World*. He also rejected the charge that he had 'gravely impaired the spiritual influence of the Cathedral', citing the extensive messages of goodwill he continually received from Christian communities around the world and reiterating the statistics he had earlier given to the Archbishop about his preaching and other duties in the Cathedral throughout 1939. Johnson concluded his letter to *The Times* by saying that:

> It is with real pain that I regard these differences, which affect the personal relations of those who were, and I hope still are, my personal

friends, and I deeply and sincerely deplore this raising of issues which may lead to all the heat of public controversy and the exacerbation of feelings and differences, and which can do little good and perhaps much harm to the Established Church and the Faith in which I believe.[6]

* * *

The scandal of the canons' letter polarised public opinion as, yet again, Hewlett Johnson manifested an extraordinary capacity for arousing both bitter hatred and fierce loyalty. Many of the scores of letters he received were vitriolic in their condemnation of him. The Reverend M Rush was 'one of thousands of your brethren in the Sacred Ministry who deplore and abominate your support of Anti-Christian Warfare ruthlessly forwarded by the Russian Government'.[7] P H Newman and his friends were 'disgusted and appalled' by the Dean's Bolshevik and anti-Christian attitude. 'At least be honest and leave the Church of God', they pleaded, 'and openly join your friends who are so desirous of squeezing the country to death.'[8] These two correspondents, whose letters have been selected because of their relatively moderate language, articulated the abhorrence of many.

Yet for each letter of criticism that Hewlett Johnson received, there were more that praised him for his moral courage in making a stand against the crabby obduracy of the canons. None matched the wit of the correspondent who urged Johnson to 'make it another Balaklava and capture these canons',[9] but all revealed a deep vein of disgust at the vindictiveness of the Chapter. H Ramsay told Johnson that he had written to them 'asking them to come out of their trance and realise that they are not now living in the seventeenth century and should follow Jesus Christ's example and spend more time amongst the poor'.[10] The Reverend S Hopkins wanted to say 'how fully you represent the attitude of a large number of Christians of whom I am proud to be one. It is a satisfaction, because of its rarity, to find a leader of the Church where high principles are combined with courage and intellect.'[11] 'Thousands of truly Christian people are with you in spirit and understanding', Lily Shearer assured the Dean. 'May the Peace of God keep you and uphold you in your efforts to show forth the Christian ideal.'[12] And there were many more who wrote in a similar vein.

The Archdeacon of Westminster, Lewis Donaldson, struck a deeper note of professional concern.

The [canons'] letter as a whole means that the freedom of the ministry, pulpit and platform is assailed – just because a group of canons are

not themselves in agreement with their Dean's course of action. ... I
urge you therefore to stand firm ... for the freedom of your (and our)
office and ministry. ... I am certain that your ministry is needful in
Canterbury and elsewhere. Stand fast, therefore.[13]

The letters that Hewlett Johnson received from members of the public in
the wake of the canons' letter in *The Times* showed yet again that, although
a figure of intense hatred to some, he reflected the views and sentiments of
many ordinary people at the time. Yet it could hardly be said, after the
furore had died down, that he had become a popular national figure. He
still retained an extraordinary ability to touch people's emotions, one way
or the other, at a deep level: they seemed either to love or to hate the man.
Depending upon where they stood, he was either the prophet of the New
Jerusalem or the preacher from hell. There was precious little in between.

* * *

The canons' letter inevitably cast a long shadow over the precincts through-
out the difficult years of the war and even beyond. It would have been
impossible to pretend that the air had been cleared and normality restored
– and it hadn't. The Oxford *History of Canterbury Cathedral* observed,
benignly, that the precincts community was no longer 'at peace with
itself';[14] the truth, more brutally, is that it was all but at war with itself as
Hewlett Johnson did his valiant best to maintain the work of the Cathedral
in the face of the waxing hostility and waning confidence of his colleagues.
The troubled relationship between Hewlett Johnson and Canon John Crum
is perhaps the clearest example of the bad blood that was coursing through
the Chapter's veins. John Crum was already in post when Hewlett Johnson
arrived as Dean in 1931, and at first there was a genuine friendship
between them. Crum stood high in the Dean's esteem. When Downing
Street sought Johnson's views about his suitability for a canonry at St Paul's
Cathedral in 1934, a fulsome reference was forthcoming.

To my mind he stands foremost among preachers in the Church of
England. He makes a wide appeal to cultivated people; also to chil-
dren: at our great public schools he is in perpetual demand. His
impromptu speeches are brilliant. ... As a man I find Crum entirely
charming. He is nearer akin to genius than anyone Canterbury has
seen for a long time He is altogether delightful and my most valued
companion. I should dread his departure.[15]

But something personal occurred between the two men that turned Crum from a 'most valued companion' into an implacable enemy,[16] and by 1940 he was a willing signatory to the canons' letter in *The Times*. Not only did he sign the letter, he took a leading role in explaining its purpose to the press. Thereafter Crum's hatred of the Dean became ever more intense, to the dismay not only of Johnson himself but also of other members of the Chapter. In April 1941, following the Good Friday service, Alex Sargent (the Archdeacon of Maidstone) wrote to Johnson:

> If I may say so, I have greatly admired your self-restraint when these painful scenes have occurred. I am sorry for Crum, for he is going through agonies of mind about it all – knowing himself to be wrong. He and I had a long quiet talk about it on Tuesday – and he is trying hard, but can't be sure of succeeding![17]

The Archdeacon of Canterbury, Thomas Sopwith, was also understanding of the problem.[18] But in spite of the concern of his colleagues, John Crum was not to be stayed. He was becoming, in the Dean's eyes, rude and obstructive. Writing to Nowell in the summer of 1942 Johnson recounted an incident that had occurred at the eight o'clock service the previous day.

> I got through yesterday. Crum was abominably rude – as usual. I was celebrating and paused to collect my thoughts before beginning and say[ing] a prayer – as we all should. Crum took out his watch and in a loud voice announced '4 minutes past 8'. That is normal time. It is what the Archbishop would do. I was horrified and could hardly control my voice for the first prayers. Sargent was horrified too and said as nice things as he could afterwards. However I shall take no notice. To take notice would only make it worse.[19]

* * *

Hostilities between the two men rumbled on as Hewlett Johnson privately accused John Crum of spreading scandalous stories about him and Crum responded by refusing to take Holy Communion from the Dean.[20] The matter finally came to a head in the autumn of 1943 following a statement that Johnson was alleged by Crum to have given to the *Daily Telegraph* about his (Crum's) behaviour during a German air-raid. 'He has been spreading that tale about me for a year to my very great damage,' Hewlett wrote to Nowell. 'Now he has put it into writing, the matter is referred to the next Chapter when he will be obliged to attend. He just can't go on like

this.'[21] Crum's behaviour at that meeting (if Hewlett Johnson's account of it is to be believed) transgressed all bounds of propriety.

> The Chapter on Saturday was horrid. Crum like a wild animal. Such extraordinary venom. Said I was absolutely insincere. Put it succinctly like this. Crum: 'A man said to me lately the Dean is slimy and a liar.' Sargent at once: 'You stopped him of course.' Crum: 'No, I didn't. I agree. I always try all the time to pour ridicule and contempt over the Dean. I never hide my contempt.' Bickersteth: 'Crum, you are bringing shame on the Chapter. You are hurting us all.'[22]

John Crum finally succumbed to pressure from his colleagues, for less than a week later he resigned. Privately, Hewlett Johnson was almost ecstatic.

> CRUM IS GOING! How sad that I should have to rejoice, but I do. The position has become intolerable. He told MacNutt and Sargent after I left the vestry this morning. They have just been to talk to me. It is not to be made public yet. But what a relief! And not to me only but to many, many more. It will make work here smoother and I hope happier.[23]

Publicly, however, Johnson was far more emollient about the affair. Following his resignation, Crum had dinner with the Archbishop, William Temple,[24] at which he set out the reasons for his actions. Fearing that much of what Crum had said to the Archbishop might damage his own reputation, Johnson then wrote to Temple himself. It was a letter that revealed his characteristic desire to try to see the best in others.

> I do not propose, unless you wish it, to discuss the charges against me or defend myself. Crum may in my opinion be wrong on particular counts; I am only too conscious of many grievous things which he fails to enumerate. My earnest prayer is that this good man's sacrifice may be used by God to purge me if possible from faults which He alone sees. ... I can only express my deep grief at the rupture, for the time being, of friendship with a really great man and my sorrow for any acts of mine which have robbed the Cathedral of his outstanding services.[25]

Still John Crum was not satisfied, and at his final Chapter meeting in November 1943 he pressed Hewlett Johnson to respond to the charges that had been levelled against him as Dean. In an attempt to lay the whole sorry

saga to rest, Johnson finally sought to justify himself in a fierce but compassionate valedictory letter to his senior canon. It merits quoting at some length for the insight it gives into the Dean's pastoral handling of one whose behaviour had passed beyond the bounds of reason.

> You desire that I should justify my occupancy of the Deanery of Canterbury in view of my attitude and activities. Though under no obligation to do so, and though I should prefer to be silent, yet as you urge it as a last request I will now say what I would gladly have left unsaid. ... I feel that God has chosen me to do a special work and given me a difficult and varied training to fit me for it. I was called upon to speak the truth about a great country and to write a book [*The Socialist Sixth of the World*] that has sold in millions of copies and in many languages all over the world. That book made me the target for every kind of attack. And just where I might have expected tolerance, humility, and a readiness to learn and help, I found little or none save in an Archbishop [Cosmo Gordon Lang] whom I grew to love because of his tolerant kindness. ... Might I not have expected, at least in view of recent events, some Christian expression of regret for what, it seems to me, was the intolerance and injustice of the past? May I not ask, in all seriousness, whether your continued hostility is, in the sight of God, right or kind or wise? I have tried all these months and years to meet your attitude, which has given me the greatest pain, with patience and understanding. I have attempted no recrimination or defence of my actions, feeling that forbearance was the only Christian course. In all humility I ask 'Is not the same possible for you?' I could wish with all my heart that we might part as friends, and I was deeply moved when last Sunday morning, for the first time perhaps for years, you took the chalice from me with unaverted face. That is a memory I cherish.[26]

* * *

Canon John Crum's animosity towards Hewlett Johnson was the most blatant indicator of a divided and unhappy wartime Chapter, but none of the Dean's relationships with his colleagues was without blemish. After all, it was *all* the canons – not just Crum – who had signed the letter to *The Times* in March 1940, and such a public declaration of hostility could scarcely have been conducive to harmony in the workplace. Crum apart, Canon John Shirley, the headmaster of the King's School, was probably the most painful thorn in the flesh of the Dean, even during the war years

when the King's School had been evacuated to Carlyon Bay in Cornwall. The antipathy was often mutual, for theirs was a complex relationship that was at different times both abusive and affectionate.[27] Although Shirley spent most of the war in Cornwall, he was no stranger to Canterbury between 1940 and 1944, spending each August in residence and lodging in the Selling Gate while attending the meetings of the Chapter and preaching in the Cathedral.[28] He was, therefore, never far removed from the thoughts of the Dean who, as Chairman of the Governing Body, was ultimately responsible for the well-being of the school.

It added to the Dean's difficulties that Shirley was three hundred miles away during most of the war, for he could be less sure what the headmaster was up to. Some of the reports that he received, particularly about Shirley's handling of the school's financial matters, caused him great anxiety. In this he was not alone. The Archdeacon of Maidstone, Alex Sargent, was sufficiently alarmed by what was happening to propose a visit to Cornwall by an 'economy committee' to 'examine the situation on the spot', taking with them a qualified accountant from the Ecclesiastical Commission. The proposal was fiercely opposed by Sir Arthur Luxmoore, a governor of the school, and the visit was never made. Sargent was 'seriously upset' by Luxmoore's protection of Shirley and his refusal to countenance an on-site audit of the school's accounts.[29] Johnson confided to Nowell that 'he [Luxmoore] is in league with Shirley. It bodes ill, I fear.'[30]

Other also had their concerns about John Shirley's conduct in Cornwall. According to Hewlett Johnson, Ralph Jukes, the headmaster of Junior King's, told 'a shocking tale' of Shirley's doings at Carlyon Bay. 'Jukes sees [Shirley's] unscrupulous behaviour [towards] the lads and the misery it causes to the staff. He thinks Shirley will hang himself if given time.'[31] Clive Pare, the headmaster of the Choir School, and Gerald Knight, the Cathedral organist, both of whom had joined the staff of Junior King's in Cornwall for the duration of the war, expressed similar concerns. And as if to confirm their reports, John Shirley himself was given to remorseful introspections about his own shortcomings. In a long confessional letter to Hewlett Johnson in the spring of 1943 he poured out his soul in a remarkably candid way.

> The fact is I am 53, and for the last two years have thought harder
> than ever before – realising that not long was left to me to do all I
> might for the Kingdom – to atone, as far as humans can, for the evil
> of past sin before I must face the judgment seat of God. That thought,
> praise be, is now seldom absent from me: and I am happier than ever

in my life I have been – though a few years back I was just sick with despair and longed to put an end to life. ... I have been such a curious person, and in many ways until recent years, I have remained a child, with all the self-will of a child. Though my mother was a saint, the whole atmosphere in which I was brought up was calculated to put before you the importance of *money*, and the utilisation of every person and circumstance to its acquisition. ... And then I went to the High School, and suffered *Hell*. Then to the University, in the same town [Oxford], and living in a humble home. All my native tendencies to shyness, sensitivity, and so on were multiplied a hundredfold. Those three years brought me plenty of agony of mind and no pleasures. I became utterly self-conscious. I think this is important as helping to explain my ruthlessness and my beastliness when later in life I was successful. I know it was all my fault, my grievous fault, but I am sure that poverty was at the root of it. ... How I loathe the memory of some things – for years I lived in despair, but not now. ... Jesus died for me, and though *I* can't do anything to remove the guilty consequences of sin, He can and does. ... This has been some attempt to give you a picture of me: up to 44, a Peter Pan, a Jekyll and Hyde; since then, by the mercy of God, a more unified personality, adult, longing to know more of the power of Christ in me, grateful for what I have, a little fearful of the hereafter.[32]

There is no record of Hewlett Johnson's reply to John Shirley, but the letter may merely have reinforced the Dean's view of Shirley as someone to be treated with great care. He had seen it all before: in 1941 he had told Nowell that 'Shirley has written effusively asking to bury the hatchet. ... He's in a pious phase at the moment. ... Alas that one cannot trust him.'[33] And a few months after his confessional epistle, in December 1943, Shirley preached a sermon in the Cathedral that seemed to Johnson not only to tap into the unhealthy strand of personal sinfulness that had pervaded his letter but also to preach an outmoded message that Johnson himself had long since rejected.

Shirley preached this morning: very vehement, very orthodox – the sacrifice of Christ, the nature and depth of our sins, etc etc. It did not come well from him, somehow, nor in that old form. I feel that they have much to learn – that there is truth in the fundamental ideas about Christianity and sin etc but *not* as they see it. I held those views once: they do not hold me today. I feel a new and perhaps deeper sense of the

thing that was once differently said. And all their tilts against progress and the insufficiency of social betterment nauseates me.[34]

* * *

Hewlett Johnson's personal relationship with the Archdeacon of Canterbury, Thomas Sopwith, was altogether more congenial than his dealings with either John Crum or John Shirley. The two had many superficial similarities, each upholding an image of clerical correctness, not least in matters of dress, which the war was rapidly rendering anachronistic. Lois Lang-Sims, who knew both the Dean and the Archdeacon well, described Sopwith as a character straight out of *Barchester Towers*.

> Portly and impeccable, he appeared invariably not only in full archdiaconal rig, but with his gasmask slung over his shoulder in a polished case, and his stately gait assisted by a cane which had to be ceremoniously removed from one white-gloved hand to the other each time he acknowledged a lady in the street.[35]

Though poles apart politically, Sopwith was probably Hewlett Johnson's most loyal colleague in the early wartime Chapter, and they evidently enjoyed each other's company. He was, the Dean remarked, 'most affable' and a generous host.[36] It was a mild disappointment to Johnson when Sopwith retired in 1942; but there was a silver lining to the cloud in the shape of Julian Bickersteth, who succeeded Alex Sargent as Archdeacon of Maidstone when Sargent was promoted to the Archdeaconry of Canterbury in Sopwith's place. Bickersteth's arrival in the precincts in the autumn of 1942 was welcomed by Johnson who saw him as 'much more alive' than the other canons.[37] He was, Johnson thought, a great addition to the Chapter, and since he had not been present to sign the letter to *The Times* in 1940, he arrived with no backlog of grievances. Johnson also admired Bickersteth's sense of style, praising his 'great taste' and admiring the French impressionist paintings with which he adorned his rooms.[38]

Yet for all his personal and collegial acceptability to Hewlett Johnson, Julian Bickersteth stood within a theistic tradition of Christian belief that Johnson had largely left behind. God, so the tradition went, was a transcendent being, wholly separate from the world he had created yet immanent within it through the actions of those who believed in him and in the sacrificial death of his son. For most orthodox believers, the confessional acceptance of such a God lay at the very heart of Christianity. Indeed, it probably defined what Christianity actually was: you could not be a proper

Christian unless you accepted the church's dogmatic teaching about a God who 'really' existed and who saved his people through their faith in the death and resurrection of his only-begotten son. Of course, those who held these beliefs would also want to express their faith through the goodness of their lives; but, especially in the Protestant tradition, good works without an antecedent belief in a saving God was not Christianity – and it shouldn't be passed off as though it were. Least of all by clergymen who should know better.

It was here that Hewlett Johnson's theology was at odds with that of Julian Bickersteth. Writing to Nowell in November 1943 he told her about a lunchtime conversation he had recently had with the Archdeacon.

> He [Bickersteth] thinks my humanitarianism is wrong. He can't understand that, to me, serving God and serving man are two aspects of one thing. God is to me the root of all life and all reality. To seek to know the nature of things is to seek God, and it leads to the worship of Him as we see how marvellous it all is. To seek to know the real nature of the relationship of human beings to one another is also to seek to know God, for that too leads to worship as we see the outworking of it in a new civilisation such as Russia is. The Chapter can't get away from the idea of [God as] a BIG PERSON on a throne.[39]

As Hewlett Johnson implied in this letter, other members of the Chapter also inhabited the same theological world as Julian Bickersteth – and they too aroused a critical reaction from the Dean. When, for example, the Anglo-Soviet Alliance was signed in July 1941, Hewlett Johnson was ecstatic; and at the eight o'clock service on the following day he pointedly said prayers for Britain's newest ally, Russia. At the ten-thirty service, however, John Crum and Frederick MacNutt utterly failed in Johnson's eyes to grasp the religious significance of the moment. The Dean complained bitterly to Nowell that Crum had had nothing to say about Russia in the intercessory prayers, opting instead to pray for the purity of Canterbury and the safety of its Cathedral.

> What profanity. Praying for stones in one small part of the world, while the greatest battle in history, with our own fate and that of Russia and the world hanging in the balance, was never mentioned.[40]

Frederick MacNutt had then preached a long sermon aimed entirely at 'humanitarians with their utterly unchristian and unreligious basis' whose

neglect of the supernatural power of God to change the world was at the bottom of the present troubles. 'I try to keep my faith in God', Johnson wrote to Nowell, 'but it is not *their* God. I feel sure of that. ... I'm glad you did not hear the sermon: it was so pointed you would have exploded. I sat back with my eyes shut and entirely motionless.'

* * *

Hewlett Johnson's comments to Nowell on the theological position of his colleagues take us somewhere near the heart of his conflict with the Chapter. There were personality differences, certainly. There were professional differences over the governance of the Cathedral and the steps to be taken to prepare the building for the exigencies of war. There were deep political disagreements over Johnson's uncritical belief in the righteousness of communism. There was dismay at the unwelcome publicity that his pronouncements about the Soviet Union brought to Canterbury. There were all of these things. But never far from any of them was a clash of theological perspective that pitted belief against action, personal piety against community engagement, dogma against humanitarianism, and personal salvation against social justice.

Hewlett Johnson's most systematic attempt to merge his political and theological views came in his book *Christians and Communism*, published in 1956 when he was eighty-two and still had seven more years to serve as Dean of Canterbury.[41] Based on fifteen sermons preached in the Cathedral, the book was 'born out of forty years of study of the unique movement which unfolds itself before our eyes in the Soviet world'.[42] It was published at a difficult time for those who believed in the Soviet experiment, for 1956 was the year both of the Hungarian uprising and of Nikita Khrushchev's savage denunciation of Stalin and all his works. Unsurprisingly, then, *Christians and Communism* fared much worse in Britain than in the Soviet Union where it was translated into Russian and reportedly sold out in Moscow within hours of its release. As with *The Socialist Sixth of the World* twenty years earlier, the hand of VOKS may have been at work here alongside the hand of God. The Patriarch of Smolensk told Hewlett Johnson at the Lambeth Conference in 1958 that the book had been of such value to the Orthodox Church in Russia that he had given a copy to every priest in his diocese.[43]

Although there was little in *Christians and Communism* that had not appeared elsewhere, it offered the clearest indication of the theological gulf that had grown up between Hewlett Johnson and his colleagues. Each sermon in the book began with a quote from the Bible, usually the words

of Jesus, which defined the Christian approach to the theme. Thus, the sermon on wealth opened with Jesus' striking metaphor about the camel and the eye of the needle; the sermon on conscience and freedom with his words about the due rendering of the things that are Caesar's and the things that are God's; and so on. There typically then came a brief account of how and why western capitalism had failed to measure up to the challenge of Jesus, followed by a brief presentation of evidence about the Soviet Union purporting to show that it was actually far closer than any of the western nations to the kingdom of God on earth. Each sermon typically closed with the assertion that there were few fundamental differences between communist nations striving to attain Jesus' vision of the just society and the kind of Christianity that remained true to the teachings of Jesus. Communists and right-minded Christians were singing from the same hymn sheet – even if some were chanting the words of the 'Red Flag' and others were singing 'O come all ye faithful'. The most striking difference was that the communists were singing far more lustily than the Christians.

The gospel text that perhaps best summarised the central theme of *Christians and Communism* was one that Hewlett Johnson himself identified as central to his thinking: 'You will recognise them by the fruits they bear.'[44] Those who tried to follow the moral precepts of Jesus would be recognised by what they did, for they were closer to the heart of Christianity than those who declaimed their faith in loud words and extravagant gestures but did nothing to help the poor and the needy. So far so uncontroversial. Jesus himself had said as much: 'Not everyone who calls me "Lord, Lord" will enter the kingdom of Heaven, but only those who do the will of my Father.'[45] But Hewlett Johnson extended the argument by applying it to the fruits of political as well as personal action. If, as he believed, the earthly kingdom of God would be a community of equality and mutuality, then for all their faults and failings, the communist states of eastern Europe were nearer that kingdom than the capitalist nations of the West with their gross disparities between rich and poor, their avid protection of privilege, their exploitation of labour in the name of profit, their persecution of ethnic minorities, and so on.

Insult was added to theological injury for orthodox believers when Hewlett Johnson actually claimed support for the principles of communism in the teaching of Jesus.[46] Having defined communism, conventionally, as 'from each according to his ability, to each according to his need', he proceeded in *Christians and Communism* to trace its origins back to the New Testament. The parable of the talents, he argued, signalled Jesus' endorsement of 'from each according to his ability'; the parable of the

labourers in the vineyard bestowed divine approval on 'to each according to his need'; and the miracle of the feeding of the five thousand could reassure believers that they had nothing to fear from a centrally planned economy. Creative theology it may have been, but from Johnson's viewpoint it was not particularly radical. 'Communism', he once wrote, 'fits in with the kind of God we see in the gospels. No father could bear to see his children on one side of the table overfed while the others were hungry. Nor could he tolerate a selfish scramble.'[47]

* * *

It is not difficult to see why Hewlett Johnson laid himself open to attack by the more orthodox factions in the Church of England. However popular his views may have been with the general public (among many of whom he was seen to be far closer to the true spirit of Jesus than most other high-profile clerics) he was largely shunned by the Anglican hierarchy. In some ways this is surprising, for Johnson's views had perfectly respectable antecedents in the liberal Protestant theology of the eighteenth and nineteenth centuries, especially the writings of German theologians of the stature of Friedrich Schleiermacher, David Strauss, Albrecht Ritschl and Adolph von Harnack. His position also had recognisable connections with the writings of his more celebrated twentieth-century contemporaries Albert Schweitzer, Rudolf Bultmann and Dietrich Bonhoeffer. But however much the scholars enthused about it, liberal theology in the middle of the twentieth century was rarely preached from the pulpit. It may have been safe for seminarians but it was dangerous for congregations. Mainstream theology in Europe, studiously trying to avoid the extremes of liberalism on the one hand and American fundamentalism on the other, was dominated by the orthodoxy of Karl Barth; and while Johnson had nothing to say directly about Barth's theology, he had little time for one of his main expositors in America, Reinhold Niebuhr. In a letter to Nowell in July 1944 Johnson remarked that his recent reading of Niebuhr was leading him to fundamentally different conclusions to those of his colleagues on the Chapter.

> I dislike him [Niebuhr], but Joseph Poole [the precentor] and the others swear by him. I feel he is a buttress to them in anti-social things. The gist [of Niebuhr's theology] is that man is sinful – needs outside help – can't do things for himself. This is pessimistic – and while we're waiting for God, Russia is *doing* it.[48]

Hewlett Johnson's language here – albeit in a private letter to his wife – is slippery. On one reading, it associates him with a kind of Christian humanism in which mankind, through its own endeavours, can build the kingdom of God on earth without much help from an outside deity. While the Christian West was waiting for a transcendent God to usher in his kingdom on earth, Johnson seemed to be saying, the supposedly godless Soviets were steaming ahead and doing it for themselves. To the extent that he really did embrace such views, he was plainly distancing himself from those beliefs about God that must have seemed to many in the Church of England as the minimum requirement for an Anglican priest. Many of his critics, of course, tried to paint him into just such a corner; and having got him there, they could then dismiss him as a hypocrite in a clerical collar who no longer believed in a transcendent God.

Yet Hewlett Johnson's writings reveal a rather more subtle position than this. It is true that he eventually grew out of a literal belief in many of the church's ancient dogmas and he increasingly read the Bible as poetry and myth rather than history, but there is ample evidence in both his public writing and his private letters of a deeply held personal belief in God as a gracious and providential presence in the world. 'One can only leave it all in God's hands,' he wrote to Nowell in the depths of the war, 'and that is what I do or try to do. Prayer should be asking for God's wisdom and strength to overcome all difficulties – to know the right road and courageously take it.'[49] And Johnson also had a profound belief in Jesus as the revelation of this providential God of grace: indeed, a recurrent complaint against his more orthodox colleagues was precisely that they had largely forgotten the Jesus of the gospels, ignoring his teaching about righteous living and turning him instead into a divine object of worship that bore little relationship to the earthly man. Jesus said 'follow me'; he did not say 'worship me'. The real believers, Johnson argued, were those who thought it more fitting to follow Jesus than to worship him even if it led them to question the dogmas with which the ages had encrusted him.

> To me the tragedy is that the orthodox who give Christ so exalted a place don't heed His words and they condone things which He could not tolerate, while those who keep Him on a more human level or who leave Him on one side altogether, *are* doing his commands.[50]

Having fashioned this liberal theological shaft and honed its arrowhead, there was no shortage of clerical targets in the wartime precincts at which to aim it. Few of the Dean's colleagues escaped his private criticism as they

ploughed their scholastic furrows at right angles to his own trenchant pursuit of the 'social gospel'. Where they saw doctrine and dogma, he saw engagement and empathy. Having sat through a sermon by John Shirley on sacrifice and atonement, Johnson concluded that he had 'failed to see *inside* these things', preferring instead to remain in the safer territory of religious jargon.[51] On another occasion he had to put up with 'a long anti-human-ist tirade' from Frederick MacNutt. 'His voice was so loud', Johnson complained to Nowell, 'that I could neither sleep nor read an interesting book which I had taken with me as a precaution.'[52] Even the Dean's more sympathetic colleagues in the precincts, Julian Bickersteth and Frances Temple (the Archbishop's wife), were not entirely out of his sights.

> A new era of piety is beginning at the Cathedral. Good in some ways, but I'm not *wholly* pleased: it's still rather anti-humanistic. There's much preaching about personal prayer and public prayer in the Cathe-dral. ... The new era is led by people who are good and nice like Bick-ersteth and Mrs Temple [the Archbishop's wife]. I don't *wholly* like it, though it has its good points: it's apt to switch the struggle and it has its dangerously anti-social side. I could have been so much in it 10 or 15 years ago. Now, I want to retain elements of it, but I've passed on to something bigger.[53]

Yet the arrows of theological criticism by no means flew in one direction only: Hewlett Johnson's colleagues were good at finding ways of getting their own back.

> The Diocesan Conference was hateful to me yesterday. Dr Welch of the BBC, director of religious talks, said everything to delight the mass of clergy – the Archdeacon [Alex Sargent] and Joseph Poole [the precentor] especially – saying how they avoided mere humanitarianism and spoke mainly where they could of God, the human tragedy of sin etc. The *gospel* of human tragedy and sin!! I boiled and *looked* as cool as a cucumber.[54]

LIFE IN THE
WARTIME DEANERY

H EWLETT AND NOWELL Johnson's first child, Mary Kezia,[1] was born in the deanery in March 1940 and christened two months later on Saturday 18 May. Following the baptism, the parents and godparents gathered in the deanery garden for photographs and tea.[2] It may not be too much to describe this little party as the end of an era, for even as it was taking place arrangements were in hand for a large-scale evacuation of Canterbury. On the previous day the city had been declared a 'neutral zone' and children who had earlier been brought there from the threatened towns of Rochester and Gillingham were told they would have to move again to safer places elsewhere.[3] Two days later they left Canterbury for South Wales, followed almost immediately by the boys of the King's School as they moved to their wartime home at Carlyon Bay, near St Austell in Cornwall.[4] They were soon joined by the boarding choristers of the Choir School, which became a part of Junior King's for the duration of the war.[5]

Hewlett and Nowell Johnson now had to face the question of their own future. The Dean had no intention of leaving Canterbury, but it was quite another matter for Nowell and Kezia to stay with him. After a brief but increasingly unsafe spell in Johnson's house at Charing, just outside Canterbury, they moved to Llys Tanwg, a large Edwardian house that Johnson had bought in 1933 with money inherited from his first wife Mary. Llys Tanwg stands on high ground a mile or two south of Harlech and commands spectacular views across Cardigan Bay to the Lleyn peninsular. Accompanying Nowell and Kezia to Harlech were Fred and Elsie Crowe and their two daughters, Mary and Margaret. Others joined them as the war progressed. The Crowes had met through the congregation at St Margaret's Altrincham when Hewlett Johnson was vicar, and after their marriage they became his employees – Fred as his gardener and handyman and Elsie as his secretary.[6] In 1931 they moved from Manchester to Canterbury with the new Dean and remained close to him until his death in 1966. Elsie stayed with Nowell throughout the war but Fred often travelled

between Llys Tanwg and the deanery, sometimes driving the Dean's car loaded with food and other provisions.

Apart from short trips and occasional holidays away from Harlech, Nowell, Kezia and (following her birth in March 1942) Keren spent the entire war there, not returning to Kent until October 1944. Hewlett Johnson remained at the deanery in Canterbury. It pained him deeply that, apart from brief visits to Harlech, he was able to see so little of his only two children's early months and years, and he cursed the war that separated them from him. Neither Llys Tanwg nor the deanery had a telephone until late in the war, but (happily for posterity) the many hundreds of letters that passed between them have survived in the archive to furnish a remarkable record not only of the Dean's life in Canterbury throughout the war but also of the way in which he and Nowell coped with their enforced separation. They give a new insight into Hewlett Johnson's private persona.

* * *

As the war progressed, the deanery became home to an assorted and ever-changing group of residents. Among them in the early days were Alfred D'Eye, the Reverend Joseph Poole and the Reverend Geoffrey Keable.[7] Poole was the gifted but aloof and slightly mysterious precentor of the Cathedral; Keable was the socialist vicar of St George's, the city-centre church of which only the clock tower survived a raid in 1942. Alfred D'Eye, about whom the suspicion has never been entirely dispelled that he may have been a Soviet agent,[8] was an altogether more substantial figure in Hewlett Johnson's life. Hating his Christian name and refusing ever to use it, he was always referred to simply as D'Eye. Twenty-four years younger than Johnson, he was his mentor and companion for almost three decades, accompanying the Dean on many of his visits abroad, staying in the bomb-damaged deanery throughout much of the war, assisting him with his books and pamphlets, and advising him on what he should say in his talks and sermons. D'Eye first came to Johnson's attention in the early 1930s when he was taking adult education classes in politics and economics for the Oxford University Delegacy in Kent. An Oxford graduate, he had an encyclopaedic knowledge of his subject and was an impressively perceptive commentator on international affairs. Johnson immediately saw in him something that he himself lacked – the capacity to articulate a theoretical justification of the things he had long been saying about the evils of capitalism. D'Eye soon became a regular guest at the deanery where his pronouncements fell on very receptive ground.

Alfred D'Eye could, when he wished, be a man of great charm, but he also comes across as a prickly character who did little to endear himself to those with whom he worked. Victor Gollancz was intensely irritated by him, describing him as 'cocksure' and 'lecturing'.[9] Even Hewlett Johnson lost patience with him from time to time, especially in the tense and difficult atmosphere of the wartime deanery.[10] In 1942 he wrote to Nowell:

> D'Eye does put people off frightfully with his manner. It's alright when he's with students and people who know less and want to learn from him, but with his equals he *is* awkward and they don't like it. … He simply must be right over everything, and must force his opinions on people.[11]

For the most part, though, the two men were good companions as well as fruitful collaborators, and as the war progressed D'Eye became increasingly indispensable to Johnson, helping him not only with his preaching and writing but also with practical chores around the deanery and in his house at Charing. Johnson never ceased to be amazed at D'Eye's skill in reading the political runes, and he came to rely on him for many of his own views about the war and its aftermath. Yet for all his influence on Hewlett Johnson, Alfred D'Eye remains a shadowy figure, always in the background but rarely stepping into the limelight. Local gossip, which cannot be referenced and must therefore be taken for what it is, regarded D'Eye as a Svengali-type figure who had insinuated himself into the Dean's household for political purposes.

The security services also harboured their suspicions about Alfred D'Eye, for like the Dean, he too was tracked by them. According to a report in the National Archives, he spoke at a meeting of the Anglo-Soviet Council in Plymouth in October 1943 when he told the audience that he had 'spent the greater part of his life in Moscow'.[12] Whatever the truth about D'Eye's connections with Moscow, he was explicitly pro-communist in his views, even to the extent of addressing Hewlett Johnson on one occasion as 'Dear Comrade Dean'.[13] D'Eye was also fiercely protective of Hewlett Johnson's position as Dean of Canterbury, defending him against the various attempts that were engineered to get rid of him. When Archbishop Geoffrey Fisher demanded the Dean's resignation in November 1948, D'Eye made his views trenchantly clear, describing Fisher's action as a 'stab in the back'.[14] And when the governors of the King's School tried to oust Johnson as Chairman of the Governing Body in the mid-1950s, D'Eye saw it as 'just another of the attempts to make life uncomfortable for

you and to drive you out. On the point of principle I should say "no surren-
der".'[15] Was this merely an expression of comradeship or was D'Eye trying
to prevent one of the most effective voices of Soviet propaganda in the
West from being silenced?

* * *

As well as the resident men, several women worked in the deanery from
time to time throughout the war. They included Mrs County and Miss
Freda Watson,[16] both of whom acted at various times as cook and house-
keeper, and Miss Lily Wraight. Mrs Easton also worked at the deanery
from time to time as a general helper. To begin with, in 1940, the women
gave satisfactory service. Hewlett wrote to Nowell at Llys Tanwg:

> All goes well. Mrs County is quite good and Lily excellent. Everything
> is nicely done. I try to save Lily by having tea etc in the dining room.
> … The maids look after us well. Mrs County looks after me *splen-
> didly*, likes to be alone and polishes and cleans up all Lily's jobs. I'm
> in clover.[17]

In May 1942, shortly after the birth of his second daughter Keren, Hewlett
Johnson thought of moving either Freda or Lily to Llys Tanwg to provide
an extra pair of hands for Nowell. It was Lily who eventually went with
the instruction that Nowell could 'keep her as long as you like'.[18] Lily was
temporarily replaced in the deanery in the summer of 1942 by Miss Rosalie
Gamble, a young woman whom Hewlett Johnson had met – and plainly
been entranced by – on Whit Sunday.

> Yesterday went well. I was tired with many services. A Dean's grand-
> daughter who was present said, in speaking afterwards, that what she
> liked was my voice and my walk!! The granddaughter was a Miss
> Gamble whose grandfather was Dean of Exeter. I remember him. Her
> father is a Harley Street doctor: her other grandfather, Dr Fleming,
> was sometime Canon of Westminster. She is engaged to a doctor and
> is a poet and vivacious.[19]

Rosalie Gamble soon found herself working at the deanery, much to
Hewlett Johnson's delight. Writing enthusiastically to Nowell, he said that:

> She treats me like her Decanal grandfather and is mending all my
> clothes, gaiters, coats, cassocks. Splendid and swift with a needle. …

She is so extraordinarily good at housework. ... She mended and arranged all my clothes and washed things and sorted the rooms, all without being asked.[20]

Later, as the war progressed, Johnson had reason to be less pleased with the services of his staff, and only Freda Morton and Fred Crowe were still with him by the end of 1944. It was the cook, Mrs County, who was the first to test Hewlett Johnson's patience to breaking point. The issue between them may now seem trivial, but to a tense household thrown together in unnatural circumstances and struggling to cope with the privations of war, it was seen by Johnson as something that could not be allowed to pass unchallenged.

I had to give Mrs County a bit of my mind in a friendly way this morning. The porridge has been getting more and more like baby's gruel. I told her so and she said well, Mr Crowe did not like the other porridge and so she has to make it thinner and take the thick top off for him. I informed her that I was the boss of this home. She very meekly said 'oh yes'. I was rather vexed also on Saturday morning, when they knew I was going for a long and early ride in the car, to find a very diminutive egg in my eggcup, and when I went into the kitchen to get something, there was a very huge one in Fred's eggcup.[21]

By the autumn of 1941 the relationship between the Dean and Mrs County had deteriorated further.

Mrs C said this morning: 'I am thinking of leaving you – I can't face the cold in this kitchen and I hear all sorts of rumours in the town that I am not feeding you properly.' I don't care two hoots whether she goes or not and certainly shall not try to stop her. Indeed in some respects I shall be glad if she goes. D'Eye too. But I told her to take no heed of what the town says – just listen to me, as it's my food.[22]

A few weeks later the die was cast. 'I've decided that Mrs C must go', Hewlett wrote to Nowell. 'I shall never feel happy with her about the house. There is too much loose and easily portable stuff around and her boy now comes in every day for a meal. It's not satisfactory, and she has not been cooking so well that we shall miss her.'[23] After Mrs County's departure the cooking was done by the estimable Freda Morton – who, as well as her ability to conjure up tasty meals from unpromising ingredients,

gathered and arranged flowers for the deanery,[24] brightened up the kitchen
with colourful table cloths,[25] reprimanded children caught scrumping
apples from the deanery garden,[26] bandaged Johnson's hand when he
scrapped some skin from it while gardening,[27] grew marvellous radishes
and delicious broccoli,[28] and monitored the Dean's use of his ration
books.[29] For all of this she was paid £1 a week, rising to £1 2s 6d in Decem-
ber 1942. 'She deserves it,' Johnson informed Nowell, 'and maids' wages
are low'.[30]

* * *

By October 1940, a mere five months after Kezia's christening, the precincts
had become a place of desolation and destruction for those who were left
behind, and in that month the deanery itself was badly damaged by a
German bomb. Hewlett Johnson described the moment in his autobiography.

> Whilst we sat at lunch one day, the Deanery was dive-bombed. Hear-
> ing the sound of a bomb descending directly above us, Keable, D'Eye,
> Poole, Freda and the cook and I rushed down into the old vaulted base-
> ment pantry. There was a terrific crash, the walls rocked like a ship in
> a rough sea and settled again. ... The immensely thick walls of the
> front façade of the Deanery had fallen into a huge crater by the front
> door, which embraced the whole of the semi-circular drive. ... All the
> windows were blown out, even in the tower, and the winter gales and
> the dust and dirt from the rubble blew through the shattered house for
> month after month.[31]

A photograph in the *Kent Messenger* showed the house with most of the
windows blown out and a hole from the eaves to the ground between the
old buttresses and the porch. Much of the stucco had been blown off the
brickwork and a large pile of rubble lay in the driveway.[32] For Nowell,
three hundred miles away in Harlech, the news was deeply distressing, the
more so as she was unable to do anything to help or comfort her husband.

> How awful the news is of your narrow escape and the poor old Dean-
> ery. It was awfully good of you to have wired for I saw a notice of it
> in *The Times* and should have been very anxious. I'm awfully glad the
> damage in the house isn't as bad as it might have been. What is left, I
> wonder? Are the kitchens alright? ... Is the building safe? Oh dear,
> how I wish I could just be with you a bit, though I'm sure you'll be
> making the very best of a bad job and looking after everybody else

into the bargain. One hardly likes being here in all this peace and security when you are in the midst of discomfort and danger.[33]

A week later Nowell wrote of the yearning regret she was feeling for a half-mystical life now lost and, perhaps, never to be regained.

> It's Sunday night and we've just turned on Myra Hess on the wireless. She's played a beautiful thing – Bach, I think. And it's brought the Deanery back – our lovely, lovely old drawing room, the evening light, the soft drawn curtains, the lovely colours, all the exquisite beauty of it. And I can hardly believe it has gone. Now she is playing Beethoven. How it brings the old days back – I wonder, shall we ever build it up again? What a strange, lovely life it was, looking back. How soft, how sweet, the garden, the evening sun. One can hardly bear to think of its sweetness now. Where are you now, I wonder? Listening also to music, so gallantly, in a patched up room, or sheltering in the crypt? Beethoven playing now; he seems to stand for it all – the old loveliness, scents and sounds, the glorious old house, the being with the one loved. ... And yet also this grimmer, sterner life where courage and belief are needed.'[34]

In his bomb-damaged deanery Hewlett Johnson also reflected upon the life they had once led – less romantically than his wife, perhaps, but with more hope and optimism. In May 1941 he wrote to Nowell:

> As I left the mowing machine for lunch ... with the sun pouring on the lovely mass of flowers now in the garden, I recollected the time when there was no war and no canonical troubles and all the little Crums [the children of Canon John Crum] clustered around, and May was fresh and young ... and life pretty and smiling, and then contrasted it with *now* – and I would not change it for worlds! For at the other end of 320 miles is wifie and Kez[ia], and though the hateful war separates us so much, I'm the happiest man in the world! So there!![35]

A year later, in June 1942, Canterbury was again the target of German raids, and a great deal of damage was done within the precincts. On this occasion the deanery, still showing all the scars of the earlier raid, escaped unharmed; but the large firebombs were now a serious threat and Hewlett Johnson was taking no chances. Writing to Nowell on 8 June 1942 he reported that:

I got carpets and furniture downstairs. Cut the drawing room carpet into three or four pieces and got it down to the hall. The same with our green bedroom furniture and the Turkish and the best bed together with the nice Chippendale settee, the chairs and tables into the crypt, the little bookcases out of the drawing room ... into the hall where they can be quickly dragged out in case of fire. A long and tiring job but worth it.[36]

By now life in the deanery had become rather basic.

The dirt would distract you. No baths yet and no WC. Drain probably ruptured. So we must use the garden or public lavatories. I never clean. But the skies are peaceful and I think it is over for the present. ... Now we are rapidly clearing up as much as possible and blacking out windows to keep the weather out. The Deanery is nearly dark. Pig it as I do and don't worry. Smile! ... We are a shabby lot. I've been keeping warm with rugs and hot water bottles. It's rather fun. ... I *like* being shabby![37]

* * *

Following the extensive damage to the deanery in October 1940 the house became a bleak abode for those who were living there. Little was done by way of temporary repairs, and it was left to some hastily fastened tarpaulins to provide a degree of weatherproofing. They offered at best a partial protection against the rain and only a little against the dust and debris that blew through the house in the wake of the air raids. Blackout material was used to patch up many of the broken windows, sometimes to the obvious delight of Hewlett Johnson who revelled in the improvisations he was able to concoct.

I've fitted a blind in the staircase window. As material was so expensive I sewed two rings on my Oxford gown and it hooks up as a splendid blackout – the gown only cost a few shillings many years ago.[38]

The partial openness of the deanery to the elements, together with the unreliability of its electricity supply, also exposed the residents to the bitterly cold winters that were a feature of the war years. Though Hewlett Johnson was quite untroubled by the freezing temperatures, others were less hardy, and the cook, Mrs County, was finally unable to tolerate the cold in the kitchen.[39] Even the redoubtable Freda Morton was daunted by the

squalor of the house. 'Freda looked in with a bag to stay the night – she saw the place and fled. Scared, I think. It does look eerie here at night, perhaps.'[40] Impervious though Johnson himself was to the conditions in which he had to live, others in the precincts were concerned on his behalf – though without avail.

> The Archdeacon of Maidstone said that he wanted to speak privately to me in the vestry. 'You were all very good to me in putting me into a new house; we want to do the same for you – your house is terrible this winter.' I assured him I was quite happy and comfortable where I was.[41]

Indeed, so happy was he that when the water supply failed in the depth of winter in 1941, he delighted in an alternative arrangement.

> It is still very cold and very snowy here. I could not get my cold bath so ran down in the dark to the garden and had a snow bathe – but the snow was so dry and powdery it took a lot of rubbing on my body before it melted: it was like flour. ... Palmer caught me at my snow bath this morning as he went early to work: I told him he has seen more of the Dean than anyone in Canterbury![42]

After the bombing of the deanery in October 1940 Johnson requisitioned one of the few undamaged rooms in the house and used it as his bedroom, sitting room, reception room and study for the remainder of the war. In January 1941 he had a second-hand stove fitted, and with the cheerful addition of Freda's flower arrangements he was able to tell Nowell that his room was 'very nice'.[43] Much of the rest of the deanery, however, was 'desolate'[44] and Johnson resorted to some basic expedients to keep himself warm as he wandered around the huge house.

> I'm rather like a milk lass – I go from room to room with a shawl over my head. ... Today to save fuel I sit with my homemade blanket shawl on, with my feet on a hot water bottle and with a rug over my knees. ... I've been keeping warm with rugs and hot water bottles. It's rather fun. ... I've got myself a big pair of clogs. What a clatter we shall make when we do the clog dance together.[45]

Yet however indifferent Hewlett Johnson may have been to his own well-being, he could not do enough to ease the lot of the other less hardy residents in the deanery. He had the windows repaired in Geoffrey Keable's

room when he complained of the cold,[46] and when Joseph Poole fell ill with flu, Johnson moved him to a room in the attic where he rigged up an extravagant system of radiant heaters. 'There I lay', said Poole in one of his reminiscences, 'and roasted and sweated and it was all sort of Heath Robinson, but done with the utmost kindness of heart.'[47]

* * *

Mealtimes were among the highlights of the wartime deanery, and although Hewlett Johnson could never be described as a gourmet, he appreciated healthy food and was always ready to extol its virtues. At the end of a meal he was not above eating grated raw carrots while pontificating about their health-giving properties, and he sent Nowell details of the menus he was savouring.

> My breakfast today. 1. Masses of porridge and milk and cream and treacle. 2. Bacon and fried toast. 3. Wholemeal bread. 4. Two lettuces. 5. A bowl full of stewed rhubarb with sugar and milk!!!![48]

> [Freda Morton] made pancakes and lovely plates of winter salad. Shredded carrots, turnips, Brussels sprouts all arranged light and feathery and cut in very fine strips, and then beans, nuts and apples. Such a meal. We had much laughter and I provided a glass of sherry each. I think I overdid it slightly so I did not get up [for the 8 o'clock service].[49]

> We had a calf's head, cooked whole, yesterday and it was very good. It makes lovely soup and jelly from the water in which it is boiled. We also drink – at times – the water in which the vegetables are boiled: it is good and good for one.[50]

Supplements were added to the diet when necessary. 'Being slightly constipated – perhaps because so little green stuff and fruit – I tried some bran. It acted as a most powerful purgative and I only took about 6 spoonsful a day!'[51] And there was also the occasional meal out. In October 1941 Johnson, D'Eye and Lily Wraight had an 'excellent' three-course lunch at the Parry Hall for 9d each,[52] and on Christmas Day that year Johnson ate lunch alone at a British Restaurant. 'I'm never devoted to Xmas dinners', he explained to Nowell beforehand, 'and I shall be glad to be alone and get an opportunity to work.'[53]

The deanery garden, in which Hewlett Johnson spent most of what leisure time he had, provided fruit and vegetables for much of the year

including potatoes, beans, spring onions, lettuces, rhubarb, plums, black-berries, mulberries, cherries, pears, raspberries, radishes and watercress. Throughout the war he sent regular parcels of fruit and vegetables through the post to Nowell and the other residents at Llys Tanwg. They included not only such obvious items as apples and pears but also lettuces, water-cress (which he urged his daughters to eat crushed up in a sandwich),[54] raspberries, cherries and plums. Flowers were also sent through the post and on one occasion half a tongue. 'Mrs County ought not to have got [the tongue] – she will be surprised when she sees it has gone.'[55] The food parcels mostly arrived at Harlech intact, but when the post was delayed or the packaging weak, the contents could be inedible. Nowell never complained; she merely suggested that perhaps it would not be a good idea to send such well-ripened fruit again.

On one occasion Nowell sent fresh eggs from the Llys Tanwg chickens to the deanery. Hewlett Johnson had asked for them to aid the recovery of Mr Kitney, a Cathedral gardener; but Kitney's condition deteriorated and he was admitted to hospital. Johnson, with a typical lack of self-regard, felt guilty about eating the eggs himself and returned them to Llys Tanwg wrapped up in one of the clogs he had bought to warm his feet. Nowell was furious.

> I was *awfully* disappointed to get the eggs back this morning, one broken too. It made me quite cross! They were meant for all of you, and it was giving me such pleasure to think the hens would be useful at both ends. We have many more eggs than we need, and I could easily send half a dozen a week. Well, I must talk to you about it, but if you knew what pleasure it was to send eggs to 'Daddy', with Kezia helping me, you'd keep them.[56]

Johnson was only mildly contrite. 'I'm sorry I tripped up over the eggs,' he wrote. 'I did not mind asking for them for a sick man [but] I could not bear to eat them myself. The children need them: I don't. And I seem to be able to do so little for you all. That's why I sent them back.'[57] Nowell retali-ated by sending more eggs in the clog. It proved to be a mixed blessing.

> Your two parcels have come. What a joy! ... The clog also arrived awash, alas, with broken eggs. Freda has washed it carefully out and saved the yoke of one egg. I'm so sorry. But I still have the two first eggs which K[itney] could not have, so that will finely suffice.[58]

* * *

Entertaining at Christmas was a perennial wartime problem for Hewlett Johnson, partly no doubt because it reminded him, with a sharpness that must have cut deep, of what he was missing with his family. But seasonal festivities were not entirely abandoned: Christmas 1942, for example, was an altogether more sociable occasion when Johnson laid on a party for twenty-four choristers and their parents. Two of the boys – twins who lived at Whitstable and could not easily travel to Canterbury for the Christmas services – stayed in the deanery for three nights.[59] On Christmas Day the Archbishop's wife, Frances Temple, insisted that Johnson and the twins join her and her husband in the Old Palace. It turned out to be rather better than expected and yielded some comic moments when the twins discovered that Mrs Temple called her husband 'Bill' and then mistook the Archbishop's secretary, Miss Sinker, for the wife of the bachelor Archdeacon of Canterbury, Alex Sargent.[60] The party for the choristers and their parents a few days later passed off to Hewlett Johnson's satisfaction, even though the guests were rationed to one piece of cake each and even though 'the whole place looks bleak and the wind blows everywhere'.[61] Yet for all the merriment of the Archbishop's Christmas dinner and the choristers' party, the pain of separation was only just beneath the surface: 'I would rather eat a crust with Kez and her mother and sister.'[62] And the previous year (1941) he had written achingly to Nowell:

> It's unbelievable that Xmas is nearly here. I'll be glad when it's over, but how I should love it with you and Kez. I should love to see her at the Xmas tree and at the cradle. I would tie a long candle to a rod and tie that along the stem of the Xmas tree so that it stood out at the top and would burn without setting fire to anything as a kind of star above the tree top. I hope you got my two last parcels – chocolates and flowers.[63]

Hewlett Johnson was never able to spend a wartime Christmas with his family at Llys Tanwg, but each year he provided presents that he had assembled over several months and taken with him on earlier visits. Some of the gifts for the girls were home-made – a pram for Keren and a doll's house for Kezia; others had been purchased on his travels around the country – a cutting-out set and a three-penny bangle bought at Woolworth's in Leeds and a children's encyclopaedia that he had found in a bookshop in Bristol. There were also pencils, barley sugars, crayons, story books, colouring paper, chocolates, a piggy bank, drawings and dolls. For Nowell there were gifts of books and artists' materials that Hewlett had managed

to buy in the Charing Cross Road and even the occasional item of clothing, though not without careful prior enquiries as to its acceptability.

> I saw some slacks of rather nice corduroy for 33/6d at Peter Robinson.
> Would you like them – and if so, what is your waist measurement and
> which colour would you like, dark green or a rich dark wine colour?
> I felt a bit odd among the ladies in their own department.[64]

Nowell was obviously impressed. 'It *was* brave of you to go into the ladies department, you Darling.'[65] But the purchase was sufficiently successful to encourage her to ask for more: 'I should love another pair of corduroy trousers,' she wrote to Hewlett, 'the measurements are waist 29", length 42", and colour green or mole.'[66]

* * *

Housekeeping chores necessarily occupied some of Hewlett Johnson's time during the war years. Apart from Alfred D'Eye, Fred Crowe, Freda Morton, Lily Wraight and the other women who helped out in the deanery from time to time, there was little help available from the Cathedral staff. Johnson, Crowe and D'Eye between them rigged up blackout curtains whenever it was necessary, and the Dean even tried his hand at secondary glazing.

> I've had a terrific day of joinery! I've put double windows in 3 out
> of the 4 lights in my bedroom. The change of temperature already is
> astonishing, and it is done so cunningly that nobody can see they are
> double. I got sheets of celluloid … just the right size to cover the
> whole of each window held in place by a narrow frame. I had care-
> fully to wash the windows before fixing this, and I'm proud and satis-
> fied with the job. It will not only save much fuel but give much
> greater comfort.[67]

Johnson also had to equip the deanery with rudimentary fire precautions at his own expense, explaining to Nowell that: 'I'm bust getting the house fire protection and it costs much money – a stirrup pump 34/6d – and buckets and long shovels or rakes.'[68] And he was always searching for ways of economising in the deanery, moving fires to where they were most needed in the house and investing in heaters of a type that would save on fuel bills. Indeed, keeping a close eye on his expenditure and looking for a bargain were among Hewlett Johnson's instinctive habits. In 1940 he delighted in paying £2 for a second-hand portable cooker in excellent

condition – a saving of £3 on the cost of a new one[69] – and in 1941 he bought a second-hand stove from General Rudkin for thirty shillings.[70] In the harsh winter of 1942 he reported to Nowell that he had 'been able to buy an excellent aertex vest and drawers – 16s 6d and 17s 6d and 8 coupons'.[71] Johnson himself thought the cost was 'shocking' but added that he had bought them because 'D'Eye says it is cheap'.

Ever the engineer, any kind of improvisation gave him great pleasure, whether it was fashioning a blackout curtain from his old Oxford gown or crafting a clerical shirt front from a piece of thin steel and an old bit of cloth. 'It is light, cool, fits perfectly and looks excellent! Why pay a fabulous sum for a less efficient thing?'[72] One answer to his question came six months later when Freda Morton warned him at the end of 1943 that his clothing coupon book was about to expire and advised him to embark upon an uncharacteristic shopping spree.

> So I expended the coupons – summer pants 4 [coupons], summer vest 4, new cassock 8, new girdle 2, new collar 1, new work apron (green and comely and will save clothes while doing dirty work) 1. The cassock costs £4. 4. 0![73]

* * *

By the autumn of 1944, with the war in Europe now in its closing phases, the precincts offered a scene of dreary desolation. Alex Sargent later recollected that:

> The Precincts became shabbier and shabbier. There were barrage balloons in the Green Court and the Oaks; a large round static water tank stood outside the entrance to Chillenden's Chambers; the [King's] School Dining Room was no more than a shell; the Library was in ruins; the sites of Nos. 13 and 14 a wilderness; empty houses steadily deteriorating; broken windows in abundance. We did not lose heart, but it was depressing.[74]

Yet already the work of restoration was underway at the deanery. By March 1943 the Cathedral architect, Mr Anderson, had prepared his plans for the repair and reconstruction of the house and submitted them to the Ministry of Works for approval, and in April Hewlett Johnson informed Nowell that: 'My Deanery is to be repaired in parts. That sounds nearer to the day when you can all return.'[75] By June 1943 some relatively minor repairs were under way and in the following month the front of the house

was scraped and refaced. At the same time Johnson was conferring with the Archbishop and others about the reconstruction of the kitchen area.

> I'm trying hard for new kitchens and I think I can get them. The new kitchen would open onto the passage up to the library with a door opposite the door into the small dining room and therefore on one level with ... the small dining room. ... The heating stove would be in a hot room – the old kitchen. A warming stove would be in the maid's room.[76]

By April 1944 Mr Anderson's plans were being assessed by various architects and officials visiting the deanery,[77] and in the following month the plans were approved subject to confirmation by the Ecclesiastical Commissioners.[78] In August 1944 the reconstruction work began when 'two men came in the morning at 7 a.m. to work all day shifting things out of various rooms into the Library preparatory to the rebuilding. Joy!'[79] The scaffolding went up on 1 September 1944.[80] A lot of the labour of clearing things out had to be done by Johnson himself.

> I spent 3-4 hours on the filthiest jobs, dusting all the books in the drawing room, and banging dirt out of all the furniture ... and doing the same in the spare room next to ours, and getting the filthy mattresses and moth-eaten things out of the cupboards on the top landing, and getting various things into locked rooms to prevent theft – there are so many strange men about and some things have gone, including a fold-up table cut out of the garden shed! I had only the thinnest vest on and worked in the cool but in clouds of dust and was indescribably filthy. I had a bath all over![81]

It was the kind of work he revelled in: not only does 'exercise like this do me good',[82] it also introduced variety into the daily round. 'It's the tedium of the same routine each day which weighs. Anything, perhaps, is easier to bear than the tedium of routine.'[83] But in truth, Hewlett Johnson's life could hardly be regarded as routine.

CHAPTER TEN
CANTERBURY UNDER ATTACK

E VEN BEFORE THE formal declaration of war in September 1939, steps had begun to be taken to protect Canterbury from the air raids that were expected as soon as hostilities began. The Cathedral and its precincts formed part of the plan, for as in the Great War, the crypt was designated a public air raid shelter. But bombing technology had moved on in twenty-five years, and although sandbags and earthworks were already in place, more had to be done to protect the crypt when doubts were expressed about its capacity to withstand a direct hit on the choir above. The city surveyor suggested that, in order to cushion the impact of falling masonry, the floor of the choir should be covered in soil laid on heavy timbers. The Chapter was divided about the wisdom of such a drastic measure, but Hewlett Johnson had no doubt about either its necessity or its urgency.[1]

It turned out to be a huge undertaking as lorries piled high with loose soil drove through the great west doors of the Cathedral to deposit their loads onto the nave floor, there to await transportation to the choir. The artist William Townsend captured the scene in a series of dramatic water-colour paintings.[2] One depicted a lorry leaving the Cathedral through the west door while another, painted from the top of the pulpitum steps, showed the entire nave under several feet of soil. Townsend noted the operation in his diary.

> The cathedral nave is full of earth, lorries are rumbling in and shoot-
> ing cartloads down on the floor and now there is a wilderness four or
> five feet deep between the pillars from the west door to the choir steps.
> Services are going to be held in the crypt, which is also to serve as an
> air-raid shelter and the earth is destined to form a blanket in the choir
> above the crypt vaults.[3]

From the nave the soil was carried up the pulpitum steps to the choir where a track had been laid by coalminers from the nearby pit at Hersden. The soil was then loaded into a pit wagon and hauled by the miners up the

length of the choir to the steps of the high altar from where it was taken to the ambulatories.[4] It is difficult to know how extensively the soil was laid, for although the city surveyor's plan had apparently been intended to cover the whole of the choir, it seems from Hewlett Johnson's account that, in the event, only the choir aisles and ambulatories were thus protected.

A barrage of criticism immediately descended upon him. Led by certain newspapers that were only too happy to seize the opportunity of landing a few punches on the Red Dean, he was accused of desecrating the Cathedral by over-reacting to the German threat. William Townsend noted in his diary that:

> I heard a good many critics of the Dean for this preparation; from the old verger who thought it was witness to a lack of faith in God who could protect his own house to the ladies of Canterbury shrieking 'why on earth don't they get rid of the Dean'. I think he is quite right to do all he can to protect people, once he has decided ... that the crypt shall be an official shelter; and then God may protect his house.[5]

The Friends of Canterbury Cathedral joined the chorus of complaint in October 1939 by asking the Chapter to undo what had already been put in place.[6] The request had to be taken seriously, and Hewlett Johnson wrote a lengthy letter explaining and justifying the actions the Chapter had taken. He pointed out that:

> In doing what they have done, the Dean and Chapter break no really new ground; for in the days when England knew at first hand the dread experience of war, from Saxon times to the 17th century, the Churches of England have ever been the refuge and sanctuary of the people.[7]

Johnson concluded that: 'Friends may rest assured that their Cathedral, though a refuge in these days of trouble, is still the house of GOD and a place of fervent prayer.'

* * *

Other precautions were also taken to protect the building and its contents. All the medieval glass and some of the Victorian glass was removed for safekeeping and some of the more important monuments, including the tombs of King Henry IV and the Black Prince, were sandbagged. The Cathedral itself was, of course, far too large to be protected in any effective way, though some ingenious measures were floated.

Hewlett Johnson considered camouflaging the roof by painting it brown and green, and Canon John Crum wondered if it would be possible to encase the Bell Harry Tower in sandbags.[8] Following major raids in the summer of 1942, the idea was also mooted of surrounding the Cathedral with rubble and craters to make it appear that the building had already taken many direct hits and was no longer a worthwhile target.[9] Care also had to be taken to protect those who lived in and used the precincts. Home Office-approved trenches were dug in the Green Court and gates into the precincts were kept open at all times, allowing unfettered public access to the physical and spiritual shelter of the Cathedral. After the panic of the 'phoney war' had passed, some of these measures were reversed: the Green Court was transformed from an outdoor shelter into a huge vegetable patch, and access to the precincts was regulated when bicycles belonging to the King's School boys began to be stolen in uncommonly large numbers.[10]

Although it was the destructive capacity of the large blast bombs that understandably dominated the fears of the Cathedral authorities, it was quickly realised that the smaller firebombs could be just as destructive. A fire spreading through the roof timbers above the stone vaulting could do untold damage before it was even noticed. In January 1941 a Cathedral working party proposed a series of measures for dealing with firebombs that landed on the roof, and Hewlett Johnson spent time with the fire brigade examining the roof and working out ways of tipping the bombs to the ground below.[11] It was decided to have two professional firemen on duty on the roof every night with volunteers below.[12] As the bombing raids continued, the volunteers eventually joined the professionals on the roof, and their combined efforts saved the Cathedral from serious fire on several occasions. Typically, Johnson took the opportunity provided by the inspections of entertaining two senior Kent firemen to tea in the deanery and found them 'dead keen to talk of Russia and socialism'.[13]

* * *

The course of the German bombardment of Canterbury from 1940 to 1944 was witnessed at first hand by Hewlett Johnson who wrote of his experiences to Nowell at Llys Tanwg. Although the story of the bombing of Canterbury has been told a number of times, Johnson's reports add a vivid extra dimension to a broadly familiar picture. His observations began in July 1940 when, as part of Hitler's plan to take control of the Straits of Dover in preparation for an invasion, the English Channel became the first target of the German bombers.

Yesterday I motored with D'Eye to … the outskirts of Folkestone, Dover and then on to Deal. We were in three raids but they were not at all terrible, not nearly so bad as the siren! At Folkestone a German plane came right overhead and the chasers seemed to miss it. Guns fired off beside us. We were right in the country. At Dover it was nearly overhead: at Deal it was behind clouds. I think our planes, according to the papers, got the better of several German planes.[14]

Johnson observed prophetically that:

I can't help thinking that if Hitler fails to carry it off now in invading England successfully, he will prove to have blundered fundamentally in not springing his surprises upon his most formidable foe *first*. We were utterly unprepared for invasion, had he attacked us first instead of France.[15]

After the blitz in October 1940 that badly damaged the deanery, the threats of further raids on Canterbury receded as Hitler repeatedly postponed his planned invasion of Britain. Johnson wrote in February 1941 that:

I don't *think* invasion will come. Some big bangs took place [last] night and Fred came into my room as did the others. But the plane circled over us, leaving its trail in the sky and the moonlight. The bombs hit the barracks at which they were obviously aimed.[16]

Land mines were dropped near Canterbury for the first time in May 1941, causing both Hewlett Johnson and Alfred D'Eye to leave the deanery for the crypt.[17] Johnson feared the mines more than the bombs, for they came down silently in parachutes and the German planes flew low to hit their targets. By the beginning of 1942 the raids were becoming more frequent and more dangerous. Johnson described to Nowell the scene that he and D'Eye had witnessed on the night of 1 January when the Canterbury siren (known affectionately as 'Tugboat Annie') sounded at 3 o'clock in the morning.

We walked up to the Gate Inn where the Old and New Dover Roads conjoin, and watched what would happen. A few raiders came. The first dropped a bunch of incendiaries two or three miles wide of Canterbury. Then one of our fighters came preventing our guns aiming at him. Then came the Germans and we heard machine gun fire and then a tremendous barrage with the converging searchlight rays spotting the

raider's moves till it came *right on us*. Then the all too familiar whistle
of falling bombs. We fell with our faces in the ground, and it seemed as
if the bombs were coming straight for us. Then there were four great
explosions and then 'whack', a piece of shell or shrapnel landed on a
roof or car roof just by us, and then all was over and we stood up and
watched the clouds of dust and dirt drift from the crater in the woods
nearby. We saw as we walked on a fire about 1½ miles away and
thought it was the burnt out plane. We learnt it was a fire our military
had lit hoping that the Germans would think it was smouldering
Canterbury – as they did! … The raid over, we wandered back to the
Deanery, wandering among the firemen etc. … It was a weird sight.
Poor Canterbury, it looks appalling and yet grand. The people have
been splendid and there is a magnificent feeling of friendliness with
everybody. It is a joy to be in the street.[18]

* * *

The most damaging raid on Canterbury occurred on the night of 31 May
– 1 June 1942. Lois Lang-Sims, living in the precincts with her mother,
provided a graphic eyewitness account of the night's events.

The target of the raid was the Cathedral itself. The planes were circling
overhead and coming in by turns, low-diving almost … to the level of
Bell Harry Tower: so that, as we listened, it seemed impossible to us
that the Cathedral had not been hit. … An hour passed. Again and
again the planes returned and now, to judge from the continuous roar,
the whole of the Precincts seemed to be in flames. I looked out. [The
Cathedral] was still there; it had not been touched; and never before
had I seen, never again would I see it as beautiful as this. In the light
of the flames the stones had turned blood red: the Cathedral was crim-
son-dyed against a backdrop of smoke. The Precincts were ringed with
fire. … The air was filled with a steady, mighty roar and … sparks,
like giant fireflies, performed a measured dance on the wind from the
flames; dipping and sailing and curtseying in the air, they drew before
the Cathedral a veil of openwork.[19]

Four days later Johnson recorded his own impressions of the aftermath in
a letter to Canon John Shirley in Cornwall with the King's School.

The Cathedral stands in a wilderness of desolation; Crum's house shat-
tered, MacNutt's and Starr House nothing but shells, the Library three-

quarters destroyed, and a fearful desolation at the west end of the King's School Dining Hall, kitchens and classrooms. The whole of that little courtyard opposite the old school house a scene of indescribable havoc, and the school house itself badly shaken. The Cathedral itself, though all the windows are blown out, stands up grand and unhurt, save for honourable scars here and there. The sun pours in everywhere; all the dark gloom has left the Chancel and Mrs Fergusson's flowers give a triumphant blaze of colour. The whole thing is prophetic of the future to me.[20]

Johnson also furnished Nowell with a vivid description of the carnage.

Canterbury looks appalling. I think no town has suffered more for its size: 400 shops and business premises and houses quite gone: 1500 more badly damaged: the Cathedral library terribly smashed: MacNutt's house consumed, Shirley's a wreck and Sargent's too. From Maltby's and the cattle market to Mercery Lane gone, and the same in other great areas. Jerry let us have it with a vengeance. The loss of life amazingly small, only some 20 as far as is at present known. And only 47 badly wounded cases. We all escaped, running in socks and under-clothes to the crypt.[21]

In the following days, the aftermath of the raid began to unfold.

I've been up the major part of 3 nights. Last night we had a very near miss. Jerry came over at 2.0. Then a release at 2.10. Then alarm at 2.30 and he began in earnest for 1hr 25 minutes. We had 14 balloons up and an excellent barrage of guns: that kept him high. But he dive-bombed once and dropped a bomb which made an unbelievable crater about 100 feet wide and 45 feet deep. The citizenry themselves are splendid and by day and night greet me with welcomes and smiles. I went around the town immediately the rain ceased visiting the vari-ous fires and where they were digging the dead out of houses. I never returned till 7.15 and was out again at 8.30 after breakfast – a few minutes lie down. The exercise does one good. I'm urging more to sleep in the crypt tonight and D'Eye and I are going again in the car to sleep at Miss Harper's flat near the cricket field. When the siren sounds we shall go out and watch, and then return at once to Canterbury when the blitz is over. Nearly everybody leaves the town *centre* at night, so there is not much use in staying. I would not have missed this

for anything: what a time to help in a humble way and what ways with the hearts of all kinds of people.[22]

The Cathedral looks *glorious* without its windows, such a blaze of light you could not believe the difference it has made to the choir. ... Canterbury at the moment puts a gulp in my throat. I could weep. Not at the desolation but at the people's kindness and smiles. Everybody seems to smile. ... This week has seemed like something apart. It seems a year since the blitz began. So much of life has been crowded into so short a space of time. If materially Canterbury is at its worst, spiritually it is at its best.[23]

Such hot, dry and lovely summer weather. But the dust! Wreckage everywhere. Town busy by day. Sight-seers. Deserted by night. Cathedral more lovely than ever before. What a boon to be without the glass. It's worth all the rest of the damage to the fabric to let the sunshine in.[24]

Canterbury was to remain at risk from the skies for another two years, in part because it was on one of the main flight paths to London. Hewlett Johnson documented the raids in his letters to Nowell at Llys Tanwg. In January 1943: 'We had a tempestuous night with air raid warnings and visits to the crypt, and then a balloon was struck by lightning and came down flaring with the rattle of the cable.'[25] In April 1943: 'Many warnings now. Crypt four nights running, but nothing dropped. Guns overhead last night. The planes come at about 12.30 or 1.00, just when one is nicely asleep.'[26] In October 1943: 'Raids pretty constant now. There is little danger if precautions are taken – but a great nuisance. The planes disturb us every night now – high fliers easily attacked but keeping London very restless.'[27] In March 1944: 'Nights are not dangerous but we are much disturbed and we have visits to the crypt in the middle of them for lengthy periods. It's a great nuisance.'[28] In June 1944: 'We were in the crypt most of the night. London had a bad night. At least now we know what it is: we were puzzled last night because the balloons were down: there's no use for them [against the V-1 flying bombs]. These raids are nuisances: the actual damage is comparatively small.'[29] In June 1944: '[The V-1s] pass over Canterbury but are exhausted and explode as they fall at their journey's end. They are difficult to hit because they fly so low – about 1,000 feet. At that height they go over with terrific speed and the guns get no chance.'[30]

* * *

In spite of the battering that Canterbury took from the skies between 1940 and 1944, the worshipping life of the Cathedral was maintained throughout the war. A smaller than usual choir, including day-boys from the rump of the Choir School and others evacuated to Canterbury from the English School of Church Music at Chislehurst, maintained the musical life of the Cathedral under the direction of the precentor, Joseph Poole. Colour was provided, and spirits cheered, by the magnificent Mrs Gertrude Fergusson, whose flower arrangements never failed to inspire the worshippers. The preaching was shared out among the canons, but not, it seems, equally. Canon John Shirley was away with the King's School in Cornwall for much of the war and Canon Frederick MacNutt had more than his fair share of absences through illness. By the summer of 1944 the Dean and the Archdeacon seemed to be taking most of the services between them.[31] Though there is nothing that even approximates to a count of services taken or sermons preached, Hewlett Johnson must have carried the major burden of preaching for much of the war. The Sunday evening services were entirely his, and unless his absence from Canterbury was sanctioned or unavoidable, he saw it as his duty to attend at least one service in the Cathedral each day.[32] In bursts he preached intensively: in March 1941 he wondered whether, having preached eight sermons in a month, he had set a new record for a Dean.[33] It was a demanding part of his work, the more so because he seems usually to have prepared a new sermon for each service, taking a great deal of trouble researching and composing it. Johnson's wartime letters to Nowell were full of sermon ideas that were currently occupying him; but like any prolific preacher or speaker, there were times when inspiration failed. In June 1942, following the hugely damaging German raids on Canterbury, he wrote simply to Nowell: 'Sermons seem rather difficult these days.'[34]

There was, too, an added problem with Hewlett Johnson's throat that had troubled him for most of his life. Since there were no loudspeakers in the Cathedral until soldiers rigged some up in May 1944,[35] it was very difficult to preach in the choir and all but impossible in the nave.[36] But congregational sizes were good throughout the war, due in large measure to the attendance of soldiers quartered in east Kent. There were even occasions when extra services were requested. 'A parson buttonholed me to preach next Sunday afternoon at 4 in the Cathedral to his 150 men who are stationed at St Edmunds. There is no room for them at 6.30, for on top of our already full service we are to have 150 balloon men.'[37] Yet for all his popularity as a preacher among the troops, Johnson was regarded with suspicion by the military chaplains. He told Nowell in May 1941 that the

chaplain-general for the South-east had forbidden the other chaplains to attend his services, and some officers had also followed suit. Johnson complained that he was 'somewhat depressed at the sight of the empty benches where the officers and chaplains used to sit'.[38]

As well as the regular round of services there were marriages, christenings and funerals to conduct; and from time to time the Cathedral was host to some high-profile services. A service in September 1943 was attended by 'an Archbishop, two Bishops and an Archdeacon',[39] and another in May 1944 by Countess Stamford, Lord Harries and 'all the swells'.[40] Other visitors included Albert Schweitzer, Eleanor Roosevelt, the King and Queen of Siam, the Queen of Rumania and, to celebrate the end of the war in 1946, King George VI, Queen Elizabeth and the two princesses.[41] Yet for all his experience and love of the limelight, Hewlett Johnson often found the big civic services quite tense and daunting.

> A packed church this morning: two Archdeacons, Mrs Temple, Hore Belisha [Secretary of State for War until 1940] etc! I think it went well, though I was tired and my voice was not at its best. I was nervous, too. But Bickersteth was pleased, Hore Belisha was pleased, Pierce was pleased, and Hughes of the Kentish Gazette was very pleased and wants to publish it whole! So you may get a chance of seeing it. I'm glad beyond words that *it is done*.[42]

* * *

The ceremonial highpoint of the war years was the enthronement in 1942 of William Temple as the ninety-eighth Archbishop of Canterbury. By March of that year the incumbent Archbishop, Cosmo Gordon Lang, had decided that the continuing demands of the war required a younger man with energy and vision. It grieved Hewlett Johnson, who had enjoyed a warm personal relationship with Lang in spite of their professional disagreements.[43] The timing of the Archbishop's farewell service also displeased the Dean, for he had hoped to spend a few days at Llys Tanwg with Nowell, who was then in the late stages of her second pregnancy.

> The Arch[bishop] has just decided to preach his farewell sermon on Tuesday March 23. I just don't at the moment know what to do. It is heartbreaking. I wish he had not arranged everything so badly and without consulting a soul. I shall not make up my mind yet what to do. … I'm mad to be with you and I hate this beastly war.[44]

Archbishop Lang's farewell service in the Cathedral was packed with people coming to hear him for the last time. Defying the extreme cold and an unheated building, the congregation filled the choir and the transepts before spilling over onto the altar steps and the space behind the high altar. In his address Lang spoke movingly of Canterbury Cathedral at a time when its very survival was on the line.

> There is no prayer which I shall offer more ardently than that which we have offered this afternoon, that it [the Cathedral] may be protected from all danger and preserved for centuries yet to come to give its abiding and glorious witness from all the changes in things seen and temporal to the things which are unseen and eternal. As I look round I say with a full heart: 'Peace be within thy walls'.[45]

The enthronement of William Temple as Archbishop of Canterbury in April 1942 caused a certain amount of procedural fluttering in the ecclesiastical dovecotes. The issue was whether the Dean or the Archdeacon of Canterbury had the legal right to enthrone the Archbishop. There were some weighty historical justifications behind the Archdeacon's claims, but George Bell, the Dean at the time of Cosmo Gordon Lang's enthronement in 1928, had secured the privilege for himself. Now, supported by the rest of the Chapter, Archdeacon Thomas Sopwith was arguing for the privilege to be returned to its rightful place. Hewlett Johnson was initially opposed to the change, but he yielded to the Chapter's demands 'for the sake of peace and because it all seemed petty'.[46] He wrote to Temple's successor as Archbishop of York, Cyril Garbett, explaining the reasons for his decision and asking that it should be seen as his personal choice that should not pre-judge the issue for his successors.

Having got this procedural point out of the way, the formal proceedings leading up to the enthronement now began. By the beginning of April, with Cosmo Gordon Lang retired and William Temple not yet enthroned, it fell to the Dean and Chapter to guard the office of Archbishop. The first thing Hewlett Johnson had to do was to arrange the election of the Archbishop by the Greater Chapter – a pre-Reformation ritual that had prevented an unacceptable Archbishop from being foisted on the monks of Christ Church Priory. In reality, of course, there was no possibility of the twenty-nine honorary canons of the Greater Chapter refusing to elect Temple; but the motions had nevertheless to be gone through and the burden of organising the meeting, including a carefully costed tea, fell to the Dean.[47] The meeting of the Greater Chapter eventually passed without

a hitch and everyone relished the buns and cakes. Even Johnson's implacable opponent, Canon John Crum, thought that he had done things well.[48]

The enthronement service was something that Hewlett Johnson did not look forward to, as he confessed to Nowell.

> How thankful I shall be when all this enthronement fuss is over. The place seethes with it. War is quite forgotten and people are thoroughly enjoying themselves: maybe it is good. This afternoon we've had rehearsals and some more to come now with the Arch[bishop] after the civic welcome in the Guildhall to which I have to go in half an hour.[49]

Yet William Temple's enthronement on 22 April 1942 turned out to be a splendid and colourful occasion that, for a moment in time, diverted people's attention away from the drab monochrome of the war. Hewlett Johnson described it as 'grand and picturesque' but he confessed to being glad when it was over and things could to return to what passed for normality. 'I wonder I got through it as well as I did', he wrote to Nowell. 'My heart has never been in the pomp etc at *this* time. My real interest lies elsewhere. Temple was good and nice and kind and his address quite good. Yet the great institution, how it blocks the way in things that really matter.'[50]

After the ceremony Hewlett Johnson dined with Canon John Shirley at the Royal Fountain Hotel in St Margaret's Street, Canterbury. Within a matter of days it had been obliterated in a German raid.

* * *

Hewlett Johnson's unlikely wartime association with General Bernard Montgomery, a former pupil of the King's School, began early in 1941 when Montgomery, at that time the commander-in-chief of the 5th Corps, invited the Dean to preach to his troops at Tonbridge.[51] Johnson stayed the night, telling Montgomery about his book (*The Socialist Sixth of the World*) and discussing alternative visions of Europe beyond the war. Later that year Montgomery invited the Dean to dine with him at the County Hotel in Canterbury. 'I had an excellent time with him', Johnson told Nowell, 'and gave him a copy of my book. He was most interested. It is very amusing to become someone whom generals want to consult.'[52] Further dinners ensued, and in February 1944 Johnson was summoned to take tea with Montgomery in his private train at Canterbury West station. It was, plainly, a momentous event even for someone as well known as the Dean, and he relished recounting the story of it.[53]

The conversation began in a general way, with Montgomery asking questions about communism and the Soviet Union that Hewlett Johnson doubtless answered in great detail. Montgomery then wanted to know about the National Anglo-Soviet Medical Aid Fund that Johnson and D'Eye had set up in 1941 following Hitler's attack on the Soviet Union.[54] The Soviet Ambassador, Ivan Maisky, was the patron and the sponsors read like a roll-call of the great and the good in wartime Britain, among them the Duchess of Atholl, Jacob Epstein, Margery Fry, J B S Haldane, Augustus John, David and Megan Lloyd George, J B Priestley, J Scott Lidgett, Edith Summerskill, Sybil Thorndike, G M Trevelyan, and Beatrice and Sidney Webb. By the time Johnson was meeting Montgomery in 1944 the Fund had raised a quarter of a million pounds.[55] It was, though, seen in Whitehall as a distinctly pro-Russian organisation that was as much concerned with promoting the interests of the Soviet Union as sending it drugs and bandages, and the government deliberately tried to steal its thunder by encouraging the formation of a rival organisation, the Red Cross Aid to Russia Fund, headed by Mrs Clementine Churchill. When Johnson asked Montgomery if he would donate a flag to be auctioned in aid of the Anglo-Soviet Medical Aid Fund, Montgomery replied that he had already given one to Mrs Churchill; but he later sent the Dean a signed copy of his farewell message to the 8th Army.

The conversation then turned back to the Soviet Union. Montgomery asked whether Johnson thought that Russia's advance westwards through Europe would stop when she had recovered her own territory. Johnson replied that, if it were possible, Russia would gladly end hostilities there and then and 'live in peace'. They talked about the deaths and casualties in both Germany and the Soviet Union and they compared the differing leadership styles of Stalin, Hitler and Churchill. And then the Dean was invited to sign the General's visitors' book and the meeting was over. Much to Hewlett Johnson's pleasure, a crowd of people had gathered on the opposite platform to watch the two men emerge from the carriage.

The meeting in General Montgomery's railway carriage left a very favourable impression on the Dean.

> I like Monty! He has developed and matured. There is no less kindness and courtesy but an assurance, an authority, a directness, a capacity to abstract information, a successful way of getting at it quickly and briefly. He is a man of quick decisions, picking out the salient and vital points. He knows how to ask leading questions.[56]

* * *

If Hewlett Johnson's brief acquaintance with Bernard Montgomery was cordial, his passing contact with Winston Churchill was not. It happened after the war, in the summer of 1947, when Johnson was reported in the *News of the World* as having said, in connection with Churchill's famous wartime speech about 'fighting on the beaches', that:

> Mr Churchill put his hand over the microphone and, in an aside, said to me with a smile, 'We will hit them over their heads with beer bottles, which is all we have really got'.[57]

Churchill, who presumably did not believe that the *News of the World* had simply made the whole thing up, sent a cuttingly understated letter to Johnson pointing out that he had no recollection of the Dean being present when he had made the speech – not least because it had been delivered in the House of Commons and had never been broadcast.[58] Johnson's reply contained a very rare apology for unintentionally annoying Churchill but, never shy to justify himself, he claimed that his words had been misreported by the *News of the World*. He had actually picked up the story from Archbishop William Temple over dinner at the Falstaff Hotel in Canterbury. Temple's version was that Churchill had, at that point in his speech, turned and made the remark as an aside to Mr Amory who was sitting beside him on the front bench.[59] It would have been typical of Johnson to have changed some of the details to liven up the story – especially a story that placed himself in a one-to-one relationship with Winston Churchill – but there is now no way of recovering the truth.

CHAPTER ELEVEN
A FAMILY APART

THE DEEP SATISFACTIONS and pleasures that Hewlett Johnson derived from his labours in the public arena were matched – perhaps even eclipsed – by those he found within the bosom of his family. For all that he relished the publicity and controversy that came to him as Dean of Canterbury, it was in the seclusion and intimacy of his private life that his deepest needs were met. His childhood spent in the loving security of a late-Victorian middle-class family had nurtured in him a firm belief in the family as the natural fount of happiness and fulfilment; and although he and his first wife Mary had no children, they had created a family atmosphere in their vicarage at Altrincham that drew the parish's children and adolescents into its warm embrace. Mary's death in 1931 was devastating for Johnson, not only for the personal bereavement it brought him but also for the veil it drew between him and the family ideal around which he had constructed so much of his Christian vision and ministry.

Yet Mary's death, tragic though it was, allowed Hewlett Johnson in the last third of his life to create a different, more personal family life in which he was to find great joy and satisfaction. Mary was no longer a physical presence in his life, of course, but her spirit pervaded his second marriage to Nowell Edwards. Indeed, Johnson believed that, in some mystical way, Nowell had been 'given' to him by Mary and that together they were engaged in the great work of creating God's kingdom on earth. The continuing spiritual presence of Mary, combined with the constancy of Nowell's love and the delight that Johnson took in the children of his old age, were crucial in sustaining him throughout the war. For his part, Johnson strove fiercely to protect his family from the insults that were hurled at him. Whatever battles might be raging outside the deanery, there was a privacy inside that brooked no intrusion. It was within his family, where he had no need to act a part or make a stand, that Hewlett Johnson was able to be most truly himself.

A poignant indicator of the depth of Hewlett Johnson's love for his family is seen in a remarkable letter he wrote to Nowell in August 1940

when the risk of an imminent German invasion was high and the possibility of his death or kidnap was very real. Intended to be read by Nowell only in the event of such a happening, the letter was a striking testimony to Johnson's Christian faith as well as his uxorial devotion. It is quoted here almost in full.

> Darling Wife and Darling Kez[ia]. You will not get this letter unless invasion takes place. In that event it will be my duty to remain here [in Canterbury]. I ask you to take the situation bravely and confidently. Look on the hopeful side always. Remember: 1. We are in a very safe place from the hazards of battle and we shall be discreet. 2. The Germans probably will behave quite reasonably with us and we may soon become repossessed of Canterbury. 3. Even if they were brutal to us, it would be only in my case I feel sure because we stand for something big and Eternal; and it is upon that which is Eternal and upon the Source of all that is big that we can confidently rely – I here and you there [in Harlech]. The whole thing can and will in that event be *TRIUMPHANT*. We shall have had a share in a divine task; we shall, as Mary has, receive something which can never be taken from us, and we shall be enabled to help one another in all kinds of incalculable ways in the days to come. God is never defeated nor does God lightly cast off those who suffer in the warfare of righteousness. We can both rest on Him. I shall be supported by you and your prayers and you by me and mine and Mary's. ... And you will carry on bravely and happily with our darling babe. God bless you both, Beloved Nowell. Oh what a joy that God has given us to one another.[1]

* * *

Yet for all the manifest love and commitment that Hewlett and Nowell had for each other, theirs was hardly a marriage of equals. No marriage can be fully understood by outsiders, of course, but the hundreds of letters they wrote to each other, particularly during the years of their wartime separation, consistently reveal Hewlett as the senior partner and Nowell as the junior. In one sense this is scarcely surprising: at the time of their engagement in 1938 he was twice her age and had already experienced one long and fulfilling marriage. He was also a high-profile figure in ecclesiastical circles. There was, though, more to it than the obvious gulf of age and experience. There is some evidence that Nowell was less keen than Hewlett on seeing their relationship as a mystical trinity that included Mary as well as themselves. For Nowell, 'Auntie Mary' had been a somewhat remote figure, and the idea

that her spirit was now mingling with her own to guide and motivate Hewlett would have been unnerving for any second wife – the more so in Nowell's case as she had supposedly been providentially 'given' to Hewlett by Mary. The problem (if problem it really was) was compounded by the fact that Hewlett was seemingly insensitive to any of this, taking it for granted that Nowell understood and accepted his continuing invocation of Mary's presence in their lives.[2]

There is a consistency in this, for although Hewlett was always deeply solicitous for Nowell's welfare, he often assumed that he knew what was best for her, whatever she herself might have thought. Yet Nowell cannot be dismissed as an insecure young wife dependent on her husband for her identity. Quite the opposite: she was an able and determined woman, highly intelligent and expressively articulate. Though never a first-wave feminist in the mould of, say, the suffragettes or those who agitated for change in the marriage laws, she would have had much sympathy for the second-wave feminists of the fifties and sixties who felt themselves frustrated by the strictures of a male-dominated society. Woven into these strengths, however, were strands of doubt and dependency. She was less secure in her Christian faith than Hewlett and she was inclined to take a lead from him in forming her political judgements. She had periods of what were loosely described in her letters as 'nervous debility', and in the postwar years she felt herself isolated in the Cathedral precincts with few close friends of her own. The small number of women who came to know her well believe that for much of the time Nowell consciously sacrificed herself to a higher cause with a loyalty and stoicism that continued to support her husband even as the waves of scorn were crashing around him.

* * *

For both Hewlett and Nowell Johnson, the separation caused by the Second World War added to the already demanding circumstances of their lives. Apart from short holidays to nearby places such as Llanfair and Ffestiniog, Nowell and her daughters spent the entire war at Harlech. Johnson remained in Canterbury but was able to visit Llys Tanwg a few times each year, usually for a week or ten days at a time. In between the visits he and Nowell had to make do with letters, parcels, cards, presents, drawings from the girls and such like. Nowell's extant letters to Hewlett are much less numerous than his to her, and for obvious reasons they are of less historical value. They give detailed and graphic accounts of daily life at Llys Tanwg during the war years, including the tensions within the household, the difficulties of managing the budget, the practical problems of maintaining the

house and garden, and the endless sequence of minor illnesses suffered by the children. Her letters are shot through with an aching hope that she could one day return to the idyllic life they had shared in Canterbury before the war. Anchored in Harlech, with no possibility of returning to Canterbury in the short term, she wrote repeatedly of her anxieties about Hewlett's safety and comfort, and she even contemplated leaving Kezia and Keren at Llys Tanwg and returning to the deanery for a time.

Nowell's yearnings for a normal family life were fulsomely echoed by Hewlett. '*Really what I want is my wife and Kez*', he wrote emphatically in June 1941.[3] 'I'm very homesick for you both and I want to be with you and dig the garden and play with the babe and help you with your troublesome task. This war is *vile*. It's hateful to be parted.' And three months earlier he had written:

> How I long to run away and leave it all and arrive at Harlech and hug you and dance baby and get the early morning tea and give baby her bottle and repair the garage and dig over the garden and cut the gorse and then drive down to the shore and see baby crawl in the sand and hear her say Daddy ... and all the other lovely things we do together.[4]

Receiving news of the air raids on Canterbury were particularly anxious times for Nowell, not least because of the gap that usually occurred before she had any confirmation of Hewlett's safety. She was, of course, by no means the only wartime wife at risk of being left a widowed mother, but not too many husbands could have been living in the close shadow of a building high on the list of targets for the Luftwaffe, and even fewer could have been on a Nazi hit-list of public figures to be captured or killed in the event of invasion. Having read reports in *The Times* and the *Mirror* of the substantial damage to the deanery in October 1940, Nowell wrote:

> I long to see you and wish so much that I could be by your side for a bit. What savage attacks they have made on the Cathedral; it's amazing they haven't hit it as yet, but one fears how much they will go on trying. ... Oh, there are such hundreds of things I long to ask and to say, and I can't tell you of all my love coming to you and aching so to be able to *do* something to protect and help you, Beloved. God keep you and bless you – as I know He will. What I long for is your bodily safety and to be with you again.[5]

And following the devastating raid on Canterbury on the night of 31 May – 1 June 1942 she wrote:

> O Darling, Darling One, thank God a thousand thousand times that you are safe. Thank God – and not only for the babes and my sake but for all the people for whom your work can go on helping. God bless and keep you safe through it all. Of course I long to be with you and to be able to help as you are doing. It seems awful to sit impotently here while all this desperate trouble and suffering is borne. What a ghastly time, and what utter, utter madness. How long can it go on? Poor dear Canterbury, what has happened to it? There will be many casualties, I fear, and I long to hear from you. And the beautiful Cathedral, is it safe? And the Deanery? I still think of it as it used to be, with sunshine and flowers and open windows. Will you take special care of yourself these days, Darling? Get really good meals and all the little things, for I know you'll be everywhere helping all the time. How glad I am that you were there to help and not away that night. I know you'll feel that. I want to see you and kiss you and be with you to help and feel you safe, O Darling One – instead of being so far away. This almost makes we want to leave the babes. If only I could just be there to help – to get meals for you and to help with the homeless and the children.[6]

* * *

Life at Llys Tanwg during the war was largely routine and often boring as Nowell strove to care for her two young daughters while running a fairly extensive household. With her throughout the whole of the war were Elsie Crowe and her two daughters, Mary and Margaret. Elsie's husband Fred, who was employed by Johnson as a handyman, divided his war years between Canterbury and Harlech, as also did Lily Wraight. Local girls came in as daily helps. A number of paying guests were accommodated at the house during the holiday season, mainly for the much-needed rental income they generated. Alfred D'Eye was a regular visitor to Llys Tanwg and his daughter Joy was evacuated there for part of the war. Families were billeted on Nowell from time to time, commonly from working-class areas of North Wales, and her mother and brother Menlove were also among the periodic residents in the house.

Though a young woman of thirty-four when she first moved to Llys Tanwg at the outbreak of war, Nowell often struggled to manage the wider household as well as the care of her own two young daughters. 'This life of we women, buried together in a tiny congested atmosphere, is most

trying', she wrote to Hewlett in September 1941. 'It's too much to do with babies and the hundreds of tiny details to have time or energy to break through.'[7] Nowell's difficulties stemmed partly from the fact that she did not enjoy the best of health – she wrote of a 'nervous debility' and of a 'heart condition' that caused her to weaken and faint – and partly from the frustration of rarely being able to do the one thing she most desired: painting. There was also the fact that her background had ill equipped her to manage a socially mixed group of people. For all her socialist instincts, Nowell (like Hewlett) still held an almost Edwardian view of the superiority of the middle classes, and she found it difficult to maintain appropriate boundaries when forced together in close proximity with others of a lower social status. She sought Hewlett's advice about whether Kezia should be allowed to play with the other children living temporarily at Llys Tanwg (including Joy D'Eye and Mary and Margaret Crowe), and she was concerned lest Kezia's sensitivities be dulled by one of the 'rougher' families billeted at Llys Tanwg from time to time.

Elsie's Crowe's position in the household exposed the ambiguity of Nowell's position, for although she was a family friend of long standing, she was also a servant who was not above forgetting her place. On one occasion in 1941, after a particularly troublesome display of over-familiarity on Elsie's part,[8] Hewlett urged Nowell to remember her status and assert her rightful authority. His language is surprising.

> I fear you are having a very bad time with Elsie and it's all the worse as you will not be feeling well. ... The wisest thought is to treat her as a soul that needs correction or training as with a child and would suggest 1) get rid of vexation as much as possible, look upon her state as a pathological sickness, and 2) keep fairly stiff, aloof. Don't cringe up to her. ... She is just in that state of culture which respects 'superiority'. ... Let her see that you are a lady and if she cannot rise to the privilege of comradeship then the older relationship of mistress and maid must continue. I find this is necessary and it is part of the training that is good for them. It is moral training. Russia has had to do this.[9]

In spite of the obvious asymmetry of their contents, the wartime letters of Hewlett and Nowell Johnson were meat and drink to each other. His were full of stories of his action-packed days as Dean of Canterbury, hers contained news about Kezia's tantrums and Keren's colds; but it was exactly what each needed to hear from the other. Intellectually isolated at

Llys Tanwg with her hands full of babies, bolshie servants, unwanted guests and flooded chicken runs, Nowell voraciously devoured Hewlett's colourful accounts of his travels around wartime Britain, his meetings with senior figures in all walks of life, and the things that were happening in the precincts. She rejoiced in the opportunity to comment on the sermons and pamphlets he was preparing, and she welcomed his forceful views about the progress of the war and the prospects for peace. For his part, Hewlett had just as great a hunger for news about the funny sayings of Kezia and the escapades of Keren, the problems caused by the rats and rabbits in the garden, the availability of the right kind of coal for the boiler, and the frequent visits to the vast sandy beach beneath the house. It is easy, too, to imagine how Nowell's evocative descriptions of the blood-red sunsets over Cardigan Bay must have cheered her husband as he sat in the cold and damaged deanery, dreaming of the next time when he too would be there to see them with his family.

* * *

Hewlett Johnson's wartime visits to Llys Tanwg were a double-edged pleasure for him. Intensely anticipated from the moment the previous one ended, they invariably lived up to his expectations but left a depressing ache as soon as they were over. Time and again he wrote to Nowell of his desolation at leaving the light and laughter of Llys Tanwg and arriving back at a cold, dark and cheerless deanery in Canterbury. In the early stages of the war, when he managed to increase his petrol allowance by dint of the travelling he was expected to do as Dean, Johnson made the journey by car.[10] 'I can manage about petrol now,' he wrote to Nowell early in 1941. 'I've put a good deal of my January supply in cans and I've got my February coupons.'[11] But by the end of 1942, as the Ministry of Fuel and Power (Petroleum Department) made clear with fine precision, the rules had tightened in a way that prohibited any further drives to Wales.

> Any allowance of motor fuel which may hereafter be made to you for use in your private car, is to be treated as issued subject to the condition that it shall be used solely for journeys (necessitated by duties of your Office as Dean of Canterbury) for which other means of transport are not reasonably practicable, within the area bounded on the North by a line drawn from West to East, through a point thirty-five miles North of Charing Cross, on the West by a line by a line drawn from North to South through a point thirty-five miles West of Charing Cross, and on the remaining sides by the sea.[12]

Johnson's accounts of his early car journeys to and from Harlech, sometimes in the blacked-out darkness of wartime Britain, were rarely without incident. Several times he found himself lost when signposts had been removed or falsified, and on one occasion he was tricked by an ostensibly helpful man who, having hitched a lift to his own home on the back of an assurance that it was on Johnson's route, then left him stranded in the middle of nowhere. There were breakdowns – a leaky radiator at Dinas Mawddwy and a punctured tyre at Welshpool – and twice Johnson was stopped by the police for lighting offences. On the second occasion he pulled rank.

> The police pulled me up for too high lights at Faversham and that means being reported *twice*. So I went to the Chief Constable here early this morning and he is sending a constable to try the lamps with me tonight. So it will settle the trouble, I think, but it was worrying until I saw the Chief. I don't want to appear in court.[13]

Journeys that gave him an opportunity to talk to people about Russia were, in Johnson's view, never wasted ones. Often he picked up hitch-hikers, usually servicemen, and twice he was stopped by the police and asked to take some soldiers to the next town.[14] By Johnson's own account, the conversations with his passengers invariably turned towards communism, and when on one occasion his two passengers were destined for the barracks at Canterbury, the journey climaxed at the deanery with the presentation of signed copies of *The Socialist Sixth of the World*. A night journey from Harlech to Canterbury in July 1942 gave him an opportunity, rarely missed, of doing whatever he could to help those he encountered on his travels.

> I had a lovely drive to Birmingham. I rested at 1 o'clock on the top of a hill between Dinas Mawddwy and Welshpool where I ate your excellent sandwiches and then slept till 2, reaching Welshpool at 3, Shrewsbury at 4 and Smethwick at 6.30 in time for a light supper [before speaking at a public meeting]. I left [Smethwick] at 10.45 and reached Birmingham at 11.15 and, escaping Coventry by a by-pass south of it, drew up at a lorryman's café and had bread and butter and cheese and tea with the lorrymen and had a good talk. They told me very bitterly of the rule which made them obliged to exceed the speed limit in order to deliver the goods to the docks in London at a certain hour. If the police catch them they have to pay the fine and get their licence endorsed. I got them to write down concrete particulars and send them to me and I would do what I could about it.[15]

Some journeys were notable for the gastronomic delights that could be found even in wartime Britain.

> I left Crewe at 11.30 [p.m.] and never stopped driving till 6.15 and had breakfast at Towcester at 8.30 – lovely warm room and *such* a breakfast – plate *crammed* with bacon, bacon gravy, poached egg and tomatoes. Rolls, farm butter, milk, sugar and marmalade and only 2/6d. That kept me going till I reached Canterbury at 2.30.[16]

* * *

As the war progressed and his petrol allowance became squeezed, Hewlett Johnson took to travelling by train. Again, his journeys were rarely without incident as carriages became increasingly crowded and timetables less reliable. The V1 flying bombs and V2 rockets caused havoc in 1943 and 1944 when they landed on the tracks in and around London. 'Travelling in London is no fun,' Hewlett wrote to Nowell in July 1944. 'The train at Victoria was delayed, I think, by a bomb. Victoria station has been badly hit, and the damage was much extended along the line during the week.'[17] On a journey to Brighton, Johnson decided to avoid London by travelling along the coast as he feared there was a good chance of a bombing raid in the capital. In the event, the journey to Brighton was uneventful, but on the return leg: 'I saw four bombs pass over, and at another station, where we stopped for twenty minutes, two blown to pieces in the air by planes – a grand sight.'[18] Generally, though, Johnson found little in the passing scenery to engage his interest and much to dismay him. The urban landscapes of the midlands and the north were, he thought, particularly depressing and represented all that was ugly and unlovely in England. Writing about a journey to Newark, where he addressed a large meeting, he told Nowell that although the journey itself was comfortable, 'the day was dreary to the last degree, rain and gloom and industrial filth over everything. I don't like the east of England and I don't like industrialisation.'[19]

Getting from Llys Tanwg to one of the main junctions could be a trying experience. Hewlett Johnson's usual practice was to travel from Llandanwg station to Ruabon and then pick up a connection to Birmingham. Sometimes the journey went well, sometimes not.

> It certainly was a wet walk [to Llandanwg station], a driving wind and rain. A wretched train came in from Harlech 20 minutes before mine was due and I thought it was mine and the clocks must be wrong and

that I had missed it again. I had 25 minutes to wait which was well because I dried at a good fire: my coat was soaking and the rain came through to my knees. But I stuffed a sock between the wet breeches and my dry legs, and in a very hot carriage dried out absolutely without a suspicion of cold. How clever? A crowded train and I was very glad of Lorne's excellent meal which more than sufficed, and there is some for tonight's train. For I am now seated, in extravagant luxury, in the Paddington Station lounge [en route to a speaking engagement in Somerset] enjoying a good 1/6d tea.[20]

Johnson sometimes paid extra for a first-class ticket, as when he forked out 2s 3d to join Sir Clough Williams-Ellis ('he is very interesting and friendly') from Ruabon to Birmingham;[21] but he seems usually to have taken his chances in third-class. The difference could be striking, as he reported to Nowell when he travelled from Ruabon to Chesterfield (where he was speaking at a public meeting) via Birmingham and Derby.

How I got in the Birmingham train at Ruabon I don't know. I gave it up once. Piles left on the platform. The next train at 1 was impossible for my meeting, but I squeezed in after a baby boy who was under our feet and we got the mother with him in the passage between the two doors – not even in the corridor where 17 of us were jammed. Then another still more packed train most of the way to Derby. The egg and tomato descended on my head from the upturned bag on the rack: they bowled onto the floor and both tasted *excellent*! I was glad of them. I got coffee at Ruabon and tea here [at Derby]: there was a great crush and no system.[22]

Returning from a visit to Llys Tanwg in the summer of 1943, Hewlett Johnson was the victim of an awkward theft at Birmingham.

I put your case with my night things and £4 or £5 and all my colours and some vests etc in it while I got an address book out to direct an envelope. When I stooped to pick it up it had *gone*! And remains gone. Very vexing. But I try to take it rationally. My diary was also in it, and my long black stockings and handkerchiefs, and the big black stock that I use at Harlech, and my new razor and tooth brush, and all my pocket odds and ends which I had thrust into it at the last moment, and my blacking outfit![23]

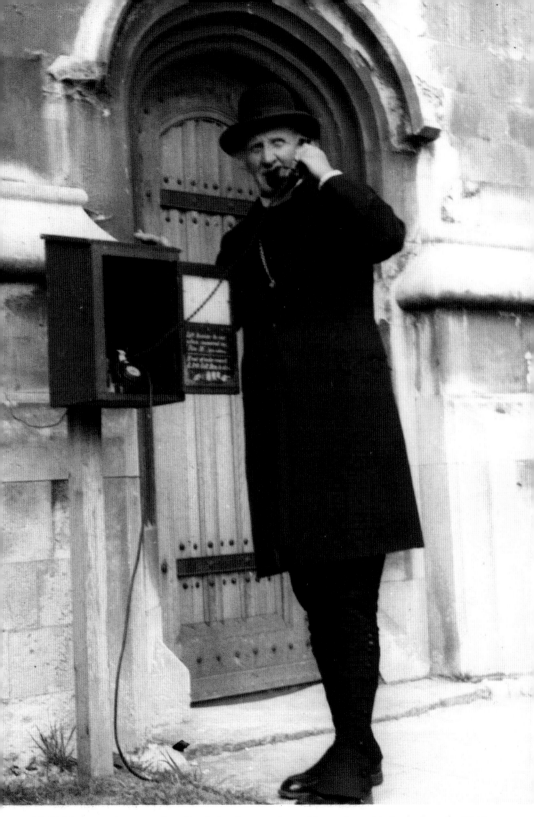

25. Taking part in a wartime fire brigade exercise at Canterbury Cathedral, early 1940s.

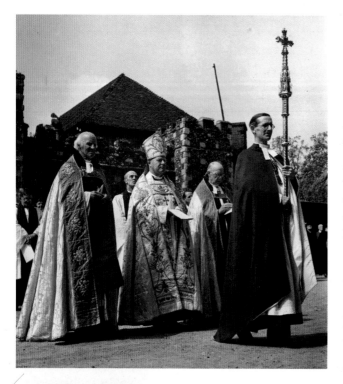

26. The enthronement of Archbishop William Temple, April 1942. Temple is flanked on his right by Hewlett Johnson and on his left by his chaplain Ian White-Thomson, later to succeed Johnson as Dean of Canterbury Cathedral.

27. Hewlett Johnson inspecting damaged buildings in The Burgate, Canterbury, following the bombing raid on 31 May/1 June 1942.

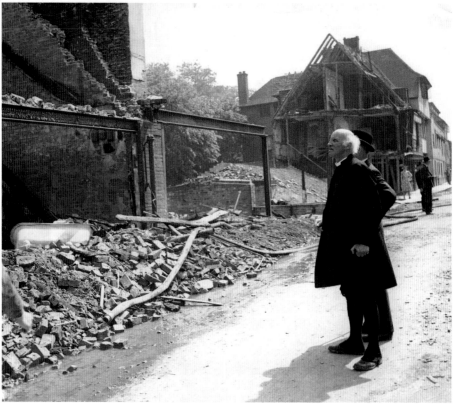

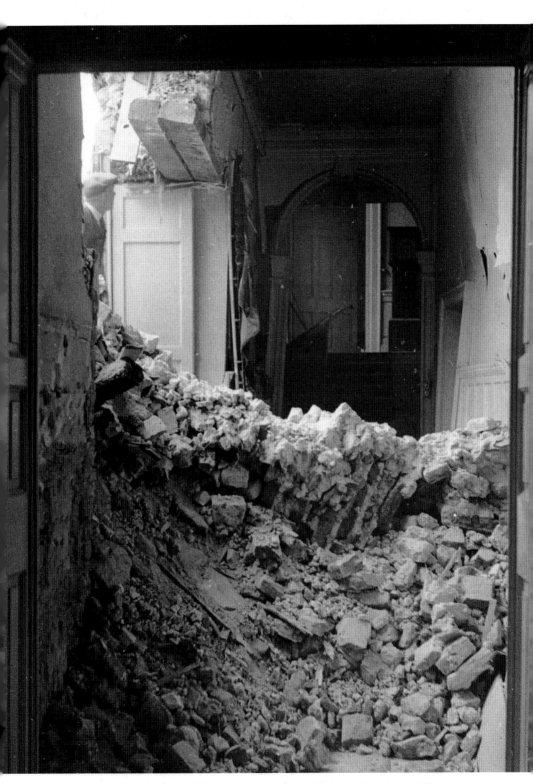

28. Bomb damage in the front hall of the Canterbury deanery, October 1940.

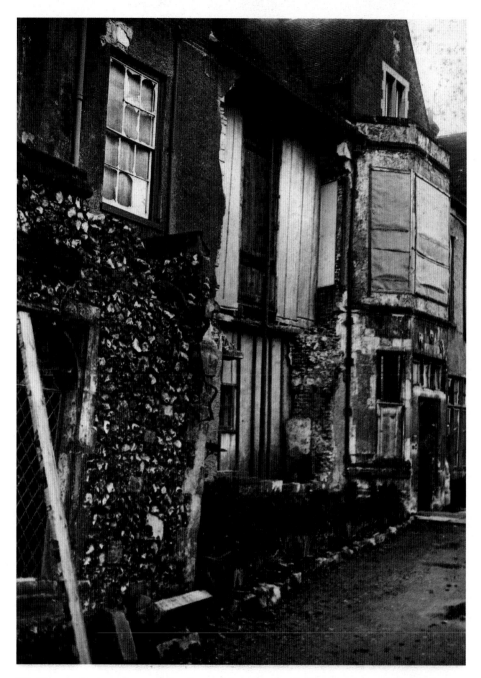

29. The patched-up front of the Canterbury deanery following damage caused by bombing raids in October 1940.

30. Hewlett Johnson inspecting damage in the precincts following the bombing raid on 31 May/1 June 1942.

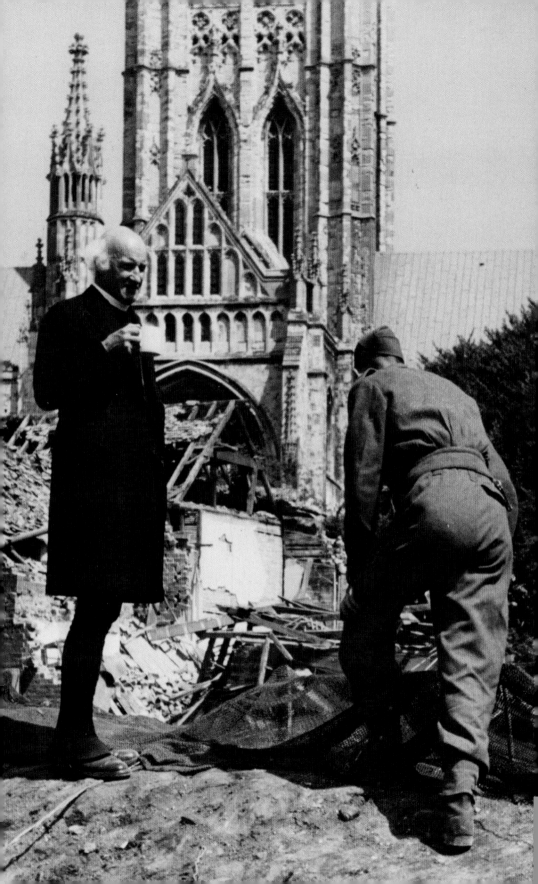

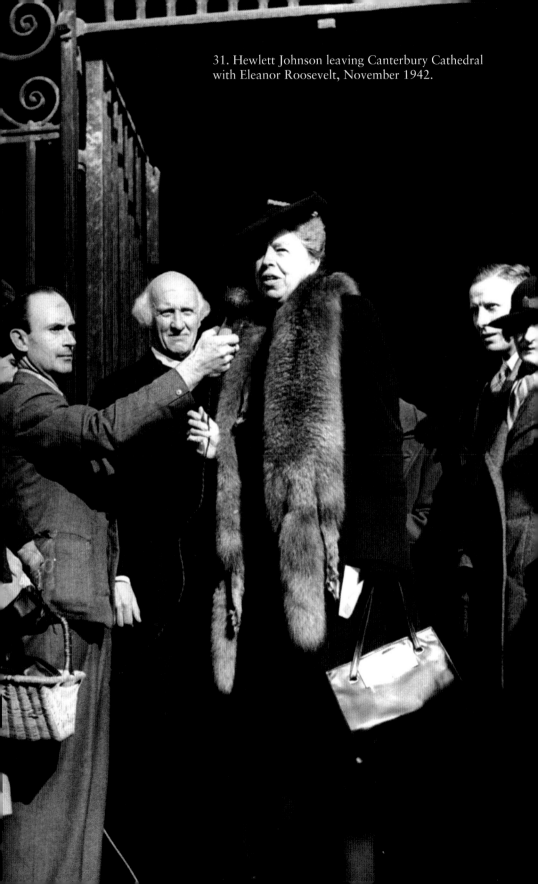

31. Hewlett Johnson leaving Canterbury Cathedral with Eleanor Roosevelt, November 1942.

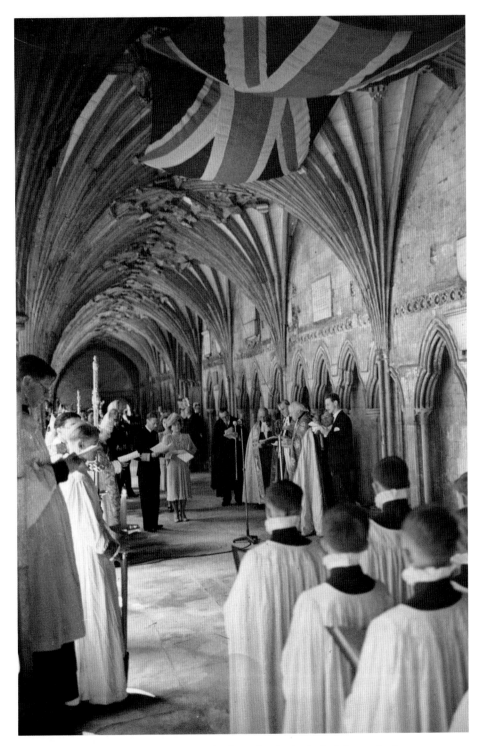

32. King George VI and Queen Elizabeth in the Cathedral cloisters during a visit to Canterbury Cathedral for a thanksgiving service in 1946. Hewlett Johnson and Archbishop Geoffrey Fisher are also visible in the picture.

33. Margaret Babington, Honorary Steward of the Friends of Canterbury Cathedral, circa 1945.

34. The enthronement of Archbishop Geoffrey Fisher in Canterbury Cathedral, April 1945. Fisher is flanked on his right by Hewlett Johnson and on his left by the Archdeacon of Canterbury, Alex Sargent.

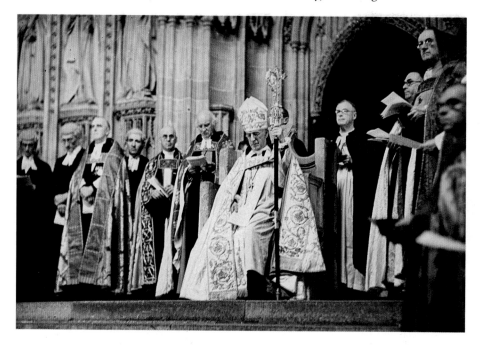

35. Hewlett Johnson with Alfred D'Eye (second from left) and VOKS
guide Inna Koulakovskaya in Leningrad, 1945.

36. Field Marshall Sir Bernard Montgomery accepting the Freedom of
the City of Canterbury, October 1945. Hewlett Johnson and
Archbishop Geoffrey Fisher are also visible in the picture.

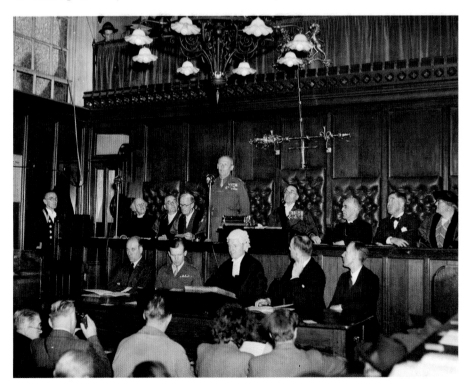

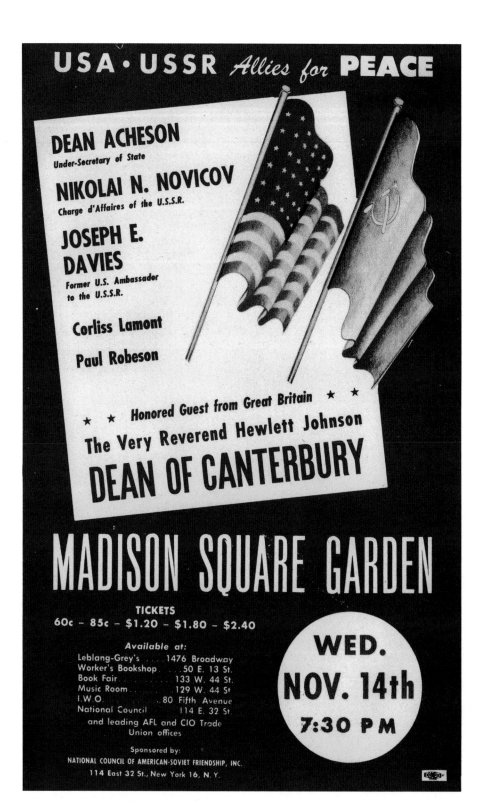

37. Poster for the rally in Madison Square Garden, New York, November 1946.

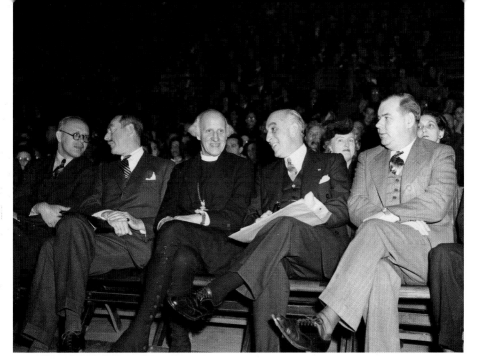

38. Hewlett Johnson at Madison Square Garden, November 1946, with (from left) Nikolai Novikov, Dean Acheson, Joseph E Davies, and union leader Albert Fitzgerald.

39. Hewlett Johnson speaking at Madison Square Garden, November 1946.

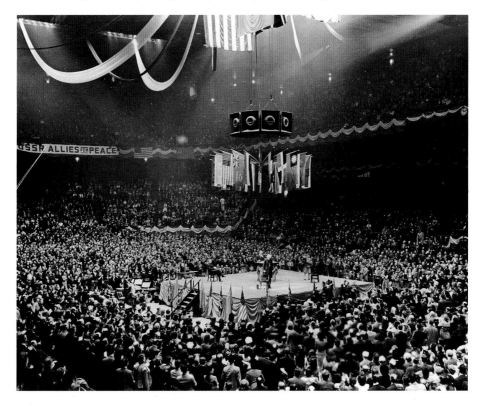

40. With the actor
Charlie Chaplin (left)
and the American
chemist and peace
activist Linus Pauling
(centre), late 1940s.

41. Hewlett, Kezia
and Nowell Johnson
in the Canterbury
deanery, circa 1946.

42. Hewlett Johnson taking tea with his family in the Canterbury deanery, 1948.

43. With Patriarch Alexei of Moscow (third from left) and
Metropolitan Nicolai of Kiev (far right) in Moscow, 1945.

44. Being welcomed on arrival in Australia, April 1950.

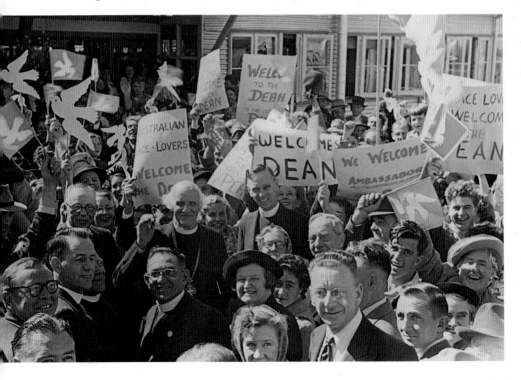

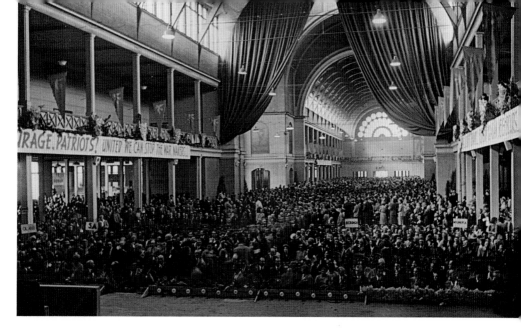

45. Hewlett Johnson's audience at the National Peace Congress in the Melbourne Exhibition Building, April 1950.

46. Hewlett Johnson with Pablo Picasso (second from right) and other delegates at the World Peace Conference in Warsaw, November 1950.

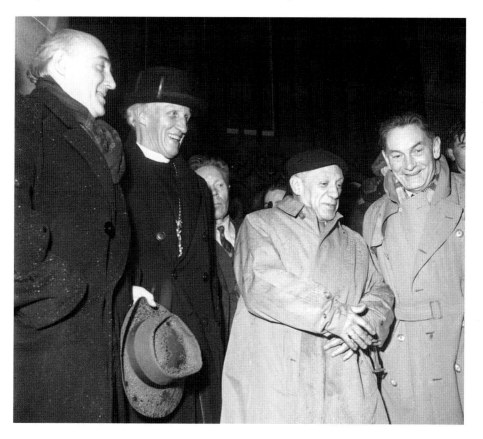

47. Hewlett Johnson speaking at a peace rally in about 1950.

The final part of the railway journey home, from London to Canterbury, was often the worst. For some reason, engines had sometimes to be changed at Chilham (two stops before Canterbury) and tiresomely long waits could ensue. Johnson described sitting in the complete darkness of a blacked-out carriage at Chilham station watching the red glows as his fellow passengers drew on their cigarettes. In the summer of 1944 he described an encounter with a family at Chilham station that revealed not only his deep gratitude for the privileges of his own life but also a rough sympathy for a family far less favoured than his own.

> I got back safely last night. A family of 8 – a mother and a pack of small, ill kempt and ill behaved little creatures – were at Chilham wait-ing for the train. I talked with her. Her home in Deptford had gone, and they were all in the shelter when *it* was bombed. A rescue party got them out: they expected to see them all dead and the first man to reach them fainted, but none were hurt. But the haunted look on the poor woman's face and the whole of that miserable family – she ought never to have had that pack of children – was a lurid light on our civilisation and in vivid contrast to the loveliness of Canterbury and its services and our own babes.[24]

* * *

On Saturday 7 October 1944 Nowell wrote in her diary: 'Hewlett, self, Kezia, Keren, Lily and Norma travelled from Harlech to Charing, leaving on 6.35 a.m. train, carriage through to London, where we were met by Fred with the car. Waited at Paddington Hotel. Lily and Norma went on by train, we went by car. Greeted by Freda at The Towers,[25] with every-thing very nice.' The long family separation was over.

CHAPTER TWELVE
VICTORY IN EUROPE

B Y THE BEGINNING of 1945 the face of Canterbury had changed dramat-
ically from the day of Kezia's christening in May 1940. Although the
Cathedral itself had escaped serious damage, the precincts had been devas-
tated and much of the city laid to waste. Thirty-five separate bombing raids
had been made on Canterbury, in the course of which 445 high explosive
bombs and over 10,000 incendiary bombs had been dropped. One German
bomber, a twin-engine Junkers 88, had crashed in the city and one V1
flying bomb had fallen on it. Seven hundred and thirty-one houses had
been destroyed and a further 954 damaged. One hundred and fifteen
people had been killed, 140 seriously injured, and 240 slightly injured.[1]
Everywhere work was starting on clearing the rubble, demolishing build-
ings that could not be salvaged, and repairing those that could. The dean-
ery was among the first buildings in the precincts to be tackled, work
beginning shortly after the scaffolding was erected in September 1944.[2]

Changes were also occurring in the Cathedral community. The King's
School, including Junior King's and the Choir School, was about to return
from its wartime exile in Cornwall. From Hewlett Johnson's perspective it
was both good and bad news – good because it enabled the formation of
a much enlarged choir as the returning Choir School merged with the
remnant that had sung throughout the war, and bad because it brought the
King's School headmaster, Canon John Shirley, back to Canterbury as a
resident thorn in the Dean's flesh. Changes were also occurring in the
Chapter: Canon John Crum had left and Thomas Sopwith had been
replaced as Archdeacon of Canterbury by Alex Sargent. Julian Bickersteth
had joined the Chapter as the new Archdeacon of Maidstone and Canon
Frederick MacNutt was about to give way to Canon Aubrey Standen.
These, with few subsequent changes, were to be the men who would steer
the Cathedral through the first decade of the peace.[3]

There had also been a change at the very top of the Anglican hierarchy
when Archbishop William Temple died suddenly in October 1944. Though
he and Hewlett Johnson had never enjoyed as close a relationship as many

expected, they had worked harmoniously together through the two diffi-
cult wartime years of Temple's archiepiscopacy. Johnson described his
death as 'an incalculable loss not only to Canterbury but to the Church
throughout the world.'[4] He had good reason to be grateful, for Temple had
sometimes gone out of his way to facilitate Johnson's more controversial
activities. In 1942, for example, the Archbishop had somehow persuaded
the Ministry of Fuel and Power to regard the Dean's efforts in promoting
a sympathetic understanding of the Russian people as a legitimate part of
his decanal duties for the purpose of determining his petrol allowance.[5] It
was probably Frances Temple whose loss from the precincts was felt the
more personally by Hewlett Johnson, for theirs had been a long and close
relationship. She had written a tender letter of condolence to him when his
first wife died in 1931, and during the worst of the war she 'used to visit
us in the bombed Deanery, coming in and out with no ceremony, ignoring
dust and dirt and rubble, radiating cheerfulness and leaving a happy atmos-
phere behind her'.[6] William Temple was succeeded as Archbishop of
Canterbury by Geoffrey Fisher, who was enthroned in April 1945. Of the
four archbishops whom Johnson served, Fisher was the least sympathetic
to the things he believed in, and (as will be seen) some tetchy exchanges
were to take place between the deanery and Lambeth Palace over the
sixteen years of his archiepiscopacy.

Victory in Europe (VE) Day was celebrated in Western Europe on
8 May 1945. Throughout Britain it was a day for relief, thanksgiving
and celebration. Streets in Canterbury were festooned with bunting
and the Westgate Towers, the river and the Christchurch Gateway were
all floodlit. The festivities were reported in the *Kentish Gazette and
Canterbury Press*.

> People packed the streets, full of good humour. Soldiers had the day off
> and joined the throng. ... In the afternoon there were tea parties for
> children in the gaily-bedecked streets. ... The citizens flocked to the
> Cathedral on Victory in Europe morning, and crowded the great Nave
> for the act of Thanksgiving. The mighty congregation included the
> Mayor and members of the City Council, and many men and women
> of the Services.[7]

One person was conspicuous by his absence: the Dean of Canterbury. He
was in Moscow.

* * *

At the end of April 1945, a few days after Geoffrey Fisher's enthronement as Archbishop, Hewlett Johnson left Canterbury for a three-month visit to the Soviet Union, Poland and Czechoslovakia. He was now seventy-one. He had been invited by VOKS and was accompanied by Alfred D'Eye. The visit was partly a 'reward' for the extraordinary work they had both done for the Joint Committee for Soviet Aid, which through its nation-wide fund-raising efforts had sent large quantities of supplies and equipment to the beleaguered cities of Russia.

> We collected, through the unselfish work of many local committees throughout the country, a million and a quarter pounds, as well as many blankets, garments and medical supplies. Some of our best X-Ray equipment was got into Leningrad during the siege, and D'Eye and I were to see it later ... and hear of the fine service it had done. We also supplied all the equipment for the Stalingrad Hospital, and when we visited it saw the memorial book with its fine heraldry and the names of British towns and villages and factories whose contributions had made the gift possible.[8]

Johnson and D'Eye were treated with uncommon respect and generosity, beginning with their welcome at Moscow airport by Mr Kemenov of VOKS and Madame Maisky, the wife of the former Russian ambassador to Britain.[9]

> Every facility was afforded me for speedy travel. I expressed a wish to go to Leningrad: a plane took me there; to Armenia on a special date and for a special mission: a plane took me there. The same with Stalingrad and Asia: a special plane, manned by the men who flew Molotov to San Francisco, took me there too. Special planes took me to Warsaw, Cracow and Danzig, and also to Prague.[10]

Because of the time difference, VE Day was celebrated in Moscow on 9 May. The day began for Hewlett Johnson at the British Embassy where he preached at a service of thanksgiving attended by, among others, Mrs Clementine Churchill, who had also been invited to the Soviet Union in recognition of her work for the Russian Red Cross Fund.[11] In the afternoon Johnson and D'Eye visited Patriarch Alexei of Moscow and Metropolitan Nicolai of Kiev, two of the highest clerics in the Russian Orthodox Church. After 'friendly talks and customary toasts', the Patriarch, a 'noble figure with a handsome face and long uncut hair and beard', presented

Johnson with 'a magnificent jewelled enamelled crucifix suspended by a massive gold chain' which he placed around the Dean's neck.[12] The Dean treasured the crucifix for the rest of his life, never failing to wear it whenever he was in public. It was an act that repeatedly annoyed Archbishop Geoffrey Fisher who tried in vain to insist that a pectoral cross should be worn only by a bishop. His plea that Johnson might compromise by wearing the crucifix only within the Canterbury precincts, where nobody could possibly mistake him for a bishop, fell on deaf ears.[13]

* * *

Two weeks after VE Day in Moscow, Hewlett Johnson and Alfred D'Eye flew to Poland where they visited Warsaw, Cracow and Gdansk. Part of the purpose of the visit was to assess the state of religion in Poland, and to that end Johnson and D'Eye attended as many church services as they could and spoke to those who were worshipping there. Their conclusions were broadly positive. They found that, while religion in pre-war Poland had been monopolised by the Roman Catholic Church, the post-war goal was one of religious pluralism, reflecting the country's strong Protestant as well as Catholic traditions. Johnson thoroughly approved. That he chose to see the Catholic Church's monopoly as 'fundamentally undemocratic and morally unhealthy'[14] must be read in the context of his antipathy towards the Vatican's unrelenting condemnation of communism; and it is surely no coincidence that the Catholic priest most praised by Johnson (Father Ferdinand Machai, the radical rector of Santa Maria in Cracow) was a member of the Polish-Russian Society for Cultural Relations.

While in Cracow, Johnson and D'Eye were taken by the Polish Commission for Inquiry into German Crimes to Auschwitz, where in late May 1945 they were among the first British observers to enter the concentration camp following its liberation by Soviet troops four months earlier. Johnson's account of the experience, published in *Soviet Success* in 1947, must have been one of the first to expose the evils of Hitler's Aryan project. For this reason, his horrific observations still bear repeating at some length.

> On a strip of malarial land, in a camp designed for 50,000 or 60,000 persons, and always crammed to capacity, 4,000,000 human beings were done to death with German thoroughness, caught in a net from which few ever escaped. ... The cells will always haunt me to my dying day. Inscriptions abound, scratched with human nails on whitewashed walls: 'Nothing to smoke; nothing to eat. It is dark. We sit here twenty-three days.' ... In one cell whose only window was a hole 4½ inches

square through a thick wall and which measured 12 feet by 7 feet and was 8 feet high, an immense number were shut in with no sanitation at all. That cell was found in an indescribable state of filth and stench. ... Those condemned to die entered a large room, and were bidden to strip, preparatory to a bath, and a 'new life'. Then down a corridor, a mingling of women, children, babes and men, they walked or were pushed into a room the size of a narrow tennis court, packed tight with hundreds of victims; savage dogs set at their naked bodies to squeeze the mass still further in; then to the sound of terrifying cries and screams, doors slammed, gas was injected, and in twenty minutes merciful death came. ... When all was still, the corpses were dragged out in two lines past dentists who extracted gold teeth and plates, and barbers who shaved the hair and thence to the furnaces; two bodies on each metal shutter; four in each oven, or under pressure, five. ... Feeling sick, we passed the vast storehouses, their cellars piled with hair – gold, brown, flaxen or grey, some already packed into tight neat bales ready to stuff pillows on which other heads would lie in Germany. In rooms above were mountains of boots, slippers and shoes; mountains of spectacles, brushes, combs and razor blades. ... On the uppermost floor, garments in piles reached to the ceilings.[15]

At one point in the visit a Russian doctor handed Johnson a baby's small woollen vest.

No words were needed to conjure up the scene when a mother's trembling hands had so recently drawn tiny limbs from the sleeves and, pressing the baby's naked body to her own naked body, had entered the death chamber amidst cries, groans, oaths, and screams and the barking of hounds, then the closed doors, the dark, the gas, and at last, death.[16]

Johnson took the vest home with him. And as he was leaving Auschwitz he was handed a white glazed soup dish adorned with the swastika and the letters SS. Raising it in the air, he crashed it violently to the ground where it broke into a thousand pieces on the concrete floor. 'As the echoes died down we all stood in silence and then passed out into the bright sunshine of a late May day. So may the echoes of hateful Nazi Fascism depart forever from God's earth.'[17]

* * *

From Cracow, Hewlett Johnson and Alfred D'Eye flew to Gdansk where, in the pleasant garden suburb of Sopot, they were taken to a villa that had been known officially as the German Institute of Hygiene but had in fact had been a Nazi factory for rendering bodies from the concentration camps.

> It was raining, and as we descended the sodden steps [of the Institute] a Polish Lieutenant turned to me and said: 'You must be prepared for a sight which will hurt your heart'. We entered cellars dimly lit from basement windows. As our eyes grew slowly accustomed to the light, we found ourselves surrounded by ranges upon ranges of red-painted travel-stained steel cases, 5 feet 6 inches long, 4 feet wide and 4 feet deep. Each case was fitted with headless, stiffened corpses, or mutilated fragments of corpses. These bodies numbered 340. Some were headless. Some cut into small pieces for convenient packing. Some had been slit open from neck to abdomen; the large pockets of fat removed, the incision sewn roughly up with string.[18]

Nearby was a long shed, with a chimney and a loft, which was described as the factory's laboratory. It was equipped with all the latest apparatus including vats and boilers complete with stainless steel clamps, handles and taps. 'In that range of rooms human bodies were rendered down by German scientists to make soap for human needs. Scented soap.'[19] Johnson was moved to anger.

> I doubt if ever before war has left so revolting a memorial of human wreckage and depravity as is witnessed by this human soap factory, by these cases of stiffened corpses, and by all this scientific machinery. … There was a devilish coldness and inhumanity about the whole thing. An utter disrespect for life or values of any kind which make it particularly revolting. And this human soap factory is only the final stage of one vast process of human murder, the end of the belt of mass destruction of human life and values.[20]

* * *

After their disturbing experiences in Cracow and Gdansk, Hewlett Johnson and Alfred D'Eye returned to Moscow, where Johnson was able to pick up letters from Nowell that had been opened and presumably read by the British censor.[21] They then flew to Stalingrad where they inspected the ruined streets and collapsed buildings before meeting and dining with Alexander Karaganov, the Vice-President of VOKS.[22] Johnson's idealistic

description of Karaganov sits oddly with the deeply political purposes of VOKS and its manipulative behaviour towards its guests.

> Karaganov is a handsome youth who enjoys life to the full, eager to swim in the Volga and eat a merry lunch beneath the trees. Eager for argument or discussion on any matter social or literary, and affording many sidelights on the young Soviet mind. Discussing labour efficiency and output of work with him, I urged that though Russia's Total Plan, preventing useless and unsocial work, free from boom, depression and unemployment, was admirable, yet in minor matters our efficiency often succeeded theirs: our universal use, for example, of pickaxes instead of crowbars or of barrows wheeled by one instead of boxes with poles carried by two.[23]

There is an obvious temptation to read this passage almost as a piece of mild satire. Did Johnson *really* take at face value this handsome youth who swam in the Volga and ate a merry lunch beneath the trees while enjoying a conversation about the relative merits of pickaxes and crowbars? Much the same question arises in the case of Inna Koulakovskaya, Johnson's VOKS guide on the Asian part of his visit. An attractive woman in her late twenties,[24] she was eulogised by the Dean as a romantically impossible paragon of feminine virtue. She read Chaucer in the original and had translated J B Priestley's play *An Inspector Calls* in five days. It was currently playing in Moscow. She was fluent in French and English and could discuss literature, philosophy and theology. She was sincere, modest, thoughtful and witty, never flagging in her duties as a VOKS guide and never making any mistakes.[25] And to crown these abundant gifts and graces, Inna Koulakovskaya had served in the Red Army, was married to the man who was now the chief editor of VOKS, and had a three-year-old child. She had also raced the Dean around the Great Square in Leningrad on a bicycle.[26] Again, one wonders whether Johnson was making gentle fun of a young woman who may have been trying too hard to impress her charges. But no: it seems that he genuinely and openly accepted both her and Alexander Karaganov as bright and personable young Russians who felt truly privileged to be showing their great country to an elderly English clergyman. The truth about their relationship with the Dean of Canterbury is likely to be rather more complex. What, one wonders, did *they* have to say about *him* in the reports they filed with VOKS?

As their tour continued, Johnson and D'Eye went from Stalingrad to Armenia where they attended the consecration of the Catholicos, the

formal title of the Archbishop of the Armenian Apostolic Church. The ceremony took place in the cathedral at Echmiadzin, one of the oldest Christian buildings in the world, and was attended by delegates from Armenian churches in Europe, Asia, Africa and America. It was, by Hewlett Johnson's own account, a marvellously colourful and symbolic occasion made even more significant in his description of it by his need to underscore the freedom of Christian worship in the Soviet satellite states. He himself was selectively favoured at the ceremony, though whether on account of his fame in the Soviet Union or because he was mistakenly thought to be the Archbishop of Canterbury (a common enough occurrence) is unclear.

> The favoured few, after the hierarchy had done homage, advanced and, kneeling, kissed the old man's hand. As he kissed me warmly on the face I wondered if ever before had a member of the Anglican Church shared in any similar Service of Consecration in that same cathedral church.[27]

The honour was reciprocated in 1956 when the new Catholicos visited Canterbury. In his speech of welcome in Canterbury Cathedral, Hewlett Johnson recalled the 'ever memorable service when your saintly predecessor was consecrated to his great office', and (perhaps with half an eye towards Archbishop Geoffrey Fisher) he recaptured some of the highlights of the time he had spent in Armenia as Canterbury's representative at the ceremony.

> With you I shared the festivities of a glorious week, with your delegates from the four quarters of the globe, visiting your great Lake Seven and your noble theatre where we saw our own Shakespeare's *Othello* superbly played, then, at night time, watched the moon shed its light on the glorious peak of Ararat – who can forget that week?[28]

* * *

The undoubted highlight of Hewlett Johnson's three-month visit to Eastern Europe came on 12 July 1945 when he was summoned to a private audience in the Kremlin with Joseph Stalin and Vyacheslav Molotov, a man whom Winston Churchill described in *The Gathering Storm* as a politician of outstanding ability and cold-blooded ruthlessness. Johnson was given two hours' notice of the audience, which began at 8.00 p.m. and lasted for fifty minutes. It was a rare honour. Even foreign ambassadors could spend years on the Moscow political circuit without personally meeting the Generalissimo, yet here was the Dean of Canterbury being granted a

private interview with him in the depths of the Kremlin. Why? There are no certain answers. He had, it is true, achieved a measure of international fame as an articulate apologist of Stalin's regime – but so had other equally well-known people from all walks of life. He had also, through the Joint Committee for Soviet Aid, raised a great deal of money to help the Russian victims of the German occupation – but Mrs Churchill had raised even more through the Red Cross Aid to Russia Fund. And it could scarcely have been a recognition of Johnson's political standing, for Kremlin analysts must have known that he had little if any influence in Church House and none whatsoever in Whitehall. Why, then, was the Dean of Canterbury the beneficiary of such a rare privilege? And what was in it for Stalin and Molotov?

The short answer is that we don't know. The only account of the conversation is Johnson's own,[29] and in at least one respect it is demonstrably false. Although the meeting took place on 12 July, a week after the British general election that had brought Clement Attlee and the Labour Party to power, Johnson reported that he and Stalin had spoken about the *forthcoming* British elections.

> I assured him that if not at this election certainly at its successor the Labour Party would be returned to power.[30]

To add to the difficulty of understanding the purpose of the audience, Johnson cast himself as the main contributor to the conversation, with Stalin adding the odd question or affirmation, nodding his encouragement, and only occasionally making a point of substance. A great deal of reading between the lines is therefore needed to extract any useful conclusions.

The initial exchanges were bland. Stalin asked if Johnson had enjoyed his trip to Armenia and the Caucasus and Johnson replied that he had been 'deeply impressed' with all he had seen there. The conversation then moved easily on to Georgia, Stalin's homeland, where Johnson spoke sycophantically (or perhaps nervously) about his visit.

> I visited the cottage where your Excellency was born. The new setting of marble which protects your old home in no way clashes with the little house it shelters. The gardens were full of bloom and I was presented with an armful of roses. Next I visited the seminary in Tbilisi where you were taught and the small suburban house in whose deep and hidden cellar you operated your illegal press. It was clever work.[31]

He then recounted how he had stood bareheaded before the tomb of Stalin's mother in a church above Tbilisi. Stalin said: 'My mother was a simple woman'. Johnson replied: 'A good woman. One often sees the mother in the disposition of the child.'[32]

The conversation then turned to weightier matters as Hewlett Johnson asked Stalin if he could suggest ways of fostering understanding between their two countries in the post-war era. It is here, one senses, that Stalin delivered the first of two messages that he wanted Johnson to broadcast on his return to Britain.

> We were friends in the war. That was natural enough, confronted as we were by a common and terrible foe. Now the Germans are beaten ... it will be less easy to avoid friction. But we desire it, and we want to keep firm the unity already achieved not only by words but by deeds. We have no wish whatsoever to hurt England. We would act towards England as friends. ... Whether we succeed or not will depend largely on your politicians. If they have the will, we have the will.[33]

Stalin and Johnson then exchanged sympathetic comments about the anti-Soviet bias of the British and American press, largely owned as it was by 'the wealthy class'. Stalin exchanged glances with Molotov when Johnson spoke of his membership of the editorial board of the *Daily Worker*, whose circulation of 100,000 copies could have been five-fold greater if more paper had been available. The *Daily Worker* consistently published the truth about the Soviet Union, Johnson said, but most of the British press had belittled Russia's strength and determination – especially its military strength – throughout the war.

Hewlett Johnson next asked if he could talk about the 'religious question' in the Soviet Union, to which Stalin nodded his assent. The Dean observed that although the stories reaching the West about the suppression of religious freedoms in Russia were 'not unbiased' – indeed, they were positively exaggerated – nevertheless the question of religious freedom had always loomed large in the minds of British Christians. Stalin responded with the second of the messages that he seemingly wanted Johnson to take home with him. He explained that, since the Patriarch of the Russian Orthodox Church had pronounced an anathema on the Soviet government shortly after the October Revolution, the state had had no option but to defend itself. In any case, the church had been far too closely identified in most people's minds with the discredited regime of the Tsars. 'But all that is now gone', Stalin added, 'and the war has created a new and different

situation. The war has revealed to the Church the patriotism of the State and to the State the patriotism of the Church.'[34] And a little later, after Johnson had delivered a mini-sermon about how those who professed belief in a God of justice and love acted as if they did not, while those who denied it acted as if they did, Stalin repeated the message to make sure the Dean had really understood it. 'Religion,' he said, 'is a matter of conscience. Conscience cannot be ignored. Worship and religion are free.'[35] It was what Johnson wanted to hear.

Finally, after some remarks about the Soviet medical system and the importance of encouraging the free movement of people between Britain and the Soviet Union, Hewlett Johnson ventured to raise a final issue.

> I speak with diffidence and hesitation, for I would avoid all appearance of meddling with your internal affairs; but one matter, small in comparison with greater affairs but apt to cause ill-feeling out of all proportion to its magnitude, troubles us, and we are anxious to remove any and every unnecessary cause of friction between our peoples.[36]

After Stalin beckoned him to proceed, Johnson drew his attention to the thirty or so Englishmen who had married Russian women but who, having recently been ordered out of the Soviet Union, were not allowed to take their wives with them. Could this hardship be remedied? Stalin flashed a questioning glance at Molotov who smiled and nodded his assent. 'Something will be done,' Stalin said, but then amended his response: 'Something will probably be done: it is a matter for the decision by the Supreme Soviet.'[37] And then the interview was over. Johnson thanked Stalin for his courtesy in seeing him and ended by 'assuring him that we recognised how much workers and others in my own country and indeed in all the world owed to him and his people for their mighty share in smashing fascism and introducing a new planned order into the world'.[38] Stalin bowed, hands were shaken, and Hewlett Johnson quickly found himself standing outside the walls of the Kremlin scarcely able to believe that, moments before, he had been closeted with one of the most powerful men in the world.

* * *

What was the audience all about? It is difficult to say, for Hewlett John-son's account of the conversation suggests that it was largely devoid of direction or structure. There had evidently been no agenda. At face value, the interview allowed Stalin to make a couple of forceful points (about peace with Britain and the freedom of religious worship in the Soviet

Union) that he presumably hoped the Dean would take with him on his travels, and it allowed Johnson to establish his credentials as an ardent fellow-traveller and Russophile. It also reinforced his belief in Stalin as a man of peace, wisdom, honesty, good humour and sincerity. But were these relatively modest outcomes enough to justify Stalin's invitation to the Dean to come and chat? Or did he and Molotov have a hidden agenda that Johnson simply failed to perceive? There is, after all, an air of naivety about Johnson's account of the meeting, portraying himself as rather too eager to please and taking everything that Stalin said at face value. He was, of course, careful to observe all the courtesies expected of the guest of one of the most powerful men in the world, but he seems to have seen the conversation as one between equals in which he asked as many questions as Stalin and (at least by his own account) did most of the talking.

Yet it takes no great feat of the imagination to sense that the reality must have been rather different, for it was plainly *not* a meeting of equals. Stalin knew why Hewlett Johnson had been summoned; Johnson had no idea of the reason and was never told. Against two ruthless political operators who held all the aces, the Dean presented himself as precisely the person he was – a trusting man of God who always assumed that other people's motives were as honest and transparent as his own. Something is missing from the story that cannot now be recovered. Did the encounter have political connections to Johnson's earlier meeting with Patriarch Alexei of Moscow and Metropolitan Nicolai of Kiev? Was the timing of the audience related in any way to the Potsdam Conference that started only five days later? Did Stalin perhaps believe that Johnson had the personal charisma to underscore his credentials as a trustworthy world leader with whom the West could do business? The questions will never be answered. It does, though, seem improbable that Stalin, with all the huge issues piling up around him, called the Dean of Canterbury in merely for a pleasant talk about matters of common interest.

* * *

Hewlett Johnson and Alfred D'Eye returned home from the Soviet Union via Czechoslovakia where they toured the Skoda works and had lunch with President Edvard Beneš.[39] By now, after three months away from Canterbury, the two travellers were keen to return home and they enquired at the British Embassy in Prague about the earliest flight available. Having at first been told that they would have to wait four days, they were then informed that, if they were ready in an hour and a half, a plane could be found to take them. The rest of the story is pure *Boy's Own Paper* stuff.

I said, 'I have much luggage, including a large portrait.' 'You can take any luggage up to four tons', they said. So we hurried, collected our luggage and reached the plane in time; a British bomber plane. There were no passengers but ourselves. D'Eye went forward with the pilot, who said to him: 'Where shall I drop you in England?' D'Eye replied: 'Manston [some fifteen miles from Canterbury] would be very convenient.' So we landed at Manston and a car carried us to the Deanery, and a lorry carried the luggage.[40]

Hewlett Johnson's war was now over, but his Deanship still had a long way to go. Indeed, at the age of seventy-one he was some way short even of the halfway mark, and many more controversies still lay ahead.

TAKING AMERICA
BY STORM

B Y AUGUST 1945, when Hewlett Johnson resumed his decanal duties
following his and Alfred D'Eye's visit to the Soviet Union and Eastern
Europe, the world was beginning the long, painful and dangerous process
of adjustment to the political realities of peace. In fact a great deal had
been changing even as the two were on their travels. Just before their depar-
ture at the end of April 1945 the battle for Berlin was reaching its crescendo
as Russian troops surrounded the city and the bloody endgame began on
the devastated streets. On 30 April Adolf Hitler committed suicide in his
bunker and three days later Berlin capitulated. The triumphal celebrations
in Moscow on VE Day were unsullied by any premonition of the events
that were soon to turn the Soviet Union into Western Europe's iconic foe.
On 16 July 1945, four days after Johnson's audience with Stalin in the
Kremlin, America successfully tested an atomic bomb in the deserts of New
Mexico, and on the following day the conference began at Potsdam that
was to map out the shape of post-war Europe. Germany's eastern border
was moved westwards to the Oder-Neissen line and parts of Poland's east-
ern territories were permanently annexed to the Soviet Union. The politi-
cal morphology of Central and Eastern Europe was shifting dramatically:
Stalin had already annexed Estonia, Latvia and Lithuania, and by 1948
Poland, Czechoslovakia, Hungary, Albania, Bulgaria and Rumania had
become Soviet satellite states.

Beyond Europe, another terrifying threat to global peace was erupting
even as Hewlett Johnson was settling back into the civilising rhythms of
cathedral life. On 6 August 1945 America dropped an atomic bomb on
Hiroshima followed three days later by another on Nagasaki. About a
hundred thousand Japanese citizens died in the two attacks and a similar
number were injured. A moral threshold seemed to have been crossed that
threatened to strip away another veil of human innocence and plunge the
world into an uncertain future of blackmail and fear. And when the Soviet
Union successfully tested its own atomic bomb in 1949, Europe suddenly
seemed a million miles from the heady celebrations of VE Day four short

years earlier with its bonfires and buntings, its joy and jubilation, its happi-
ness and hope.

Although conversions can rarely be dated with any precision, the
threats to European and world peace that began to unfold in the wake of
Potsdam and Hiroshima marked a distinctive shift in the political message
that Hewlett Johnson now began to preach. Until this point, his core argu-
ments had revolved around the moral, social and economic superiority of
communism over capitalism – a superiority, so he believed, that was explic-
itly sanctioned by the Christian gospel. Now, without retreating from those
arguments, he came to see their relevance to far wider issues of peace as the
world began to divide on dangerously ideological lines. If the remaining
decades of the century were to be defined by a mutual suspicion between
capitalist and communist super-powers, each rapidly acquiring enough
nuclear weapons to blow the planet to bits, there was an urgent need for
understanding and respect on *both* sides of the widening divide. Neither the
obscenity of a nuclear arms race nor the increasingly distorted accusations
that were flung from West to East and back again were answers to the
acute perils facing humanity.

> We had only just passed through the Second World War. Were the
> nations again going to divide, capitalist countries against the emerg-
> ing socialist countries? This seemed the paramount danger, and I felt
> the urgent concern as a Christian to try to bring understanding of this
> new socialism and to show that ... the Soviet Union was in fact doing
> things in her country and for her people that any Christian society
> should do.[1]

It was a position that still allowed Hewlett Johnson to parade his antipa-
thy towards the United States. Not only was America in thrall to the false
gods of capitalism, its government was now in danger of leading the coun-
try into a catastrophic arms race that would diminish the chances of peace
with each new atomic warhead added to the stockpile. But it was also a
position that, in Johnson's view, required him as a prominent apologist for
the Soviet Union to preach the gospel of peace by persuading the Ameri-
can people that they had nothing to fear from the Communist bloc. And
so, in the autumn of 1946, Johnson crossed the Atlantic to meet the Pres-
ident in the White House and speak to the masses at Madison Square
Garden in New York City.

* * *

It is not entirely clear why an English cleric with a track record of anti-Americanism should have been given such a prominent platform in the United States so early in the cold war. The optimism that President Franklin Roosevelt had initially felt about the prospects for peaceful co-operation between West and East had largely dissipated, and his successor from April 1945, Harry Truman, was adopting a more cautious approach as anti-communist sentiment began to build among ordinary Americans. A speaking tour by the high-profile Dean of Canterbury might risk sending conflicting messages to Moscow. The British government may also have had some qualms, for there is every reason to believe that Hewlett Johnson was coming to be seen in Whitehall as something of a loose cannon. He was, after all, still being tracked by the secret services and it was to be another six years before he would finally be dismissed by Downing Street as a self-publicist who was no longer a major threat to the nation.[2]

Hewlett Johnson's invitation to visit America in 1946 came from the National Council of American-Soviet Friendship – an organisation that had friends in high places but was widely regarded as subversive. The Council had arranged a large public rally in Madison Square Garden with Nikolai Novikov, the Soviet Ambassador, speaking on behalf of the Soviet Union and Dean Acheson, Under-Secretary of State, speaking for the United States. Johnson was invited to offer a British perspective on the importance of East-West understanding. The rally was chaired by Joseph Davies, a former American Ambassador to the Soviet Union who had participated in the Potsdam Conference and was currently a special advisor to President Truman. Before the rally Davies gave a reception at which Johnson met many leading figures in American public life. Among them were Henry Wallace, Roosevelt's Vice-President from 1941 to 1945, and Fiorello La Guardia, the irascible Mayor of New York who had made the city a national model for the New Deal programmes.[3] However much the British government may have disliked it, the Dean of Canterbury was now an international figure who could not easily be ignored.

The gathering in Madison Square Garden was large. Twenty-one thousand people were in the auditorium and a further ten thousand outside. Very little is known about the rally. Hewlett Johnson himself said nothing about it in his memoirs beyond recording the warning given from the chair by Joseph Davies against any temptation by the United States to use its temporary lead in the nuclear arms race to threaten the Soviet Union. It is a safe bet that Johnson, as one of the principal speakers, said much the same. But if nothing has survived of Johnson's words, a fascinating glimpse into his style was given later by Dean Acheson, who followed him on the platform.

He [Johnson] received a tumultuous ovation as he sashayed around the ring like a skater in the black coat and gaiters of an English prelate, his hands clasped above his head in a prize-fighter's salute. [Johnson's speech] became an antiphony, the Dean shouting rhetorical questions, the crowd roaring back the responses. After an ovation, as much for themselves as the speaker, or for him as one of themselves, my hour had come. I felt like a bartender announcing that the last drink before closing time would be cambric tea.[4]

Whether it was the theatricality or the substance of his speech that delighted those who heard it, Hewlett Johnson suddenly became the darling of the American media, giving interviews to daily papers and prominent periodicals such as *Life* and *Time*. At the invitation of the American Episcopal Church he spoke at a large ecumenical gathering in New York City, followed by meetings in Boston, Chicago, Toronto and Montreal. While in Canada he had a personal meeting with the Liberal Prime Minister, William Mackenzie King, who was already aligning his country with the United States and Britain in the cold war stand-off with the Soviet Union.[5] If Hewlett Johnson was little known across the Atlantic before his tour, after it he was a much more recognisable public figure.

The high point of Hewlett Johnson's visit to the United States came in November 1946 when he was granted an audience with President Truman in the White House. It came sixteen months after his meeting with Stalin and lasted for forty minutes.[6] Others present at the meeting in the Oval Office included Johnson's long-time friend and American fellow-traveller, Corliss Lamont. Unlike the audience with Stalin, which he recounted at length in his autobiography, Johnson had very little to say publicly about his meeting with Truman; but in a private letter to Nowell he touched in a little more detail upon the contents of their conversation.

We talked of serious matters. … Knowing the object of my visit, he [Truman] said that it was of great importance that our three countries, Great Britain, the USA and the USSR, should come to a mutual understanding. On that depends the peace of the world. I quoted Stalin's words to me: 'It will be difficult but it can be done', and I avowed my belief that it would be done. 'Do you really think so?' 'Yes', I said confidently. 'I hope it may be so. It's our last chance. If we fail it is the end of civilisation.' 'I shall endeavour to do my part', he said. 'I can get on with Stalin.'[7]

The Dean of Canterbury must have been one of a tiny coterie of non-governmental emissaries who could act as personal intermediaries between Stalin and Truman. Perhaps he was set up for it, perhaps not; but in either case it takes little effort to imagine the anxiety that his international peregrinations must have caused in many circles, including the Foreign Office and Church House.

* * *

Corliss Lamont, who accompanied Hewlett Johnson to the audience with President Truman in the White House, came from a wealthy family in New York. His father, a multi-millionaire banker, was at one time the chairman of J P Morgan, and Lamont himself in later life was one of America's most noted philanthropists. For twenty years he was director of the American Civil Liberties Union, and in his capacity as chairman of the National Council of American-Soviet Friendship he was instrumental in securing Hewlett Johnson's invitation to speak at the Madison Square Garden rally. Such activities were bound to attract the attention of the US government, which once described Lamont as 'perhaps the most persistent propagandist for the Soviet Union to be found anywhere in the United States'.[8] When Senator Joseph McCarthy began his purges against communist sympathisers in the 1950s, Corliss Lamont became an obvious target. His passport was withdrawn and in 1953 he was arraigned by the Senate Permanent Sub-Committee on Investigations to answer the charge of aiding and abetting the infiltration of communism into the American army. There was apparently a certain amount of evidence to support the arraignment but the charge was eventually dropped.

Alongside Corliss Lamont, Hewlett Johnson had cultivated a circle of American friends who, like himself, were able to blend their Soviet sympathies with a Christian faith that was equally at home in the pulpit and on the stump. One was Paul Robeson, the black bass-baritone who was one of the finest American football players of his generation and who later made everlastingly famous Jerome Kern's song 'Ol Man River'. Another long-standing friend was Sherwood Eddy, whom Johnson had known since at least the mid-1930s when he (Eddy) had led a visit to Russia that included Nowell Edwards among the party. Eddy was a regular visitor to Canterbury, usually staying at the deanery and often bringing with him groups of teachers and ministers whom he was conducting around Europe. He had tried to join Johnson on his fact-finding visit to the civil war in Spain in 1937 but had been refused permission by the American authorities.[9]

Another enduring trans-Atlantic friendship was with John Howard Melish, the rector of the Episcopal Church of the Holy Trinity in the fashionable New York suburb of Brooklyn Heights. His son William was associate rector of the same church at the same time. Melish junior, who succeeded Corliss Lamont as chairman of the National Council of American-Soviet Friendship, was once charged with membership of multiple other organisations officially listed by the US Attorney General as subversive.[10] When Johnson was invited to preach at Holy Trinity in November 1948, the tolerance of the parish towards the communist inclinations of its father-and-son ministers reached breaking point and the vestrymen asked the Bishop of Long Island to terminate John Melish's appointment.[11] A battle broke out in the parish, much of which creditably revolved around the question of whether, in a country of free speech, clergymen should be allowed to speak out on political matters.[12] The case twice went to the State Supreme Court before Melish was reprieved. When he retired as rector of Holy Trinity in 1952, Hewlett Johnson successfully petitioned for him to be succeeded by his son William.

Few of the waves stirred up by Hewlett Johnson's transatlantic encounters with socialist millionaires and subversive clergymen lapped back to the gates of the Canterbury precincts, but one of his connections improbably turned out to be of immense value. Faced with the enormous task of restoring the Cathedral and rebuilding the precincts in the aftermath of the war, the Chapter moved heaven and earth to raise the £400,000 that the work was eventually to cost. An appeal fund was set up and gifts large and small came in from all over the world. The largest single amount was given by Corliss Lamont's parents, Thomas and Florence Lamont. Moved by Hewlett Johnson's appeal for funds during his American visit in 1946, they gave a private gift of £125,000 – almost a third of the total final cost of the restoration work. Such a magnanimous gift placed the Chapter, still implacably hostile in its collective attitude towards the Dean,[13] in a quandary: the canons were obviously in no position to refuse, but they did not relish the positive attention that too visible an acknowledgement would draw towards Johnson's standing in the United States. In the event, the gift was accepted and a commemorative plaque was affixed in a little-visited part of the cloister where few would chance to see it. Placed below it was a framed poem by the Poet Laureate, John Masefield, extolling the generosity of Thomas and Florence Lamont. Both the plaque and the poem are still there.

* * *

It was not only Hewlett Johnson's colleagues on the Chapter who were disturbed by his burgeoning international reputation at this time. So too was the Archbishop of Canterbury, Geoffrey Fisher. Irritated by the Dean's refusal two years earlier to heed his advice about wearing (or rather, not wearing) the pectoral cross that had been given to him by the Patriarch of Moscow in 1945,[14] Fisher again tried to rein in Johnson in the summer of 1947 when the Dean told him of his intended visit to a number of Eastern European countries including Rumania, Bulgaria, Yugoslavia and Czechoslovakia. After taking soundings from the Foreign Office, Fisher advised Johnson that for political and diplomatic reasons, the visit should be confined to Czechoslovakia – a country that did not raise the same awkward political issues as the others and where Johnson was in any case to receive an honorary doctorate from the University of Prague.[15]

Hewlett Johnson's lengthy reply to Fisher was, like all his letters to Lambeth Palace, punctiliously formal and correct in its style while making his feelings abundantly clear. Having suggested to the Archbishop 'in all humbleness' that tactful diplomacy, in the sense in which the Foreign Office understood the term, was not an appropriate guide for Christian behaviour, Johnson pointed out that:

> If it became known that I was not permitted to visit these countries because of undue pressure from the Foreign Office and yourself, it would have a world-wide publicity and significance of the gravest kind, and do immense harm in the Church and to our country. It could be interpreted in only one way – that we wished to enlarge the distress and suspicion that forces here were working for a deeper cleavage between these new countries and ourselves. Such is the very opposite … of what we ought to do.[16]

And so, having set the Archbishop's advice on one side, Hewlett Johnson went ahead with his plans. Accompanied yet again by Alfred D'Eye he visited Hungary, Yugoslavia (where he spent a day with Prime Minister Josip Tito), Bulgaria, Poland and Czechoslovakia (where he duly received his doctorate). Waiting for him on his return to Canterbury was a renewed complaint from Lambeth Palace that he was still being mistaken for the Archbishop of Canterbury far too often for Geoffrey Fisher's comfort. Whenever the mistake occurred, moreover, Johnson seemed hardly to be going out of his way to correct it. The point was reached in December 1947 where the Archbishop felt obliged to issue a press statement distancing himself in no uncertain terms from his irritating Dean.

It is unfortunately the case that recent actions and utterances of the Dean of Canterbury have given rise to widespread misunderstandings and misconceptions both on the continent and in the United States. ... It has been supposed that the Dean of Canterbury must necessarily be acting on the instructions of the Archbishop of Canterbury and presenting his views. ... The Dean's office and jurisdiction in this country does not extend beyond the confines of the Cathedral body of which he is head. ... The Archbishop of Canterbury has neither responsibility for what the Dean may say or do, nor the power to control it.[17]

Perhaps unwisely, Geoffrey Fisher sent Hewlett Johnson a preview of the press statement,[18] allowing the Dean time to compose and publish his response alongside the charge. Having acknowledged that the Archbishop had correctly described the limits of his jurisdiction as Dean of Canterbury, Johnson went onto the offensive by reminding the readers of the *Daily Telegraph* that, having been appointed by a socialist Prime Minister (Ramsay MacDonald), he had a plenipotentiary mandate to speak for the working classes.

I thus naturally became a Christian spokesman with the Anglican Church for the great mass of English opinion in the mines, factories and fields. ... That Christian spokesmanship is my right. That is my responsibility. And I am justified, in the discharge of that responsibility, to use all the weight that the honoured name of Canterbury lends. I intend jealously to maintain my right to voice with such weight as my office affords this point of view.[19]

It would not be true to say that Fisher backed down in the face of Johnson's robust defence of his position, but privately he took a more conciliatory view of their spat. In a letter to the Dean later that month (December 1947) he said that 'there is no question at all of private strife'; but he nevertheless managed to get a little barb of his own lodged beneath Johnson's skin by pointing out that 'my statement referred only to confusion in foreign countries and did not touch this country where your position is well understood by most people – though their understanding of it would differ very widely from the view which you expressed of it.'[20]

* * *

The summer of 1948 provided a certain amount of light relief for Hewlett Johnson when he was approached by the clothing manufacturer Kangol with the offer of a free beret (choice of six colours available) if he agreed to be photographed wearing it for advertising purposes;[21] but he was soon immersed again in more serious matters when his application for a visa to revisit the United States in August 1948 was refused by the American Embassy on the grounds that the invitation had come (once again) from the National Council of American-Soviet Friendship.[22] Undeterred, his would-be hosts regrouped under the new banner of an 'Ad Hoc Committee of Welcome to Dean Johnson' headed by Ralph Barton Perry, an Emeritus Professor at Harvard who had recently given the prestigious Gifford Lectures in Glasgow under the title 'Realms of Value'.[23] Over a hundred prominent American citizens supported Perry in reissuing the invitation in this new guise.[24] They included, as well as a stellar cast of clerics and academics, the playwrights Arthur Miller and Elmer Rice, the novelists Thomas Mann and Mark Van Doren, the poet Louis Untermeyer, the conductor of the Pittsburgh Symphony Orchestra, Fritz Reiner, and the president of the American Academy of Music, John Lewis Jr. When Johnson reapplied for a visa in October 1948, the United States Embassy had little realistic option but to agree,[25] and he left for North America in the following month.

Landing first in Canada, Hewlett Johnson spoke at large meetings organised by the National Council for Canadian-Soviet Friendship in Windsor, Toronto, Ottawa and Vancouver before moving on to the United States where he gave twenty-one talks in eastern and mid-western cities. He spoke twice in Detroit, where people were said to have paid two thousand dollars for a seat, and in Chicago an enthusiastic audience in the opera house was led in rapturous applause by Mrs Anita McCormick Blaine, reputedly one of the richest women in America. She was so struck by this charismatic English cleric that she promptly invited him to dinner. Johnson accepted with some misgivings but came away with a gift of a thousand dollars for the peace campaign.[26] The generally widespread enthusiasm of those who heard him was not, however, shared by the press. Press cuttings reveal that the reports of his meetings ranged from hostile to bitter. The *New York Eagle* carried the banner headline: 'Red Dean peddling the commie line, undeserving of courtesy.'[27] The *Tucson, Arizona, Citizen* warned its readers to 'Beware the Trojan Horse'.[28] The New York-based *Journal-American* made fun of 'the Red Dean's howlers'.[29] The *New York Mirror* attacked him as a 'champion of Stalinists'.[30] The *Daily News* proclaimed: 'Red Dean assails US and lives up to his name.'[31] The *Gary*

Post-Tribune described him as 'an outstanding propagandist for communist Russia'.[32] But one editor was unable to make up his mind, describing Johnson as either 'the world's outstanding symbol of international understanding' or 'one of the world's principal outlets of communist propaganda'.[33] In America, as in Britain, Hewlett Johnson displayed the astonishing ability to polarise public opinion in a way that no other major figure could do. People adored him or hated him. There was no middle ground. Nobody, it seemed, could be neutral about him.

* * *

The highlight of Hewlett Johnson's 1948 American visit, as it had been two years earlier, came right at the end with another huge rally in Madison Square Garden, New York City. The warm-up speakers included Henry Wallace and William Melish and the entertainment was provided by Paul Robeson. The text of Johnson's speech has been preserved, but the words alone give little indication of the dazzling theatricality of the occasion. In fact there would be no first-hand account of the drama inside Madison Square Garden had it not been covered for the *Manchester Guardian* by a young journalist, Alistair Cooke, who made it the subject of one of his early letters from America. Even allowing for Cooke's acerbic reportage, his startling account of the rally captured something of the compelling style of a master demagogue at work.

> Four blinding shafts of blue converge on the entrance. The crowd comes to its feet craning, gabbling all the dialects of Central Europe and the accents of Manhattan, the Bronx and Brooklyn. And suddenly he is standing there, black and bland and towering, his hair spun smooth as cotton candy, a huge crucifix glittering on his chest. The gasps expand into cheers as two ideas come together: he looks like a divinity and he looks like the portrait on every dollar bill. He is George Washington, canonised and dropped from heaven.
>
> It takes three minutes for decent calm. He puts his script down and disdains it for fifty minutes. He starts slowly, in a cathedral monotone, warning them of the daily grind of the war nobody wants – the blitzed children, the gassed Jews of Auschwitz, the third-degree scar of Hiroshima. His tone abruptly changes. He has been in Eastern Europe. Come with me, he says, as his pink, pink face glows with the tender memory: in Hungary, the secret ballot, the upright invigilators; in Rumania, medicine for all, one whole year of every doctor's life dedicated to the peasants; in Armenia, religious farmers, fine daughters at

school till sixteen, everybody reading *War and Peace*. Always he returns to the source from which these blessings flow – the Soviet Union, whose only 'invasions' have been of great liberties: the right to work, the right to education, the right to health free for all. These are 'the liberties that alone can crown our great liberties of the West'.

He pauses and smiles inwardly. Some of my good people at Canterbury, he says like a father recalling the sweet confusions of his favourite child, say I minimise our Western liberties. He throws out his long arms, spreads the bony fingers, and bellows: 'Who am I to minimise these things? I who go to bed at night beside the bones of Thomas à Becket, who died for liberty, and Stephen Langton, who forced King John to sign Magna Carta?' There is a laughing roar from the people who have never heard of Becket but who see in this defiant priest the sanction of their own un-American defiance, who think of priests in the old country slaughtered or decayed, who see not a twentieth-century Anglican but their own forsaken Church reincarnated from medieval Bohemia and liberated tonight in – glory be – Madison Square Garden.

He waves the applause aside as an argument thrashed and done with. He is on the verge of his essential appeal. There are many dark things about Russia, yes, but 'we ignore the beauty of the much greater things because of that horror.' In the end, when we stand before the judgement seat, it will be Christ's great standard or nothing. Will it be: did you attend church regularly? His great nostrils dilate in unspeakable scorn. 'No.' Will it be: did you say your prayers every night and morn? 'No.' Again the predatory hands embrace the whole audience, wheezing in the dark. It will be: 'I was naked. What have you done about *that*? I was sick. What have you done about *that*? What have you done about *human need*?'

The roof seemed to fall in on him. Again he was bland and stiffly bowing. Again the blue spots converged. And the cheers leaped and sprayed benedictions all around him. ... The crowd trudges out in a slow stampede. Outside, the *Daily Worker* is already in print, telling the obedient that this is the truth about Communism. Was that, then, what we heard and felt? It sounded more like Christian fundamentalism. It looked more like John Wesley riding the circuit through a Roman circus.[34]

* * *

Hewlett Johnson returned to Canterbury just before Christmas 1948 to find the deanery festooned with a great banner, hung by his two young daugh-

ters, which read in bright pink letters: 'Welcome Home Daddy'.[35] But the welcome was muted when he found himself at the centre of yet another fearful row with Lambeth Palace. It had begun in October 1948 when, shortly before departing for America, he had given a speech in Cardiff that had seemed to include an insulting reference to Lord Halifax as a 'lackey of Hitler'.[36] An eminent Anglican layman, Halifax had been Foreign Secretary at the time of the Munich agreement in 1938 and was regarded by many as one of the architects of appeasement. As such, he was a legitimate target for attack; but Halifax had friends in very high places, and offensive remarks about him were unlikely to go unpunished. The task of disciplining the Dean fell yet again to the Archbishop of Canterbury, Geoffrey Fisher, who wrote to Johnson in the rather resigned tones of one who knows that he will rarely get the upper hand against this irritating priest.

> A letter has just reached me from a correspondent who heard you speaking recently in Cardiff. I need not detail the general comments given to me about the speech, but a particular phrase is quoted: ... 'Lord Halifax – that lacquey [sic] of Hitler'. I feel I ought to inquire whether you did in fact use that phrase, and if so whether you would be willing to make an apology for doing so.[37]

Johnson defended himself with a brevity that may well have taken the Archbishop – well used to the Dean's prolix exculpations – by surprise.

> My dear Lord Archbishop. ... I never made any jibe at Lord Halifax. I merely quoted, when asked a question, the words of Jan Masaryk.[38] I spent the evening of Munich with Masaryk in his London Embassy. [We] sat silent while the terrible news came through. Masaryk paced up and down the room and exclaimed: 'Halifax, that lackey, that errand boy of Hitler!' Yours sincerely, Hewlett Johnson.[39]

But Geoffrey Fisher persisted, and his attempt to regain the high ground took the form of a long and carefully thought-out letter. After pointing out that Johnson's defence of his position was entirely unconvincing and that his slur on Lord Halifax was 'disrespectful to a great Christian gentleman', he launched into a general attack on the Dean, accusing him of becoming 'the advocate of a particular political system' and of 'lending yourself to governments of communist countries to support their regime'.[40] There were, Fisher insisted, only two ways in which the dilemma could be resolved: either Johnson could abandon his political activities or he could resign his office.

It was exactly the same option that Cosmo Gordon Lang had put to the Dean a decade earlier,[41] and Fisher had no more success in forcing the issue than his predecessor. In four pages of closely argued self-justification at the end of December 1948, Johnson not only defended his use of Masaryk's quote but also refuted the wider charges that Fisher had thrown at him. Typically, he redefined Fisher's accusation of 'advocacy of communism' as that of 'influencing men's minds in the direction of warmer relations between the Soviet Union and Great Britain'. Without such warmer relations, Johnson warned, war seemed inevitable. Having thus recast the charge, Johnson's defence was relatively straightforward: he was acting only in the interests of peace, from which no right-minded person would seek to dissuade him. He had both the right and the obligation to do so and he would not be bullied into silence.

> I only claim the same rights in these things that you do. You and the Anglican bishops have a unique political position in the country which enables you to take what political side you choose. I only claim, though without the vote in the House of Lords which you possess, the same right of speech which you exercise. If you attack the countries of Eastern Europe ... surely in the interests of peace one voice in the Church may defend them. Or is that voice to be silenced too?[42]

For these reasons, the Dean concluded crisply, 'I regret I cannot accept your suggestion to resign the Deanery of Canterbury.' At this point the Archbishop beat a tactical retreat.

> Since you are unaware of the dilemma, there is nothing more to be said. I have at least relieved my own conscience by stating it to you.[43]

CHAPTER FOURTEEN
TRIALS, TRAVELS
AND TRIBULATIONS

H EWLETT JOHNSON ARRIVED home from his exhausting tour of Canada
and America just before Christmas 1948. With him came gifts for
Kezia and Keren of American dolls that blinked and cried and relieved
themselves in a realistic way.[1] The girls were thrilled. Once the year turned,
however, the pace of the Dean's life – and the fame and controversy that
now surrounded him wherever he went – quickened again. Although he
celebrated his seventy-fifth birthday in January 1949 he showed no signs
of letting up in his fight for the things he believed in, and in quick succes-
sion he became embroiled in two high-profile European affairs, those of
Victor Kravchenko and Cardinal Joseph Mindszenty.

* * *

Victor Kravchenko was a Russian engineer who joined the Communist
Party in 1929. He served in the Red Army during the Second World War
and later worked with the Soviet Purchasing Commission in Washington.
Kravchenko became increasingly disillusioned with the policies of the
Soviet Union, and in 1944 he applied for political asylum in the United
States. The Soviet authorities branded him a traitor and demanded his
extradition; but the request failed and asylum was granted. In 1946
Kravchenko published a book based upon his experiences as a Soviet offi-
cial, *I Chose Freedom*, in which he wrote critically of the irreparable
damage that Stalin had inflicted on the Russian people. The book, which
included damaging analyses of the collectivisation of the farms, the labour
camps, the bureaucratisation of Soviet life, the demise of religion, the weak-
ening of trade unionism and the demoralisation of the professions, was a
damning indictment of Stalinism.[2]

Among the attacks on Victor Kravchenko that were occasioned by the
publication of *I Chose Freedom* was one by the French Communist maga-
zine, *Les Lettres Françaises*, which published an article in 1948 by a
Communist journalist, André Ullmann, alleging that the book was based
upon trumped-up evidence. Kravchenko responded by suing *Les Lettres*

Françaises for libel. The ensuing trial in Paris in 1949, which lasted for several weeks and involved scores of witnesses, became known as 'the trial of the century' – for since the case revolved around the truth or otherwise of Kravchenko's allegations, it was the Soviet Union itself that was as much on trial as *Les Lettres Françaises*. The magazine's lawyers mobilised a posse of witnesses to challenge Kravchenko's accusations. Some of his former colleagues were flown in from Moscow to denounce him, and high-profile figures from around Europe who could further demolish Kravchenko's claims to be telling the truth were summoned to give their evidence. One who went from Britain was Konni Zilliacus, the Labour MP for Gateshead. Upon returning to Britain after testifying in Paris, Zilliacus wrote to Hewlett Johnson urging him also to attend the trial and speak for *Les Lettres Françaises*.

> I am the bearer of all sorts of messages, appeals and entreaties to you from the defendants in the Kravchenko trial [who are] most anxious that you should testify, particularly on the question of religious freedom in Russia. ... I believe you could really do something very valuable for the cause of better understanding between the West and the Soviet Union if you were to give testimony, because what you said would be widely reported throughout the world and particularly in the British and American Press. The falsehood that the Churches are persecuted in the Soviet Union and Eastern Europe is, as you know, particularly outrageous and rampageous today and your testimony would strike a mighty blow on the other side. In a French court you could simply hold forth, giving a sort of lecture or making a speech.[3]

Hewlett Johnson duly obliged and submitted his evidence before flying to Paris in February 1949,[4] but instead of having a platform from which to 'hold forth', he unexpectedly found himself under pressure from Kravchenko's lawyers to justify statements he had made about religious freedom in the Soviet Union in his most recent book, *Soviet Success*.[5] On his return from Paris he wrote to Konni Zilliacus explaining that he had had to work hard defending the book and had been obliged to draw on the testimony of others by way of support.[6] In particular, Johnson had made much of the statement of Patriarch Alexei of Moscow that *Soviet Success* was 'impartial' and that it 'described the situation of our country and particularly our Church'.[7] But his reliance upon the Patriarch's statement had also placed Johnson in a risky position, for if Kravechenko won his libel suit against *Les Lettres Françaises*, then doubt would be cast by implication on

the claims that he (Johnson) had made in *Soviet Success* about the reality of religious freedoms in the Soviet Union. In the event, the French court did find in favour of Kravchenko, and damages of 50,000FF were awarded against *Les Lettres Françaises*. On appeal, the verdict was upheld by a higher court but the damages were reduced to only 3FF on the grounds that the publicity given to the trial had boosted the sales of Kravchenko's book.[8]

Although those who had testified against Kravchenko came out of the trial with their reputations dented, the verdict did little long-term damage to those who supported the communist cause. In particular, it did not deter the Communist Party of France from pressing ahead with its planned peace conference, which Johnson attended – again in Paris – at the end of April 1949.[9] Usually regarded as the inaugural meeting of the World Peace Congress, the Paris conference recommended the creation of affiliated 'national peace committees' in each country (the British committee was formed in the following month) and it established a World Committee of Partisans for Peace (renamed the World Peace Council in 1950).[10] By associating himself so prominently with the genesis of what was to become a major political movement in the nuclear age, Hewlett Johnson was nailing his colours to a new tree that was every bit as controversial as the one that had sustained his love affair with the Soviet Union; but on this occasion, his prominent association with anti-American intellectuals from around the world drew no rebuke from the Archbishop of Canterbury. For the time being Geoffrey Fisher was keeping his powder dry.

* * *

As with the Kravchenko affair, and probably for much the same reasons, Hewlett Johnson made no reference to the Mindszenty case in his autobiography. Joseph Mindszenty, a priest in the Roman Catholic Church in Hungary, became Archbishop of Esztergom and head of the Church in September 1945. He was made a cardinal in the following year. During the Second World War Mindszenty defied the Hungarian National Socialist Party which had sent some 80,000 Hungarian Jews to their deaths at Auschwitz; but he also opposed the totalitarian aspirations of the Communist Party of Hungary led by Mátyás Rákosi – a man whom Hewlett Johnson had met and admired.[11] The liberation of Hungary by the Red Army in 1945 marked the start of Moscow's influence in Budapest, culminating in the 1947 national election in which the Communist Party won the largest number of seats in the coalition government. With Rákosi now the Prime Minister, the Communists gradually gained control of the government; and when László Rajk, the Foreign Secretary, was executed in 1949

for denouncing Moscow's attempts to impose its own policies on Hungary, Rákosi was free to pursue an increasingly Stalinist rule. Thousands of Hungarians who opposed him were executed or imprisoned, and those within the Communist Party who joined the protests were expelled. The seeds were being sown for the Soviet suppression of the Hungarian uprising in 1956 that was to challenge Hewlett Johnson's moral sensibilities to the limit before he was eventually able to justify the appearance of Soviet tanks on the streets of Budapest.[12]

As a result of his outspoken opposition to Mátyás Rákosi's Stalinist policies, Cardinal Mindszenty was arrested by the secret police in December 1948 and charged with treason. Under torture he confessed that he had conspired with the United States to start a third world war and that he himself had ambitions to become the political leader of post-war Hungary. His trial became a *cause célèbre* in the West where leaders across the religious spectrum, Protestant and Jewish as well as Catholic, mobilised support for the Cardinal. Even before the court delivered its verdict, Pope Pius XII publicly condemned all those who had been involved in arranging the trial and later he excommunicated them.[13] Hewlett Johnson was among a very small group of clergymen who refused to join the general condemnation. In January 1949, a few days before the trial began, he argued that Christian leaders should not claim any special privileges that would place themselves outside the law. In any case, it would be wrong to jump to premature conclusions before the trial had run its course. But his anti-Catholic views were by now sufficiently well known for his critics to read more into his position than these superficially innocuous observations might have implied, and the response was swift. Church leaders rushed to condemn him for his disloyalty to a Christian brother and for his myopically ideological view of events in Hungary. A correspondent to the *Daily Telegraph* with first-hand experience spoke for many who had never met Mindszenty but who sensed that he had been victimised for speaking the truth.

> I have been surprised to read the Dean of Canterbury's fulsome disclaimer about 'no attack on religion in Hungary'. I am a Hungarian who recently arrived in this country, and can contradict him flatly. Having known Cardinal Mindszenty, I can assert that the statements now attributed to him cannot possibly be true. For five years this brave man spoke on behalf of all Christians, and resisted oppression. In November the Communist Government invited him to leave Hungary, but he said it was his duty to remain, and so they have had to seek other means of repressing this modern Thomas à Becket.[14]

As was his wont when attacked, Hewlett Johnson immediately went onto the offensive, asserting that the Catholic Church had no right to immunity from the state's machinery of justice and deploring the way in which Christian leaders had sprung to the defence of Joseph Mindszenty before all the facts had come to light. The nub of the disputation, however, lay in the reliability of the evidence of Mindszenty's allegedly treasonable acts. At his trial the Hungarian government had released a bundle of documents (known unofficially as the 'Yellow Book') that were said by the prosecution to be evidence of the Cardinal's guilt. Mindszenty's defendants claimed that the documents had been fabricated on government orders; but Johnson – who had managed to obtain pre-trial copies of them[15] – chose to see them as authentic. He even claimed that the Vatican believed the 'Yellow Book' to be genuine, and he was ordering a copy of it for the public library in Canterbury.[16]

Outrage at Mindszenty's trial became localised when the Roman Catholic priest of St Thomas, Canterbury, laid into Hewlett Johnson in a letter to the *Kentish Gazette and Canterbury Press*. Father de Laubenque castigated the 'Yellow Book' as 'a criminally dishonest publication' and he utterly rejected the repugnant suggestion that the Vatican had acknowledged its validity. Fr de Laubenque continued:

As the Dean accepts without question the evidence of the 'Yellow Book', it is not surprising that he equally readily accepts the assertions of his friends beyond the Iron Curtain who declare that there is no religious persecution in those unfortunate countries, while shutting his eyes and ears to the growing volume of tragic evidence that is daily convincing more and more members of his own Communion of the true state of affairs. There is persecution in those countries – persecution that is atheistic and diabolic in objective and technique. The Dean is content to leave the verdict to history. No such easy way of escape is open to me. He who does not condemn injustice, cruelty and hypocrisy approves by his silence.[17]

Thereafter Hewlett Johnson kept uncharacteristically quiet, and he made no mention of the Mindszenty affair in his autobiography. As for Cardinal Mindszenty, he was duly found guilty of treason and sentenced to life imprisonment. He was released during the Hungarian uprising in 1956 and was granted political asylum in the United States Embassy in Budapest. In 1971 he was allowed to leave the Embassy for Austria where he died two years later.

* * *

In the summer of 1949 Hewlett Johnson was admitted to hospital for the investigation of severe stomach pains.[18] His symptoms were found to be the result of mental and physical stress and he was advised to take a complete break from his labours. He agreed to spend a month in Italy with Nowell provided he could, on the way, speak at the second meeting of the World Peace Congress in Rome. It was this meeting that gave birth to the World Peace Council, a non-governmental member of the United Nations formed to promote peace among the nations and to work for nuclear disarmament.[19] The first two presidents of the Council were Frédéric Joliot-Curie, a devout Communist and already a co-holder of the Nobel Prize for Chemistry, and J D Bernal, a world-class scientist and former member of the Communist Party of Great Britain who later became a prominent figure in the Campaign for Nuclear Disarmament. Both were close to Hewlett Johnson. The Rome meeting of the World Peace Congress was held in the great square facing the Lateran and was, by all accounts, a dramatic affair.

> The sun was setting as the meeting began, and the silhouettes of the buildings against the sky were a noble sight. As darkness fell, torches were lit and were passed from hand to hand towards the centre, looking like stars. On the platform were many famous peace fighters from countries all over the world. Pablo Picasso was near us. When my turn came to speak, I was greeted by this responsive enthusiastic crowd, and when I finished voices rang out in Italian. Professor Bernal turned to me saying: 'Did you hear that, Dean? They are shouting: An honest priest, he should be our Pope!'[20]

After it was all over, the Johnsons travelled south to a small villa at Formia, near Naples, that had been lent to them by a Communist member of the Italian Parliament, Signor Sereni.[21] Hewlett Johnson looked back on the holiday as the best that he and Nowell had had together.[22] She painted; he read and wrote; and together they explored the Neapolitan countryside. On one occasion they boarded a local bus and bought tickets 'to the end of the route'. They had no idea where the bus was going but were game to see it through in the hope that 'the end of the route' would prove to be worth reaching.[23] David Caute mischievously used the story as a parable about the Soviet fellow-travellers: having bought their tickets they had little idea where they were going but were determined to enjoy the ride and hope for the best when they got there.[24] Most of them (to continue Caute's parable) left the bus long before it arrived at its destination, but Hewlett Johnson typically stayed on board until the very end. 'How far are you prepared

to go?' was the critical question always asked of the fellow-travellers. 'To the end of the route' came the Dean's reply.

* * *

In 1950, at the age of seventy-six, Hewlett Johnson was invited by the Australian Peace Council to speak at the National Peace Congress in Melbourne in April. Travelling by air, it took him five days to reach Sydney, where he was greeted by an enthusiastic crowd and promptly gave the first of many press conferences. It was a potentially inflammatory arrival, coinciding as it did with the introduction of a bill into the Australian parliament that would outlaw the Communist Party. The Prime Minister, Sir Robert Menzies, had staked a good deal of political capital on getting the bill through parliament, much to the anger of the political left. A popular poster depicted Menzies marching in step with Adolf Hitler above the caption: 'Hitler, like Menzies, promised to make everything alright by banning the Communists – and look what happened.'[25] It could all have led to a damaging confrontation between Hewlett Johnson and the Australian government; but he had an immensely resourceful supporter in a very high place. Jessie Street, the wife of the Lord Chief Justice of Australia, was a remarkable woman. Born in India in 1889, she was internationally acclaimed for her tireless campaigning on behalf of women, social justice and peace, and at the time of Hewlett Johnson's visit in 1950 she was a colleague of Pablo Picasso on the World Peace Council. She had chaired the Australian Medical Aid and Comforts Fund for Russia during the war and was widely known for her Soviet sympathies. Like Johnson, Jessie Street was being discreetly observed by the Australian secret services, and like Johnson, she rejoiced in the soubriquet of 'Red Jessie'.

With such a formidable and sympathetic ally, Hewlett Johnson was shielded to some extent from the wrath of those who vehemently objected to his presence in the country.

> She was a leading spirit in my campaign; she was a magnificent worker and organiser. Seldom have I met a more capable or forceful woman. Mrs Street was loved by the dockers and workers and dreaded by the millionaires. She worked like three women. She had engaged an immense hall in the Melbourne Exhibition Building, where more than 12,000 people attended the public opening of the Peace Congress. The hall was packed, in spite of the fact that the authorities had stopped the suburban trains and trams. Crowds turned up in carts and drays, on

lorries and bicycles, and on foot. I entered by a hundred-yard-long children's guard of honour.[26]

The opening plenary session of the Congress on 16 April 1950 was chaired by the left-leaning Reverend A M Dickie, the Chairman of the Australian Peace Council, and featured a dozen speakers among whom Hewlett Johnson had the star billing.[27] On the following three days a number of commissions discussed specific peace-related topics, among them the world struggle for peace, nuclear disarmament, and the contribution of artists and writers to the peace movement. Johnson spoke to one of the commissions on 'a programme for peace' and he was again the principal speaker at the closing rally attended by some eight thousand people. Deeply disappointed that he had no support at all from the Anglican hierarchy at home, Hewlett Johnson was hugely encouraged to find such a receptive welcome for his message on the other side of the world. But as in Britain and America, there was a political fly in the Australian ointment, for the prominence of left-wing activists among the peace movement in all three countries was fuelling the suspicion that diehard Soviet sympathisers and erstwhile fellow-travellers were merely regrouping under a different banner. In America, in particular, the belief was growing that the peace movement was trying covertly to undermine the nation's capacity to respond to the Soviet Union's growing nuclear threat. In Britain, similar charges were soon to be hurled at the Campaign for Nuclear Disarmament. It was, of course, not quite the same issue in Australia, which had no intention of acquiring nuclear weapons; but the peace movement there was nevertheless becoming tarred with the same brush of suspicion and even hatred. Sir Robert Menzies' plan to outlaw the Communist Party of Australia, coinciding as it did with Hewlett Johnson's arrival in the country, merely underscored the point.

* * *

After Melbourne, the going got rather tougher for Hewlett Johnson. In Sydney he was faced with groups of rowdy students, said to have been organised by the Roman Catholic Club, and the main public meeting had to be moved to a city park when the authorities refused permission to use the only hall in Sydney of a suitable size. Even then, obstacles were placed in his way: the park was flooded with water before the meeting began and the use of a microphone was prohibited. Once again the resourceful Jessie Street came to the rescue, persuading the Iron Workers' Union to construct a platform with a concealed microphone that sprang up through a trapdoor

in the floor when Johnson rose to his feet. And when a collection to defray the cost of staging the meeting was forbidden, Jessie Street proceeded to sell signed photographs of the speakers to the crowd. From the meeting in the park, Hewlett Johnson moved on to Sydney Cathedral where his sermon on 'war, peace, atom bombs, and Russia's peaceful offers and intentions'[28] was relayed to a congregation gathered outside and heard by an estimated five thousand people. Then to Brisbane, where he spoke to about three thousand people in the town hall and raised the equivalent of £1,600 for the peace movement before travelling the next day to Ipswich for an outdoor meeting of three thousand railway workers.

After two further meetings in Adelaide, Hewlett Johnson had planned to go to New Zealand, where he had been invited to speak at a peace rally, before crossing the Pacific to Canada; but he was forced to change his route when the American authorities refused him a visa to land for a refuelling stop in Honolulu on the flight from Auckland to Toronto. So, unable to visit New Zealand, he left Sydney on 30 April 1950 and flew to Toronto via Darwin, Singapore, Bombay, Karachi (where he held a press conference in the airport and wrote an article for a local newspaper) and London (where he was met briefly by Nowell, D'Eye and representatives of the British Peace Committee). He arrived in Toronto on 5 May to be greeted by 'a mile of bannered cars with loud speakers announcing my arrival'.[29] The following day he spoke to twelve hundred people in the Maple Leaf Gardens, raising 7,200 dollars for the peace movement, before moving on to further rallies in Ottawa, Hamilton (twice), Windsor, London, Timmins and Vancouver.

Hewlett Johnson had a mixed reception in Canada. Those who attended the rallies were, for the most part, enthusiasts for peace, but outside the meetings he encountered hostile crowds opposed to his distinctive blend of faith, disarmament and communism. In Hamilton a 'band of fascist youths' broke into his hotel but hammered on the wrong bedroom door; in London he faced heckling from an 'obstructive crowd'; in Timmins he was besieged by a 'crowd of hooligans'; and in Vancouver hundreds of 'hoodlums' threw firecrackers and eggs and fought with the police.

> While I was speaking a stone crashed through a side window, landing, fortunately, on the Press table. This was somewhat ironic in that the Right Wing Press had been stirring up daily opposition to my tour. ... The police said the crowd was dangerous and they therefore arranged an escape route by the back door. As I climbed over a fence, a flash photo was taken. I was informed that this was used throughout Canada to intimidate other towns against my meetings.[30]

Hewlett Johnson left Canada on 27 May 1950. It had been, in his own words, 'a stormy visit' at a time when the cold war was 'being whipped up viciously'.[31] He felt that those who had braved the hostility to attend the rallies had been courageous people wrongly accused of disloyal motives. Arriving back in England after his mammoth tour he was met with similar accusations, especially from a right-wing press only too eager for further ammunition with which to smear his name. Once again calls were sounded for his resignation and Archbishop Geoffrey Fisher decided to re-enter the fray. While in Toronto, Johnson had reportedly charged Fisher with profound ignorance of what was happening in Russia and had accused him of failing to understand the mood among a section of the Anglican clergy. Letters passed across the Atlantic in which Fisher complained bitterly about the Dean's behaviour abroad and Johnson defended himself with his customary mixture of deference and defiance. But on his return to Canterbury the Dean found a letter from the Archbishop which suggested that he was getting the hang of dealing with this troublesome priest by giving as good as he was getting. The argument may have been a little opaque but the tone was confident.

> Thank you for your letter written from Toronto making clear that you had not made any remark relating to my relation with my clergy. I was quite certain that you had not made the remark reported that I was illiterate about my clergy, as that was such an illiterate remark in itself! But I am glad to know that you made no reference at all to that subject. It is very natural that you should say that you know more about Russia than I do, but whether I should accept the same as true would depend upon the kind of knowledge referred to – for instance, whether it was regarded quantitatively or qualitatively. Yours sincerely, Geoffrey Cantuar.[32]

* * *

Back in Canterbury for a few days, Hewlett Johnson had time to do little more than entertain Princess Margaret on a royal visit to the Cathedral, receive invitations to visit China, Sweden, Holland and Denmark, and speak to twenty thousand people at a peace rally in Lincoln's Inn Fields[33] before he was off again on his travels.[34] In June 1950 he was a guest speaker at a series of large religious gatherings in Czechoslovakia that brought together priests and pastors of many churches and religious denominations from both Eastern and Western Europe. It was a difficult platform on which to parade his Stalinist sympathies, for following its *coup*

d'état two years earlier, the Communist regime in Czechoslovakia was busy setting limits to the freedom of religious expression in the country. Church schools were abolished; all but three theological faculties for the training of priests and pastors were closed; monasteries were dissolved; and priests became salaried servants of the state. The Roman Catholic Church had become a prominent symbol of resistance to an atheistic state, and Johnson's widely known disdain for the Vatican's unwavering opposition to communism must have made for some uncomfortable moments. Quite uncharacteristically, he omitted all references to his speeches and conversations in his autobiography, reverting instead to his favoured ploy of romanticising the faith of ordinary people while praising the government for making it possible. At Velehrad, one of the most important pilgrimage centres in Moravia, Johnson attended the great annual pilgrimage to the monastery of Saints Cyril and Methodius.

> From early dawn vehicles of every description – coaches, buses, lorries and handcarts drawn by tractors – converged at the monastery with fifty-six special trains run by the Government. Dense crowds, at least 50,000, filled the great square facing the baroque church. Mass was said in the open air. The throng joined in the responses. ... Nothing could have been more enthusiastic, homely or friendly. This was religious pilgrimage, these were pious folk, in a country with a Communist Government since 1948.[35]

The next day he went to a pilgrimage-cum-political rally at Tabor, in southern Bohemia, where the Czech reformer Jan Hus had preached five centuries earlier. Unable to resist the temptation of linking Hus's reforming zeal with that of the Czech government, he observed that: 'Here in the new economic socialist order we were witnessing the second half of the early reformer's aims, freedom from economic, as well as from ecclesiastical, domination.'[36] It must have stretched the imagination to suppose that Hus would have seen the goals of an atheistic government as the culmination of his own work, but that did not deter Johnson from making connections where he wanted to see them.

> These crowds [of pilgrims], gay in summer clothes, followed with tumultuous applause the speeches of the Premier and Prime Minister, who emphasised the moral and economic strength of the socialist order based on service and not profit.[37]

Church and State, faith and citizenship, history and contemporaneity joined in one harmonious embrace. It was an uplifting vision – if it was true.

* * *

Hewlett Johnson's astonishing year of travel climaxed in November 1950 when he spoke at the third World Peace Congress (after the Paris and Rome meetings in 1949). It was originally to have been held in London, but the idea was abandoned almost at the last minute when the British government concluded that to hold a communist-dominated meeting in a major European capital would 'whip up popular support throughout the world for Soviet policies towards peace, disarmament and atomic warfare.'[38] It was a measure of the extent to which the peace movement had already become inextricably linked in the political – and possibly also the public – imagination with left-wing activists. The city of Sheffield offered to host the meeting at short notice, and arrangements were rapidly put into place. The British Peace Committee, which organised the event, boldly assured the delegates that it would constitute the 'greatest international gathering this country has ever seen';[39] but once again the government sensed danger. Deeply concerned about the American response to the presence in Britain of hundreds of activists from behind the iron curtain, the Prime Minister (Clement Attlee) eventually decreed that:

> We are not willing to throw wide our doors to those who seek to come here to subvert our institutions, to seduce our fellow citizens from their natural allegiance and their daily duties and to make propaganda for those who call us 'cannibals and warmongers'.[40]

Sensing the likelihood of defeat, the leaders of the British Peace Committee met in Bloomsbury on 11 November 1950 to consider their tactics. When news came through to them that the President of the World Peace Council, Frédéric Joliot-Curie, had been refused entry to the country at Dover along with fifty other delegates, the organisers had no option but to cancel the Congress in Sheffield. For reasons that are not entirely clear, Warsaw became the immediate alternative, and hundreds of delegates were forced to re-arrange their plans in mid-journey and find transport to Poland. Several countries, plainly still fearful of communist infiltration, tried to ban their nationals from attending the Congress. The Australian government decreed that any of its citizens who travelled to Poland would have their passports immediately cancelled. The indomitable Jessie Street was among the handful of Australians who defied the ban.[41]

In the event, some two thousand delegates managed to reach Warsaw and the Congress took place in a vast factory that had been rapidly transformed into a conference centre with the aid of drapes, banners, streamers and sculptures. Hewlett Johnson made a short speech and received 'a wonderful applause'.[42] He returned home in November 1950 having travelled fifty thousand miles since setting off for Melbourne seven months earlier. He was now a world figure in the international peace movement and a convenient whipping boy of several western governments including his own. Yet although he was an elderly man of seventy-six with a major Cathedral to run (the reader might be excused for having forgotten this), Hewlett Johnson seemed to draw extraordinary physical energy and moral power from a crusade in which he passionately believed. It was as well he did, for many more controversies and confrontations still lay ahead of him.

RUSSIA AND CHINA REVISITED

Nineteen fifty-one began for Hewlett Johnson much as 1950 had ended – with his participation in a World Peace Congress. Fighting off an attack of shingles, he travelled to East Berlin in February for the fourth Congress (after Paris, Rome and Warsaw). While in Berlin he gave the accrued royalties from the sale of his books in East Germany (about 60,000 marks) to the Communist-controlled Humboldt University to fund a scholarship for orphaned children. He later received an honorary degree from the University in recognition of his services to education in East Germany.[1] It was an honour, certainly, but far less meritorious than his award of the Stalin Peace Prize.

The Stalin Peace Prize was created in 1949 to honour Joseph Stalin's seventieth birthday. It was to be the Soviet Union's answer to the Nobel Peace Prize, which in the post-war era was never likely to be awarded to anyone sympathetic to the Communist bloc.[2] But unlike the Nobel Prize, the Stalin Peace Prize was usually awarded to several people each year, the recipients being chosen by an international panel of judges for their work in 'strengthening peace among peoples'. The first two winners, in 1949, were the Icelandic novelist and poet Halldór Laxness and the Brazilian writer Jorge Amado. Pablo Picasso received the Prize in 1950. The co-winners with Hewlett Johnson in 1951 were the German novelist Anna Seghers, the French scientist Frédéric Joliot-Curie, and Soong Ching-Ling, the widow of Sun Yat-Sen, the founder and first leader of the Chinese National People's Party. Later recipients of the Stalin Peace Prize included Bertolt Brecht, Fidel Castro, Seán MacBride, Nelson Mandela, Julius Nyerere, Kwame Nkrumah, Indira Gandhi, Linus Pauling, Paul Robeson and Dorothy Hodgkin. Several of these were also Nobel laureates. Following Nikita Khrushchev's denunciation of Stalin in 1956 the award was renamed the International Lenin Peace Prize, and former winners were invited to return their citations for reissue under the new nomenclature. Johnson declined.

Accompanied by Nowell, Hewlett Johnson received his award on 27 June 1951 at a lavish ceremony in the Kremlin. The presentation was

made by Professor Dmitri Skobeltsyn, the noted Soviet physicist and chairman of the international panel of judges. The ceremony was followed by a banquet 'of great warmth and feeling' at which Johnson received the personal congratulations of Nikita Khrushchev, later to succeed Stalin as First Secretary of the Communist Party. The day closed with a performance of *Swan Lake* by the Bolshoi Ballet. In the following days there were tours of Moscow and the surrounding countryside. As so often in his journals, Johnson could not resist describing the scenes he saw in tones that romanticised the paradisiacal nature of Soviet society.

> A visit to a kindergarten in beautiful wooded countryside was another joy. The little children in white shorts and sun hats played under the trees and paddled in the pools. It was planned to bring all small children from Moscow streets to the verdant countryside during some of the hottest summer weeks. Mothers and fathers visited them and served on kindergarten committees.[3]

The message was fairly transparent: such tender scenes, which really could have occurred under almost any political system, were the visible fruits of communism.

* * *

The Stalin Peace Prize bestowed not only honour but also cash – a hundred thousand roubles, convertible into other currencies. There is no direct record of any such payment among Hewlett Johnson's papers, but at the time of the award he was still under surveillance by MI5 officers who had access to his private bank account. According to their records, £4,000 was transferred from the Narodny Bank in Moscow to Barclay's Bank in Canterbury in June 1951, followed a year later by a second instalment of £6,000.[4] The extant records of MI5 suggest that the combined sum of £10,000 was seen by the secret services as prize money. (To set it in context, £10,000 in 1951 was worth about £230,000 at today's prices.) Although there was never any doubt about the legitimacy of the payments, MI5 was plainly interested in the Dean's personal finances, even to the extent of tapping into his private bank account. The government, too, took an interest in his financial affairs, as a 1952 Cabinet briefing paper reveals.

> His [the Dean's] financial position is not altogether clear. His salary is understood to be £2,000 per annum with his house provided. He has in addition private means, principally invested in house property.

While he does not finance his own journeys abroad, his expenses are heavy, including as they do the cost of repairs to his house property and substantial gifts to individuals and organisations in which he is interested. The income from his own writings is probably small, since, in the U.S.A. for example, all the profits went to the Communist Party there and in East Germany they were used to create 'Johnson Peace Scholarships'.[5]

The paper concluded that:

He is comfortably off. His peregrinations abroad have been paid for him quite openly by his sponsors and the Russians have obviously placed a high value on his services, but insofar as the Dean has acted quite openly, they cannot be regarded as being sinister.

The Cabinet paper captured the essence of Hewlett Johnson's financial situation rather well. His savings and investments were mainly inherited, not only from his own family but also from his first wife, Mary. When she died in 1931 she left him a large quantity of antique furniture, silver, pictures and other artefacts, most of which were sold and the income invested largely in property.[6] In the summer of 1952, when the Cabinet was poring over his finances, Johnson owned four flats and three garages in Canterbury, two houses in south-east London, two properties in the village of Charing (one of which was run as a café to provide work for Fred and Elsie Crowe in their later years) and Llys Tanwg in Harlech. Some of these properties produced an intermittent income, but they were bought mainly as security for his young wife and family in the event of his death. As well as investing in property, Johnson also put money into war bonds, building societies and insurances (with Nowell as the beneficiary), and he owned shares in several companies including the family firm of Johnson Wireworks and – rather surprisingly – the Lonrho conglomerate in Southern Africa.

Yet if Hewlett Johnson was capital-rich, he often found himself income-poor. The cost of maintaining his several properties was outstripping the income they were producing,[7] and the café in Charing ran at a loss. By the summer of 1940 he was faced with a bank overdraft of almost £900.[8] (To set this in context, £900 in 1940 would be worth about £36,000 at today's prices.) In January 1942 he found himself having to borrow £50 (worth almost £2,000 today) 'to tide me over this very heavy time of the year with income tax, car tax, insurance etc all coming in'.[9] Matters were little better after the war, in spite of the Stalin Peace Prize money, and when Kezia and

Keren were offered places at St Thomas' Hospital Medical School in 1958 and 1960, Johnson was obliged to sell some artefacts to help finance their training. They included a Chinese porcelain horse, said to date from the Tang dynasty, that he had inherited from his first wife Mary, a bust of himself by his friend Jacob Epstein, and a 1699 edition of Miguel de Molinos' famous *Spiritual Guide* that he offered to the Methodist industrialist and film producer J Arthur Rank on the grounds that it might once have been owned by Charles Wesley.[10]

A further reason for Hewlett Johnson's periodic financial difficulties was his instinct for giving his money away. Money was important to him and he enjoyed the lifestyle that it enabled him to have, but he was never a slave to it. Nowell had urged him during the war to spend money on small comforts and luxuries that would have eased the rigours of life in the deanery; but that was not in his nature. He was instinctively ascetic towards himself while giving to others without fuss or fanfare. He often responded with personal donations to the genteel begging letters he received from Anglican clergymen who had fallen upon hard times in retirement, and he gave much of the income from the sale of his books to left-wing causes in the many countries that he visited. Johnson was repeatedly charged with hypocrisy in publicly condemning capitalism while privately enjoying its fruits, and there is an obvious element of truth in the charge; but he was never interested in the accumulation of capital for its own sake and he typically spent his money, gave it away, or invested it for his young family as soon as he got it. In terms of the confrontation between God and mammon, there was rarely any doubt about the colours the Dean was wearing.

* * *

In 1952 Hewlett Johnson returned to China for the first time since his epic travels in 1932. The invitation came from the Chinese government via an official whom Hewlett Johnson had met at the British Peace Council in 1950.[11] He and Nowell set off in May 1952, accompanied as so often by Alfred D'Eye, and they were in the country for about seven weeks. The political and economic situation in China had changed dramatically since Johnson was last there. Then, China was in a state of deep flux, with local warlords dominating many rural areas and the Japanese army occupying much of the north-west of the country. The Chinese Nationalist Party (the Kuomintang) led by Chiang Kai-shek was in control of the provinces to the south of the Yangtze River, and the beleaguered rump of the Communist Party was trapped in its southern stronghold in the Kiangsi Soviet.

But two years after Hewlett Johnson's first visit, in 1934, the Kuomintang forced the Communists out of Kiangsi and, led by Mao Tse-tung and Chuh Teh, they began their famous six thousand mile 'long march' from Juikin in the south to Yenan in the north. It proved to be the making both of the Chinese Communist Party and of Mao Tse-tung, and by the mid-1930s a three-cornered struggle for power had emerged between the Communists, the Nationalists and the Japanese. After the Japanese surrendered in 1945, a fearsome civil war broke out between the Nationalists and the Communists that finally brought victory for Mao Tse-tung. In October 1949 the People's Republic of China was inaugurated with Mao as chairman, and within six months the Nationalist army had fled to the island of Formosa (now Taiwan). For the first time in a hundred years, China had a strong government intent on rebuilding the ravaged country as a modern communist state.

* * *

Like most western observers of China, much of what Hewlett Johnson expected to see had been shaped by Edgar Snow's book *Red Star Over China*, first published in Britain in 1937 by Victor Gollancz Ltd.[12] It was one of only six books that Johnson cited in the entire 450 pages of his autobiography, and his personal copy of it is well thumbed. Edgar Snow, a respected American author and journalist best known for his work on Chinese communism, was highly influential in shaping western views of China at a time when little was known about the Communist-controlled areas of the country. *Red Star Over China* was the product of several months that Snow spent with the Red Army, and it was this first-hand experience that gave the book its credibility. Mao Tse-tung, who reportedly talked to Snow at great length, came to see it as a valuable tool of propaganda in the West. Among those who were impressed by it was President Roosevelt, who summoned Snow to a meeting in the White House to discuss his work.[13] Mao's assiduous cultivation of Snow has recently come to be seen as part of a carefully crafted operation to airbrush out the blood-stained history of his rise to power.[14] He is said to have checked everything that Snow wrote, changing and rewriting it where necessary to suit his purposes; but Snow apparently disputed this interpretation of events, claiming that 'Mao never imposed any censorship on me'.[15] Indeed, in the Chinese edition of *Red Star Over China* he supposedly confessed that he found Mao's words 'honest and true'. So too, in all likelihood, did Hewlett Johnson.

So in May 1952, with all their expenses paid by the Chinese government, the Johnsons and D'Eye set off with high expectations about the

Communist regime of Mao Tse-tung. They were not disappointed. In Peking they met Rewi Alley, a New Zealander who had lived in China for twenty-five years and who had been working for the Chinese Communist Party since the creation of the People's Republic in 1949.[16] Johnson relied quite heavily on Alley for his information about daily life under the Kuomintang, and his suspicions were confirmed when Alley recounted tales, based upon his own earlier experiences as a factory inspector in Shanghai, of the miserable existence of many people in pre-revolutionary China. He spoke of the desperate plight of seriously ill children forced to work long hours in the factories with little food, of the sheer brutality of the Kuomintang police, and of the dejection of peasants sitting listlessly in the streets of derelict villages.[17]

That was then. In less than three years everything had changed. 'The villages are transformed', Rewi Alley told Hewlett Johnson. 'The land is cultivated as never before. Not a patch is left untended. The land thrives. The peasants say it is pleasant to handle one's own harvest, no longer claimed by landlords.'[18] And as he travelled around China, Johnson added his own impressions to Alley's rosy scenario. Women had been liberated, children were no longer exploited for their labour, public health had become a public mantra, rural nurses and midwives had been retrained in modern techniques, traditional culture had started to flourish again, roads and sewers had been repaired, and so on. It is little wonder that Johnson enthused about the miracles wrought by Mao's Tse-tung's enlightened system of government.

> Only the support of the mass of the people of all classes could have achieved so much progress in so short a time. If you wanted visible proof that the struggle was bearing fruit, you only had to go into the streets of any town or village in China, to see the rising generation, to see the boys and girls; to see the babies as they lay in their mothers' arms or tottered bare to the skin on a hot summer's day along the city pavements or along the lanes. You needed to see no further proof that health-conscious China was producing a vital, vigorous and happy race.[19]

* * *

A highlight of the visit, echoing Hewlett Johnson's audience with Stalin and Molotov seven years earlier, was his meeting with Chairman Mao Tse-tung and Premier Chou En-lai.[20] Before the meeting, he and Nowell had been invited to dine with Chou and his wife. There was an instant rapport.

It was a most pleasant evening with a long talk before dinner. Chou En-lai, with his brilliant intellect, has a great sense of humour. Madame Teng [his wife], a survivor of the Long March, a perfect hostess and very capable, has great sympathy and kindness.[21]

The subsequent audience with Mao Tse-tung (with Chou En-lai also present) took place on 29 June 1952 in Mao's private quarters in the Forbidden City. Johnson recorded much less of his conversation with Mao than he had of his earlier discussion with Stalin. He talked of his experiences of the floods in China in 1932, and Mao assured him that the new hydraulic works in the Yangtze basin were preventing any recurrence of those far-off disasters. So much had changed, Mao stressed, even in the few years since the civil war. The warlords had lost their power, the land reforms were beginning to bite, and China was ready to trade with the world – especially with Britain, whose machines were sorely needed in the factories and on the farms. China was, Mao insisted, seeking friendly relations with all nations.

Hewlett Johnson then turned the conversation to the state of religion in China, describing the meetings he had been having with Christian leaders of all denominations. Chou En-lai reminded Johnson that China could not ignore the recent history of Christianity in the country or pretend that certain things had never happened. He particularly deplored the legacy of western missionaries who, under the pretext of preaching Christianity, had actually been spreading the values of imperialism and capitalism. 'The Church', Chou told Johnson, 'could only solve its problems by complete dissociation from every imperialist connection abroad.'[22] It was a message the Dean had already assimilated from his extensive meetings with Christian leaders of all denominations. One told him that he found it easier to preach the Christian gospel under communism than it had been under the Kuomintang, and another observed that 'it is clearly and definitively stated in our common programme that the people have full freedom in religious faith'.[23] The Dean told Mao and Chou how reassured he was to find that the Chinese Christian churches had severed almost all their historic links with western missionaries and were now standing on their own feet. If church leaders were still being persecuted, they had probably been supporters of Chiang Kai-shek.

* * *

The Korean war, which was about to enter its third year when Hewlett and Nowell Johnson left for China in May 1952, loomed large in the Dean's discussions with Christian leaders during his visit. In particular, it

was from them that he first heard about the suspected use of bacteriolog-
ical weapons by American forces fighting under the United Nations flag in
North Korea. By the time Johnson met Mao Tse-tung at the end of June he
had already resolved to raise the issue on his return to Britain, a resolve that
Mao presciently described as 'brave'.[24] Typical of the complaints about
bacteriological warfare that Johnson received was the manifesto of the
Chinese Catholic Church, signed by some 13,000 Chinese Catholics.

> As free and fortunate Catholics of New China, we have in religious
> conscience raised strong protests with the American aggressors who
> have waged the bacteriological warfare in Korea and China in viola-
> tion of international conventions and against human morality. The
> bacteriological warfare waged by the American aggressors has already
> been proved to be an irrefutable and ironclad fact through the inves-
> tigations made by both Chinese and foreign people and through close
> examinations by scientists.[25]

The story had all the ingredients necessary to interest the Dean, and he
rapidly set about investigating the accusation. He visited places where germ
warfare was alleged to have been used, examining the evidence and ques-
tioning the local peasants. The nub of the charge was that American
aircraft had dropped a variety of germ-laden objects on communities not
only in North Korea but also across the border in north-east China. They
included flies, fleas, mosquitoes, lice, grasshoppers, spiders and rats,
together with paper, pens, soap, food and clothing that had been contam-
inated with typhus, typhoid, yellow fever, dysentery, bubonic plague,
cholera and smallpox.

The evidence, which Hewlett Johnson described as 'conclusive and
irrefutable',[26] fell into four broad groups. Firstly, there were the supposedly
unequivocal conclusions of scientists based in Peking who had studied the
claims and found them convincing. Secondly, there were the visits than
Johnson had made personally to some of the affected areas where 'strange
insects' had suddenly appeared in gardens and on farms at the wrong times
of the year. Thirdly, there were the testimonies of Christian leaders in China
such as the Anglican Bishop Lindel Tsen who had not himself been in
Korea but who had 'personal friends and acquaintances' who had seen
'flies, mosquitoes, spiders, rats and other insects in patches on the glitter-
ing, snow-covered ground at a season when usually such insects could not
have existed'.[27] And fourthly, there was a supposed confession by two
American airmen, Kenneth Enoch and John Quinn, who, having been shot

down and captured in Korea, admitted to having been trained in the use of germ warfare in Japan and to dropping 'germ bombs' from United States Air Force planes on two occasions in January 1952.

Hewlett Johnson placed great store by Enoch and Quinn's confession, describing it as 'final and unanswerable'.[28] It has to be said, however, that the concluding paragraph, ostensibly written by Enoch without coercion, bears all the hallmarks of a forced admission concocted by the airman's captors.

> Now that I have been captured by the Chinese People's Volunteers, I have been well-fed, well-clothed, received medical treatment, cigarettes, candy and many other kindnesses. I have seen the truth as printed by the democratic Chinese press; and all these truths and kind treatment show all the more clearly the lies and the untruthful war propaganda of the Wall-Street radio and press, who picture the Chinese as barbarian criminals, and who lead American troops to believe that, if captured, they will be shot, or worse. I am beginning to see very clearly just who is the peace-lover and who is the warmonger responsible for this inhuman war, and I am determined to struggle for peace against Wall-Street capitalism, to clear my conscience of my past error. I am filled with determination to join the peace-loving camp, and with the determination to become a new man.[29]

* * *

Convinced by the authenticity of Kenneth Enoch's confession as well as by a large quantity of documentary evidence about the use of germ warfare in North Korea and north-east China, Hewlett Johnson saw it as his pastoral duty to respond to the concerns of Christian leaders in China and expose the scandal on his return to Britain.

> I returned home completely convinced that organs of US Government, and/or its armed forces, were trying out for experimental purposes a great variety of bacteriological and chemical weapons, using methods some of which seemed to be developments of those used by the Japanese Army.[30]

He lost no time setting to work. Within a short time of arriving back in Canterbury at the beginning of July 1952 he had prepared a sixteen-page pamphlet, *I Appeal*, charging the United States with the use of bacteriological weapons and marshalling the evidence.[31] On the cover was a drawing

by Nowell of a Chinese baby who looked as though it could have been killed in a germ attack. A copy of the pamphlet was sent to every member of the House of Lords in anticipation of the debate that was due to take place there about Johnson's claims. Having done that, Johnson then used the pulpit of Canterbury Cathedral publicly to charge the United States with the use of bacteriological weapons; and predictably, the sky fell in on him. The vilification began even before his plane had touched down on English soil when John Junor let rip in the *Sunday Express*.

> Is there one Englishman capable of believing that this country has sunk so low that she deliberately spreads leprosy behind the enemy lines in Korea? Is there one Englishman capable of sustaining and supporting such a slander now circulated in Moscow against the fine and gallant British soldiers in Korea? ... With his gold cross of Christ glinting in the sun, Dr Hewlett Johnson flies home this weekend from Peking. He comes home to trouble such as he has never known before. This time there will be no tolerant welcome for the aged cockatoo of Communism. This time he will not lightly be dismissed as merely 'harmless'.[32]

With much of the rest of the British press jumping onto the bandwagon of vilification, the politicians also decided to weigh into the controversy. John Profumo (later to become embroiled in a spectacular scandal himself) expressed his 'grave concern' about Hewlett Johnson's accusations[33] and the MP for Canterbury, John Baker-White, accused him of spreading a 'wholly evil and loathsome allegation'.[34] The Conservative MP for Tynemouth, Dame Irene Ward, denounced him in the House of Commons as a 'wicked and irresponsible old man' and she asked whether he could be charged with treason.[35] The Attorney General, Sir Lionel Heald, advised the House that no *prima facie* evidence existed to support such a charge. On the following day (15 July) the House of Lords indulged itself at much greater length in a mock trial of the Dean that had unmistakeable echoes of the 'trial' that King Henry VIII had conducted against another of Canterbury's troublesome priests, Thomas Becket, in 1538. On each occasion the accused failed to appear (though for different reasons, of course) and on each occasion the verdict – without the benefit of hearing the case for the defence – was a foregone conclusion.

* * *

The debate in the House of Lords was opened by the Labour peer Lord Ammon, who asked the Lord Chancellor whether any legal action could be

taken against the Dean of Canterbury for, among other things, 'bringing the Established Church into contempt and disrepute'.[36] Ammon charged Hewlett Johnson with preaching 'a materialistic doctrine or philosophy based on hate, bitterness and all uncharitableness'.[37] Then the Archbishop of Canterbury, Geoffrey Fisher, rose to his feet and gave voice to his pent-up frustrations about the man he had never successfully managed to repri-mand. Sheltered by the cloak of parliamentary privilege, Fisher castigated the Dean as 'blind, unreasonable and stupid'.[38] On the specific issue of Johnson's claims about the American use of bacteriological warfare in North Korea and China, the Archbishop charged him with acting as judge and jury on complex matters about which he had made no more than a cursory examination. Had Johnson returned home demanding a full and impartial investigation of the charge, nobody would have complained. But no: having glanced at the evidence and found the Americans guilty, he then proceeded to castigate them 'with all the fervour of a fanatic'.[39] And by doing it all in the name of Christianity, he was (as the Bishop of Chich-ester, George Bell, had recently said) 'blurring the Christian witness against atheism' in a way that 'shocks those who know the sufferings and perse-cutions which Christians have had to bear at the hands of Communists'.[40]

So what could be done about this 'melancholy spectacle'? The answer, the Archbishop told the House with evident regret, was 'very little'. Provided the Dean remained merely unreasonable and self-deluded (rather than certifiably mad), the law could not touch him, and an ecclesiastical charge of heresy would stand no chance of succeeding. There was always the Church Dignitaries (Retirement) Measure of 1948 that allowed an Anglican priest to be tried for 'unbecoming conduct', but it specifically excluded the 'social or political opinions of a dignitary'.[41] In any case, it would be utterly wrong to restrict the freedom of speech of any individual in a parliamentary democracy. Rather, the Archbishop thought that 'it is wisdom to bear with the folly and unreason and delusions of others ... as a price well worth paying to preserve this precious freedom of speech'.[42] So there their Lordships had it. The Dean of Canterbury was a public nuisance to both Church and State and 'a thorn in the flesh of us all', but as long as he remained within the law he would simply have to be tolerated. It would, though, help everybody if the press lost interest in him.

The general sense of impotence in the ensuing debate was palpable. The Lord Chancellor, Lord Simonds, spoke of the wickedness and folly of the Dean's conduct but confirmed that he had done nothing treasonable. Lord Teviot of Burghclere, quoting the words of scripture that 'all things are possible', urged the Government to contemplate new legislation that

would enable the Church to remove 'not only the Dean but also others throughout the country whom I would not mind seeing unfrocked'.[43] The House rumbled its agreement. The Labour peer Lord Strabolgi attacked those who wanted to prevent the Dean from speaking freely but urged that, in order to put at rest the minds of Britain's many friends around the world, an independent enquiry should be held into the allegations about bacteriological warfare. Only one peer, the Duke of Bedford, spoke unequivocally on Hewlett Johnson's behalf, pointing out that the Dean was merely doing what Christian leaders in China had asked him to do and reminding their Lordships of the impressive array of knowledgeable individuals who believed that the United States was indeed guilty as charged. But the House was unimpressed by Bedford's speech and the debate wore on. The Marquess of Salisbury, closing for the government, seemed to speak for most of their Lordships when he 'entirely repudiated the Dean's irresponsible and most reprehensible statements':[44]

> The Dean is not dangerous, he is merely contemptible. And the course most consistent with the dignity of this House and of this country is to treat him with the contempt he most surely deserves.[45]

* * *

The debate in the House of Lords was not, however, quite the end of the furore, for even as the Lords were preparing to vent their wrath against the Dean, a meeting of the Cabinet was held on 10 July 1952 to consider the forthcoming debate.[46] Knowing, perhaps, what the Archbishop of Canterbury was planning to say, the Cabinet discussion focused mainly on the question of whether the Dean could be sacked if the Queen were to be presented with a prayerful address from both houses. No direct answer emerged. More interested in the political than the legal ramifications of the Dean's behaviour, the Cabinet decided that whatever the legalities, it would be 'inexpedient' to go down that particular route. 'Such action would have the effect of giving even wider publicity to the Dean's activities and would attribute to them a greater degree of importance than they deserved.' Insofar as he was a danger, it was almost entirely because of his great publicity value, but with advancing age his effectiveness as a propagandist was wilting. 'From a security point of view', the Cabinet concluded, 'the more people ignore him, the better.'

At the same time (July 1952) the Prime Minister, Winston Churchill, faced separate calls for a special tribunal to be set up to investigate Hewlett Johnson's claims about the American use of bacteriological weapons in

North Korea. Churchill refused, ostensibly because to do so would 'invest the activities of the Dean of Canterbury with an importance they do not possess'. The British press were delighted. The *Daily Graphic and Daily Sketch* spoke for many when it declared in an editorial that:

> It [the setting up of a tribunal] would have flattered his self-esteem. It would have given him new importance in Moscow and Peking. It might even have added the name of Dr Hewlett Johnson to the shoddy roll of Communist 'martyrs' by depriving him of the Deanery whose dignity he has abused and whose traditions he has tarnished. Rightly, the Prime Minister has declined to add to the Dean's exaggerated sense of his own importance in this way.[47]

There may, however, have been something else in Churchill's mind – a covert admiration, perhaps, for a man who in certain respects was not dissimilar to himself. Politically, of course, the two were as far apart as it was possible to get, but the biographical similarities between them are quite striking.[48] Born in the same year, both were prolific writers without professing to be great thinkers. Both were stubborn to the point of obduracy. Both were fervently committed to ideologies (imperialism in the case of Churchill and communism in the case of Johnson) that were later to become discredited. Both displayed a ferocious energy that old age did little to diminish. Both had a self-belief that seemed at times to border onto arrogance. Both were accomplished orators who relished the limelight of publicity. While deploring his politics, Churchill may have recognised in Johnson something of his own obstinacy and courage.

David Caute backed up the theory about Winston Churchill's covert admiration for Hewlett Johnson with a story that, if true, locates the Prime Minister's sympathies closer to the deanery in Canterbury than to Lambeth Palace.[49] At the very least it is a little-known gem of Churchillian wit. Explaining why no disciplinary action could be taken against Hewlett Johnson for his public accusations about germ warfare in Korea, Churchill is reported to have attributed it to the fact that, in framing the Thirty-Nine Articles of Religion in 1563, the Elizabethans had inadvertently omitted any reference to germ warfare. So too, regrettably, had the Victorians when drafting the Church Discipline Act of 1840. Hewlett Johnson would have warmed to the story far more enthusiastically than Geoffrey Fisher – if either ever heard it.

* * *

Did the Americans engage in bacteriological warfare in North Korea and China? The question has never been answered definitively. At the time, in 1952, the British government vehemently denied the charge, as also did the International Red Cross and the World Health Organisation. Denouncing these denials as western bias, the Chinese government arranged for an 'independent' investigation by the World Peace Council, which set up an International Scientific Commission to investigate the allegations. Among its members was Professor Joseph Needham, the distinguished British biochemist and the only person to have been simultaneously a Fellow of the Royal Society, a Fellow of the British Academy and a Companion of Honour. In its Report in September 1952 the Commission concluded that the allegations were true and that the United States had indeed been experimenting with biological weapons. Ten years later, in February 1962, Needham wrote to Hewlett Johnson reiterating his commitment to the Commission's conclusions.

> Nothing whatsoever has happened to induce me to revise my opinion consistently held since 1952 that the American side in the Korean war did try experiments in bacteriological warfare using insect vectors and means broadly of that kind. I still consider it extremely probable that they were testing out the efficacy of a particular type of bacteriological warfare in which the Japanese had long specialised.[50]

There the matter may have rested, but in 2007 Jung Chang and Jon Halliday published a new biography of Mao Tse-tung that has been acclaimed as an authoritative account of the Chinese leader. Chang and Halliday concluded that, although Mao used the accusations of germ warfare to whip up hatred for the United States inside China, they had in fact been fabricated. They relied for this conclusion on interviews they had conducted with two Russian generals who had been in Korea at the time: Valentin Sozinov, chief advisor to the North Korean Chief of Staff Nam Il, and Igor Selivanov, chief medical adviser to the North Korean Army.

> Both told us they had never seen any evidence of germ warfare, and Selivanov stressed that in his position he would have known about it if it had happened. Other leading Russian officers and diplomats involved concurred.[51]

CHAPTER SIXTEEN
BEING DEAN IN THE 1950s

AFTER THE PHYSICAL and emotional upheavals of the 1940s, life in the precincts was a little less traumatic in the 1950s. At a personal level it was a decade in which Hewlett Johnson could, for the first time in his life, enjoy the pleasures of marriage and fatherhood in a setting that came close to domestic happiness. A photograph taken for *Pictorial Press* in 1948 showed Hewlett and Nowell taking tea with Kezia and Keren in the restored deanery drawing room.[1] The girls are charmingly dressed in summer outfits that could well have been brought back from their father's visit to Eastern Europe in 1947, and Nowell is dignified and relaxed in the privacy of her own home. It was hardly a typical family photograph, not least because it was artificially posed for public display and the Dean was wearing his customary frockcoat and gaiters; but it did reflect Johnson's conscious attempt to give his family as ordinary a life as his extraordinary circumstances would allow. Deliberately spurning the opportunity of a private education for his daughters, he sent them first to the Methodist primary school in Canterbury and then to the Simon Langton Girls Grammar School where they were able to forge their own friendships entirely unconnected with the precincts.

Yet however assiduously Hewlett Johnson tried to protect his family from the fusillade of outrage that continually burst about him, the persistently tense atmosphere of the precincts inevitably took its toll. Robert Hughes, who had the advantage (denied to the present author) of talking at length to many of the Dean's contemporaries in the 1970s, sketched out the human reality of the situation.[2] Returning to the deanery depressed and hurt from one bruising meeting of the Chapter after another, Johnson's mood was bound to rub off on the others. Kezia and Keren grew steadily aware of the enmity that lay beyond the walls of the deanery as, time and again, they saw their father ostracised by his colleagues and savaged by the press. To the natural embarrassment that adolescents feel towards their parents was added, in their case, the discomfiture of their father's high public profile. To sit in a café on holiday and endure the stares and sniggers

of others around them was agonising,[3] and even at school there was no escape when their father strode onto the premises and caused the headmistress, Miss Nora Campling, to turn 'all pink and quivery'.[4] Much later, when Kezia became engaged, her fiancé was said to have been 'hard put to convince the gossip-writers … that to love a Johnson daughter … did not make him an agent of the Kremlin.'[5]

Nowell, too, was sensitive to the negative vibrations around her. Lacking her husband's robust ability to shake off criticism and scorn, she stoically endured 'the lonely war that her loyalty compelled her to fight.'[6] Lois Lang-Sims, who knew the Johnson family for many years, wrote sympathetically of her that:

> It was as if she were deliberately holding her own against the spiteful world. The spate of malice directed against the Dean and his family by the élite of the city … could never be anything but incomprehensible to a woman whose character was so naturally disposed towards friendliness: she would never get used to it, never cease to flinch in a constantly renewed astonishment and distress. And yet she had a tremendous dignity and pride. She knew – she must have known – that she could outshine, by their own petty standards, the whole female contingent of that snobbish little society which blossomed out from the Cathedral and its Precincts.[7]

Nowell had a full life in the 1950s as she played the part expected of a Dean's wife while also pursuing her own activities as a magistrate, artist, and carer to her elderly mother in Folkestone and her increasingly ill brother, Menlove, in Charing. But it was, in all likelihood, a rather lonely life: her husband was occupied incessantly from morning to night, and with the exception of Peta Pare, the wife of the Choir School headmaster, she had few close friends or confidantes.[8] There was no trusted shoulder for her to weep on, no sounding board against which to protest her frustrations over the treatment of her family. For Nowell, life at the deanery never recaptured the haunting beauty of the brief time between her marriage and the outbreak of war.

* * *

The life of the Cathedral went serenely on, as it had done for centuries, with barely a perceptible ripple. As the 1950s unwound, the Festival of Britain and the coronation of Queen Elizabeth II were celebrated; the new library was opened to replace the one that had been destroyed in 1942; the

Black Prince's achievements were copied and the originals placed in an environmentally controlled display case; several bays in the cloister were repaired; the apse in St Gabriel's Chapel was opened up; and the arrestingly colourful windows by Harry Stammers and Erwin Bossanyi were dedicated in St Anselm's Chapel and the south-east transept respectively. The Friends of Canterbury Cathedral continued their pre-war tradition of organising annual festivals of music and drama, but although they still attracted some big names (among them Robert Speaight, Alfred Deller, Dame Sybil Thorndike, Sir Lewis Casson, Sir Kenneth Clark, Christopher Hassall, Maria Korchinska and Sir Adrian Boult), they seemed to lack the innovative spirit of the 1930s. It was partly that the driving force behind the Friends, the redoubtable Margaret Babington, was suffering increasing ill health (she died in the precincts in 1958), and partly that the King's School had begun its own rival attraction in what came to be known as King's Week.

For Canon John Shirley, the headmaster of the King's School, the success of King's Week threw into relief his long-standing disagreements with the Friends.[9] In a letter to Hewlett Johnson in March 1954 in which he tendered his resignation from the Friends' Council, Shirley dismissed many of the Council members as little more than the tame nominees of Margaret Babington who never came to the Cathedral and who were interested only in cluttering it up with 'such things as banners, candle sticks, prayer-books, draperies and furniture':[10]

> I think I yield to no one in admiration for Miss Babington's gifts, but I cannot appear to be in any sense one of her stooges. By those gifts she has made those Friends into a considerable body, which has produced much money. That is excellent, but the Cathedral does not exist as a theatre from which to stage-show the Friends and, in particular, their Treasurer-cum-Secretary.

John Shirley was not, however, averse to raising money for the King's School, even to the extent of enlisting the Dean's support. When the fund-raising for his own memorial (a new hall to be named the Shirley Hall) began to lose momentum in 1956, he tried to enlist Hewlett Johnson's help in writing personal letters of appeal to potential donors.[11] It would, Shirley thought, show that 'we were all in it together.' Whether the Dean complied with Shirley's request is unknown; but even had he done so, it would have been with a degree of reluctance and even distaste. A year later, in the midst of a furious row between the King's School and the Cathedral, Johnson

wrote an uncharacteristically caustic appraisal of Shirley in a letter to Alfred D'Eye.

> Only too thankfully would I be relieved of the always nauseating task of listening to a Shirley speech which never held up an ideal to the boys and was simply a flippant appeal for money for further expansion.[12]

* * *

Nineteen fifty-six, the golden jubilee of Hewlett Johnson's ordination as priest and the eighty-third year of his life, was a difficult one for the Dean as he faced renewed public criticism for his stance on a number of world events. In February Nikita Khrushchev delivered a speech to the 20th Congress of the Russian Communist Party in which he tried to bring reconciliation to the Soviet people after the terrors and atrocities of the Stalin years. It was a comprehensive and brutal denunciation of much of what Stalin had done and the way in which he had done it. The speech, which was supposed to have been given to a closed session of the Congress, was quickly leaked and used throughout the capitalist world to discredit Stalin and, by association, communism also. Nowell was probably more shaken by it than Hewlett, for nothing could now disturb his estimation of the former Soviet leader. 'Stalin will be judged by history', he wrote in his autobiography, 'and I have no doubt as to what, in part, this judgement will be. Stalin began to build socialism in a backward peasant land surrounded by the armies of powerful foes. By the time Stalin died the Soviet Union was the world's second industrial power.'[13] Johnson's refusal to endorse Khrushchev's denunciation of Stalinism sent out a clear message of defiance to his detractors: even in his eighties, the Red Dean was not for turning. Four of the canons described the resulting situation as 'poisonous' and called for 'a policy of complete quiet, reticence and inactivity' as the proper way to 'true wisdom'.[14]

The Soviet suppression of the popular uprising in Hungary in the autumn of 1956 further alienated Hewlett Johnson not only from his colleagues in the precincts but also from the great mass of public opinion in Britain. In a nationwide revolt that began as a student protest but quickly spread throughout Hungary, the hard-line Stalinist government of Mátyás Rákosi – a man whom Hewlett Johnson had met and admired – was overthrown and replaced by the more moderate but still Communist government of Imre Nagy. During the ten days that Nagy's National Government was in power many political prisoners were released, including Cardinal Mindszenty whom Hewlett Johnson had refused to support

in 1949 in his outspoken opposition to Rákosi.[15] After seeming at first to accept the reality of the new political landscape in Hungary, the Kremlin changed its mind and on 4 November 1956 a large Soviet force invaded Hungary. Within two months a new Soviet-backed government had been installed in Budapest and all public opposition suppressed.

Western reaction to the Hungarian uprising and its aftermath was broadly critical of the Soviet Union. In Britain, thousands of members resigned from the Communist Party in protest, unable to accept the 'official' Soviet line that the Hungarian government had appealed for help in crushing an American-backed plot to seize power. Those who remained loyal to the Soviet Union found themselves performing breathtaking contortions with their consciences. For Hewlett Johnson, the Hungarian conflict was another moment of acute moral crisis, not least because at its height he had preached a sermon in Canterbury Cathedral condemning the fiasco of the contemporaneous British and French invasion of Egypt to reclaim the Suez Canal. 'Today', Johnson proclaimed from the pulpit at the very moment that Soviet tanks were preparing to roll into Budapest, 'we are arraigned before the whole world and condemned for the very things for which we paid so high a price. We are guilty of naked aggression.'[16] What, having set up such a dramatic hostage to fortune, was the Dean now to say about the Soviet Union's naked aggression in Hungary?

According to Robert Hughes, Hewlett and Nowell Johnson 'withdrew to Llys Tanwg and debated alternatives for hours as they walked on Harlech beach.'[17] Should they admit their mistakes and misjudgements and go back on all they had stood for? Should they disappear into decent obscurity in a remote country parish? Should they simply retire to Llys Tanwg and grow vegetables? In the event they did none of these things: while declaring himself 'shocked' by the events in Hungary and no more able morally to condone them than the disastrous invasion of Egypt, Johnson insisted that the two political contexts were very different.[18] Whereas nobody had invited the British or French armies into Egypt, Rákosi's government *had* invited the Soviet troops into Hungary – and for a far more laudable purpose. The Egyptian escapade had tried deliberately to put the clock back to the dark days of colonialism whereas the Hungarian occupation was intent on *preventing* a return to the dark days of fascism in Europe.[19]

Few believed the Dean as a new wave of anti-Soviet sentiment swept the country in the aftermath of the Hungarian uprising. As always in his most controversial moments, Johnson received many letters of support for his position; but the press portrayed him with blood on his hands and

Canterbury closed ranks against him. The Simon Langton Girls School (where Kezia and Keren were pupils) started raising money for Hungarian refugees and John Shirley announced that he would be offering two free places at the King's School to students from Hungary. He also placed the deanery and its occupants out of bounds for the King's School boys. Ominously, the governors began to plot Johnson's removal as Chairman of the Governing Body.

* * *

It was the boys of the King's School who began the process of destabilising the Dean when they presented him with a petition, signed by three hundred of them, deploring his attitude towards the events in Hungary.[20] 'We hope', the boys said, 'that this appeal to your strong humanitarian sense will shatter your misconceived faith in the Soviet Union.' It was a bold stand by the pupils against the Chairman of the Governing Body. A little later, in November 1956, the governors met to discuss the harm that was being done to the school by the Dean's activities.[21] They began to explore ways of easing him out. There was, however, a problem, for under the Ministry of Education's rules, the Dean could only be removed as ex-officio Chairman through a change in the school's constitution;[22] and that would be a complex business. When the King's School Visitor, Archbishop Geoffrey Fisher, heard what was afoot he had little option but to intervene. He may, though, have found himself in a quandary, for much though he may have wished to see Hewlett Johnson's position undermined, perhaps to the point of persuading him that it was finally time to retire, he well understood the long-term implications of severing the ex-officio link between the Deanship and the Chairmanship of the Governing Body.

The Archbishop proposed a compromise: would Johnson be prepared voluntarily to absent himself from meetings of the Governing Body for a certain period – say, a year – in order to buy time for a more enduring solution to be found?[23] Genuinely anxious not to damage the King's School in any way, Johnson agreed; but the compromise did not endear itself to the governors, who by now would stop at nothing short of the Dean's removal from office. In February 1957 the Governing Body debated a recommendation from the Finance Committee that the school's constitution should be changed to require ex-officio governors to retire 'upon attaining the age of 80'.[24] It was a blatantly political attempt to get rid of Johnson, for as he pointed out, there was another octogenarian governor (Somerset Maugham) who would be entirely unaffected by the recommendation as his was not an ex-officio appointment.[25] Knowing that the Archbishop was

for once on his side, Johnson held firm, castigating the governors for thinking they could both give away his own rights as Dean and prejudice those of his successors. And then, in a wonderful aside that showed he had lost none of his feistiness, Johnson mischievously dismissed the recommendation as entirely irrelevant to his own position since he had *already* attained the age of eighty and would therefore never again be in position to do so. Finally came the blackmail: if he were to be ousted, then 'my lips will be unsealed on many matters'.[26]

Recognising when they were beaten, the governors rejected the Finance Committee's recommendation. 'The effect', the Clerk to the Governing Body told Hewlett Johnson, 'is that there will be no retiring age of ex-officio Governors [and] the Dean will be Chairman unless he retires from the Chairmanship.'[27] The way was now clear for the Archbishop's earlier solution to be adopted, namely that Johnson should remain as Chairman but voluntarily absent himself from meetings of the Governing Body for a year or two while a longer-term solution was being sought.[28] In agreeing to this way forward, Johnson took the opportunity of explaining his side of the story to Fisher.

> You may perhaps surmise that this whole situation is engineered by Canon Shirley who prides himself that he has dislodged a Chairman of Governors by his own skill. There was an occasion some years ago when I had to make a long statement to the governors owing to a tissue of lies by the Headmaster. He buried his head in his hands and hoped that the Dean would give him another chance. Shirley has never forgotten that, though I have been out of my way to be kind and helpful to him ever since. ... I feel that the situation might be disastrous if it was discovered that the Headmaster of a school could discharge the Chairman of Governors in an effort to suppress free speech.[29]

This was not, however, the end of the matter. Further discussions must have taken place behind the scenes, for a few days later the Archbishop informed Johnson that he had finally reached an agreement with the governors under which Johnson would remain on the Governing Body but would surrender all his powers and duties as Chairman. An 'Acting Chairman' would be appointed in his stead for a specified period of time.[30] Fisher may well have had his doubts about the arrangement, not only because it severed the link between the Deanship and the Chairmanship that he had been so anxious to maintain but also because it over-rode the agreement he had earlier reached with Johnson. If the Archbishop harboured any fears

about a characteristically defiant response from the deanery, he did not have long to wait. Having displayed what he had thought was a 'magnanimous spirit to those who wished to damage me and derogate my office', Johnson declared himself 'shocked' by Fisher's new proposals, which went 'infinitely further than your original and happy suggestions'.[31] He told the Archbishop:

> I would infinitely prefer the world to know the kind of intolerance and attack upon freedom of speech of which this is a symbol. Even now I am not sure that it is not my duty in the interests of School and Cathedral that these should be brought to the public. ... It is intolerable that the School should censor the utterance of the Cathedral. ... I very greatly regret having to say what must be said firmly, that I am utterly unable to accept these new proposals.

Caught between Hewlett Johnson's fierce defence of his own position and the governors' equally fierce determination to oust him from the chair, Geoffrey Fisher somehow managed to find the authority to re-impose his original solution. When the Governing Body met again in April 1957 it finally accepted his recommendation that Johnson should remain as Chairman without attending any of the governors' meetings.[32] On formal occasions such as speech days, when the Dean would normally be expected to speak, his place would be taken by the Archbishop. It was a reasonable compromise all round: the historic link between the Deanship and the Chairmanship remained intact; Hewlett Johnson was spared the embarrassment of being seen to have been silenced by John Shirley; and the governors had got the Dean out of their hair for the time being. In fact, the episode had a positive conclusion, for Hewlett Johnson was invited to resume his full functions as Chairman in 1961, two years before he retired.[33]

* * *

Hewlett Johnson's confrontation with the King's School was by no means his only brush with authority in the 1950s. On Easter Sunday 1956, a few weeks after Nikita Khrushchev's denunciation of Stalin at the 20th Congress of the Russian Communist Party, Georgi Malenkov paid a sudden visit to Canterbury together with the Soviet Ambassador to Britain, Jacob Malik. Malenkov (who, like Johnson, had trained originally as an engineer) was a heavyweight Soviet politician who, with the self-interested support of Lavrentiy Beria, the former chief of Stalin's secret police, became

Chairman of the Council of Ministers following Stalin's death in 1953. Malenkov was forced to resign after two years, partly because of his closeness to Beria (who had been executed for treason in 1953) and partly because of the slow pace of domestic reforms in the Soviet Union; but he remained in the Politburo and it was he, together with Bulganin, Molotov and Kaganovich, who tried to oust Khrushchev as First Secretary of the Communist Party in the summer of 1957. The attempt was unsuccessful and Malenkov was expelled from both the Politburo and the Central Committee of the Communist Party. Four years later, in 1961, he was expelled from the Communist Party itself and sent into internal exile in Kazakhstan where he became a manager in a hydroelectric plant.

Georgi Malenkov's visit on Easter Sunday 1956 had been hastily sprung on the Dean only three days earlier. A timetable for the visit was quickly drawn up and communicated to the Archbishop of Canterbury when he arrived to preach at the Easter morning service, but there were no plans for him to meet the visitors. After lunch in the deanery, Malenkov and Malik were taken by Hewlett Johnson into the Cathedral for a tour, beginning in the crypt where the Dean paused to await the end of Easter evensong in the choir above.[34] Judging his timing carefully, Johnson then took the party up the Dean's Steps to the north choir aisle, only to discover to his horror that he had underestimated the speed at which the evensong procession – which, unbeknown to him, included the Archbishop – would move from the choir to the vestry via the very same aisle. In a scene worthy of Trollope, the archiepiscopal procession moving eastwards met Johnson, Malenkov, Malik and a couple of Soviet bodyguards moving westwards. In the absence of any protocol that might have dealt with the situation, the two processions passed each other in a silence that was broken only by the Archbishop wishing the Dean a good afternoon.[35]

* * *

Hewlett Johnson assumed that his Soviet visitors, not unfamiliar with church ceremonial, would find this brief and largely silent encounter unexceptionable; but Geoffrey Fisher saw it differently. Incensed by what had happened, he wrote to Johnson in the strongest possible terms.[36] Part of the Archbishop's anger centred on the Dean's discourtesy in exposing him to the embarrassment of the occasion. Johnson had, Fisher complained, 'outraged our feelings by ignoring the ordinary requirements of good manners.' The Archbishop's anger, however, went much deeper than a mere matter of courtesy: his magisterial rebuke cut to the very heart of a Christian principle that he believed the Dean had now abandoned.

The day was Easter Day. You are Dean of Canterbury Cathedral. On this day pre-eminently the Cathedral is the shrine of the Church's supreme acts of Christian worship. ... On this day you bring M. Malenkov to Canterbury. He has beyond all doubt sent to their deaths very many victims of the Soviet system without any semblance of a trial. In this grim story he stands on the side of the crucifiers and against Christ the crucified. He entirely disbelieves the Resurrection of Christ. He rejects any idea of new life in Christ. He denies that there is a God. ... To bring this man and all that he stands for to Canterbury on Easter Day was a foolish and insensitive thing to do. To bring him into the Cathedral on Easter Day was an offensive thing to do. ... He could only enter the Cathedral as an avowed infidel and as a persecutor of the Christian faith: and you, the Dean, demeaned yourself to acceptance of infidelity and approval of persecution by bringing him in. ... You injured the feelings of everyone for whom the Cathedral on Easter Day is above all a proclamation of the Gospel. ... You could not easily have found a more public moment at which to identify yourself with an infidel and a persecutor of the Church.

And then, as if to lance an ugly boil of resentment that been gathering for years, Geoffrey Fisher tore into Hewlett Johnson with a vehemence made even more dramatic by the archiepiscopal authority with which it was delivered.

Your spiritual tragedy is that you are apparently so blind and self-satisfied. You are reported as saying that the term 'Red Dean' has now become a term of affection. I must tell you that you are wrong. The truth which you will not allow yourself to see or believe or regret is that you are a constant cause of grief and indignation to all but a few members of the Church of England and a cause of perplexed anger to a vast number of Christian people of the Anglican Communion and outside it all over the world. The truth is that apart from your dignified presence, your amazingly effective reading voice and your courteous manners you are bringing nothing to the life and witness of the Cathedral or of the Church of England except sorrow and confusion and righteous anger.

All but the strongest (or, perhaps, the most self-confident) of Anglican priests might have paused for thought upon receiving such an epistle from their Archbishop; but Hewlett Johnson was lacking neither in strength nor in self-confidence, and he had soon composed a four-page response to the

charges made against him.[37] It began in a characteristically low key that nevertheless managed to hint at what was to follow. 'I hope', he wrote, 'that I may with all humility leave it to others greater than ourselves to discover the truth of the criticisms and accusations that you make, and which perhaps in calmer moments may be tempered with charity.'

With this preamble out of the way, Johnson then went onto the offensive as he disarmingly responded to the Archbishop's charge that he had 'demeaned himself' by bringing an 'infidel' into Canterbury Cathedral on Easter Sunday. 'Would you', he asked Fisher, 'shut the doors of any Christian Church on any non-Christian or non-believer at any time?' Should not an even greater welcome be given to those who do not believe than to those who do? And what better time to do so than on Easter Sunday, the day of resurrection and new hope? Indeed, no less a person than the head of the Anglican Church (the Queen) would shortly be receiving Malenkov and Malik in a private audience. 'By doing so does she not, as it were, place her imprimatur upon them? And if she may receive them, should not I?' And then, at the end of the letter, came another of Hewlett Johnson's trademark barbs. 'I see', he mildly observed in a PS, 'that Westminster Abbey and St Pauls have both welcomed the guest [Malenkov]. Surely it was no incorrect action that made Canterbury, the Metropolitical Church, take the lead?'

* * *

The whole of this remarkable episode, revealing as it does so much of the personal and professional animosity between Geoffrey Fisher and Hewlett Johnson in the 1950s, occupied only a couple of uninformative paragraphs in the Dean's autobiography. 'I'm afraid', he wrote tantalisingly, 'that I got a furious letter from the Archbishop.'[38] What Johnson evidently did not know when he wrote those words – but would probably have made a meal of if he had – was that Georgi Malenkov came from a noble Macedonian family and had had a childhood upbringing in the Russian Orthodox Church. Towards the end of his life, when all political power had drained from him, he reverted to the Christian faith of his early years and on his death in 1988 he was buried beneath a Christian cross.[39] It is an intriguing postscript to an otherwise unedifying story, but it might be seen as a vindication of Johnson's plea that even 'infidels' should be welcomed into a Christian place. Who is to say that Malenkov's late reversion to Christianity did not owe something to the events in Canterbury Cathedral on that Easter Day in 1956?

* * *

The inexorable build-up of nuclear arsenals throughout the 1950s was a matter of deep pastoral concern to Hewlett Johnson, for he regarded the appalling but very real prospect of a nuclear war as being as much a moral issue as a political one. Having publicly condemned the United States for its nuclear assaults on Hiroshima and Nagasaki in 1945, and having preached in Canterbury Cathedral in 1950 against the nuclear ambitions of both America and the Soviet Union,[40] he viewed with utter dismay the superpowers' acquisition of the hydrogen bomb in 1954. The American test at the Bikini Atoll in the Marshall Islands in March that year was, he said in another fierce sermon in the Cathedral, 'the greatest man-made physical upheaval of all time', and he saw it as the imperative duty of all Christian people to 'insist that negotiations be renewed at once with a view to a universal banning'.[41]

Three years later, in 1957, the Campaign for Nuclear Disarmament (CND) was formed, and from 1958 it organised an annual march over the Easter weekend from Trafalgar Square to a vigil at the Atomic Weapons Establishment at Aldermaston in Berkshire. Hewlett Johnson was not among the five thousand who attended the first public meeting of the Campaign in London in February 1958, but he and his family were soon to do their bit. Alongside Canon John Collins, Kezia and Keren made several Easter pilgrimages to Aldermaston, with Hewlett and Nowell joining them for the last few miles.[42] And in May 1960 Johnson spoke on behalf of the British Peace Committee in Trafalgar Square on the day before the collapse of the much-heralded summit meeting in Paris between the four nuclear powers – Britain, the United States, the Soviet Union and France. The collapse followed three days of bitter recriminations triggered by the downing of an American U2 spy plane over Sverdlovsk. The civilian pilot, Gary Powers, was arrested, tried and sentenced to ten years' imprisonment for espionage but was exchanged for a Soviet KGB agent in 1962.

The most spectacular episode in Hewlett Johnson's anti-nuclear protestations came in 1959 when he had a large and professionally painted sign affixed above the front door of the deanery: 'Christians Ban Nuclear Weapons'. The lettering was white on a blue background. When grammatical purists pointed out that Christians were not in a position to ban nuclear weapons, a comma was inserted after 'Christians', thereby changing the entire meaning of the phrase. Johnson explained in a press statement that he had erected the sign in response to a complaint from Chinese bishops attending the Lambeth Conference in 1958 that the Conference had condoned the principle of nuclear deterrence. 'I have put up this notice on my door to show them [the Chinese bishops] that there are Christians

in England and Canterbury who realise the danger and the absolute nega-
tion of Christianity to fail to protest against weapons of mass destruc-
tion.'[43] If the bishops ever saw the famous photograph of Hewlett Johnson
standing beneath the sign, they may well have felt themselves vindicated;
but others were less pleased. Facing as the deanery does onto the Green
Court of the King's School, the sign could not possibly be missed by staff,
pupils and parents, and retribution was swift. Within a week a King's
School pupil had thrown a pot of red paint at it and later the white letter-
ing was over-painted in blue. Restorations duly took place and the sign
remained in place until Johnson's retirement in 1963 when it was snaffled
by a King's School pupil and carted off as a trophy.

There is no record of the response of the King's School headmaster,
Canon John Shirley, but he must have been angered by the Dean's latest
stunt. The very last thing he would have wanted was for prospective
parents, on setting foot in the Green Court for the first time, to find them-
selves exhorted to ban nuclear weapons. It is, though, appropriate to end
this survey of the 1950s with John Shirley, for although the atmosphere of
the precincts owed much to his complex relationship with Hewlett John-
son, the decade ended with a kind of reconciliation. In May 1959 Shirley,
now aged sixty-nine and with only three more years to serve as headmas-
ter, sought to draw a line beneath the animosities that had marred his deal-
ings with Hewlett Johnson. In a letter full of anguish and humility, he
exposed his fears and frailties to the colleague he had so often crossed, and
(if not quite in so many words) he sought forgiveness.[44] In this act of contri-
tion, John Shirley revealed himself at the end as a man who was realising
that he may soon be facing an eternal reckoning and needed to put certain
things in order. He wrote to Johnson:

> I know I often seem a silly fool, but I am not entirely that. I am bitterly
> conscious of my own sinfulness, but pride and aggrandisement and
> careerism and unkindness and contempt of others who have not risen
> so far seem to me as bad as anything else. And I am terrified when I
> look back on my life and know how much the sin and how paltry the
> good: and at times I would prefer to believe there *is* no purpose and
> therefore no after-life. I have been busy night and day rather than study
> and think and face the future (the eternal one I mean) of my *self*. I
> haven't had a self: it's been submerged, and now it refuses to be, but I
> don't know what to do with it.

And then John Shirley turned to his relationship with Hewlett Johnson.

At the earliest moment I want to get straight with you. I have really hated all the quarrels we have had. You were defending one thing and I another – but I was more sad and distressed than you would have believed. How I would like friendship and mutual understanding to take the place of enmity, and the intervening years to be blotted out. I'm nearly 70 and you are 85: you may well reach 95 and more, but I shan't be able to keep pace. It amazes me how you retain your zeal and enthusiasm and faculties. You are younger in mind than any of us and far wider in the scope of your interests. And I, who have boxed myself up in one job and neglected all other faculties, I do not look forward to the attractions of old age.

It cannot be documented, but perhaps, as these two old men approached the end of their professional lives, one as the Dean of England's greatest Cathedral and the other as the Headmaster of one of England's greatest schools, there was finally a reconciliation that allowed their respective institutions to move into a new era unencumbered with the detritus of past battles.

CHAPTER SEVENTEEN
TRAVELLING ON

DEFYING AGE AND INFIRMITY, Hewlett Johnson continued to travel until almost the end of his life. Although there were large parts of the world that he never visited (including South America, the Indian subcontinent, Africa and South-east Asia), he was an indefatigable traveller from his earliest forays into Europe at the turn of the century to his final odyssey around China in 1964 in a 'special plane' provided by the Chinese Premier, Chou En-lai. Three of his passports, from 1938 to 1964, have survived in the archive: battered and almost falling to bits, every page is crammed with visas, permits, entry and exit stamps, tax receipts and notes by immigration officials.

In October 1954, when Hewlett Johnson was eighty, he and Nowell returned once again to the Soviet Union as the guests of VOKS.[1] His account of their visit is instructive for the insight it gives into the generous way in which guests were still being treated by VOKS in the period following Stalin's death. The first week was spent largely as tourists in Moscow and included a visit to Johnson's old friend Alexei, Patriarch of Moscow, at his country dacha. From Moscow he and Nowell flew via Aktubinsk and Samarkand to the old city of Dushanbe, renamed Stalinabad in 1929 in honour of Stalin. The capital of Tajikistan, Stalinabad had once been a small settlement in a backwater of the Soviet Union, but the coming of the railway had transformed it and by 1954 it was a city of 300,000 people with a large public library, a flourishing university, and tree-lined boulevards. Accompanied by their VOKS guide Yuri Andreyev, the Johnsons visited collective farms, rural communes and a large irrigation project in the Vaksh Valley that brought water to vast areas of otherwise parched land. Hewlett Johnson needed no encouragement to see it as part of Stalin's great legacy for his people.

From Stalinabad the Johnsons moved on to Tashkent, in Uzbekistan, where a typical VOKS programme of visits had been arranged for them. Staying in a country dacha set in a large garden, they toured the city, saw a performance of *Hamlet* in Russian, visited a school for musically gifted

children from all over the Soviet Union, and met up again with the Imam of Tashkent whom Johnson had encountered on his previous visit in 1945. He described the reunion with great sympathy.

> Entering a courtyard, we passed into a charming, quite humble house, but with a pretty painted room where a meal was prepared. ... The meal started, as it had done nine years ago, by the traditional breaking of bread and offering of salt by the Imam. We ate grapes and strawberries, very sweet and delicious; the old Imam repeatedly piling them up on our plates. ... After lunch we saw the library, full of ancient books, scrolls and documents. Saying goodbye to us, the Imam presented me with a silk robe and embroidered cap, and most charmingly gave my wife two embroidered caps for the children, and put a third on her head and gave us a most affectionate farewell.[2]

There were further similar visits to Samarkand and Alma Ata before the party returned to Moscow in time for the revolutionary celebrations in Red Square and a reception in the Kremlin. It was the sort of gathering that, with its distinguished guests and glittering formalities, Johnson really rather enjoyed.

> We joined in the brilliant assembly of ambassadors and military men in uniforms from all over the world; civilians in impeccable evening dress, ladies in splendid gowns; and among the many ordinary people workers and peasants from towns and collective farms from all over the Soviet Union. We moved from the large brilliant rooms to the old part of Tsar's palace, with its vaulted painted ceilings and walls; we met many artists and scientists and old friends. Malenkov, Molotov, Voroshilov and Government leaders were there, with heads of States and Ambassadors. Later, Malenkov and Molotov spoke with us and Malenkov asked whether my religious principles allowed me to drink a health. I replied: 'Yes', and we clinked glasses.[3]

* * *

Two years later, in the late summer of 1956, the entire Johnson family embarked upon an epic fourteen-week visit to Central Asia, China and Mongolia that saw them travel over 15,000 miles, take twenty-six flights, and 'cover ground untouched by any English travellers in any previous century.'[4] Hewlett Johnson was now eighty-two and Kezia and Keren were sixteen and fourteen. The initial part of the visit, to Moscow and Karaganda

(in Kazakhstan) was arranged and hosted by VOKS,[5] and in Karaganda it involved the near-obligatory inspections of state farms and a hydro-electric power station. There is no direct evidence about the organisation and funding of the Chinese part of the visit, but it had obviously been planned with great care and no little expense.[6] On entering China the family was greeted by a welcoming party at Ürümqi, in Xinjiang Province, where they met their young guides for the rest of the tour: Miss Rae Chen, the English-speaking daughter of the Anglican Bishop Chen; Dr Tang Hsian-djin, a doctor from Shanghai who became the medical officer for the journey; and Mr Wang Hsiao-po, an interpreter.[7] All their services were to be needed on a long and strenuous tour that made considerable physical demands on the family. Writing of an excursion they made into the mountains from Ürümqi, Johnson noted in his journal that:

> On this particular day [involving a journey by Jeep into the Tien Shan Alps to a height of 8,000 feet] we had risen at 6 a.m. and arrived back tired at 10.30 p.m. to find some sixty people waiting to enjoy a farewell feast with us, which lasted about three hours. We were flying next morning at 5.30 a.m.! This was one of the hazards of having to accept so much hospitality, so kind in itself, but adding to the exhaustion of long travel. The girls constantly ran temperatures and we were grateful for the skill of the doctor who accompanied us.[8]

From Ürümqi, their journey took the Johnsons along the old silk road to Lanchow and Xining on the Yellow River; then to Xian, the one-time capital of China and now the capital of Shaanxi Province; then to Chongqing in Szechuan Province; then to Kunming and through the gorges of the Yangtze River to Hankow; then by overnight train to Peking and a visit to the Great Wall; and finally to Ulan Bator, the capital and largest city in Mongolia. They returned home via Siberia and Moscow, where they renewed their acquaintance with their VOKS guide from 1954, Yuri Andreyev.[9] The tour had educational as well as recreational aims. For Nowell, it was a welcome opportunity to paint and sketch (many of her sketches were used as illustrations in *The Upsurge of China*), and for the girls it offered a kaleidoscope of educational experiences. For Hewlett it was yet another opportunity to witness and record the triumphs of a one-party Communist state.

The family's travels were eloquently recorded in *The Upsurge of China*, published in Peking in 1961. As well as Nowell's sketches and extracts from the diaries kept by Kezia and Keren, the book also included material

from Johnson's earlier visits to China in 1932[10] and 1952.[11] The result was an interesting and informative travelogue marred by the lack of an index and total silence on the documentary sources from which the factual and statistical material in the book was drawn. In this respect, *The Upsurge of China* raised similar questions of authorship and provenance that had surrounded *The Socialist Sixth of the World* twenty years earlier;[12] but whereas large parts of the latter had been lifted and edited from Soviet propaganda supplied by VOKS, much of *The Upsurge of China* seems to have been written by Johnson himself. It is with the introduction of statistical data about China's industrial and economic performance that concerns about provenance and accuracy creep in, and they are not allayed by Johnson's subscription to *People's China*, a bi-monthly journal published in Peking by the Foreign Languages Press and sold in English speaking countries from 1950 onwards. Most of the articles were Chinese propaganda in one form or another. Johnson's own copies of *People's China* are quite heavily annotated and were probably the source of much of the 'factual' material in *The Upsurge of China*.

* * *

Nineteen fifty-seven saw Hewlett Johnson travelling to Poland and Moscow.[13] The invitation, which this time included Nowell and Keren, came from the Polish government, and if not entirely arranged through VOKS, the visit bore close resemblances to the typical VOKS template. Accompanied by their Jewish guide Maria, they were shown the reconstructed centre of Warsaw and attended productions of Sartre's *The Flies* and Bizet's *Carmen*. From Warsaw they were driven to the spa town of Krynica-Zdrój in the Beskids mountains where they stayed in the Writers' Trade Union Rest Home amidst scenery that allowed Johnson to indulge his penchant for romanticised descriptions of rural life.

> Peasants were working everywhere, old women and children were minding two or three cows, a few goats or a gaggle of geese. ... Here in the lovely hills one might hear the Polish folk songs, sung by a single man or woman or child, or by a group working together. Everywhere in the mountains were holidaymakers, paddling and bathing in brooks and rivers, or sunbathing in the meadows. City children were there in large groups, brown and happy in the sunshine.[14]

The tour moved on to Zakopane, a winter sports resort on the border with Czechoslovakia, where the Johnsons went white water rafting in hollowed-

out tree trunks steered by peasants in 'gorgeously embroidered waistcoats and tight-fitting white trousers'.[15] The tour ended in Cracow, a city that Hewlett Johnson had first visited in 1945 and from where he had been taken to witness the liberation of Auschwitz.[16] In Cracow he renewed his earlier acquaintance with Father Ferdinand Machai, the radical rector of Santa Maria, and the party toured a new steel plant at Nowa Huta, a garden suburb to the east of the city. It was for Johnson another sign of the post-war triumph of communist industrial development.

In November 1957 Hewlett and Nowell were yet again in Moscow as guests of the Soviet government to attend the fortieth anniversary celebrations of the October Revolution. The celebrations in Red Square were spoiled for Hewlett by a cold that forced him to remain in his hotel and watch the event on television; but Nowell was in the square with Kenneth Leslie, the Canadian editor of *The New Christian*. Separated from their guide by the vast crowds, the pair had the 'happy experience of finding their own way home on foot, making their way through the jubilant citizens of Moscow with their flags and banners, flowers and balloons, seeing the dancing in the streets, the youth groups singing and promenading, the children crowding round puppet shows'.[17] A day or two later Hewlett and Nowell attended another gala reception in the Kremlin where they talked with Nikita Khrushchev and Vyacheslav Molotov, met senior priests from the Russian Orthodox Church, and renewed a number of old acquaintances from the golden days of fellow-travelling.

* * *

In the spring of 1959 Nowell Johnson fell ill with what was later diagnosed as congestion of the lungs.[18] One evening, nursing her alone in the deanery, Hewlett collapsed and was taken to the Kent and Canterbury Hospital where double pneumonia was diagnosed. Within days he was preaching at an Easter service in Canterbury Cathedral, but he was far from well, and now aged eighty-five was in need of prolonged rest. An invitation came for a month's convalescence in the Soviet Union, and he and Nowell flew once again to Moscow where they both spent several days in a clinic undergoing extensive health checks. These completed, they were flown to Yalta on the Black Sea for a long convalescence on 'the Riviera of the Crimea' amid oleander bushes, semi-tropical gardens, shaded walkways and a golden beach 'lapped by the cerulean sea'. There they had special baths and a variety of other treatments that greatly improved their health. It was while he was in Yalta that Hewlett Johnson heard of a Rumanian doctor, Anna Aslan, who had developed a new drug, Gerovital H.3, that supposedly

countered many of the effects of ageing, including hearing loss. It was exactly the sort of thing to excite the Dean, not least because of his own increasing deafness, and he and Nowell returned home from Yalta via Bucharest to meet Dr Aslan and learn more of her magic bullet.

At the Geriatric Institute in Bucharest, Hewlett Johnson met and was impressed by a number of Dr Aslan's patients who seemed to be doing very well on the drug, and he submitted himself to a course of injections of Gerovital H.3. Returning to Canterbury in the summer of 1959 he continued to use the preparation, receiving further supplies prescribed by the Institute in Bucharest and brought into Britain by a specialist Rumanian importer.[19] The effect was, Johnson believed, very beneficial. Writing to Dr Aslan in July, he was able to report that:

> I certainly had a great test this last weekend. Taking the service at the Cathedral on Sunday, flying the same day to Geneva with a Resolution from a tremendous meeting in Trafalgar Square; I interviewed all the Secretaries, met many members of the Press, and many photographs taken, all in the cause of world peace; got back home late last night, ready for a function at Canterbury this afternoon. Despite the fact that I missed meals, beyond coffee, rolls and butter for 24 hours, I feel extremely well, and look it![20]

News spread quickly of the Dean of Canterbury's endorsement of the anti-ageing effects of Gerovital H.3, and for the rest of his life he was approached by correspondents wanting to know more about the preparation and how it could be obtained. The medical profession, however, had its doubts. When Dr Aslan gave a paper at the Royal Society of Medicine in London in October 1959 she got a poor reception from doctors who pointed out that, far from being a wonder drug, Gerovital H.3 was actually procaine hydrochloride – a local anaesthetic commonly used by dentists.[21] This was indeed the case, but that did not exclude the possibility of a placebo effect, and Johnson probably continued to take it until his death in 1966. He found it particularly efficacious in warding off summer arthritis.

* * *

At about the same time that Dr Anna Aslan was explaining the benefits of Gerovital H.3 to the Royal Society of Medicine in October 1959, Hewlett and Nowell Johnson were once again on their way to China.[22] It was a measure of the esteem in which Johnson was now held in China that he was

able to ask for and receive a fully-funded invitation from the Chinese government. The visit began in Peking, where he and Nowell inspected some impressive new buildings including the National People's Congress Hall and the railway station. Johnson noted that: 'The workers had built the station in three months, it was their station, and their desire was to speed up the welfare of the Chinese people.'[23] He heard similar tales of workers' efficiency at a new reservoir he visited near the site of the Ming Tombs and also in the rural communes that were revolutionising agricultural techniques over very large areas. In both cases, workers and managers had combined their efforts to maximise their productivity for the benefit of the people. The Dean, familiar with the problems of cooperation between workers and managers from his time at Ashbury's Carriage Works many years earlier, was impressed.

> The closer integration of workers and management was of supreme importance; the managers invaded the workshops, did the actual production and looked for ways of improving techniques. Officials left their offices and shared the labour on the land, thereby feeling where the shoe pinched and how the pinch could be removed. Improved methods and experimental plots showed rich and positive results in heavier harvests.[24]

Asking if they could visit communes that were among the least successful, Hewlett and Nowell Johnson were taken on an itinerary that allowed them to revisit some of the places they had seen with their daughters three years earlier: Loyang, Xian, Chengtu, Chongqing and Hankow. Along the way there were stops to see factories, schools and communes of all shapes, sizes and organisational patterns – though from Johnson's descriptions none of the communes appears to have met the criterion of being 'less successful'. In the Golden Cattle Commune, some distance from Chengtu, they were given a riotous welcome by small children who called Nowell 'auntie' and Hewlett 'grandpa' and invited them to share food with their extended families in 'gaily painted' buildings.

> Food was free, members could eat in the communal dining room or take food home. We dined with the peasants; each family sat at its own table, and most had grandparents, husband and wife and children round it. We saw the old people's home built round a courtyard full of flowers, vegetables and trees, and heard again stories of past terrible privation and starvation of the old who had no family.[25]

After the rural communes came a visit to the industrial town of Wuhan at the confluence of the Yangtze and Han Rivers in Hubei Province. There the Johnsons saw large new residential areas that were being built around the city and they were told of the hospitals, clinics, sanatoria, cinemas, theatres and schools that serviced them. Knowing his engineering background, Johnson's guides took him to see the impressive new road and rail bridge, recently completed, which spanned the Yangtze River from Wuhan to Hankow, and later he and Nowell went to the mountain reservoirs of Huai-jun and Miyun. Leaving Huai-jun by train, they had an unexpected encounter when an official approached their compartment and told them that the Chinese Premier, Chou En-lai, would like to see them. 'Come and have lunch', Chou said, entering their compartment. The relationship that had begun on Johnson's visit to China seven years earlier in 1952 was effortlessly revived over lunch.

> In the dining car Nowell sat next to Chou En-lai, I opposite with the interpreter. ... We discussed much that we had seen. The Premier asked numerous questions about England, and he was extraordinarily well informed. ... He asked penetrating questions about English housing, food, prices, wages and employment. ... Chou En-lai is a born leader of men, a man of immense vitality and will-power – he exuded vitality and has a quick wit and much humour. No wonder Mr [Dean] Acheson described him as the world's ablest diplomat.[26]

As they parted, Chou En-lai said to Hewlett Johnson: 'I will invite you to China every five years until you are two hundred. We shall expect you to make twenty-three more visits!' Five years later, in 1964, the next invitation arrived. It was to be the last.

* * *

A brief excursion to East Germany in 1960 to receive an honorary doctorate from East Berlin's Humboldt University (together with, among others, Albert Schweitzer, Kuo Mo-jo and Fujio Hirano)[27] was followed three years later by Hewlett Johnson's first visit to a Communist country outside Eastern Europe, China and the Soviet Union: Cuba.[28] The invitation, which coincided with the fifth anniversary of the country's independence, had come from the Cuban Chargé d'Affaires in London during a visit he had made to Canterbury in December 1963. Now aged almost ninety, Johnson set off with Nowell at ten days' notice on Boxing Day, having spent Christmas Day with an old friend and ally from Australia, 'Red' Jessie

Street.[29] Unable for political reasons to fly from America to Cuba, their route took them to Havana via Prague and Gander (where they were delayed by snow storms), arriving in Havana under a tropical sun. They were accommodated in a palatial hotel, the Havana Riviera, which had once been the capital's casino but had since been 'fitted out for the millionaires and playboys of the Americas'.[30] It is part of the charm and contradiction of Hewlett Johnson that this habitually ascetic old man, who had spent a lifetime railing against the greed of capitalism, seemed thoroughly to enjoy himself in the fading decadence of what was once described as the Las Vegas of the Caribbean.

Hewlett and Nowell Johnson were in Cuba at a critical time in the country's history (late 1963 and early 1964) as it moved towards a system of government modelled on the Soviet Union. Five years after the revolution that had brought Fidel Castro to power, it was a Communist island nation set in a capitalist sea – and there were those who did not like it. By the beginning of 1961, three years before the Johnsons' visit, hundreds of thousands of Cubans had fled to the United States as the country became, in effect, a client state of the Soviet Union and signalled the fact with a New Year parade that featured Soviet tanks and other military hardware. Alarmed, the United States under its new President, John F Kennedy, launched an abortive attempt to overthrow Castro's government by landing an invasion force at the Bay of Pigs in April 1961. Within a few days Cuban armed forces, trained and equipped by eastern bloc countries, had easily repelled the invaders (many of whom were Cuban exiles). Doubtless emboldened by the ease with which the attempted invasion had been rebuffed, the Cuban and Soviet governments began covertly to build bases in Cuba from which intermediate-range nuclear weapons could be launched against the United States; and in October 1962 an American U2 spy plane returned with the photographic evidence. The ensuing crisis was the closest the cold war came to nuclear meltdown as Kennedy and Khrushchev squared up to each other in a nail-biting trial of psychological and political will. Khrushchev blinked first and an agreement, part public and part secret, was signed between the two leaders under which Khrushchev dismantled the Cuban bases and Kennedy withdrew some of the American inter-continental ballistic missiles sited in Europe and Turkey. The world breathed (relatively) easily again.

All of this would, of course, have been very familiar to Hewlett Johnson, but he chose not to dwell on it. The extensive notes he made of his Cuban visit were heavy on Cuban history and hopeful of future Cuban glory under Castro, but the Bay of Pigs and the missile crisis were for him little more

than transient blips on the radar. Much more engrossing were the anniversary celebrations in Havana, 'gay with lights, decorations and crowds of people'.[31] A reception was held for the guests by the Cuban President Osvaldo Dorticós and his wife. Amidst the brilliance and glitter of the occasion, Johnson learnt with obvious pleasure of the impact his book, *The Socialist Sixth of the World*, had had in Latin America. In Cuba alone 75,000 copies had been printed and circulated, and (so he was told by Fidel Castro's brother Raúl) an entire generation of Cubans had had their knowledge of the Soviet Union shaped by it. Its authority was said to lie partly in the fact that it had been written by a churchman and could therefore be trusted.

Then, into the swirl and hubbub of the reception strode the Cuban Minister of Industry – a handsome, bearded young man in battledress, 'strong, vital and buoyant'.[32] He was Che Guevara, an Argentine Marxist revolutionary, physician, author, guerrilla leader, intellectual, diplomat, military theorist and possible martyr[33] whose name was a ubiquitous symbol of rebellion and whose instantly recognisable face, complete with trademark beard and beret, was stencilled on student union buildings throughout the world. He too had read *The Socialist Sixth of the World* – or, more probably, the American version, *The Soviet Power*. After that, word came to Hewlett Johnson that Fidel Castro wished to speak to him and he was taken to an alcove where Castro stood surrounded by friends and guests. Hewlett and Nowell found themselves next to 'a lady with a sad, beautiful face' whom they recognised as Dolores Ibárruri (commonly known as La Passionara), a Communist politician from the Spanish Basque region who had been a Republican leader in the Spanish civil war. She greeted them with affection. Fidel Castro then came up to speak.

> He asked: 'How do you like Cuba?' I told him that I had welcomed the Soviet Union in 1917, the first introduction of a socialist country into the world; and I was now able to see in Cuba the introduction of socialism in the world of the Americas. I knew that in time it would grow and spread. Fidel went on: 'I said to the others, what shall I talk to the Dean about? You have all told him you have read his book; I shall tell him this too; we all read his book.'[34]

After other small exchanges of conversation, Johnson told Castro of Chou En-lai's invitation to him to visit China every fifth year until he was two hundred: Castro immediately matched it, but the invitation was never issued.

Hewlett and Nowell Johnson's journey home from Cuba was the mirror image of their outward one. Leaving Havana in brilliantly hot

weather with people bathing in the sea and relaxing on the beaches, they arrived at Gander in deep snow and a freezing blizzard. Taking their leave of new friends they had made in Havana, they returned to England via Prague, reaching home on 9 January 1964. Immediately, Johnson began to make notes for a book about Cuba and to seek a publisher.[35] With some 7,000 words written, he contacted the editor of the Moscow-based journal *International Affairs* offering a book of 40,000 words.[36] 'I venture to think', he wrote, 'that this would not harm your journal or the writers, but would give further wings to their words, and help the great struggle for Cuba and Communism.' There is no record of any reply and the book was never finished. The notes, large parts of which were dictated to Nowell and written in her hand, formed the basis of the chapter on Cuba in Johnson's autobiography, *Searching for Light*. The chapter was almost certainly written by Nowell after Hewlett's death.

* * *

Hewlett Johnson's last excursion abroad was in May 1964 when the Chinese Premier, Chou En-lai, honoured his pledge, given five years earlier, to invite the Dean to China every five years until he reached the age of two hundred.[37] He was now ninety and in ailing health. He may well have sensed that it would be his last opportunity to set foot on Communist-controlled soil. The twenty-four hour journey from Canterbury to Hong Kong was draining for both him and Nowell. Unable to sleep, Johnson arrived extremely tired and disorientated, and Nowell was deeply anxious for him. From Hong Kong (about which, interestingly but perhaps predictably, Johnson had absolutely nothing to say) they were driven across the border to Canton where they were met by those who were to escort them on their way, including their medical officer for the journey, Dr Chiang Chin-wen. 'Nowell's relief was great', Johnson observed, 'for she knew that every care would be taken of me.'[38] Also there to greet the Johnsons were the Governor of Kwangtung Province, the Mayor and Mayoress of Canton, and Mr Huan Shiang, a former Chargé d'Affaires in London who had been sent by the Chinese Premier, Chou En-lai. Other friends from previous visits to China had also made the journey to Canton to welcome them. It was as if they, too, sensed that it would be the Dean's last visit to China and wished to honour him in person.

In many respects the visit closely resembled the previous ones they had made. As well as Canton, Hewlett and Nowell visited Nanchang and Hangchow in south-eastern China before ending, as they usually did, in Peking. On the way they visited farms and communes, inspected hydro-

electric power stations, toured schools and hospitals, took tea with groups of peasants, saw Ching The Chen chinaware being made, watched films brought into their hotel suites, discussed food rationing and family planning, and attended many church services. Old friendships were renewed, including those with Bishop Ting, Anna Louise Strong and Rewi Alley. The tour was, though, dominated by concerns about Johnson's health, and changes had to be made to the planned itinerary as it proceeded. Both Hewlett and Nowell had medical checks in Canton, and a visit to Nanking had to be aborted in favour of an extended rest in Hangchow. The medical care that Johnson received was exemplary: not only did he have the constant attention of a travelling physician, he and Nowell made all their internal flights on Chou En-lai's 'special plane' equipped with a bed and an oxygen cylinder. During their stay in Peking they both underwent thorough health checks by some of China's top specialists. Johnson was hoping for some improvement in his hearing loss, but the doctors 'all agreed that my age was against real improvement'.[39]

In Peking, where the Johnsons stayed in a newly constructed government guest house set in beautiful parkland, they found a copy of *The Upsurge of China* in their room signed by Chou En-lai, and later they dined with the Premier and his wife. In the course of the conversation the subject of nuclear weapons came up. Chou explained that while China would prefer the complete dismantling of nuclear arsenals, self-interest and pragmatism required the other nations of the world, including China, to defend themselves against the United States and the Soviet Union. If China developed nuclear weapons, Chou explained, the balance of power would change. China's aim would never be to intimidate other nations; rather, China would use its weaponry 'to help oppressed people and emerging nations'.[40]

On their last afternoon in Peking the Johnsons were summoned to meet Mao Tse-tung in the Great Hall of the People in Tiananmen Square. In a conversation lasting an hour, Mao asked about the Johnsons' impressions of their visit and told them of his aspirations for his country. The living standard of the Chinese people was still very low, he explained, but they were willing to work hard. In China's favour was the fact that it was one of the most solvent countries in the world with very little external debt, and prices for essential raw materials were falling. It was an optimistic note on which Hewlett Johnson ended his final conversation with a world leader. As they left the Great Hall, Mao insisted on seeing them to their car and helping Johnson in. 'Live long', he wished him in traditional Chinese style, 'and come back to see us again'. But Mao may have

48. Hewlett Johnson in the Canterbury deanery.

By a decision of the Committee for the International STALIN Prizes dated _April 6_ 1951 an International STALIN Prize "For the Strengthening of Peace Among the Nations" is awarded for outstanding services in the struggle for the preservation and strengthening of peace to

Dr. Hewlett Johnson
Dean of Canterbury

THE DEFENCE OF PEACE IS THE CAUSE OF ALL THE PEOPLES OF THE WORLD!

Chairman of the Committee
for the International Stalin Prizes

Vice-Chairmen
of the Committee

49. Hewlett Johnson's citation for the Stalin Peace Prize, June 1951.

DECREE
OF THE PRESIDIUM OF THE SUPREME SOVIET OF THE USSR

ON THE INSTITUTION OF INTERNATIONAL STALIN PRIZES
"FOR THE STRENGTHENING OF PEACE AMONG THE NATIONS".

1. International Stalin Prizes "For the Strengthening of Peace Among the Nations" are hereby instituted.

The prizes shall be awarded to citizens of any country of the world, irrespective of political, religious or racial distinction, for outstanding services in the struggle against the warmongers and for the strengthening of peace.

2. Persons awarded an International Stalin Prize receive:
 a) a diploma of a Laureate of the International Stalin Prize;
 b) a gold medal embossed with the portrait of J. V. Stalin;
 c) a money prize of 100,000 roubles.

3. From 5 to 10 International Stalin Prizes "For the Strengthening of Peace Among the Nations" shall be awarded annually by a special International Stalin Prize Committee, to be set up by the Presidium of the Supreme Soviet of the USSR and to be composed of representatives of the democratic forces of various countries of the world.

4. The prizes shall be awarded every year on the birthday of Joseph Vissarionovich STALIN — December 21st.

The first prizes shall be awarded in 1950.

Chairman of the Presidium of the Supreme Soviet of the USSR N. SHVERNIK

Secretary of the Presidium of the Supreme Soviet of the USSR A. GORKIN

Moscow, the Kremlin, December 20th, 1949.

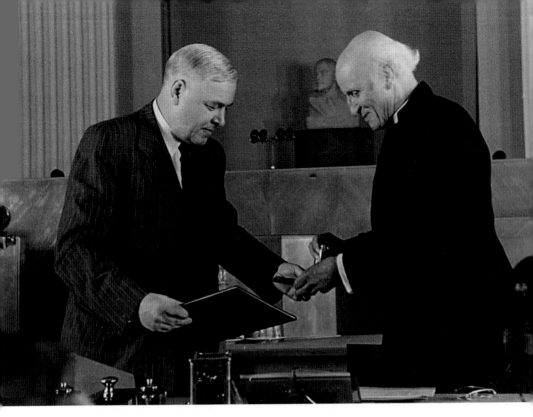

50. Receiving the Stalin Peace Prize from Professor Dmitri Skobeltsyn in the Sverdlov Hall of the Kremlin, Moscow, June 1951.

51. Hewlett and Nowell Johnson at the Kremlin reception for winners of the Stalin Peace Prize, June 1951. On the far right is Nikita Khrushchev.

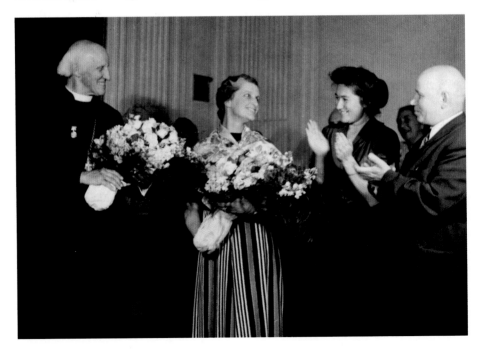

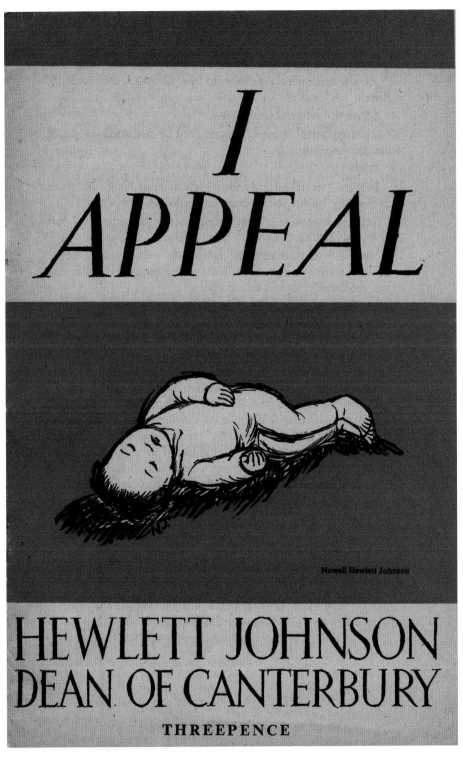

52. The cover of Hewlett Johnson's pamphlet *I Appeal*, charging America with the use of biological weapons in North Korea and China, 1952.

53. Surrounded by Russian dancers from the Beryozkha Dance Company visiting Britain, 1954. Nowell Johnson is just visible behind Hewlett's left shoulder.

54. Hewlett and Nowell Johnson with the Imam of Tashkent, October 1954.

55. Hewlett, Kezia, Keren and Nowell Johnson with VOKS guide Yuri Andreyev at Alma Ata, August 1956.

56. With Georgi Malenkov outside the deanery, Easter Sunday, April 1956.

57. Outside the front door of the Canterbury deanery, circa 1959.

58. Hewlett Johnson and John Shirley (foreground), headmaster of the King's School, probably late 1950s.

59. Hewlett and Nowell Johnson arriving at Moscow Airport as guests of VOKS, October 1954.

60. The enthronement of Archbishop Michael Ramsey in Canterbury Cathedral, June 1961. Ramsey is being escorted through the choir, flanked on his right by Hewlett Johnson and on his left by the Archdeacon of Canterbury, Alex Sargent.

61. Hewlett Johnson with Archbishop Michael Ramsey at the televised Christmas service in Canterbury Cathedral, December 1961.

62. Hewlett Johnson meeting Fidel Castro in Cuba, January 1964.

63. Hewlett and Nowell Johnson (far left) at the Peking Dance School, June 1964.

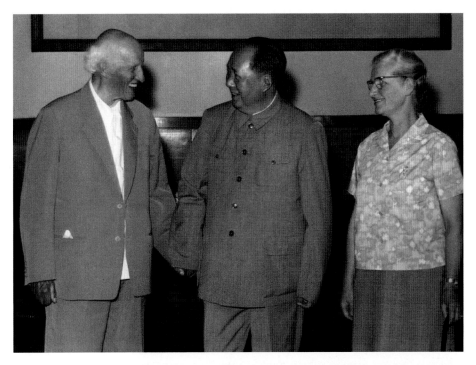

64. Hewlett and Nowell Johnson with Chairman Mao Tse-tung in the Forbidden City, Peking, June 1964.

65. Hewlett and Nowell Johnson with the Chinese Premier Chou En-lai (third from left) and Madame Chou (far left) in Peking, 1964.

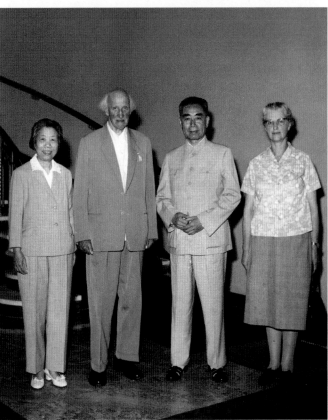

66. Hewlett Johnson with the pectoral cross given to him by Patriarch Alexei of Moscow on the Soviet VE Day, 9 May 1945.

67. Llys Tanwg, the large Edwardian house near Harlech that Hewlett Johnson purchased in the 1930s and where Nowell, Kezia and Keren Johnson spent the war years from 1940 to 1944.

68. The Canterbury deanery in 2011.

69. Hewlett Johnson in about 1952.

sensed that this time it was a hollow wish. From Peking, Hewlett and Nowell returned to Canton in Chou En-lai's 'special plane' before travelling back to England via Hong Kong and Karachi. Johnson wrote in his autobiography:

> It was sad indeed to leave China, with its faith and endeavour, its work and creativity – not motivated by money or fame but by the need of the whole people. The incentive for work, not material gain for the individual, but the ideological basis of the betterment of the men, women and children of the entire country.[41]

CHAPTER EIGHTEEN
THE FINAL YEARS

I N THE SUMMER of 1961 Hewlett Johnson celebrated thirty years as Dean of Canterbury. Canon Derek Ingram Hill, who by the time of his own death in 2003 had become the repository of almost everything that was worth knowing about Canterbury Cathedral, recalled the Dean's installation in June 1931.

> How well I saw it all from my vantage point with Dr Palmer in the organ loft and how well I remember the small details. And now in 1961 most of that company are dispersed. May I as one survivor send my best wishes to you as another and rejoice that your thirtieth anniversary is to be crowned this June by the great ceremony of the Enthronement of the new Archbishop. I wonder if any Dean before will ever have served under four archbishops in the whole history of our Church and Province. Even Prior Eastry only equalled this, and he was in office for 46 years.[1]

Ingram Hill was right to describe Hewlett Johnson as a survivor, for by the summer of 1961 many of the principal actors in the drama of Johnson's Deanship had either left the stage or were soon to do so. The members of the Chapter that he inherited in 1931 had long since gone and even some of the more recent additions were fading from the scene. Julian Bickersteth retired as Archdeacon of Maidstone in 1959, three years before his death in 1962, and was replaced by Gordon Strutt. Alex Sargent was succeeded as Archdeacon of Canterbury by Michael Nott, and Aubrey Standen, who died in 1962, was replaced by Herbert Waddams. Though much younger than Hewlett Johnson (he was fifty-one when he was installed) Waddams' interests were probably too close to – and his views too much at odds with – the Dean's for them to see eye to eye. During the Second World War, when he was working for the Ministry of Information, Waddams had been one of the three-man Anglican delegation led by the Archbishop of York, Cyril Garbett, that had visited Russia to investigate the state of religion

under Stalin.[2] They had returned with a message that, though cautiously upbeat in tone, was far removed from Johnson's expansive and trusting optimism.[3] Later, in the 1950s and 1960s Waddams had written about religion in the Soviet Union. Like Johnson, he consistently championed a rapprochement between the Church of England and the Russian Orthodox Church but he shared none of the Dean's unbounded enthusiasm for Stalinism and he had few illusions about Stalin's motives towards the Church. There was never likely to be much common ground between Waddams and Johnson.

Other familiar faces in the precincts were also fading from view in Hewlett Johnson's final years as Dean. Sydney Campbell was replaced as organist by Alan Wicks, and Joan Thoseby, who had succeeded Margaret Babington as Steward of the Friends of Canterbury Cathedral, died suddenly in 1963. Percy Baker, a virger and vesturer for forty-four years who had 'virged' Johnson from the deanery to the Cathedral (the last to do so) and had robed him in the vestry, died in 1964. The Cathedral's longest serving employee, Samuel Cauldwell, celebrated his hundredth birthday in 1962 having retired as head of the glass workshop six years earlier. Cauldwell's service to the Cathedral far outstripped even that of Hewlett Johnson, having been in the Chapter's employment for seventy-two years. He had even witnessed the great fire of 1872.

A seismic shift in the politics of the precincts occurred in 1962 when Canon John Shirley retired from the headship of the King's School at the age of seventy-two and was succeeded by the Reverend J P Newell. Shirley had been in the post for twenty-seven years. His retirement was marked by a visit to the school from the Queen Mother and a service of thanksgiving in the Cathedral. In retirement Shirley wanted still to be of use in the precincts, and while this was probably now of little concern to Hewlett Johnson (whose own retirement was not far away), it was less acceptable to Herbert Waddams who 'did not altogether welcome this additional assistance'.[4] The old guard was visibly yielding to the new – and John Shirley and Hewlett Johnson, who retired within a year of each other and died within a year of each other, were the fading giants of the old order.

* * *

From the wider viewpoint of the Anglican Communion, the most momentous departure from the Canterbury scene in Hewlett Johnson's final years as Dean was that of Archbishop Geoffrey Fisher who retired in May 1961 after sixteen years as Primate of All England. Courteously, Fisher gave Hewlett Johnson twenty-four hours notice of the announcement of his

impending retirement,[5] allowing the Dean time to compose a strikingly gracious response to the man who had once described him in the House of Lords as 'blind, unreasonable and stupid'.[6] Fisher's announcement had, Johnson told him, given him 'a feeling of sadness which haunted me all day'.[7] He continued:

> Our personal relations have been so happy, especially of late, that I shall miss you very much, but, of course, will wish you 'God speed' in your well-earned holiday. You are retiring at the peak of your justifiable fame and the peak of your Church's affections.

On Hewlett Johnson's invitation, Geoffrey Fisher preached for the last time in Canterbury Cathedral on Whit Sunday 1961, and at his request the normal practice of the Archbishop preaching from the pulpit in the nave was changed to allow him to deliver his valedictory sermon from his throne in the choir.[8] Shortly after retiring, Fisher sent Johnson a photograph of himself. 'I am always very shy of inflicting anybody with a photograph of myself', he wrote in the accompanying letter, 'but perhaps you could endure to have one, and it gives me very great pleasure to send it as a reminder of a most happy friendship in the past.'[9]

Geoffrey Fisher was succeeded as Archbishop of Canterbury by Michael Ramsey, the hundredth occupant of the office. For the third time in his tenure as Dean, it fell to Hewlett Johnson to organise the process. Ramsey was elected by the Greater Chapter on 15 June 1961 and a few days later was introduced to his new colleagues at a reception in the deanery. The enthronement – the last great ceremonial occasion in Canterbury Cathedral over which Johnson presided – raised again the delicate question of whether the legal right to enthrone the Archbishop (technically called the 'mandate') rested with the Dean or the Archdeacon of Canterbury. It had caused a measure of ill will at William Temple's enthronement in 1942 before Johnson, wishing at all costs to avoid an unseemly tug-of-war over the mandate, had yielded to the Archdeacon, Thomas Sopwith, while insisting that his decision should not compromise the privilege for his successors as Dean.[10] Now the claims had to be staked once more, and Alex Sargent got in quickly with a lengthy letter to Johnson explaining why the mandate was rightly the Archdeacon's.[11] After reviewing the historical precedents, Sargent shrewdly reminded the Dean that he (Johnson) had vigorously upheld the historic rights of his own office during his conflicts with the King's School governors in the 1950s. 'I have heard you [say] more than once', Sargent wrote, 'that we have no right to give away things which we hold in trust.'

Eventually a compromise was agreed, and on 27 June 1961 Michael Ramsey was enthroned *twice* – first by the Archdeacon in the bishop's throne in the choir and then by the Dean in the Chair of St Augustine on the pulpitum steps. Technically it was the Archdeacon's enthronement that confirmed Ramsey in his office, and had Hewlett Johnson dropped dead while the Archbishop was making his way from the choir to the nave, the legal part of the business would still have been done and dusted. Happily no such catastrophe occurred, and Ramsey's second enthronement was witnessed not only by those who were in the nave on that summer's day but also by millions who watched the proceedings on television (the BBC having paid the Dean and Chapter £750 for the broadcasting rights).[12] Though he had no option but to go with the procedural flow, Hewlett Johnson had reservations about the whole thing.

> The pomp and ritual were magnificent to eye and ear, but I sometimes wondered how much real religion had a place in such services. There were many fervent humble hearts, but there was also much jostling for precedence, much thought of worldly advantage; this, sadly, being part of the trappings of a great and powerful organisation – but a far cry from the lonely figure of Jesus of Nazareth.[13]

* * *

Domestic matters, fuelled by a new spirit of the age, dominated Hewlett Johnson's workload in the early 1960s. As visitor numbers increased, the problem of car parking and transistor radios in the precincts became more pressing and new considerations arose about maintaining the reverential atmosphere in the Cathedral while recognising its importance as a museum for sightseers of all faiths and none. Live broadcasts went out; limited flood-lighting came in; and innovative technologies were tried out. In 1962 Sir John Gielgud narrated the history of the Cathedral through the dramatic new medium of son-et-lumière. Grandstands were erected on the Green Court where once there had been a wartime vegetable patch, and crowds braved the rainy weather to see the murder of Becket re-enacted on the northern flank of the Cathedral. But the new demands of the sixties were taking their toll on Johnson, not least because, even in his late eighties, he was still maintaining a hectic schedule of visits and talks away from Canterbury as well as attending to his decanal duties within the precincts. Between 1959 and 1963 he and Nowell travelled to China (twice), Rumania, the GDR, Cuba and the Soviet Union and, often to the dismay of his colleagues, he continued to speak, write and broadcast on politics and religion.

In 1961 Hewlett Johnson was as defiant as ever in a BBC radio broadcast on communism and Christianity, and in March 1962 he was the subject of *Head On* – a series of television programmes, produced by Granada TV, about the lives of controversial public figures. Fronted by Jeremy Thorpe, the programme consisted of pre-recorded interviews with a number of both friendly and hostile witnesses, with Johnson responding live in the studio to their comments and criticisms. Among his critics were Dame Irene Ward, who had described Johnson in the House of Commons in 1952 as 'a wicked and irresponsible old man', and Canterbury's MP John Baker-White, who claimed (in the context of the 1952 controversy over the use of bacteriological weapons by American forces in North Korea) that the Dean had 'swallowed a whole lot of poppycock as easily as he would swallow half a dozen Whitstable oysters put before him on the Deanery table'.[14] Johnson's supporters on the programme included the Cambridge theologian A C Bouquet, his former curate at Altrincham who praised his life-long attempts to expound the Christian faith in terms that ordinary people could understand and relate to, and Percy Webster-Cory, a fellow oarsman in the Wadham College boat in the early 1900s, who remembered Johnson as 'a first-class mixer, a big fine hearty sort of man who never wore his religion on his sleeve'.[15]

Hewlett Johnson's fluent and humane replies to his critics on the programme revealed him as an old man who had lost none of his ideological fervour and whose mind was still in very good – if not quite perfect – working order. When Jeremy Thorpe concluded the programme by asking him what he would like to do next, the immediate answer came back: 'continue'. The large number of supportive letters that Johnson received from members of the public may well have fortified him in his determination to carry on; but this was now a rapidly diminishing option, and shortly after the programme was broadcast he suffered a setback that convinced his wife, at least, that retirement could not be far away.[16] Alone in the deanery on a Friday night in April 1962, Johnson slipped and fell, breaking his collar bone and bringing papers and the telephone on his desk crashing down around him. He managed to crawl into bed where he lay in great pain until the morning when he somehow got himself down the stairs to the telephone in the drawing room. After a short stay in hospital and a brief recuperation at his house in Charing, Johnson returned to work in a weakened condition; but it was all becoming too much for him. Negotiating the steps to the high altar in the choir was now a major undertaking, and kneeling was painful.

Matters came to a head at the end of 1962 when another furious row erupted in the Chapter. Having interviewed some of those involved in it, Robert Hughes described it as 'so unpleasant and so trivial that, fourteen years later, none of the protagonists would discuss the details'.[17] Whatever might or might not have happened, the die was now cast. After discussing his options with Nowell, who had been wanting him to retire for many months, Hewlett Johnson tendered his resignation to Archbishop Michael Ramsey on the last day of 1962. It was to take effect from the end of April 1963. Early in the New Year Johnson wrote to the Prime Minister, Harold Macmillan, who accepted his resignation on behalf of the Crown. The newspapers were informed and the deanery was besieged for days by journalists wanting to catch a final word from one of the most controversial voices of the twentieth century. Hewlett Johnson preached in the Cathedral for the last time on 27 April 1963. Three days later he relinquished the Deanship at the age of eighty-nine. Reflecting on his extraordinary career in Canterbury, he later observed that:

> I had always felt my post to be a trust; it was a position where I tried to keep the privilege of free thought alive in a Church which, like all longstanding organisations, tended always to crust over and stagnate, instead of keeping on the living edge of thought. The vast upheavals of the twentieth century, the birth of Socialism, the efforts towards Communism and a juster society for masses of under-privileged people, made me endeavour to carry on, in spite of increasing age, hoping always to help further in some understanding of these things.[18]

* * *

Even after he had announced his retirement, Hewlett Johnson remained an enigmatic figure who deeply divided public opinion. He received a great number of warm and grateful letters from members of the public who praised his long and courageous struggle to defend the moral heart of Christianity against an ecclesiastical hierarchy more concerned with propriety than with preaching the unvarnished gospel of Jesus Christ. Johnson's unfailing generosity in the face of the abuse he received from those around him was, for these admirers, a matter of joy and thanksgiving. His equally vociferous detractors also found reasons for joy and thanksgiving, for this arrogant and insufferable priest was finally about to depart the public stage. In January 1963 the *Church Times* published an anonymous letter that tried to set Johnson's Deanship in toxic aspic. He had, the writer claimed, demeaned his office and betrayed the Christian faith through his

advocacy of godless regimes around the world. It was not for Johnson to respond on his own behalf, but one who tried to do it for him was the Reverend Bernard Fielding Clarke, the examining chaplain to the Bishop of Derby and a long-time friend of the Dean. A socialist who, like Johnson, had spent his ministry exploring the moral links between Christianity and communism and had suffered in the process, Fielding Clarke wrote a measured rejoinder to the editor of the *Church Times*.

> There are many of us who are thankful that from the Mother Church of the Anglican Communion a prophet has spoken who can discern the positive moral achievement of Communism in spite of its errors. To see the working out of God's purpose by forces which deny God is, I suggest, not political naïvety, but biblical realism. It was, after all, the opponent of Communism, Berdyaev, who said that "one must have lost all sense of right and wrong if one considers Capitalism more Christian than Communism". History will probably show that it was not the Dean but his critics who were naïve and unrealistic.[19]

Fielding Clarke added for good measure that 'unlike your correspondent, I will give my name for publication'; but his letter was rejected by the editor.[20]

The former Archbishop of Canterbury (now Lord Fisher of Lambeth) wrote a kindly letter to Hewlett Johnson in which he tried to set their sometimes turbulent relationship in a more benign perspective than the record would later show; but even in his impending retirement Johnson was not of a mind to blur the facts, as he wrote to Fisher:

> I do not think it is true to say that there was only slight tension between us. I felt the tension was very great, but I also felt that it was the tension of two principles rather than of two persons, I representing one line of social and political thought and you representing another. I know that my activities made life hard for you, and in that respect we both suffered. I never felt personal animosity and only regretted that the principles which divided us prevented me from enjoying your society and your friendship as I should like to have done.[21]

* * *

Moving from the deanery after thirty-two years was a massive undertaking that reduced Hewlett and Nowell Johnson almost to tears. Never one to throw away anything that might be useful in the future, the sheer size of the building had allowed Johnson to consign the accumulated posses-

sions of the years to the capacious attics of the house. Now it all had to be cleared and much of it disposed of. A great deal was simply burnt. He and Nowell were helped by the forbearance of his successor as Dean, the Very Reverend Ian White-Thomson, who placed no pressure on them to vacate the deanery; but they had very little help from their neighbours in the precincts and had to do most of the work themselves. 'No gestures of friendship or help were forthcoming', wrote Robert Hughes of these diffi-cult few weeks, 'and the family struggled to sort and clear thirty years accu-mulation of magazines, papers, presentation gifts, paintings and household possessions.'[22] Although Hewlett Johnson had decided that it would be wrong for him and Nowell to remain in the precincts in their retirement, they could not bear to leave Canterbury; and so they moved into a house they had owned in the St Dunstan's area of the city for several years. Orig-inally named 'Orchard Villa' but immediately changed by the Johnsons to 'The Red House', the house had been let as flats and needed a good deal of structural work to transform it into the home in which they intended to spend the rest of their days. It is said that, when they moved in, their carpets were laid on back numbers of the *Daily Worker*.

By the time he and Nowell moved into The Red House, Hewlett John-son's financial affairs were far from settled. He still owned most of his properties (though the café in Charing had been sold in 1962 for £8,500),[23] but they were yielding little income and a sizeable overdraft was building up at Barclays Bank. In July 1962 the manager wrote to Johnson express-ing his concern at 'the rather permanent state of the overdraft on your account which now stands at £7,584'[24] – the equivalent in purchasing power of about £120,000 at today's prices. It was a sizeable sum when set against his stipend of £2,300 and his pension of £700 from the Church of England Pensions Board.[25] Adding to the financial pressures on Johnson was the fact that one his two daughters was studying medicine in London and the other was soon to marry and start a family. Something had to be done – and it was. Shares were sold, including most of those that Johnson held in the family firm;[26] some of the furniture and fittings in the deanery (amounting to £1,319) were sold by private treaty to the Chapter;[27] and personal possessions were sent for auction at Sotheby's in London and Burrows in Ashford. With one exception, the auctioned items raised no more than a few hundred pounds between them. The exception was the 1942 bust of Hewlett Johnson by Jacob Epstein, for which he was offered £1,000 by a private collector in June 1963.[28] Johnson declined to sell and sent the bust for auction at Sotheby's. As a matter of courtesy he explained to the sculptor's widow, Lady Kathleen Epstein, why such drastic action

had been necessary.[29] At auction in December 1963 the bust was purchased by the collector who had made the original offer. In 1992 it was sold for £12,000 to the Royal Museum and Art Gallery in Canterbury.

* * *

Because of the advanced age at which he resigned the Deanship, Hewlett Johnson's retirement was not a long one; but it kept him busy. He travelled (to Cuba in 1963 and China in 1964); he kept in touch with various organisations with which he was associated (including the *Daily Worker* and the British Soviet Friendship Society); and he continued to give the occasional talk (including one to a large meeting organised by the *Daily Worker* in the Manchester Free Trade Hall). In 1964 he paid a nostalgic visit to his former parish of St Margaret's in Altrincham where he signed the visitors' book: 'Johnson, Hewlett'.[30] Honours also continued to come his way, most notably the award in 1964 of the Frédéric Joliot-Curie Peace Gold Medal by the International Institute for Peace in Vienna. The citation read:

> This award expresses the gratitude felt by all defenders of peace for your devotion to their great cause, and it pays tribute to the meritorious and fruitful work you have done for disarmament, peaceful coexistence and the wellbeing of mankind.[31]

Fleeting interests engaged him from time to time, among them automatic handwriting and extra-sensory perception. Nowell finally had as much time as she wanted to paint and continue her service as a magistrate in Canterbury, and there was the joy of seeing the wedding of their younger daughter, Keren, and the birth of her two children. For Hewlett, who had still been childless when he reached his sixty-sixth birthday, it must have seemed an achievement of almost biblical longevity to hold his two grandsons.

In January 1964 Johnson celebrated his ninetieth birthday with a dinner at the Connaught Rooms in London hosted by the British Soviet Friendship Society of which he was still President. The Soviet Ambassador to Britain, Alexander Soldatov, was present and Johnson was the principal speaker. Toasts were drunk to the Queen and the President of the USSR. This landmark birthday elicited fulsome and eloquent tributes from all over the world to Johnson's life-long efforts in promoting international friendship and peace. They were personal expressions of love and goodwill from very diverse admirers. From a high place in the Soviet Union Nikita Khrushchev, no longer the political giant that he had once been, wrote:

I heartily congratulate you on the occasion of your birthday. Your efforts for the strengthening of peace and international security, and for the elimination of the threat of nuclear warfare, have won for you the respect and love of all sincere friends of peace. The Soviet people, together with progressive world opinion, highly esteem you as an indefatigable fighter for the triumph of the idea of humanism, and as an advocate of friendship and brotherhood between the people of all countries. In our country, you are well known and valued as a great friend of the Soviet people.

And from a far lowlier place, a dozen engineers from north Kent wrote:

With this card we send our thanks and appreciation. Our love and respect as well are joined with our admiration of your strength and courage and example to us lesser mortals. In times of stress and uncertainty your light shone ever strong as a beacon for us to steer by.

* * *

Much of Hewlett Johnson's retirement was taken up with preparing his autobiography, *Searching for Light*, which was published posthumously in 1968. The original title had been *Seventy Years of Crisis*. The final title, though more positive and better reflective of Johnson's life-long pursuit of knowledge, glossed over his unshakeable conviction that he had, in fact, found his light from a fairly early age; and having found it, he never looked for another. *Searching for Light* was compiled rather than written, for most of it had either been published in Johnson's earlier books or was lifted from the many journals and diaries that he and Nowell kept on their travels. Nevertheless, a great deal of selecting, sorting, editing, updating and new writing still had to be done. Although Hewlett's name appeared as the sole author, much of the hard graft was done by Nowell who not only acted as Hewlett's amanuensis in his final months but also took on the considerable burden of checking facts, writing to numerous people from her husband's past, and making sure that the final result was, in her own words, 'a fitting testimony of his life-long search for truth and light'. She was helped in her efforts by Hewlett's companion and mentor of thirty years, Alfred D'Eye, who continued to visit Nowell until her death in 1983. D'Eye died in 1995 at the age of 97.

In the concluding chapter of *Searching for Light*, Hewlett Johnson wrote of the profound changes that had taken place in his lifetime. He wrote of the pointless loss of life in the Great War, of the emergence of

communism, of the great depression and the rise of fascism, of the ghastly cruelties of Auschwitz, of the demise of imperialism, and of the evils of a western capitalist system that still enriched the wealthy at the expense of the poor. He wrote of all these things. But above all he wrote of the Christian faith that had led him to a God who demanded justice and brotherhood for all people. He wrote of his fundamental belief in the resurrection of Jesus Christ, without which he could not be a Christian. He wrote of the indomitability of the human spirit when life is lived in the presence of God and tested by the standards of Christ. He wrote of his conviction that after death the human personality goes on in a fuller and more perfect way. 'It is these beliefs', Hewlett Johnson wrote, 'that have sustained me in many dark days when otherwise I might have been tempted to take the easier, more fashionable worldly courses.'[32] And in the concluding paragraph of *Searching for Light* he penned the last of the millions of words he wrote over a period of eight decades:

> And so the going, as the coming, should be an occasion only for joy, since from our birth we go to an immortal rebirth, where we wait to receive those who follow after. 'Thine eyes shall see the King in his beauty. They shall behold a land of far distances.'[33]

Three weeks later, in October 1966, Hewlett Johnson died in Canterbury. The proximate cause of his death was pneumonia – the old man's friend. There was some doubt among his family and friends as to whether the Chapter would allow his funeral service to be held in the Cathedral, but it was a doubt that was instantly dismissed by the new Dean, Ian White-Thomson, who unhesitatingly gave his consent. The Cathedral was packed, not least by multitudes of Canterbury citizens who came to mourn the man who had 'shared their dangers and scandalised their conventions' for more than three decades.[34] The Cathedral choir, augmented by boys from the King's School that had ostracised and rejected him, sang the Russian Kontakion of the Departed. 'With the saints grant rest, O Christ, to the soul of thy servant, where there is neither pain nor sorrow nor sighing, but life unending.' As these great words from the Orthodox liturgy resounded through the Cathedral that Hewlett Johnson had loved and served to the utmost, they were heard not only by the people of Canterbury but by the Archbishop, the Dean, the Archdeacon, the Canons (including John Shirley), the Mayor and Corporation of Canterbury, the Soviet Ambassador, and representatives of dozens of groups and organizations who had had reason to be grateful for Hewlett Johnson's concerns. The funeral was

a fitting recognition that after all his travels, both physically and intellectually, the heart of this peripatetic old man belonged in Christian Canterbury. His ashes were interred in the cloister garth next to those of The Very Reverend Dick Sheppard whom he had succeeded as Dean. The inscription on the ledger reads, simply: 'Glory To God, Peace On Earth, Goodwill Toward Men'.

Nowell Johnson continued to live in The Red House until her own death in 1983. She too had her funeral service in Canterbury Cathedral, after which her ashes were interred with those of her husband in the cloister garth. One who knew her well but wishes to remain anonymous wrote after the service:

> I'm glad they did her honour at the last. She, too, had been 'despised and rejected'. The tides of favour had ebbed and flowed. She had shared with her husband the penalties of bold speech and independent thought, opprobrium, and the turning away of friends. But she was honoured at the last. The funeral had a simple splendour. She would have hated ostentation, but the splendour seemed as natural as the grandeur of the mountains. The choristers' voices soared to the vaulted roof of the Cathedral. The light touched the coloured brilliance of the windows and lit the gold threads of the gorgeous cloth which covered her coffin. There was a procession of robed clergy. Deans and Archbishops were there to honour her. I'm glad they did her honour at the last.

CONVICTIONS AND CONTRADICTIONS

I N THE HALF CENTURY since his death, history has not treated Hewlett Johnson very kindly. Indeed, he is in danger of being forgotten. Once one of the most talked-about men in the country, his name is now little known beyond the dwindling circles of those who still remember him and his family; and aside from his stalwart admirers in and around Canterbury, of whom there are still many, the moniker of 'The Red Dean' has become more a term of scorn than of affection. This has certainly been the case among those who have written publicly about him in the years since his death. In 1973 David Caute said of Johnson in his book *The Fellow-Travellers*:

> One suspects that his pride was great, which is not normally accounted a Christian virtue, for rarely did he admit his mistakes and not even Khrushchev's revelatory speech in 1956 could convince him that he had erred in his judgements. The ultimate impression is that of the sublime merging with the ridiculous, as when this hugely tall figure with the puffs of white hair billowing over his ears stood on stage with the tiny, masked members of the Peking Opera, clapping with them, smiling, clapping ...[1]

David Edwards, in his sympathetic biography of Canon John Shirley, wrote of Hewlett Johnson in 1969 that he:

> ... ruined his genuine concern for the progress of the peoples of the world by a naivety which time and again made him both the dupe and the mascot of Communist propaganda. No word of criticism of ... Stalin's Russia or of Mao's China ever fell from his lips, and the tragedy of this foolishness was all the greater because many people in post-war England were blinded by prejudice *against* Russia and China.[2]

Edwards went on to observe, in the context of what he described as the 'unseemly disputes' between Johnson and Shirley, that:

Shirley's opposition merely echoed the general attitude of indignation. The Dean's lack of realism was also reflected in his conduct of cathedral affairs, causing Shirley many hours of anxiety and controversy. ... The Dean took care to be regular in his attendance at his statutory duties, but his powers of judgement decayed long before his superb physique. In countless details he had to be watched, and often circumvented, by his colleagues who shared with him the responsibility for the good government of Canterbury Cathedral.

Robert Hughes, in his book *The Red Dean*, was more balanced in his assessment of Hewlett Johnson, but he too noted the flaws in the Dean's character that others had pointed up.

It has been said that he [Johnson] was nothing but a propaganda gift-horse to the cold manipulators of the Kremlin. It can be argued that Russian flattery of eminent but silly fellow-travellers has done more than anything else to weaken Western opposition to Communism – and that Hewlett Johnson was among the most eminent, and the silliest, of those so flattered.[3]

To his own assessment, Hughes added that of Johnson's one-time friend and collaborator, Victor Gollancz, who concluded that:

The Dean was destroyed ... by a number of tragic defects, many of which merge into one another. By spiritual pride: by intellectual arrogance, coupled with a brain not quite of the first order: by vanity: by the temptations ... inherent in a magnificent presence: by an absence of mental scrupulosity or pernicketiness: and, certainly not least, by his ability as an actor. What an actor the man was![4]

Even those whose appraisals were rather more generous than Gollancz's might have wished to amend their judgements in the light of later events that changed the face of Eastern Europe in the 1980s and 1990s. Writing immediately after Hewlett Johnson's death in 1966, Donald Soper, the eminent Methodist minister who had once attacked Johnson for claiming that Jesus was a 'materialist',[5] said of him that:

His insistence that the elements of true Socialism in Marx-Leninism are nearer to the Kingdom of Heaven than any other doctrine may still turn out to be as obvious a truth by the end of the twentieth century

as it was regarded an obvious blasphemy at the beginning. If so, and I for one believe it, it will be said of the Red Dean that the common people heard him gladly, and that is an imperishable memorial.[6]

* * *

Like so many others who sensed the historical inevitability of communist ideologies, Donald Soper was to be proved wrong in his judgement. The only imperishable memorials to Hewlett Johnson are his gravestone in the cloister garth at Canterbury and his pectoral cross in the Cathedral treasury. For all his lifetime achievements, Johnson left little for posterity to treasure or revere. His books are largely discredited, his autobiography is no longer read, he effected no real or lasting change in the political consciousness of the nation or even of the Church of England, and his name is associated with no 'school' of theological thought or praxis. He was, it might be said, a one-man popular front who ploughed a principled but lonely furrow, declining to enter into the great debates that define a generation's outlook and eschewing any direct engagement with political processes. Like many of the fellow-travellers, his love affair with the Soviet Union was conducted at an emotional distance. He never joined the Communist Party of Great Britain (or even the Labour Party) and he never advocated revolution among the capitalist nations of the West. He willed the results but was hazy about the means. It is true that he spoke about the Soviet Union to huge audiences, frequently and at great length, but he rarely debated with them or even listened to them. His habitual response to difficult questions was to send a signed copy of *The Socialist Sixth of the World* with the advice that somewhere inside it lay the answer.

Impossible though it is to be sure, Hewlett Johnson would probably have regarded the impermanence of his achievements with a degree of equanimity, for much though he enjoyed the limelight of publicity, he set little store by worldly fame or success; and until he came to prepare his autobiography in the closing years of his life he never gave a thought to his legacy. The role model to which he comes closest is probably that of an Old Testament prophet seized with a vision of the justice of God and burning to proclaim it to a resistant world – Amos, perhaps, who in about 750 BCE railed against the exploitation of the poor by the rich in the prosperous kingdom of Israel. When Amos demanded that 'justice flow like a river and righteousness like a never-failing torrent',[7] it could almost be Hewlett Johnson at his most eloquent. If those in high places were scandalised by the message, or if he himself incurred the wrath of those who rejected his words, then so be it. That is commonly the lot of prophets. They are in business

neither for earthly fame nor for future glory but to proclaim, *to their own day and age*, the truths that have been vouchsafed to them. Their only reward is that of knowing that they have remained faithful to their vision.

It has sometimes been suggested that the whole of Hewlett Johnson's life was really a carefully crafted and convincingly executed lie – that he knew all along the untruth that lay at the heart of what he was saying but was so addicted to the world's attention that he could not stop himself. As Victor Gollancz put it: 'What an actor the man was!' But this cannot be the case – and it was certainly not Gollancz's view until his falling out with Johnson over *The Socialist Sixth of the World* in 1939.[8] It is all but impossible to read Johnson's sermons and fail to be grasped by the sincerity of his motives, for at the heart of his preaching was a profound and wholly orthodox strand of Christian belief. Here is how he expressed that belief in the Granada TV programme *Head On* in 1962.

> Imagine that our Lord stood on the border of East and West and looked West and heard John F Kennedy, the President of the richest country in the world, say: 'Tonight seventeen million Americans will go hungry to bed and six million will wake up tomorrow morning knowing that they do not have the means to feed and clothe their families properly because they cannot get a job and because the system of subsidies in America makes it more profitable for many farmers to leave their land fallow than to grow food.' And then imagine that our Lord looked East and saw lands where nobody was hungry, where nobody was unemployed, where every child was well-clothed and well-educated, and where economic activity was inspired by service rather than profit. If we then compare these two with Christ's standard of judgement in his parable about the sheep and the goats [in Matthew's gospel], which one do you think comes closest to it?[9]

This kind of argument, which Hewlett Johnson rehearsed over and over again in many different guises, cannot be dismissed as the product of a self-obsessed or delusional mind. Nor can it be rejected as a travesty of Christian theology. Whatever else can be charged against him, insincerity and unorthodoxy are not among them. Johnson's preaching of the gospel was neither extreme nor eccentric; and this, ultimately, is why he was never ousted by those who wanted to see him go. Gullible he may have been in worldly terms, but a priest whose sermons are rooted in the New Testament is all but inviolable. Hewlett Johnson took the words of Jesus seriously and he preached them faithfully. His voice was the authentic voice of

Christian preaching, and his ministry was the authentic ministry of one who had committed his life to the Christian gospel.

In his personal and private life, too, Hewlett Johnson held fast to Christian virtues and values. He always looked for the best in others, even when he doubted it was there. He was invariably cheerful and unfailingly courteous to all whom he met. He bore the slights and insults to which he was repeatedly exposed with almost super-human magnanimity. He was generous with his time, charitable with his money, and forgiving to those who traduced him. He was patient, peaceful and persistent. He was a faithful husband through two long marriages and a loving father to the daughters of his old age. Hewlett Johnson was, in short, a good man who led a good and Christian life. Those who have tried to discredit him by smearing his moral or spiritual qualities have been directing their fire at the wrong targets.

* * *

What, then, are the substantial indictments against the Red Dean of Canterbury? There are two principal ones. The first is that he openly and consistently supported regimes and ideologies that explicitly rejected the God of traditional Christian belief. How, his critics asked in genuine bewilderment, could he possibly remain a priest in the Church of England – much less Dean of Canterbury – while counting Stalin's Russia a more Christian country than Britain? Even Ivan Maisky, the Soviet Ambassador to Britain in the 1930s and a close acquaintance of the Dean for more than a decade, was at a loss for an answer.[10] As early as 1937 Archbishop Cosmo Gordon Lang thought that he had found it, but he was far from happy with it.

> I know myself what you mean when you say such words as: 'It does not matter what people say with their lips, even if it means denying that there is a God, if they have religion in their hearts'. But phrases of this kind are obviously bound to give rise to serious misunderstanding.[11]

They are; and they did. Hewlett Johnson recognised the fine line he was treading when he acknowledged in the 1962 television programme *Head On* that: 'It all depends what you mean by God'. Although he was never very interested in theological formulations, his position seems to have become less theistic and more panentheistic as his ministry proceeded: that is, he came to see God less as an omnipotent being who 'really exists' and who controls and directs the course of human history, and more as the

summation of all that is true in the world, wherever it is found and in whatever ways it may be manifest. 'God is to me the root of all life and all reality', he wrote to Nowell in 1943, 'and to seek to know the nature of things is to seek God.'[12] Thus, he was able to say with complete sincerity that for all their rejection of formal doctrines about God, communist societies could be counted religious – Christian, even – if people were striving for a way of living consistent with the truth that was revealed in Jesus. The idea that God could be defined *only* through creeds and dogmas promulgated by religious institutions was, for Johnson, to constrain the divine in ways that were unimaginative as well as unbiblical.

It could be argued that, in doggedly pursuing this panentheistic line for more than half a century, Hewlett Johnson was ahead of his time. The post-war publication of popular books such as Paul Tillich's *The Shaking of the Foundations* and John Robinson's *Honest to God* began an unprecedented public debate about the nature and being of God that might have made Johnson's theology seem far less radical, fifty years on, than it was at the time. His views were arguably more in tune with those of reflective Christians in the early twenty-first century than in the mid twentieth century. Johnson cannot be blamed for that: indeed, he can be admired as a visionary who was ahead of his time and who paid the price at the hands of others still several steps behind him.

The deeper criticism that may be made of Hewlett Johnson's position is that his understanding of social justice, around which much of his theology revolved, embodied a rather limited view of human need. For the most part, a just and fair society for him was one in which people's material needs – for food, shelter, education, employment, health care, income maintenance and so on – were guaranteed by a state that placed service above profit, that protected the poor from exploitation by the rich, and that required everyone to contribute to the common good. These were the desiderata to which Johnson constantly returned, and of course there can be no disputing their importance for human welfare. Yet there are other equally important but less tangible elements in the matrix of human need about which he had much less to say. If people are to flourish, they need not only material security but also a social and political environment that respects their freedom and allows them to grow. They need to elect their own political representatives and hold them to account. They need a government that respects the rule of law and protects them from arbitrary arrest and imprisonment. They need the freedom of religious expression and worship. They need to accept a measure of responsibility for their own lives and to live with the consequences of their mistakes. They need an

economic environment that allows them to take risks in the hope of greater rewards. They need to feel themselves more than mere ciphers in vast national plans managed by cohorts of bureaucrats adrift on a sea of statistics. We shall never know what Hewlett Johnson would have made of the collapse of European communism in the late 1980s, but had it been revealed to him on his deathbed, he may well have been puzzled. Why, he might have asked, should people want to turn their backs on a scientific system of government that had given them such stable material conditions? Those who tore down the Berlin Wall in 1989 might have given him a familiar answer. Man cannot live by bread alone.

* * *

The second substantial charge against Hewlett Johnson is that he knowingly took a partial and blinkered view of the realities of life under the Communist dictatorships of Eastern Europe and China. His critics accuse him of ignoring (or at best minimising) the evidence of the crimes that were being committed against humanity and of gullibly accepting things at face value before passing them on uncritically to those who read his books and heard his speeches and sermons. The charge, in other words, is not only that he turned a conveniently blind eye to anything that contradicted or undermined his preconceptions but that he failed adequately to question the truth of what he was told. By compromising the intellectual duty of care expected of someone in his influential position, his words appeared far trustworthier than they really were and had a much greater impact than they merited. Johnson understood and even, to an extent, accepted this indictment when he pointed out that the job of a defence counsel is not to present a rounded and balanced view of the evidence but to put the defendant's case in the best possible light. There are others in a court of law whose job it is to press the charges and weigh the evidence. By the same token, there were plenty of writers and journalists in the mid-twentieth century who were all too willing to press the charges against Stalin and Mao Tse-tung. He, Johnson, was merely trying to correct the imbalance by presenting the case for the defence in the most favourable light.

Yet the charge against Hewlett Johnson is deeper and more enduring than that of merely correcting an imbalance. It is that, for several decades, he was a persistent and articulate apologist for Stalinism. Having (in all likelihood) accepted the hospitality of VOKS on his first visit to Russia in 1937, he continued to enjoy the largesse of a political organisation that was more concerned with enabling its clients to function as 'conduits of influence' in their own countries than with giving them a balanced view of

life in the Soviet Union. Through his largely uncritical acceptance of the material he received from VOKS, Hewlett Johnson became one of the most prominent voices of Soviet propaganda in the Christian West; and he remained beholden to VOKS long after most of the other well-known fellow-travellers had quit. Each successive visit to the Soviet Union must have made it increasingly difficult for him to retain his critical independence, and each new edition of *The Socialist Sixth of the World* must have made it harder for him to question the accuracy of its contents. By the time he was plagiarising the memorial to Stalin that was published by the British Soviet Friendship Society in 1953,[13] Hewlett Johnson had long since passed a critical point of no return.

But guilt in a criminal case usually requires *mens rea* as well as well as *actus reus* – a guilty mind as well as a guilty act. There can be little doubt that large parts of *The Socialist Sixth of the World* were lifted from material disseminated by VOKS. But was there also a guilty mind? Did Hewlett Johnson really understand that he was falling short of the intellectual responsibility that should have been his? Did he knowingly deceive his readers through, for example, his wild use of statistics, or was he himself as much a victim of mistaken trust as they were? It is here that the picture becomes muddied. It is here, too, that the contradictions in Johnson's character emerge most clearly.

On the one hand, Hewlett Johnson must have been aware of the real purposes of VOKS, at least in broad terms, and he must have realised that much of the material they generated was little more than propaganda. By the beginning of the Second World War a great deal was known in the West about the crimes against humanity that were taking place under Stalin's watchful eye, and Johnson could scarcely have failed to notice the stark contrast between reports coming out of the Soviet Union and much of what he was saying in *The Socialist Sixth of the World*. Others had certainly noticed. Bennet Cerf, an executive at Random House, had assured Victor Gollancz in 1939 that the book would be 'hooted out of court' in America,[14] and William Chamberlin dismissed it in 1941 as 'a work written in a complete factual vacuum, a Utopia projected in the author's mind and then forcible planted in the Soviet Union'.[15] Other critics concurred.[16] It is scarcely credible that Hewlett Johnson had never considered the ambiguity of what he was doing.

On the other hand, it would have been deeply at odds with Hewlett Johnson's personal morality to have knowingly and deliberately misled people. He was, more than most, an honest man who would no more condone a lie than return the abuse that was flung at him. There is, then,

a contradiction at the heart of Johnson's behaviour that can be accommodated only by hazarding some possibilities that may or may not be true. Perhaps he argued himself into a state of mind in which his stupendous self-belief distorted his judgement and blurred the boundaries between reality and imagination. Perhaps his certainty about the moral strength of his position subconsciously allowed him greater latitude in handling his evidence than, say, a scientist or a lawyer could have ventured. Perhaps he came to believe in his heart the things that he was saying even as he grasped in his head the arguments of those who doubted them. Perhaps the realisation finally dawned on him that he had reached a point at which he could no longer re-think his position without destroying himself and therefore had no option but to go on. Perhaps. But we cannot be sure. In the end there remains a contradiction.

* * *

The story of the Red Dean of Canterbury is one of both triumph and tragedy. The triumph is that his life was one of immense achievement and fulfilment. He deserves to be remembered in history as a good man, an outstanding priest and a fine Dean of two Cathedrals. Whatever view is taken of his faults and failings, Hewlett Johnson fought tenaciously for the things he believed in, and he did more in his long and active life than others might achieve in half a dozen lifetimes. He saw more, spoke more, wrote more, travelled more, experienced more, learnt more, served more, suffered more. Through his writing and speaking he touched the hearts and minds of a vast multitude of people around the world, many of whom gratefully acknowledged his moral leadership and applauded his courage in speaking out where others found it expedient to remain silent.

Johnson's life was a veritable kaleidoscope of experiences: from the slums at the bottom of the hill in Altrincham to the faded decadence of Havana; from the bombed-out deanery of war-torn Canterbury to the glittering ballrooms of the Kremlin; from the horrors of Auschwitz to the splendours of cathedral services the world over; from the bandit-infested mountains of China to the sunsets over Cardigan Bay; from the polluted streets of Manchester to the Forbidden City in Peking; from stormy meetings of the Canterbury Chapter to audiences with Stalin, Mao and Truman; from the adulation of the masses in Madison Square Garden to the scorn of the House of Lords; from blacked-out journeys around wartime England to cosseted journeys around China in a plane laid on by Chou En-lai; from the shop floor at Ashbury's to dinner with one of America's richest women; from tea with General Montgomery to cocktails with Molotov; from a

family meal in a Chinese commune to Christmas dinner with the Archbishop of Canterbury. His was an astonishing life that elicits both admiration and respect.

The tragedy is that, for all of Hewlett Johnson's achievements and fulfilments, his judgements on some of the greatest issues of his day were badly flawed and ultimately discredited; and it is these that have effectively consigned him to the footnotes of history. This is a far from dishonourable place to be, but it is less than it might have been. Time has not burnished his memory in the decades since his death, nor is it likely to do so in the future. He will probably continue to be remembered as the Red Dean of Canterbury who stubbornly supported a murderous and godless regime and who stirred up controversy wherever he went. It will probably count for little that there was so much more to his life and work than that. And herein lies the tragedy: that a man of such immense physical, moral and intellectual energy should in the end have been the architect of his own limitations. It could have been different. It should have been different. A man with his gifts and abilities should surely have left a far more imperishable memorial than the lingering incense of controversy. 'Good lives', Hewlett Johnson wrote following the death of his first wife Mary in 1931, 'are inextinguishable. They go marching on.' The sadness is that the same cannot be said with any great conviction of his own good life.

NOTES

Note on abbreviations used

A number of books appear frequently in the Notes. For those most commonly cited, the full reference is given on the first instance that the book appears, and the following abbreviated references are used for all subsequent uses:

The Fellow-Travellers	David Caute, *The Fellow-Travellers*, New Haven and London: Yale University Press, rev. ed. 1988
A History of Canterbury Cathedral	Patrick Collinson, Nigel Ramsay and Margaret Sparks, eds., *A History of Canterbury Cathedral*, Oxford: Oxford University Press, 1995
The Red Dean	Robert Hughes, *The Red Dean*, Worthing: Churchman Publishing, 1987
Searching for Light	Hewlett Johnson, *Searching for Light*, London: Michael Joseph, 1968
F J Shirley: An Extraordinary Headmaster	David L Edwards, *F. J. Shirley: An Extraordinary Headmaster*, London: SPCK, 1969
The Socialist Sixth of the World	Hewlett Johnson, *The Socialist Sixth of the World*, London: Victor Gollancz Ltd., 1939; 21st impression, October 1945.
The Soviet Power	Hewlett Johnson, *The Soviet Power*, New York: International Publishers, 1941
Western Intellectuals and the Soviet Union	Ludmila Stern, *Western Intellectuals and the Soviet Union, 1920–40*, London and New York: Routledge, 2007

CHAPTER 1 (PAGES 5–17)

1. Hewlett Johnson, *Searching for Light*, London: Michael Joseph, 1968, p. 26. Unless otherwise specified, much of the material in this chapter is taken from this source, pp. 13–38.
2. *Searching for Light*, p. 14.
3. *Searching for Light*, p. 20.
4. *Searching for Light*, p. 19.
5. *Searching for Light*, p. 18.
6. *Searching for Light*, p. 24.
7. *Searching for Light*, p. 31.

8 *Searching for Light*, pp. 30-31.
9 *Searching for Light*, p. 33.
10 *Searching for Light*, p. 21.
11 Emily Johnson to Hewlett Johnson, 7 October 1890. Archive number 6173.
12 D S Stewart to Hewlett Johnson, 27 November 1894. Archive number 6175.
13 *Searching for Light*, p. 29.
14 *Searching for Light*, pp. 29–30.
15 *Searching for Light*, p. 30.
16 Robert Hughes, *The Red Dean*, Worthing: Churchman Publishing, 1987, p. 17.
17 Hewlett Johnson, *The Soviet Power*, New York: International Publishers, 1941, p. 16.
18 *The Red Dean*, p. 20.
19 *The Soviet Power*, p. 18.
20 *Searching for Light*, p. 32.
21 Quoted in *The Red Dean*, p. 19.
22 'Testimonial from the Ashbury Railway Carriage and Iron Co.', 15 March 1898. Archive number 6220.
23 *The Soviet Power*, p. 18.
24 *Searching for Light*, p. 35.
25 *Searching for Light*, p. 35.
26 Mrs J Wykeham-Musgrave to Hewlett Johnson, 3 March 1903. Archive number 6156.
27 *The Red Dean*, p. 23.
28 *Searching for Light*, p. 36.
29 Charlie Johnson to Hewlett Johnson, 7 February 1902. Archive number 6172.
30 *Searching for Light*, p. 37.
31 *Searching for Light*, p. 37.
32 The Attestation of Johnson's ordination as Deacon in 1905 and Priest in 1906 is in archive Box 12.

CHAPTER 2 (PAGES 18–31)

1 *The Soviet Power*, p. 19.
2 *Searching for Light*, p. 47.
3 *The Soviet Power*, p. 19.
4 *Searching for Light*, p. 47.
5 *The Red Dean*, pp. 27–28.
6 Attributed to Sir Kenelm Digby (1603–1665).
7 Petition to the Local Government Board. Testimony from Hewlett Johnson and Others, 12 May 1914. Archive number 6188.
8 *Searching for Light*, p. 73.
9 *The Illustrated London News*, 25 April 1925. Archive number 6507.
10 Samuel Proudfoot to Hewlett Johnson, 1 January 1912. Archive number 6216.
11 *Searching for Light*, p. 41.
12 Spencer Hogg to Hewlett Johnson, 3 May 1914. Archive number 6190.
13 F Wainwright to Hewlett Johnson, 6 April 1919. Archive number 410.
14 William Stiff to Hewlett Johnson, 14 April 1918. Archive number 874.
15 Arthur Taylor to Hewlett Johnson, 11 June 1917. Archive number 398. Taylor made further complaints to Johnson in a second letter dated 18 June 1917. Archive number 397.

16 *Searching for Light*, p. 51.
17 *The Soviet Power*, p. 20.
18 Hewlett Johnson to the Chaplain-General, 8 August 1914. Archive number 407.
19 Herbert Bury to Hewlett Johnson, 12 March 1917. Archive number 887.
20 Herbert Bury to Hewlett Johnson, 16 March 1917. Archive number 888.
21 *Searching for Light*, p. 51.
22 Hewlett Johnson to the Chaplain-General, 8 August 1914. Archive number 407.
23 *Searching for Light*, p. 51.
24 *Altrincham Guardian*, cutting undated but contextually January 1931. Archive number 6310.
25 *Searching for Light*, p. 51.
26 Herbert Ryle to Hewlett Johnson, 6 July 1916. Archive number 821.
27 P Giles to Hewlett Johnson, 23 March 1920. Archive number 864.
28 Quoted in *Searching for Light*, p. 56.
29 *Searching for Light*, p. 57.
30 *Searching for Light*, p. 40.
31 *The Interpreter*, January 1905, Vol 1, No 1, pp. 1–2.
32 Handley Moule to Hewlett Johnson, 18 January 1905. Archive number 6177.
33 Emily (née) Johnson to Hewlett Johnson, 4 January 1912. Archive number 5672.
34 *The Red Dean*, p. 36.
35 Reg Groves, *Conrad Noel and the Thaxted Movement: an adventure in Christian Socialism*, New York: Augustus M Kelly, 1968 (republication).
36 Conrad Noel to Hewlett Johnson, 20 September 1909. Archive number 6207.
37 *The Soviet Power*, p. 21.
38 *Searching for Light*, p. 46: 'The rules of the Mothers' Union had always horrified me. Mary Magdalene would have had no chance in the Mothers' Union or kindred associations.'
39 Quoted in *The Red Dean*, p. 30.
40 *Searching for Light*, p. 46.
41 Petition to the Local Government Board. Testimony from Hewlett Johnson and Others, 12 May 1914. Archive number 6188.
42 J Critchlow to Hewlett Johnson, 11 May 1914. Archive number 6189.
43 *Searching for Light*, p. 368.
44 *Searching for Light*, p. 50.
45 *Searching for Light*, pp. 50–51.
46 *Searching for Light*, p. 84.
47 The significance of Johnson's conversation with the embassy secretary is confirmed in *Searching for Light*, p. 85: 'The dinner given by Lady Barlow brought me in touch with the Soviet Embassy in London.'
48 National Archives, File KV2/2151. P.F.R. 75 Anglo-Russian Cooperation Comm: No. 188380, 4 September 1920.
49 National Archives, File KV2/2151. Copy of M.P.O. Application, 28 August 1920.
50 National Archives, File KV2/2151. Letter sent from Scotland House, 6 September 1920.
51 See Chapter 15.

CHAPTER 3 (PAGES 32–43)

1 *Searching for Light*, p. 63.
2 *Searching for Light*, p. 64.

3 Nigel Nicholson, *King George the Fifth: his Life and Reign*, London: Constable, 1952, pp. 510–511.
4 *Searching for Light*, p. 66.
5 *Manchester City News*, 8 May 1925. Archive number 6503.
6 Hewlett Johnson, 'Boys and Girls: a Plea for Common Sense', *Manchester Evening News*, 19 May 1925. Archive number 6552.
7 *The People*, 13 January 1929. Archive number 9556.
8 *Searching for Light*, p. 66.
9 *Manchester Evening Chronicle*, 25 June 1925. Archive number 6504.
10 *The Daily Telegraph*, 4 November 1927. Archive number 9602.
11 *Daily Dispatch*, 29 December 1927. Archive number 9606.
12 *Manchester Guardian*, 19 June 1925. Archive number 6501.
13 *The Red Dean*, p. 49.
14 *Daily Express*, 30 December 1927. Archive number 6538.
15 *Manchester Evening Chronicle*, 29 December 1927. Archive number 6537.
16 *Manchester City News*, 8 May 1925. Archive number 6503.
17 Letter in *The Times*, 9 October 1929. Archive number 9627.
18 *Manchester Evening Chronicle*, 5 March 1925. Archive number 6521.
19 *Manchester Evening Chronicle*, 3 December 1925. Archive number 6566.
20 *Searching for Light*, p. 70.
21 *Salford City Reporter*, 24 September 1927. Archive number 6571.
22 *Manchester City News*, 12 November 1927. Archive number 9548.
23 Letter in *Manchester Guardian*, 8 August 1928. Archive number 6534.
24 *Manchester Guardian*, 17 December 1924. Archive number 6515.
25 *Manchester Guardian*, 19 June 1925 Archive number 6501.
26 *Manchester City News*, 16 June 1928. Archive number 9621.
27 *Manchester Guardian*, 6 December 1929. Archive number 9553.
28 *Searching for Light*, p. 77.
29 *Searching for Light*, p. 72.
30 *The Red Dean*, pp. 49–50.
31 *Searching for Light*, p. 73.
32 *Daily Dispatch*, 24 May 1926. Archive number 6525.
33 *Searching for Light*, pp. 71-2.
34 *Searching for Light*, p. 72. The reference to C.3 children cannot be clarified. Contextually, it seems to refer to a standardised score for assessing the health and physique of school-aged children.
35 *Searching for Light*, p. 75.
36 *Daily Dispatch*, page 15 December 1928. Archive number 6530.
37 *Manchester Evening Chronicle*, 30 October 1925. Archive number 6545.
38 *Daily News*, 4 January 1927. Archive number 9585.
39 *Searching for Light*, p. 89.
40 *Mother's Union Journal, Manchester Diocese*, No. 112, March 1931. Archive number 6307.
41 Quoted in *The Red Dean*, p. 55.
42 The letter has no date and no archive number.
43 Archive number 6296.
44 'Inventory and Valuation of the Antique and Modern Furniture, Pictures, Plate, Ornamental Items, Books, Linen and other Effects belonging to The Very Reverend Hewlett Johnson DD on the premises of The Deanery, 466 Bury New Road, Higher Broughton, in the County of Lancaster. Capes, Dunn & Co, Auctioneers and Valuers', 27 and 28 May 1931. Archive number 296.

45 George Edwards to Hewlett Johnson, 10 January 1931. Archive number 6315.
46 *Searching for Light*, p. 150.
47 George Edwards to Hewlett Johnson, 20 June 1927. Archive number 5703.
48 George Edwards to Hewlett Johnson, 13 July 1927. Archive number 5704.
49 *The Red Dean*, p. 53.
50 George Edwards to Hewlett Johnson, 18 August 1932. Archive number 5706.
51 J Perrin, *Menlove: the Life of John Menlove Edwards*, London: Victor Gollancz Ltd, 1985.
52 George Edwards to Hewlett Johnson, 18 August 1932. Archive number 5706.

CHAPTER 4 (PAGES 44–54)

1 See Chapter 8.
2 Hewlett Johnson to Nowell Johnson, 9 February 1940. Not numbered in the archive.
3 Hewlett Johnson to Nowell Johnson, 11 December 1942. Not numbered in the archive.
4 Patrick Collinson, Nigel Ramsay and Margaret Sparks, eds., *A History of Canterbury Cathedral*, Oxford: Oxford University Press, 1995, p. 318. Robert Hughes claimed that 'the truth of this little-known account has been vouched for to the author by a reliable Palace source.' *The Red Dean*, p. 55.
5 Ramsay MacDonald to Hewlett Johnson, 30 March 1931. Not numbered in the archive.
6 Cosmo Gordon Lang to Hewlett Johnson, 26 March 1931. Archive number 6103.
7 *Searching for Light*, p. 303.
8 *Searching for Light*, p. 180.
9 *A History of Canterbury Cathedral*, pp. 319–320.
10 A leading Fabian, Beatrice Webb, recorded in her diary in January 1906 that Gardiner had come to tea and she 'impregnated him with our views'. Quoted in *A History of Canterbury Cathedral*, p. 307.
11 Quoted in *A History of Canterbury Cathedral*, p. 321.
12 *A History of Canterbury Cathedral*, p. 319.
13 *A History of Canterbury Cathedral*, p. 317.
14 *Searching for Light*, p. 163.
15 *The Red Dean*, p. 60.
16 *Searching for Light*, p. 92.
17 Charles Andrews to Hewlett Johnson, 30 September 1931. Archive number 293.
18 *Searching for Light*, p. 94.
19 *A History of Canterbury Cathedral*, p. 320.
20 Nehru's wife, Kamala Kaul, died in February 1936. Nehru spent nine years in prison between 1921 and 1946.
21 *Searching for Light*, p. 93.
22 *Searching for Light*, p. 93.
23 Cosmo Gordon Lang to Hewlett Johnson, 16 September 1931. Archive number 6735.
24 Hewlett Johnson to Albert Schweitzer, 13 September 1931. Archive number 5831.
25 Hewlett Johnson to Albert Schweitzer, 3 October 1931. Archive number 5832.
26 Albert Schweitzer to Hewlett Johnson. Date obscured. Archive number 5834.
27 *Searching for Light*, p. 97. Edda Mussolini became the Countess of Cortellazzo and Bucarri on her marriage to the fascist propagandist Galeazzo Ciano. It is

understandable that Johnson would have wished to portray her in a prejudiced light.

28 *Searching for Light*, p. 105.
29 *Searching for Light*, facing p. 161.
30 *The Red Dean*, p. 71.
31 *Searching for Light*, p. 107.
32 Hewlett Johnson, 'Famine in China', *Manchester Guardian*, 22 April 1932.
33 *Searching for Light*, p. 111.
34 *Searching for Light*, p. 113.
35 *Searching for Light*, p. 120.
36 Evans F Carlson, *Twin Stars of China*, Westport, Conn: Hyperion Press, 1975.
37 *Searching for Light*, p. 123.
38 *The Red Dean*, p. 73.
39 *A History of Canterbury Cathedral*, p. 320.

CHAPTER 5 (PAGES 55–68)

1 See Chapter 3. Nowell Edwards was the daughter of Hewlett Johnson's first cousin George Edwards.
2 The painting is displayed in the north choir aisle of Canterbury Cathedral.
3 *The Red Dean*, p. 79.
4 Nowell Edwards to Hewlett Johnson, 2 December 1932. Archive number 5700.
5 Nowell Edwards to Hewlett Johnson, 31 October 1933. Archive number 5712.
6 *The Red Dean*, p. 79.
7 Nowell Edwards to Hewlett Johnson, 23 July 1933. Archive number 5699.
8 Nowell Edwards to Hewlett Johnson, 14 July 1933. Archive number 5726.
9 Dean of Canterbury, *Annual Report to the Canterbury Chapter, 1931–32*. Archive number 3314.
10 Samuel Bickersteth to Thory Gardiner, 18 July 1932. Archive number 7413.
11 Thory Gardiner to Hewlett Johnson, 25 May 1934. Archive number 7403.
12 This is the correct spelling of the title that, in some other cathedrals, is spelled 'verger'.
13 Hewlett Johnson to Albert Coole, 19 April 1933. Archive number 3273.
14 Albert Coole to Hewlett Johnson, 20 April 1933. Archive number 3274.
15 Hewlett Johnson to Albert Coole, 22 April 1933. Archive number 3275.
16 *Searching for Light*, p. 125.
17 Archive number 5521.
18 The order of service for the unveiling of the 'royal window' on 10 June 1933 is archive number 5505.
19 Mrs C A H Maitland to Margaret Babington, 11 January 1933. Archive number 5525.
20 Margaret Babington to Hewlett Johnson, 20 January 1933. Archive number 5522.
21 *Searching for Light*, p. 125.
22 David L Edwards, *F. J. Shirley: An Extraordinary Headmaster*, London: SPCK 1969, p. 41.
23 *Searching for Light*, pp. 125-6.
24 Arthur Luxmoore to Cosmo Gordon Lang, 26 March 1935. Archive number 7646.
25 Cosmo Gordon Lang to Hewlett Johnson, 10 April 1935. Archive number 7443.
26 *F. J. Shirley: An Extraordinary Headmaster*, p. 43. Shirley was usually called by his second name, John.

27 Cosmo Gordon Lang to Hewlett Johnson, 18 April 1935. Archive number 7654.
28 John Shirley to Hewlett Johnson, 17 April 1935. Archive number 5604.
29 John Shirley to Hewlett Johnson, 3 May 1935. Archive number 7680.
30 John Shirley to Hewlett Johnson, 6 May 1935. Archive number 7625. £1,750 in 1935 had the purchasing power of about £90,000 at today's prices.
31 Quoted in *The Red Dean*, p. 110.
32 *The Red Dean*, p. 76.
33 John Shirley to Hewlett Johnson, 4 July 1935. Archive number 7420.
34 John Shirley to Hewlett Johnson, 4 July 1935. Archive number 7420.
35 *F. J. Shirley: An Extraordinary Headmaster*, p. 21.
36 John Shirley to Hewlett Johnson, January 1936. Archive number 5599.
37 John Shirley to Hewlett Johnson, 8 February 1936. Archive number 7355.
38 John Shirley to Hewlett Johnson, 13 May 1936. Archive number 5605.
39 John Shirley to Hewlett Johnson, undated but contextually January 1937. Archive number 7295.
40 John Shirley to Hewlett Johnson, 18 May 1937. Archive number 7316.
41 John Shirley to Hewlett Johnson, 19 June 1937. Archive number 5598.
42 John Shirley to Hewlett Johnson, 9 September 1937. Archive number 5602.
43 John Shirley to Hewlett Johnson, 9 September 1937. Archive number 5602.
44 Edward Hardcastle to Hewlett Johnson, 15 September 1937. Archive number 7308.
45 Hewlett Johnson to Edward Hardcastle, 20 September 1937. Archive number 7309.

CHAPTER 6 (PAGES 69–79)

1 *Searching for Light*, p. 143.
2 Anthony Eden to Hewlett Johnson, March 1937. Archive number 194.
3 Handwritten notes of Hewlett Johnson's visit to Spain, March–April 1937. Archive numbers 169, 185 and 186.
4 *Searching for Light*, p. 144.
5 *Searching for Light*, p. 144.
6 *Searching for Light*, p. 144.
7 Handwritten text of Hewlett Johnson's radio address. Archive number 171.
8 *Feed my Lambs*. Flier for the Christian Committee for Food to Spain. Archive number 110.
9 Report of a speech given to the Canterbury Conservative Association. *The Times*, 10 May 1937. Archive number 179.
10 S E Cottam to Hewlett Johnson, 10 June 1937. Archive number 174.
11 Cosmo Gordon Lang to Hewlett Johnson, 20 April 1937. Archive number 6451.
12 Hewlett Johnson to Cosmo Gordon Lang, 24 April 1937. Archive number 6137.
13 King George VI was crowned two weeks after Hewlett Johnson's letter was written.
14 Cosmo Gordon Lang to Hewlett Johnson, 3 May 1937. Archive number 6138.
15 Hewlett Johnson to Cosmo Gordon Lang, 25 June 1937. Archive number 6142.
16 Cosmo Gordon Lang to Hewlett Johnson, 23 June 1937. Archive number 6143.
17 See Chapter 2.
18 *Searching for Light*, p. 86.
19 Ivan Maisky to Hewlett Johnson, 8 March 1963. Archive number 3441.
20 Ivan Maisky to Hewlett Johnson, 28 August 1937. Archive number 7262.
21 Ivan Maisky to Hewlett Johnson, 15 September 1937. Archive number 7264.

22 Nowell Edwards to Hewlett Johnson, 14 September 1937. Archive number 8869.
23 Hewlett Johnson to Nowell Edwards, 20 September 1937. Archive number 8838.
24 *Searching for Light*, p. 149.
25 *Searching for Light*, p. 149.
26 *Searching for Light*, p. 200.
27 *Searching for Light*, p. 213.
28 Vladimir Yakolev to Hewlett Johnson, 5 July 1956. Archive number 11189.
29 Ludmila Stern, *Western Intellectuals and the Soviet Union, 1920–40*, London and New York: Routledge, 2007, p. 158.
30 *Western Intellectuals and the Soviet Union*, p. 161.
31 Vsesoyuznoye obschestvo kul'turnykh syvazey s zagranitsey.
32 All the information about VOKS in the remaining sections of this Chapter is taken from *Western Intellectuals and the Soviet Union*, pp. 92–174. I acknowledge my entire dependence upon Lumila Stern's work for this analysis of how VOKS worked.
33 David Caute, *The Fellow-Travellers*, New Haven and London: Yale University Press, Revised Edition, 1988, p. 145.
34 Cosmo Gordon Lang to Hewlett Johnson, 22 March 1933. Archive number 6108.
35 *The Red Dean*, p. 78.
36 *Western Intellectuals and the Soviet Union*, p. 8.
37 *Western Intellectuals and the Soviet Union*, p. 124.
38 *Western Intellectuals and the Soviet Union*, p. 130.

CHAPTER 7 (PAGES 80–92)

1 Hewlett Johnson, *The Socialist Sixth of the World*, London: Victor Gollancz Ltd., 1939. All references in this chapter are to the twenty-first impression, published in October 1945.
2 *Searching for Light*, p. 155. No information is given about the source of these sale figures.
3 Victor Gollancz to Hewlett Johnson, 31 October 1939. Archive number 1291.
4 This is an estimate, based on partial data, of the number of copies printed by Victor Gollancz Ltd between 1939 and 1947.
5 *Searching for Light*, p. 155. No information is given about the source of these circulation figures.
6 United States Subversive Activities Control Board, *Herbert Brownell, Attorney General of the United States v National Council of American-Soviet Friendship*, Deposition of Dean Hewlett Johnson, Docket Number 104-53, 1954, p. 24. Not numbered in the archive.
7 *Herbert Brownell, Attorney General of the United States v National Council of American-Soviet Friendship*, p. 21.
8 *The Socialist Sixth of the World*, pp. 382-384.
9 Victor Gollancz to Hewlett Johnson, 4 October 1939. Archive number 1325.
10 Victor Gollancz to Hewlett Johnson, 8 December 1939. Archive number 1332.
11 Bennet Cerf to Victor Gollancz Limited, 11 October 1939. Archive number 1287.
12 Victor Gollancz to Hewlett Johnson, 25 October 1939. Archive number 1284.
13 Hewlett Johnson to Victor Gollancz, 30 April 1943. Archive number 9224.
14 Hewlett Johnson to Victor Gollancz, 30 April 1943. Archive number 9224.
15 *The Soviet Power*, p. xxiv.
16 *The Socialist Sixth of the World*, p. 48.

17 *The Socialist Sixth of the World*, p. 63.
18 *The Socialist Sixth of the World*, p. 80.
19 *The Socialist Sixth of the World*, p. 87.
20 *The Socialist Sixth of the World*, p. 103.
21 *The Socialist Sixth of the World*, p. 106.
22 *The Socialist Sixth of the World*, p. 217.
23 *The Socialist Sixth of the World*, p. 235.
24 *The Socialist Sixth of the World*, p. 284.
25 *The Socialist Sixth of the World*, p. 302.
26 *The Socialist Sixth of the World*, p. 367.
27 J Gilford to Hewlett Johnson, 1 February 1940. Archive number 1188.
28 John O'Meara to Hewlett Johnson, undated. Archive number 1206.
29 Quoted in *The Red Dean*, p. 109.
30 Quoted in *The Red Dean*, p. 109.
31 S R Cross, *The Christian Leader*, 12 July 1941, pp. 556–558.
32 W H Chamberlin, *Saturday Review of Religion*, 11 January 1941. Pages not numbered in the archive copy.
33 Victor Gollancz to Hewlett Johnson, 25 October 1939. Archive number 1284.
34 *The Socialist Sixth of the World*, p. 14.
35 Mr Aleshin to Hewlett Johnson, 14 December 1949. Archive number 2391.
36 Hewlett Johnson, *Joseph Stalin, by the Very Reverend Hewlett Johnson, Dean of Canterbury*, London: British Soviet Friendship Society, 1953.
37 *The Socialist Sixth of the World*, p. 384.

CHAPTER 8 (PAGES 93–110)

1 Cosmo Gordon Lang to Hewlett Johnson, 27 February 1940. Archive number 7153.
2 Hewlett Johnson to Cosmo Gordon Lang, 5 March 1940. Archive number 7151.
3 *The Times*, 13 March 1940. Quoted in *Searching for Light*, p. 159.
4 *Daily Telegraph*, 14 March 1940. Archive number 560.
5 *Daily Mail*, 14 March 1940. Archive number 560
6 *The Times*, 16 March 1940. Quoted in *Searching for Light*, p. 161.
7 M Rush to Hewlett Johnson, 16 March 1940. Archive number 470.
8 P H Newman to Hewlett Johnson, 14 March 1940. Archive number 471.
9 Sydney Palmer to Hewlett Johnson, 16 March 1940. Archive number 475.
10 H Ramsay to Hewlett Johnson, 19 March 1940. Archive number 603.
11 S Hopkinson to Hewlett Johnson, 15 March 1940. Archive number 590.
12 Lily Shearer to Hewlett Johnson, 15 March 1940. Archive number 467.
13 F Lewis Donaldson to Hewlett Johnson, 16 March 1940. Archive number 1172.
14 *A History of Canterbury Cathedral*, p. 323.
15 Archive number 6664.
16 The crux of the conflict was Crum's belief that Johnson was alienating the affections of his children and may even have been behaving improperly towards one of Crum's daughters.
17 Alex Sargent to Hewlett Johnson, 10 April 1941. Archive number 1005.
18 Hewlett Johnson to Nowell Johnson, 11 April 1941. Not numbered in the archive. 'Sargent wrote me a delightful letter concerning Crum and my attitude. He and Sopwith are peculiarly nice at present.'
19 Hewlett Johnson to Nowell Johnson, 31 August 1942. Not numbered in the archive.

20 *The Red Dean*, pp. 182–183.
21 Hewlett Johnson to Nowell Johnson, 24 October 1943. Not numbered in the archive.
22 Hewlett Johnson to Nowell Johnson, 1 November 1943. Not numbered in the archive.
23 Hewlett Johnson to Nowell Johnson, 5 November 1943. Not numbered in the archive.
24 William Temple had succeeded Cosmo Gordon Lang as Archbishop of Canterbury in 1942.
25 Hewlett Johnson to William Temple, 14 November 1943. Archive number 7859.
26 Hewlett Johnson to John Crum, 17 November 1943. Archive number 7862.
27 *F J Shirley: an Extraordinary Headmaster*, pp. 78–79.
28 *F J Shirley: an Extraordinary Headmaster*, p. 71.
29 Hewlett Johnson to Nowell Johnson, 7 April 1941. Not numbered in the archive.
30 Hewlett Johnson to Nowell Johnson, 18 February 1941. Not numbered in the archive.
31 Hewlett Johnson to Nowell Johnson, 2 April 1941. Not numbered in the archive.
32 John Shirley to Hewlett Johnson, 15 April 1943. Archive number 5589.
33 Hewlett Johnson to Nowell Johnson, 2 January 1941. Not numbered in the archive.
34 Hewlett Johnson to Nowell Johnson, 5 December 1943. Not numbered in the archive.
35 Lois Lang-Sims, *A Canterbury Tale*, Unpublished manuscript, 1997, p. 67.
36 Hewlett Johnson to Nowell Johnson, 20 March 1942. Not numbered in the archive.
37 Hewlett Johnson to Nowell Johnson, 10 June 1943. Not numbered in the archive.
38 Hewlett Johnson to Nowell Johnson, 30 May 1943. Not numbered in the archive.
39 Hewlett Johnson to Nowell Johnson, 28 November 1943. Not numbered in the archive.
40 Hewlett Johnson to Nowell Johnson, 13 July 1941. Not numbered in the archive.
41 Hewlett Johnson, *Christians and Communism*, London: Putnams, 1956.
42 *Christians and Communism*, p. 9.
43 *Searching for Light*, p. 368.
44 Matthew, 7:16.
45 Matthew, 7:21.
46 The argument is elaborated in the first sermon in *Christians and Communism*.
47 Hewlett Johnson to Nowell Johnson, 6 February 1944. Not numbered in the archive.
48 Hewlett Johnson to Nowell Johnson, 6 July 1944. Not numbered in the archive.
49 Hewlett Johnson to Nowell Johnson, 19 March 1941. Not numbered in the archive.
50 Hewlett Johnson to Nowell Johnson, 26 December 1943. Not numbered in the archive.
51 Hewlett Johnson to Nowell Johnson, 17 August 1942. Not numbered in the archive.
52 Hewlett Johnson to Nowell Johnson, 2 July 1944. Not numbered in the archive.
53 Hewlett Johnson to Nowell Johnson, 6 June 1943. Not numbered in the archive.
54 Hewlett Johnson to Nowell Johnson, 11 July 1944. Not numbered in the archive.

CHAPTER 9 (PAGES 111–125)

1 For the origin of the name Kezia see Job, 42:14.
2 *Kentish Gazette and Canterbury Press*, 20 May 1940. Archive number 8851.
3 Catherine E Williamson, *Though the streets burn*, London: Headley Bros, 1949.
4 *F. J. Shirley: An extraordinary headmaster*, p. 68.
5 *Searching for Light*, pp. 170–171.
6 *Searching for Light*, p. 403.
7 *Searching for Light*, p. 173.
8 *The Red Dean*, p. 206.
9 Victor Gollancz to Hewlett Johnson, 25 September 1939. Archive number 1295.
10 Hewlett Johnson to Nowell Johnson, 12 July 1940. Not numbered in the archive.
11 Hewlett Johnson to Nowell Johnson, 28 February 1942. Archive number 5377.
12 National Archives. File KV2/2150. Political Report Forwarded by C.C. Bristol 7. 10. 43. Reference Sub/347(8). 460/Plymouth/11,23a.
13 Alfred D'Eye to Hewlett Johnson, 3 January 1938. Archive number 1191.
14 Alfred D'Eye to Hewlett Johnson, 11 November 1948. Archive number 7912.
15 Alfred D'Eye to Hewlett Johnson, 31 December 1956. Archive number 7643.
16 Freda Watson became Freda Morton upon marrying a Danish man, but she remained in service in the Deanery throughout the war, proving to be by far the Dean's most reliable employee.
17 Hewlett Johnson to Nowell Johnson, 6 June and 11 August 1940. Not numbered in the archive.
18 Hewlett Johnson to Nowell Johnson, 9 and 12 June 1942. Not numbered in the archive.
19 Hewlett Johnson to Nowell Johnson, 26 May 1942. Not numbered in the archive.
20 Hewlett Johnson to Nowell Johnson, 30 May and 18 June 1942. Not numbered in the archive.
21 Hewlett Johnson to Nowell Johnson, 10 and 26 March 1941. Not numbered in the archive. The letter contained a pencil sketch of the relative sizes of the two eggs.
22 Hewlett Johnson to Nowell Johnson, 29 September 1941. Not numbered in the archive.
23 Hewlett Johnson to Nowell Johnson, 27 October 1941. Not numbered in the archive.
24 Hewlett Johnson to Nowell Johnson, 17 July 1942 and 8 January 1944. Not numbered in the archive.
25 Hewlett Johnson to Nowell Johnson, 22 October and 20 December 1942. Not numbered in the archive.
26 Hewlett Johnson to Nowell Johnson, 23 July 1943. Not numbered in the archive.
27 Hewlett Johnson to Nowell Johnson, 10 January 1944. Not numbered in the archive.
28 Hewlett Johnson to Nowell Johnson, 6 May 1943. Not numbered in the archive.
29 Hewlett Johnson to Nowell Johnson, 31 December 1943. Not numbered in the archive.
30 Hewlett Johnson to Nowell Johnson, 20 December 1942. Not numbered in the archive.
31 *Searching for Light*, pp. 173–174.
32 Margaret Sparks, *Canterbury Cathedral Precincts*, Canterbury: Dean and Chapter of Canterbury, 2007, p. 157.
33 Nowell Johnson to Hewlett Johnson, 20 October 1940. Not numbered in the archive.

34 Nowell Johnson to Hewlett Johnson, 27 October 1940. Not numbered in the archive.
35 Hewlett Johnson to Nowell Johnson, 25 May 1941. Not numbered in the archive.
36 Hewlett Johnson to Nowell Johnson, 8 June 1942. Not numbered in the archive.
37 Hewlett Johnson to Nowell Johnson, 12 June and 29 September 1942. Not numbered in the archive.
38 Hewlett Johnson to Nowell Johnson, 4 March 1941. Not numbered in the archive.
39 Hewlett Johnson to Nowell Johnson, 29 September 1941. Not numbered in the archive.
40 Hewlett Johnson to Nowell Johnson, 11 August 1941. Not numbered in the archive.
41 Hewlett Johnson to Nowell Johnson, 4 January 1941. Not numbered in the archive.
42 Hewlett Johnson to Nowell Johnson, 4 January and 11 January 1941. Not numbered in the archive.
43 Hewlett Johnson to Nowell Johnson, 17 July 1942. Not numbered in the archive.
44 Hewlett Johnson to Nowell Johnson, 12 July 1942. Not numbered in the archive.
45 Hewlett Johnson to Nowell Johnson, 14 January 1942, 14 May 1942, 28 September 1942, 29 September 1942, 1 January 1943. Not numbered in the archive.
46 Hewlett Johnson to Nowell Johnson, 28 January 1941. Not numbered in the archive.
47 Quoted in *The Red Dean*, p. 119.
48 Hewlett Johnson to Nowell Johnson, 17 June 1941. Not numbered in the archive.
49 Hewlett Johnson to Nowell Johnson, 23 February 1941. Not numbered in the archive.
50 Hewlett Johnson to Nowell Johnson, 9 January 1941. Not numbered in the archive.
51 Hewlett Johnson to Nowell Johnson, 29 March 1943. Not numbered in the archive.
52 Hewlett Johnson to Nowell Johnson, 30 October 941. Not numbered in the archive.
53 Hewlett Johnson to Nowell Johnson, 20 December 1941. Not numbered in the archive.
54 Hewlett Johnson to Nowell Johnson, 27 June 1943. Not numbered in the archive.
55 Hewlett Johnson to Nowell Johnson, 7 June 1941. Not numbered in the archive.
56 Nowell Johnson to Hewlett Johnson, 16 December 1942. Not numbered in the archive.
57 Hewlett Johnson to Nowell Johnson, 20 December 1942. Not numbered in the archive.
58 Hewlett Johnson to Nowell Johnson, 21 December 1942. Not numbered in the archive.
59 Hewlett Johnson to Nowell Johnson, 9 December 1942. Not numbered in the archive.
60 Hewlett Johnson to Nowell Johnson, 26 December 1942. Not numbered in the archive.
61 Hewlett Johnson to Nowell Johnson, 29 December 1942. Not numbered in the archive.
62 Hewlett Johnson to Nowell Johnson, 15 December 1942. Not numbered in the archive.
63 Hewlett Johnson to Nowell Johnson, 18 and 25 December 1941. Not numbered in the archive.

64 Hewlett Johnson to Nowell Johnson, 16 April 1941. Not numbered in the archive.
65 Nowell Johnson to Hewlett Johnson, 18 April 1941. Archive number 8580.
66 Nowell Johnson to Hewlett Johnson, 2 October 1943. Not numbered in the archive.
67 Hewlett Johnson to Nowell Johnson, 1 December 1943. Not numbered in the archive.
68 Hewlett Johnson to Nowell Johnson, 18 January 1941. Not numbered in the archive.
69 Hewlett Johnson to Nowell Johnson, 4 July 1940. Not numbered in the archive.
70 Hewlett Johnson to Nowell Johnson, 19 January 1941. Not numbered in the archive.
71 Hewlett Johnson to Nowell Johnson, 5 November 1941. Not numbered in the archive.
72 Hewlett Johnson to Nowell Johnson, 3 June 1943. Not numbered in the archive.
73 Hewlett Johnson to Nowell Johnson, 31 December 1943. Not numbered in the archive.
74 Quoted in *A History of Canterbury Cathedral*, p.327.
75 Hewlett Johnson to Nowell Johnson, 1 April 1943. Not numbered in the archive.
76 Hewlett Johnson to Nowell Johnson, 20 July 1943. Not numbered in the archive.
77 Hewlett Johnson to Nowell Johnson, 17 April 1944. Not numbered in the archive.
78 Hewlett Johnson to Nowell Johnson, 27 May 1944. Not numbered in the archive.
79 Hewlett Johnson to Nowell Johnson, 8 August 1944. Not numbered in the archive.
80 Hewlett Johnson to Nowell Johnson, 1 September 1944. Not numbered in the archive.
81 Hewlett Johnson to Nowell Johnson, 9 July 1944. Not numbered in the archive.
82 Hewlett Johnson to Nowell Johnson, 4 September 1942. Not numbered in the archive.
83 Hewlett Johnson to Nowell Johnson, 26 August 1942. Not numbered in the archive.

CHAPTER 10 (PAGES 126–138)

1 *Searching for Light*, p. 165.
2 Tate Gallery, *The Townsend Journals: An Artist's record of his time 1928–51*, London: Tate Gallery, 1976.
3 *The Townsend Journals: An Artist's record of his time 1928–51*, p. 57.
4 *Searching for Light*, p. 167.
5 *The Townsend Journals: An Artist's record of his time 1928–51*, p. 57.
6 *Searching for Light*, p. 168.
7 Quoted in *Searching for Light*, p. 168.
8 John Crum to Hewlett Johnson, 4 September 1938. Archive number 5345.
9 Hewlett Johnson to Nowell Johnson, 13 July 1942. Not numbered in the archive.
10 *The Red Dean*, p. 103.
11 Hewlett Johnson to Nowell Johnson, 8 January 1941. Not numbered in the archive.
12 Hewlett Johnson to Nowell Johnson, 24 January 1941. Not numbered in the archive.
13 Hewlett Johnson to Nowell Johnson, 30 September 1941. Not numbered in the archive.
14 Hewlett Johnson to Nowell Johnson, 4 July 1940. Not numbered in the archive.

15 Hewlett Johnson to Nowell Johnson, 14 July 1940. Not numbered in the archive.
16 Hewlett Johnson to Nowell Johnson, 19 February 1941. Not numbered in the archive.
17 Hewlett Johnson to Nowell Johnson, 29 May 1941. Not numbered in the archive.
18 Hewlett Johnson to Nowell Johnson, 2 January 1942. Not numbered in the archive.
19 Lois Lang-Sims, *A Time to be Born*, London: André Deutsch, 1971, p. 177.
20 Hewlett Johnson to John Shirley, 5 June 1942. Not numbered in the archive.
21 Hewlett Johnson to Nowell Johnson, 1 June 1942. Not numbered in the archive.
22 Hewlett Johnson to Nowell Johnson, 3 June 1942. Not numbered in the archive.
23 Hewlett Johnson to Nowell Johnson, 4 June 1942. Not numbered in the archive.
24 Hewlett Johnson to Nowell Johnson, 5 June 1942. Not numbered in the archive.
25 Hewlett Johnson to Nowell Johnson, 21 January 1943. Not numbered in the archive.
26 Hewlett Johnson to Nowell Johnson, 15 and 19 April 1943. Not numbered in the archive.
27 Hewlett Johnson to Nowell Johnson, 23 and 24 October 1943. Not numbered in the archive.
28 Hewlett Johnson to Nowell Johnson, 25 March 1944. Not numbered in the archive.
29 Hewlett Johnson to Nowell Johnson, 15 June 1944. Not numbered in the archive. The first V-1 flying bombs were launched against London on 13 June 1944.
30 Hewlett Johnson to Nowell Johnson, 18 June 1944. Not numbered in the archive.
31 Hewlett Johnson to Nowell Johnson, 24 August 1944. Not numbered in the archive.
32 Hewlett Johnson to Cosmo Gordon Lang, 5 March 1940. Archive number 7151.
33 Hewlett Johnson to Nowell Johnson, 29 March 1941. Not numbered in the archive.
34 Hewlett Johnson to Nowell Johnson, 7 June 1942. Not numbered in the archive.
35 Hewlett Johnson to Nowell Johnson, 23 May 1944. Not numbered in the archive.
36 Hewlett Johnson to Nowell Johnson, 4 March 1941. Not numbered in the archive.
37 Hewlett Johnson to Nowell Johnson, 4 June 1943. Not numbered in the archive.
38 Hewlett Johnson to Nowell Johnson, 19 May 1941. Not numbered in the archive.
39 Hewlett Johnson to Nowell Johnson, 25 September 1943. Not numbered in the archive.
40 Hewlett Johnson to Nowell Johnson, 25 May 1944. Not numbered in the archive.
41 A fine painting of the royal family's visit is displayed at the western end of the north choir aisle. Symbolically, perhaps, it shows Hewlett Johnson at the top of the pulpitum steps, isolated from all the other dignitaries.
42 Hewlett Johnson to Nowell Johnson, 3 September 1944. Not numbered in the archive.
43 *Searching for Light*, p. 181.
44 Hewlett Johnson to Nowell Johnson, 10 March 1942. Not numbered in the archive.
45 Quoted in *Searching for Light*, p. 181.
46 Hewlett Johnson to Nowell Johnson, 15 March 1942. Not numbered in the archive.
47 Hewlett Johnson to Nowell Johnson, 7 April 1942. Not numbered in the archive.
48 Hewlett Johnson to Nowell Johnson, 8 April 1942. Not numbered in the archive.
49 Hewlett Johnson to Nowell Johnson, 22 April 1942. Not numbered in the archive.

50 Hewlett Johnson to Nowell Johnson, 23 April 1942. Not numbered in the archive.
51 Hewlett Johnson to Nowell Johnson, 1 January 1941. Not numbered in the archive.
52 Hewlett Johnson to Nowell Johnson, 7 September 1941. Not numbered in the archive.
53 Hewlett Johnson to Nowell Johnson, 3 February 1944. Not numbered in the archive.
54 *Searching for Light*, p. 191.
55 Hewlett Johnson to Nowell Johnson, 3 February 1944. Not numbered in the archive.
56 Hewlett Johnson to Nowell Johnson, 3 February 1944. Not numbered in the archive.
57 Quoted in *Searching for Light*, p. 254.
58 *Searching for Light*, p. 254.
59 Hewlett Johnson to Winston Churchill, 5 July 1947. Archive number 6732.

CHAPTER 11 (PAGES 139–149)

1 Hewlett Johnson to Nowell Johnson, 25 August 1940. Archive number 8840. It is thought that Johnson gave the letter to one of his brothers who returned it after the war. It is likely that Nowell did eventually read the letter for it was in an opened envelope in the archive.
2 Hewlett Johnson to Nowell Johnson, 12 July 1940. Not numbered in the archive.
3 Hewlett Johnson to Nowell Johnson, 14 June 1941. Underlined in the original. Not numbered in the archive.
4 Hewlett Johnson to Nowell Johnson, 9 March 1941. Not numbered in the archive.
5 Nowell Johnson to Hewlett Johnson, 19 October 1940. Not numbered in the archive.
6 Nowell Johnson to Hewlett Johnson, 1 June 1942. Not numbered in the archive.
7 Nowell Johnson to Hewlett Johnson, 1 September 1941. Not numbered in the archive.
8 Nowell Johnson to Hewlett Johnson, 22 August 1941. Not numbered in the archive.
9 Hewlett Johnson to Nowell Johnson, 31 August 1941. Not numbered in the archive.
10 Johnson's petrol allowance probably fluctuated as the war progressed. In August 1941 it was 16 gallons for two months: Hewlett Johnson to Nowell Johnson, 9 August 1941. Not numbered in the archive.
11 Hewlett Johnson to Nowell Johnson, 26 January 1941. Not numbered in the archive.
12 Ministry of Fuel and Power (Petroleum Department) to Hewlett Johnson, 4 December 1942. Archive number 1134.
13 Hewlett Johnson to Nowell Johnson, 15 May 1941. Not numbered in the archive.
14 Hewlett Johnson to Nowell Johnson, 11 June 1941. Not numbered in the archive.
15 Hewlett Johnson to Nowell Johnson, 11 July 1942. Not numbered in the archive.
16 Hewlett Johnson to Nowell Johnson, 30 November 1941. Not numbered in the archive.
17 Hewlett Johnson to Nowell Johnson, 23 July 1944. Not numbered in the archive.
18 Hewlett Johnson to Nowell Johnson, 2 July 1944. Not numbered in the archive.
19 Hewlett Johnson to Nowell Johnson, 14 December 1941. Not numbered in the archive.

20 Hewlett Johnson to Nowell Johnson, 31 March 1942. Not numbered in the archive.

21 Hewlett Johnson to Nowell Johnson, 17 May 1944. Not numbered in the archive.

22 Hewlett Johnson to Nowell Johnson, 22 July 1944. Not numbered in the archive.

23 Hewlett Johnson to Nowell Johnson, 27 August 1943. Not numbered in the archive.

24 Hewlett Johnson to Nowell Johnson, 30 July 1944. Not numbered in the archive.

25 Hewlett Johnson's house at Charing, near Canterbury. Nowell and the children remained there for some time until the deanery had been fully repaired.

CHAPTER 12 (PAGES 150–162)

1 Catherine E Williamson, *Though the Streets Burn*, London: Headley Bros, 1949.

2 Hewlett Johnson to Nowell Johnson, 1 September 1944. Not numbered in the archive.

3 *A History of Canterbury Cathedral*, p. 327.

4 *Searching for Light*, p. 195.

5 Ministry of Fuel and Power (Petroleum Department) to Hewlett Johnson, 4 December 1942. Archive number 1134.

6 *Searching for Light*, p. 195.

7 Quoted in *Searching for Light*, pp. 196–197.

8 *Searching for Light*, pp. 191-192 and 200.

9 Hewlett Johnson, *Soviet Success*, London: Hutchinson and Co., 1947, p. 17. The book, which was based on Johnson's 1945 visit to the Soviet Union and Eastern Europe, was later published in America under the title *Soviet Russia Since The War*.

10 *Soviet Success*, p. 13.

11 *Soviet Success*, p. 21.

12 *Soviet Success*, p. 22. After Johnson's death in 1966 the cross was given for permanent display in Canterbury Cathedral.

13 Geoffrey Fisher to Hewlett Johnson, 8 August 1945. Archive number 6744.

14 *Soviet Success*, p. 256.

15 *Soviet Success*, pp. 247–250.

16 *Soviet Success*, p. 250.

17 *Soviet Success*, p. 250.

18 *Soviet Success*, pp. 250–251.

19 *Soviet Success*, p. 251.

20 *Soviet Success*, p. 252.

21 Archive numbers 9390 and 9391.

22 *Searching for Light*, p. 213.

23 *Soviet Success*, pp. 43–44.

24 A photograph of Johnson with Koulakovskaya is in *Soviet Success*, facing p. 32.

25 *Soviet Success*, pp. 36–38.

26 *Searching for Light*, p. 216.

27 *Searching for Light*, p. 221.

28 'Dean's Address to the Catholicos in Canterbury Cathedral, April 18th 1956.' Archive number 1390.

29 *Soviet Success*, pp. 68–75.

30 *Soviet Success*, p. 73.

31 *Soviet Success*, p. 71.

32 *Soviet Success*, p. 71.
33 *Soviet Success*, p. 71.
34 *Soviet Success*, p. 73.
35 *Soviet Success*, p. 73.
36 *Soviet Success*, p. 74.
37 *Soviet Success*, p. 75. There is some evidence that Johnson's initiative was instrumental in allowing Russian women to join their English husbands in Britain. Archive number 2934.
38 *Soviet Success*, p. 75.
39 *Searching for Light*, p. 242–245.
40 *Searching for Light*, pp. 245–246.

CHAPTER 13 (PAGES 163–175)

1 *Searching for Light*, p. 248.
2 National Archives. File KV2/2152. C.C. (52) 67th. Extract from the Conclusions of a Meeting of the Cabinet held on Thursday, 10 July 1952.
3 *Searching for Light*, p. 249.
4 Quoted in Merle Miller, *Plain Speaking: An Oral Biography of Harry S Truman*, New York: Berkley Books, 1974, p. 370.
5 *Searching for Light*, p. 250.
6 *Searching for Light*, p. 250.
7 Hewlett Johnson to Nowell Johnson, circa November 1946. Not numbered in the archive.
8 David Caute, *The Fellow-Travellers*, New Haven and London: Yale University Press, 1988, p. 290.
9 Sherwood Eddy to Hewlett Johnson, 26 May 1937. Archive number 243.
10 *Time*, 7 February 1949. Archive number 8904.
11 *Searching for Light*, p. 267.
12 Howard Melish to Hewlett Johnson, 27 December 1948. Archive number 939.
13 *Searching for Light*, p. 265. 'At best, the members of the Chapter were coldly correct. For the rest perhaps it is best to say little; nor to quote the many hurtful manoeuvres, intrigues and actions which took place. I felt the un-Christian atmosphere in the Chapter all the time.'
14 Geoffrey Fisher to Hewlett Johnson, 8 August 1945. Archive number 6744.
15 Geoffrey Fisher to Hewlett Johnson, 26 July 1947. Archive number 6740.
16 Hewlett Johnson to Geoffrey Fisher, 30 July 1947. Archive number 6739.
17 *Daily Telegraph*, 17 December 1947. Archive number 990.
18 Geoffrey Fisher to Hewlett Johnson, 10 December 1947. Archive numbers 6742 and 6743.
19 *Daily Telegraph*, 17 December 1947. Archive number 990.
20 Geoffrey Fisher to Hewlett Johnson, 27 December 1947. Archive number 6471.
21 Kangol Wear Limited to Hewlett Johnson, 16 June 1948. Archive number 8571.
22 John L Murphy to Hewlett Johnson, 27 August 1948. Archive number 7959.
23 Ralph Barton Perry to Hewlett Johnson, 17 September 1948. Archive number 993.
24 'Ad Hoc Committee of Welcome to Dean Johnson.' Undated. Archive number 994.
25 E D Kuppinger to Hewlett Johnson, 20 October 1948. Archive number 938.
26 *Searching for Light*, p. 269.
27 *New York Eagle*, 17 November 1948. Archive number 6647.
28 *Tucson, Arizona, Citizen*, 18 November 1948. Archive number 6631.

29 *Journal-American*, 14 December 1948. Archive number 6608.
30 *New York Mirror*, 15 November 1948. Archive number 6635.
31 *Daily News*, 15 November 1948. Archive number 6642.
32 *Gary Post-Tribune*, 24 November 1948. Archive number 6646.
33 Unidentified Minneapolis newspaper, 13 November 1948. Archive number 6629.
34 *Manchester Guardian*, 13 January 1949. Archive number 3507.
35 *Searching for Light*, p. 271.
36 *Searching for Light*, p. 272.
37 Geoffrey Fisher to Hewlett Johnson, 15 October 1948. Archive number 10055.
38 Jan Masaryk was a Czechoslovak politician and diplomat who was Ambassador to Britain at the time of the Munich agreement in 1938 and later Foreign Minister of Czechoslovakia from 1940 to 1948.
39 Hewlett Johnson to Geoffrey Fisher, 18 October 1948. Archive number 7911.
40 Geoffrey Fisher to Hewlett Johnson, 1 November 1948. Archive number 6382.
41 Cosmo Gordon Lang to Hewlett Johnson, 3 May 1937. Archive number 6138.
42 Hewlett Johnson to Geoffrey Fisher, 29 December 1948. Archive number 6383.
43 Geoffrey Fisher to Hewlett Johnson, 18 January 1949. Archive number 10,054.

CHAPTER 14 (PAGES 176–188)

1 *Searching for Light*, p. 272. In this account, Johnson omitted the dolls' facility for relieving themselves.
2 Victor Kravchenko, *I Chose Freedom*, Piscataway, New Jersey: Transaction Publishers, 1988.
3 Konni Zilliacus to Hewlett Johnson, 15 February 1949. Archive number 2473.
4 Johnson's typewritten testimony is archive number 2249.
5 Hewlett Johnson, *Soviet Success*, London: Hutchinson and Co., 1947.
6 Hewlett Johnson to Konni Zilliacus, 4 March 1949. Archive number 2474.
7 The Patriarch's statement is quoted in: Hewlett Johnson to John W Darr, 4 March 1949. Archive number 3503.
8 'Three francs for Kravchenko: Appeals court in Paris reduces award to Russian author', *New York Times*, 8 February 1950, p. 5.
9 *Searching for Light*, p. 274.
10 Phillip Deery, 'The dove flies East: Whitehall, Warsaw and the 1950 peace congress', *The Australian Journal of Politics and History*, Vol 48, No 4, December 2002, pp. 449–468.
11 *Searching for Light*, p. 257.
12 See Chapter 16.
13 Pope Pius XII, *Acerrimo Moerore*, 2 January 1949.
14 F D Fodor, Letter in the *Daily Telegraph*, 9 February 1949. Archive number 2276.
15 Hewlett Johnson to John Darr, 4 March 1949. Archive number 3503.
16 Hewlett Johnson, Letter in the *Kentish Gazette and Canterbury Press*, 15 February 1949. Archive number 2262. The 'Yellow Book' eventually became available for consultation on the Beaney Library premises: F Higenbottam to Hewlett Johnson, 11 March 1949. Archive number 2213.
17 C H de Laubenque, Letter in the *Kentish Gazette and Canterbury Press*, 25 February 1949. Archive number 2260.
18 *Searching for Light*, p. 275.
19 The World Peace Council was renamed at the Rome meeting from the former World Committee of Partisans for Peace that had been created at the 1949 World Peace Congress in Paris.

20 *Searching for Light*, p. 275.
21 Hewlett Johnson to J C Hardwick, 10 January 1950. Archive number 2209.
22 *Searching for Light*, p. 276.
23 Johnson's daughter Kezia confirms the truth of the story.
24 *The Fellow-Travellers*, p. 1.
25 The poster is displayed on: www.reasoninrevolt.net.au
26 *Searching for Light*, p. 277.
27 Australian Peace Congress Programme 1950. www.reasoninrevolt.net.au
28 *Searching for Light*, p. 278.
29 *Searching for Light*, p. 280.
30 *Searching for Light*, p. 280.
31 *Searching for Light*, p. 280.
32 Geoffrey Fisher to Hewlett Johnson, 27 May 1950. Archive number 6730.
33 Hewlett Johnson to Mary Jennison, 5 June 1950. Archive number 4428.
34 *Searching for Light*, pp. 282-284.
35 *Searching for Light*, pp. 283–284.
36 *Searching for Light*, p. 284.
37 *Searching for Light*, p. 284.
38 Quoted in: 'The dove flies East: Whitehall, Warsaw and the 1950 peace congress', p. 452.
39 Quoted in: 'The dove flies East: Whitehall, Warsaw and the 1950 peace congress', p. 454.
40 Quoted in: 'The dove flies East: Whitehall, Warsaw and the 1950 peace congress', p. 458.
41 Secret Cablegram from the Australian Department of External Affairs to the High Commissioner's Office London, 15 November 1950, ref MD/MCG. Displayed on: www.naa.gov.au
42 *Searching for Light*, p. 285.

CHAPTER 15 (PAGES 189–202)

1 *Searching for Light*, p. 398.
2 Of the individual winners of the Nobel Peace Prize between 1945 and 1960, five were American, three were British, and one each was Swiss, Canadian, Belgian and South African.
3 *Searching for Light*, p. 287.
4 National Archives, File KV2/2152. C.C. (52) 67th, Extract from the Conclusions of a Meeting of the Cabinet held on Thursday, 10 July 1952, paragraph 9.
5 Extract from the Conclusions of a Meeting of the Cabinet held on Thursday, 10 July 1952, paragraph 9.
6 The insured value of the artefacts that Mary bequeathed to Hewlett would be worth about £200,000 at today's prices. See Chapter 3.
7 Hewlett Johnson to Nowell Johnson, 5 July 1940. Not numbered in the archive.
8 Hewlett Johnson to Nowell Johnson, 16 July 1940. Not numbered in the archive.
9 Hewlett Johnson to Nowell Johnson, 31 January 1942. Not numbered in the archive.
10 Hewlett Johnson to J Arthur Rank, 27 November 1956. Archive number 5846.
11 *Searching for Light*, p. 282.
12 Edgar Snow, *Red Star Over China*, London: Victor Gollancz Ltd., 1937. It has since been revised and reprinted many times.

13 *The Fellow-Travellers*, p. 228.
14 Jung Chang and Jon Halliday, *Mao. The Unknown Story*, London: Vintage, 2007, p. 235.
15 Quoted in: *Mao. The Unknown Story*, p. 235.
16 Britain-China Friendship Association, *Press Statement by Dr Hewlett Johnson, Dean of Canterbury, 8 July 1952*. Archive number 1845.
17 *Searching for Light*, p. 308.
18 *Searching for Light*, p. 309.
19 *Searching for Light*, p. 313.
20 *Searching for Light*, pp. 316–321.
21 *Searching for Light*, p. 316.
22 *Searching for Light*, p. 320.
23 *Searching for Light*, p. 318.
24 *Searching for Light*, p. 317.
25 Manifesto Issued by Chinese Catholics Protesting Against the American Bacteriological Warfare, 25 June 1952. Archive number 5867.
26 *Press Statement by Dr Hewlett Johnson, Dean of Canterbury, 8 July 1952*, p. 4.
27 *Press Statement by Dr Hewlett Johnson, Dean of Canterbury, 8 July 1952*, p. 5.
28 *Press Statement by Dr Hewlett Johnson, Dean of Canterbury, 8 July 1952*. p. 4.
29 Kenneth L Enoch, *The Evidence of Two American Airmen*, 8 April 1952, p. 3. Archive number 5852.
30 *Searching for Light*, p. 324.
31 Hewlett Johnson, *I Appeal*, London: Britain-China Friendship Association, July 1952.
32 John Junor, 'This time he has overstepped it', *Sunday Express*, 6 July 1952.
33 John Profumo to Hewlett Johnson, 6 July 1952. Archive number 1760.
34 John Baker White to Hewlett Johnson, 8 July 1952. Archive number 1719.
35 *Parliamentary Debates (Hansard)*, Fifth Series, House of Commons, Volume 503, 1952, cols. 1787–1788.
36 *Parliamentary Debates (Hansard)*, Fifth Series, Volume CLXXVII, House of Lords, Official Report 15 and 16 George VI and 1 Elizabeth II, col. 1116.
37 House of Lords, col. 1118.
38 House of Lords, col. 1120.
39 House of Lords, col. 1123.
40 House of Lords, col. 1124.
41 House of Lords, col. 1125.
42 House of Lords, col. 1126.
43 House of Lords, col. 1130.
44 House of Lords, col. 1159.
45 House of Lords, cols 1163 – 1164.
46 Extract from the Conclusions of a Meeting of the Cabinet held on Thursday, 10 July 1952.
47 *Daily Graphic and Daily Sketch*, 16 July 1952. Archive number 7473.
48 I am grateful to Fred Whitemore for suggesting these similarities.
49 *The Fellow-Travellers*, p. 262. Caute did not cite the source of the story.
50 Joseph Needham to Hewlett Johnson, 4 February 1962. Archive number 5873.
51 *Mao. The Unknown Story*, p. 458n.

CHAPTER 16 (PAGES 203–216)

1 *Searching for Light*, facing p. 193.
2 *The Red Dean*, pp. 172–188.
3 *The Red Dean*, p. 173.
4 I am grateful to an informant who does not wish to be named for this arresting phrase.
5 *The Red Dean*, p. 184.
6 *The Red Dean*, p. 183.
7 Quoted in *The Red Dean*, p. 184.
8 *Searching for Light*, p. 343.
9 John Shirley to Hewlett Johnson, 12 July 1956. Archive number 7675. 'Friends! As regards the attitude of some of them, I feel the letter R might be omitted.'
10 John Shirley to Hewlett Johnson, 22 March 1954. Archive number 7672.
11 John Shirley to Hewlett Johnson, 20 July 1956. Archive number 7673.
12 Hewlett Johnson to Alfred D'Eye, 11 March 1957. Archive number 1389.
13 *Searching for Light*, p. 332.
14 Julian Bickersteth, John Shirley, Alex Sargent and Aubrey Standen to Hewlett Johnson, 18 February 1956. Archive number 1378.
15 See Chapter 14.
16 *Searching for Light*, p. 369. The sermon was preached on 3 November 1956, the day before the Soviet invasion of Hungary. The British and French invasion of Egypt had begun five days earlier on 29 October 1956.
17 *The Red Dean*, p.170.
18 *Searching for Light*, p. 370.
19 Hewlett Johnson, Notes for a talk on Hungary and the Soviet Union, 1956. Archive number 7269.
20 The petition is archive number 5606.
21 Minutes of the Meeting of the Governing Body of the King's School, 26 November 1956. Archive number 7634.
22 Minutes of the Meeting of the Governing Body of the King's School, 14 December 1956. Archive number 6692.
23 Geoffrey Fisher to Hewlett Johnson, 13 February 1957. Archive number 6720.
24 Minutes of the Meeting of the Governing Body of the King's School, 15 February 1957. Archive number 6687.
25 Somerset Maugham and Hewlett Johnson were born on the same day in 1874.
26 The Dean's Statement at the Meeting of the Governing Body of the King's School, 15 February 1957. Appended to archive number 6687.
27 J G Pemboke to Hewlett Johnson, 16 February 1957. Archive number 6689.
28 Geoffrey Fisher to Hewlett Johnson, 22 February 1957. Archive number 6690.
29 Hewlett Johnson to Geoffrey Fisher, 26 February 1957. Archive number 6722.
30 Geoffrey Fisher to Hewlett Johnson, 4 March 1957. Archive number 6765.
31 Hewlett Johnson to Geoffrey Fisher, 9 March 1957. Archive number 6771.
32 Minutes of the Meeting of the Governing Body of the King's School, 2 April 1957. Archive number 1377.
33 *Searching for Light*, p. 371.
34 Hewlett Johnson to Geoffrey Fisher, 12 April 1956. Archive number 6752.
35 *The Red Dean*, p. 163.
36 Geoffrey Fisher to Hewlett Johnson, 10 April 1956. Archive number 6751.
37 Hewlett Johnson to Geoffrey Fisher, 21 April 1956. Archive number 6753.

38 *Searching for Light*, p. 347.
39 Simon Sebag Montefiore, *Stalin: The Court of the Red Star*, London: Phoenix, 2004, p. 669.
40 The sermon is archive number 7624.
41 *Searching for Light*, p. 333.
42 *Searching for Light*, p. 397.
43 Archive number 9834.
44 John Shirley to Hewlett Johnson, 26 May 1959. Archive number 7627.

CHAPTER 17 (PAGES 217–229)

1 *Searching for Light*, p. 334.
2 *Searching for Light*, p. 338.
3 *Searching for Light*, p. 342.
4 Hewlett Johnson, *The Upsurge of China*, Peking: New World Press, 1961, p. 3.
5 Vladimir Yakolev to Hewlett Johnson, 5 July 1956. Archive number 11189. Johnson tried, unsuccessfully, to have Alfred D'Eye included in the invitation.
6 *The Upsurge of China*, pp. 9–11. In spite of describing in some detail how the visit was planned and acknowledging the help of those who had made it possible, Johnson revealed nothing about its organisation or funding. There is a reference (p. 10) to visiting 'Headquarters' in Peking for administrative reasons, but no indication of the organisation in question.
7 *Searching for Light*, p. 350.
8 *Searching for Light*, p. 352.
9 *Searching for Light*, p. 364.
10 See Chapter 4.
11 See Chapter 15.
12 See Chapter 7.
13 *Searching for Light*, pp. 373–377.
14 *Searching for Light*, p. 374.
15 *Searching for Light*, p. 375.
16 See Chapter 12.
17 *Searching for Light*, p. 377.
18 *Searching for Light*, p. 382.
19 Anna Aslan to Hewlett Johnson, 5 February 1960. Archive number 1590.
20 Hewlett Johnson to Anna Aslan, 15 July 1959. Archive number 1584.
21 Anna Aslan to Hewlett Johnson, 5 February 1960. Archive number 1590.
22 *Searching for Light*, pp. 384–392.
23 *Searching for Light*, p. 385.
24 *Searching for Light*, p. 386.
25 *Searching for Light*, p. 388.
26 *Searching for Light*, pp. 390 and 391.
27 *Searching for Light*, p. 398.
28 *Searching for Light*, pp. 410–416.
29 See Chapter 14.
30 *Searching for Light*, p. 411.
31 *Searching for Light*, p. 412.
32 *Searching for Light*, p. 413.
33 Che Guevara was executed in Bolivia in 1967 after being captured by Bolivian forces assisted by the CIA.

34 *Searching for Light*, p. 413.
35 The notes are in an unmarked box in the archive.
36 Hewlett Johnson to the Editor, *International Affairs*, 26 March 1964. Archive number 11186.
37 *Searching for Light*, pp. 418–430.
38 *Searching for Light*, p. 418.
39 *Searching for Light*, p. 425.
40 *Searching for Light*, p. 429.
41 *Searching for Light*, p. 430.

CHAPTER 18 (PAGES 230–241)

1 Derek Ingram Hill to Hewlett Johnson, 12 June 1961. Archive number 1595.
2 Steven M Miner, *Stalin's Holy War: Religion, Nationalism and Alliance Politics 1941–1945*, Chapel Hill and London: The University of North Carolina Press, 2003.
3 Dianne Kirby, 'The Archbishop of York and Anglo-American Relations During the Second World War and Early Cold War, 1942–1955', *Journal of Religious History*, 23 (3), 1999, pp. 327–34.
4 *A History of Canterbury Cathedral*, p. 331.
5 Geoffrey Fisher to Hewlett Johnson, 16 January 1961. Archive number 6769.
6 See Chapter 15.
7 Hewlett Johnson to Geoffrey Fisher, 19 January 1961. Archive number 6770.
8 Geoffrey Fisher to Hewlett Johnson, 6 April 1961. Archive number 6768.
9 Geoffrey Fisher to Hewlett Johnson, 7 June 1961. Archive number 2783.
10 See Chapter 10.
11 Alex Sargent to Hewlett Johnson, 16 February 1961. Archive number 1448.
12 *A History of Canterbury Cathedral*, p. 329.
13 *Searching for Light*, p. 403.
14 Quoted in *The Red Dean*, p. 195.
15 Quoted in *The Red Dean*, p. 194.
16 *Searching for Light*, pp. 404–405.
17 *The Red Dean*, p. 196.
18 *Searching for Light*, p. 407.
19 Bernard Fielding Clarke to the editor of *Church Times*, 14 January 1963. Archive number 4233.
20 The editor of *Church Times* to Bernard Fielding Clarke, 15 January 1963. Archive number 4234.
21 Hewlett Johnson to Geoffrey Fisher, 14 February 1963. Archive number 8453.
22 *The Red Dean*, p. 197.
23 Barclays Bank, Canterbury to Hewlett Johnson, 27 August 1962. Archive Box 13.
24 Barclays Bank, Canterbury to Hewlett Johnson, 12 July 1962. Archive Box 13.
25 The Church of England Pensions Board to Hewlett Johnson, 10 August 1962. Archive Box 13.
26 Barclays Bank, Canterbury to Hewlett Johnson, 21 February 1962. Archive Box 13.
27 Inventory and Valuation of Furniture and Furnishings at the Deanery, The Precincts, Canterbury Cathedral, The Property of the Very Revd. Hewlett Johnson, 23 April 1963. Archive Box 13.
28 CBG to Hewlett Johnson, 4 June 1963. Archive Box 13.
29 Hewlett Johnson to Kathleen Epstein, 30 October 1963. Archive number 8412.

30 *The Red Dean*, p. 199.

31 Yves Cholière and N Matkovsky to Hewlett Johnson, 6 May 1964. Archive number 7273.

32 *Searching for Light*, p. 434.

33 *Searching for Light*, p. 435.

34 *The Red Dean*, p. 200.

CHAPTER 19 (PAGES 242–251)

1 *The Fellow-Travellers*, p. 263.

2 *F. J. Shirley: An Extraordinary Headmaster*, pp. 78–79.

3 *The Red Dean*, p. 202.

4 Quoted in: *The Red Dean*, p. 203.

5 *Searching for Light*, p. 368.

6 Donald Soper, *Tribune*, 28 October 1966. Quoted in *British-Soviet Friendship*, December 1966, p. 8.

7 Amos, 5:24.

8 See Chapter 7.

9 Quoted in: Hewlett Johnson to L Fernsworth, 8 September 1962. Archive number 8473.

10 Ivan Maisky to Hewlett Johnson, 8 March 1963. Archive number 3441.

11 Cosmo Gordon Lang to Hewlett Johnson, 20 April 1937. Archive number 6451.

12 Hewlett Johnson to Nowell Johnson, 28 November 1943. Not numbered in the archive.

13 Hewlett Johnson, *Joseph Stalin, by the Very Reverend Hewlett Johnson, Dean of Canterbury*. See Chapter 7.

14 Bennet Cerf to Victor Gollancz Limited, 11 October 1939. Archive number 1287.

15 W H Chamberlin, *Saturday Review of Religion*, 11 January 1941. Pages not numbered in the archive copy.

16 See Chapter 7.

ACKNOWLEDGEMENTS

I am deeply appreciative of the encouragement that Hewlett Johnson's daughters, Kezia Noel-Paton and Keren Barley, and their husbands, Duncan Noel-Paton and Simon Barley, have given to me in writing this book. It could not have been done without their understanding and support. I am particularly grateful to them for their kind permission in allowing me to quote passages from the letters of Hewlett and Nowell Johnson and to reproduce extracts from *Searching for Light*, *The Socialist Sixth of the World*, *The Soviet Power*, *The Upsurge of China*, *Christians and Communism* and *Soviet Success*. Photographs in which they own the copyright are reproduced with their permission. The University of Kent at Canterbury, which owns the Hewlett Johnson archive, has kindly given permission for it to be used for this purpose. I would like to record my grateful thanks to the staff in the Special Collections of the Templeman Library at the University without whose interest and skill the archive could never have been tamed to the extent it has been: Sue Crabtree, Jane Gallagher, Steve Holland, Carole Pickaver and Chris Ward.

The process of producing the book has been smoothed by a number of key people involved in it. I would like to express my particular appreciation of the parts played by the Dean of Canterbury, the Very Reverend Robert Willis, the Receiver General of Canterbury Cathedral, John Meardon, the Cathedral Archivist, Cressida Williams, and the Director of Canterbury Cathedral Enterprises, Chris Needham. Malcolm Imrie did the copy-editing with great skill, and Oliver Craske of Scala Publishers co-ordinated the final stages of the production process with patience, courtesy and great deal of expertise.

In writing the book I have received a great deal of help and encouragement from many people, and I am most grateful for their various contributions. It would be invidious to rank them according to the magnitude or value of their help, so I simply list them in alphabetical order. I would, however, like to express my particular thanks to Fred Whitemore who read the entire book in draft form and whose observations on the political contexts of Hewlett Johnson's life were unfailingly helpful and constructive.

My thanks also go to Mary Ardley, David Ayers, Matthew Barley, Janet Barlow, Philip Boobyer, Gillian Butler, Monica Headley, Robert Hughes, Lois Lang-Sims, Kinn McIntosh, Ruth Matthews, David Pentin, Richard Sakwa, Joy Saynor, Bishop Malkhaz Songulashvili and Ludmila Stern. None bears any responsibility for whatever shortcomings, inaccuracies or imperfections the book may contain.

<div align="right">
John Butler

Canterbury

July 2011
</div>

CREDITS

Extracts from the letters of Archbishops Cosmo Gordon Lang and Geoffrey Fisher are reproduced by permission of Lambeth Palace; extracts from the letters of Canon Frederick John Shirley are reproduced by permission of Janet Barlow; extracts from the letters of Alfred D'Eye are reproduced by permission of Joy Saynor; extracts from *The Red Dean* (Churchman Publishing, 1987) are reproduced by permission of Robert Hughes. Material in National Archive files KV2/2151 and KV2/2152 is quoted with the permission of the National Archives.

Pages 172–173: Extract from article in *The Manchester Guardian* by Alistair Cooke on Hewlett Johnson, published in 1948, reprinted by permission of the ESTATE OF ALISTAIR COOKE

The following are acknowledged for their kind permission to reproduce images:

Plates 15, 20–24, 41 and pages ii and vi: Courtesy of Kezia Noel-Paton and Keren Barley
26, 31, 46, 69: Time & Life Pictures/Getty Images
32: The Times/NI Syndication
33: Copyright Fisk Moore. Used with permission
40: Courtesy Ava Helen and Linus Pauling Papers, Oregon State University Libraries
47: Getty Images
57: Science and Society Picture Library
67: Matthew Barley
68: John Butler

All other illustrations were kindly supplied courtesy of Special Collections, Templeman Library, University of Kent. Additional credit information is as follows:

Plate 2: Copyright Kezia Noel-Paton and Keren Barley
12, 48: Copyright Fisk Moore. Used with permission
34: Daily Express
38: Maria Bordes
42: Pictorial Press
53: Evening Standard
60: BIPPA
61: BBC

INDEX

Note: The initials HJ are for Hewlett Johnson, MJ for Mary Johnson, NJ for Nowell Johnson